FORESTS FOREVER

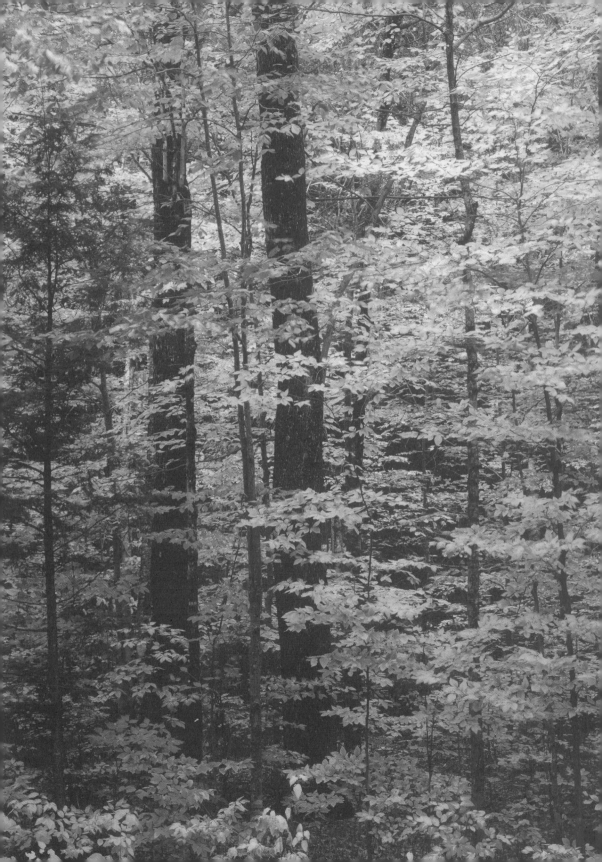

FORESTS FOREVER

Their Ecology, Restoration, and Protection

BY JOHN J. BERGER

WITH A FOREWORD BY CHARLES E. LITTLE

The Center for American Places
at Columbia College Chicago
in association with
Forests Forever Foundation
San Francisco

Center Books on Natural History
George F. Thompson, series founder and director

The Center for American Places at Columbia College Chicago
600 South Michigan Avenue
Chicago, IL 60605–1996, U.S.A.
www.americanplaces.org

Distributed by the University of Chicago Press
www.press.uchicago.edu

16 15 14 13 12 11 10 09 08 1 2 3 4 5

Library of Congress Cataloging-in-Publication Data
Berger, John J., 1945-
 Forests forever : their ecology, restoration, and protection / by John J. Berger ; with a
foreword by Charles E. Little. – 1st ed. p. cm. – (Center books in natural history ; 2)
 Includes bibliographical references and index.
 ISBN 978-1-930066-51-9 (clothbound) – ISBN 978-1-930066-52-6 (pbk.)
 1. Forests and forestry–United States. 2. Forest ecology–United States. 3. Forest con-
servation–United States. 4. Forest restoration–United States. I. Title. II. Series.

 SD143.B46 2007 2008
 333.750973–dc22
 2007026143

ISBN 10: 1-930066-51-1 (hardcover)
ISBN 13: 978-1-930066-51-9 (hardcover)
ISBN 10: 1-930066-52-x (paperback)
ISBN 13: 978--1-930066-52-6 (paperback)

To my children, Daniel and Michael:
May the forest practices we choose
assure splendid, healthy forests
for all future generations' enjoyment

"Our current treatment of the forest is radical —
destruction of forest ecosystems for short-term benefits."

—Herb Hammond
 Seeing the Forest Among the Trees (1991)

CONTENTS

Galleries I, II, III, and IV follow pages 10, 42, 122, and 202.

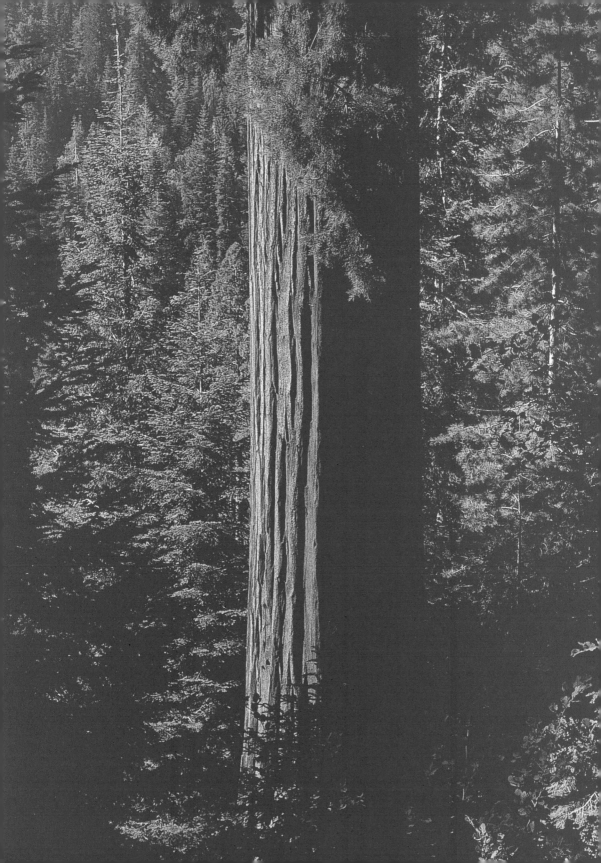

FOREWORD

BY CHARLES E. LITTLE

IN WASHINGTON STATE, not far from Sedro Woolley, southeast of Belling-ham, lies a small patch of old-growth forest rescued from clearcutting and now owned by the Lummi Nation. According to Cha-da-ska-dum, a tribal elder now deceased whose leadership was essential to the preservation of this forest, the trees are called "the standing people." As opposed, one presumes, to the walking people, some of whom carry chainsaws.

"As I walked in the lush undergrowth of the old-growth trees," wrote Cha-da-ska-dum, "a gentle breeze drifted through . . . and far away I could hear the words of the old ones saying to stop the destruction of the earth. All things are connected."

To preserve the standing people, according to Cha-da-ska-dum, is to preserve the earth. To destroy them is to destroy the earth, for all the things are connected.

I had a chance to visit Cha-da-ska-dum shortly before his death. He was lying on a hospital gurney, in pain from the angina that gripped his heart. And yet he took my hand and begged me to visit his forest as a way to understand what it meant as a natural system and as a way to understand something about myself. And so I did, in the company of Xwám-ik-sten, a young biologist and Cha-da-ska-dum's protégé. From Xwám-ik-sten I learned how the forest provided not only the great canoe cedars (among other denizens), but also shade to Arlecho Creek, which feeds a major salmon hatchery on the Skagit River, the Skagit emptying into Puget Sound, gateway to the vast Pacific where the salmon smolts (young salmon ready for the sea) go to reach maturity. The tree-shading is a necessity for the hatchery since the smolt cannot tolerate water warmer than fifty-eight degrees. No shade, no salmon. Conservationists and ecologists call such essential natural interrelationships "ecological services," and forests provide them in abundance.

For the salmon and cedar tribes of the Northwest, the ecological serv-ices of forests have spiritual as well as practical aspects. "Old growth holds a lot of stories," Xwám-ik-sten told me, "a lot of songs. It is a church. I pray for the safety of those trees." But one doesn't have to be a Lummi Indian like Xwám-ik-sten and Cha-da-ska-dum to experience such senti-ments. The trees—the standing people—can bring solace and wisdom even to the most suburbanized, SUV-driving paleface. Surely it would take a special kind of numbness to walk through Muir Woods, say, north of San Francisco, and not feel as if one were in a cathedral. Or not to be glad-dened by the Vermont woods of autumn, alight with the reds and ochers of the season. Or not to sense the mystery of those remnant bottomland hardwoods of the Southeast where the elusive Ivory-bill calls, or so some think, as if from the depths of something primordial.

This is why so many citizens of the United States of America do not casually accede to the demands of forest-destroyers, which is to say those who cannot see standing people in towering trees, but only board feet of lumber to be made horizontal as efficiently as possible, trucked down mountains in blatting semis, and then milled into two-by-fours and rafters and flooring strips and plywood.

Historically, native forests have been leveled for many reasons—for empire, for fear of the supernatural, for defense against marauders, for a place to plant crops. Such purposes, though perhaps misguided in some epic instances and taken to excess, as in the massive forest clearing of the nineteenth century in the American heartland and Upper Midwest, are nevertheless understandable. But, today, the destruction of forests simply for *money* is utterly unheroic and, in a way, unforgivable. The wood-waste in this country is, not to put too fine a point on it, obscene.

In this book, the reader will learn many things, including the system-atic deceptions of industrial forestry. The reader will also be furnished with the informational tools needed for the fight to save the forests—as well as to improve them and even recreate them. At the same time, we sus-pect that this is a wholly existential task. How can mere citizens forestall or modify the juggernaut of commercial forestry? And yet the task is, withal, valiant, humanizing, and sometimes even effective.

An image I cannot get out of my mind is of an industry goon-squad member pulling back the eyelid of one of the "Redwood Rabbis" who had gathered nonviolently to protest the violent destruction of coast redwoods in California. The reason for pulling back the eyelid was to apply pepper

spray where it would cause the most pain and permanent damage. To my knowledge, this horrid scene appeared only once on the evening news, and it was never aired again. Oddly (or perhaps appropriately), some parts of this grove of ancient trees were, in fact, preserved. The sacrifice of those gentle protesters had the effect of consecrating this forest. A sacred grove had been declared.

The idea of the sacred grove — which we ignore at our peril — is, of course, ancient, predating the orthodoxies of organized religion. But it is yet a powerful idea that must inform those who would save our trees and forests.

As the great anthropologist James Frazer points out, the old Celtic word for sanctuary is "identical in origin and meaning with the Latin word *nemus*, a grove or woodland glade." In Baltic paganism, Frazer writes, "it is believed that there is a component of the human being, the *Siela*, that does not depart with the *Vele* (soul), but becomes reincarnate on Earth in animals and plants, and especially trees." The standing people.

In Greek myth, spirits known as hamadryads dwelt in the trees of sacred groves, but, unlike the gods (or Baltic humans), they were not immortal. Should the tree die, its spirit died with it. In one of his stories, Ovid tells of a greedy landowner by the name of Erisichthon who decided to cut the largest of his trees down, for he cared not for the future but only to satisfy his immediate needs. As he took up his axe, a strange, unworldly sound emerged from the center of the tree. "I am the nymph who dwells here," the voice said. "Should I die by your hand, I warn you that an awful punishment awaits." But Erisichthon ignored the warning and with a mad energy attacked the trunk with his axe until it was severed and the huge tree crashed to the ground.

As it happened, the appropriate punishment was an insatiable hunger that "seized the bowels" of the miscreant. Hunger came upon him like an excruciating pain. Even in his dreams Erisichthon's jaws moved. He screamed at his servants to bring him food, then bring more — whatever they could find. As they heaped it before him, he devoured it without stopping. In the days that followed, he sold his belongings for food, and his forest groves as well, but even that was not enough. When there was little left to bargain with and his servants had fled, he sold his only child, a daughter, into slavery, for food.

But the fierce hunger could not be abated and, in the end, there was nothing left for Erisichthon but to devour his own limbs, to nourish his

body by eating his body. And at last he died, in a pool of his own blood, as it spurted forth from the gnawed flesh of his arms and legs.

The moral of this story is clear: "Do not mess with sacred groves."

To some extent, all natural woodlands and forests have the quality of the untouchably sacred about them. At the same time, there is the ethical concept of usufruct to consider. We are to use the bounties of the earth, its foods and fibers and other produce for the commonweal. And so there are practical matters to attend to. Forest trees are needed to build our cities and towns, to provide paper for the printing of books and cellulose for textiles, to produce drugs (in the case of the Oregon yew) for fighting cancer, and, in Cha-da-ska-dum's forest, to make red cedar canoes that can carry up to 2,000 pounds of cargo.

And so, how do we choose? Where do we send the sawyers and what places do we say are off limits? How do we set the rules for clearing or leaving the trees? How do we restore those places that have been despoiled? These are questions for the resource ecologist, which John Berger, the author of this book, actually is.

It is a commonplace for book reviewers and writers of forewords to say that such-and-such a book belongs on the shelf of every such-and-such kind of person. In this case, though, the commonplace is actually deserved. I cannot imagine a more practical book for the student and citizen-conservationist concerned with forests and forestry than this one. But don't put it on the shelf right away. First, you must study it, underline important passages, commit some of the statistics to memory. And then send an email to your senator or member of Congress or testify at a hearing, or write a letter to the editor.

The standing people are in trouble, you see. And they need your help.

Charles E. Little is the author of fifteen books, among them *The Dying of the Trees: The Pandemic in America's Forests* (Viking, 1994), *Discover America: The Smithsonian Book of the National Parks* (Smithsonian Institution Press, 1995), and *Greenways for America* (The Johns Hopkins University Press, in association with the Center for American Places, 1990). His writings have led to many innovations in conservation policy, including national legislation for farmland protection and new approaches to the protection of outstanding landscapes, such as the sacred lands of Indian America. Born and raised in Southern California, Little lived for long periods in New York City and Washington, DC, before moving to Placitas, New Mexico, in 1994.

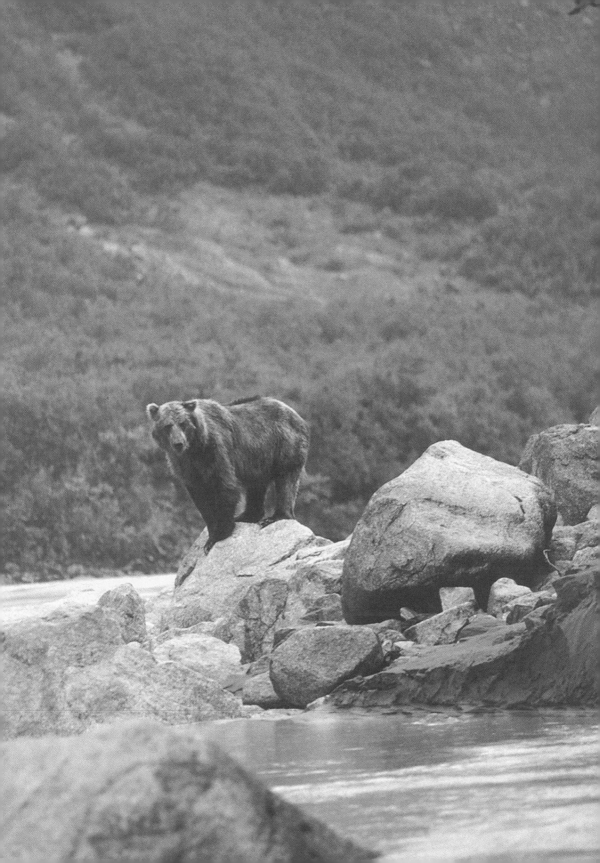

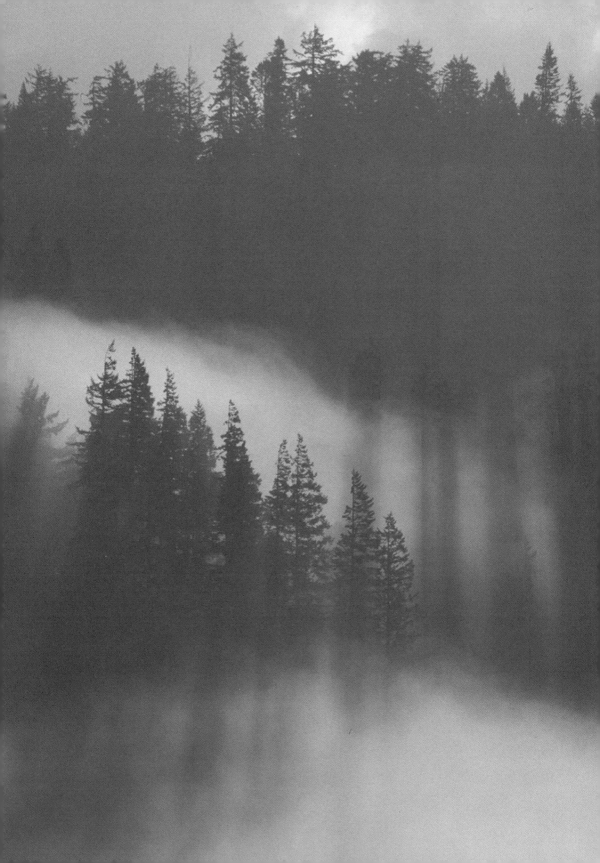

ACKNOWLEDGMENTS

THIS BOOK WOULD NOT HAVE BEEN POSSIBLE without the financial support of those private individuals (and their foundations) who believe in the enduring value of environmental education and scientific literacy. I cannot thank them enough. The major donors to this project are Elizabeth L. Helmholz, Michael S. Klein, the Mateel Environmental Justice Foundation and William Verick, Esq., Nicola Miner, John Weeden, and Robin and Marsha Williams and the Windfall Foundation. Additional generous donations were made by: Raoul and Celesta Birnbaum, Cynthia Boardman, Jeffrey Bronfman and the Aurora Foundation, Trinity Domino, Carol Donohue, Mark A. Fletcher, Ph.D., Joe Goodwine, Gretchen Hayes, George L. Helmholz, Claude Herail, Chris Houck, Paul Hughes, Betty Lo, James Newman, Jeffrey C. and Kersti Rose, Jacob Sigg, Ken Smith, Laurie Steinberg, Kent Stromsmoe, Connie Sutton, Lois M. Tow, and May S. Waldroup. I am also especially grateful to Peter Coyote for his generosity of spirit and kind assistance with the fundraising efforts, above and beyond the call of duty.

Others gave freely of their time and expertise. I would especially like to thank Martin Litton, patriarch of California conservationists and a Forests Forever Advisory Council member, for his help with fundraising, for the excellent photographs which he donated to the book, and for his vast good humor and general encouragement. I am also grateful to Aleksandar Totic, a long-time friend of Forests Forever, who lent a helping hand, and to Forests Forever Foundation's dedicated and risk-embracing board members: Mark A. Fletcher, Ph.D., James Newman, Ken Smith, and Kent Stromsmoe.

In addition to the donors, many people kindly and generously provided extensive assistance with the research, content, editing, and illustrations for this revised, updated, and expanded version of my earlier book,

Understanding Forests (Sierra Club Books, 1998). Readers of that book will note that the length has nearly doubled and that we now present wonderful photographs, many taken by well-known nature photographers. Although it took a great deal longer and was a more extensive project than initially anticipated, that is part of "the nature of the beast," and it was worth it.

In addition to the gratitude that the Forests Forever Foundation and I feel toward our donors, I owe a debt of gratitude to my new co-publishers. Paul Hughes, the executive director of Forests Forever Foundation, expressed early enthusiasm for this new edition. It most assuredly would not have appeared in its present, elegant format without his unfailing commitment. He initially helped to create the publishing partnership for the project with the Center for American Places, widely acclaimed for its award-winning books. Later, with help from Forest Forever's donors, Paul provided invaluable assistance in obtaining the funds required for producing this illustrated edition. He also contributed editorial advice and helped with the research by sharing his vast network of forestry experts. I am very grateful as well to Paul's second-in-command at the Forests Forever Foundation, Marc Lecard. Marc provided the project with astute and patient assistance with publishing, administrative, and contractual matters, and he saw that helpful descriptions of the project appeared on Forests Forever's Website and in its newsletter. Similarly, we thank Randall B. Jones, for initially taking an interest in this project and bringing it to the attention of the Center's founder, president, and publisher, George F. Thompson. George together with Paul created the administrative framework that has made this project a reality. The book has also benefited greatly from George's vast publishing experience and his astute design sense and insights.

I am deeply grateful to my research, production, and office assistant, David Spinner, for acting as the book's primary photo researcher and for diligently helping with innumerable other editorial, administrative, and office responsibilities. In addition, I appreciate the early photo research assistance to this project graciously provided by Ms. Marika Benko. Other part-time researchers who have helped us greatly are my climate research colleague, Andy Perkins, and Rebecca Lubens, a recent graduate of the Harvard University Law School.

For spending many hours reading large parts of the manuscript and for providing detailed and extensive editorial advice, I am eternally grate-

ful to über-edtior, Robert Masterson, formerly editorial maestro of the Lawrence Berkeley National Laboratory, and to my wife, Nancy Gordon, who seemingly was never too tired or overwhelmed with other family responsibilities to read a chapter in the wee hours of the night, catch my mistakes, and make valuable substantive suggestions.

I am also deeply indebted to the following generous individuals who answered questions or kindly reviewed portions of the manuscript: For substantive editorial comments on Chapter 5 ("The U.S. Forest Service"), I am especially grateful to Jim Furnish, former deputy chief of the United States Forest Service, and to Forests Forever's Paul Hughes. I am especially grateful to an extraordinary individual, attorney Doug Heiken, of the Oregon Natural Resources Council, for assiduously and graciously reading and commenting on Chapter 6 ("New Developments in U.S. Forest Policy") and on Appendix A, despite a very demanding professional schedule.

For conscientiously reading and commenting on the account of the struggle to save the Great Bear Rainforest (in Chapter 13, "Saving Forests"), my hearty thanks to Lisa Matthews of the Sierra Club's British Columbia chapter; Merran Smith, director of the British Columbia Programs of Forest Ethics; and Tamara Stark and Catherine Stewart of Greenpeace. Working with them and receiving their well-coordinated critique was a pleasure.

For assistance with Chapter 13 ("Saving Forests"), I would especially like to thank the Sierra Club's Kathy Bailey and the Environmental Protection Information Center's (EPIC) staff attorney Sharon Duggan, as well as Richard Gienger for reading and commenting on the manuscript; Earth First's Darryl Cherney, for reading and commenting on the text; and thanks also to EPIC's Cynthia Elkins for clarifying legal information and to Bob Martel, Brian Gaffney, Esq., Jill Ratner of the Rose Foundation, and Ken Miller, M.D. I appreciate the helpful discussions with Andrew George and Michael Koehler of the National Forest Protection Alliance for information on the activities of grassroots direct action groups working for forest protection.

Regarding Chapter 14 ("Tropical Forests and International Forest Issues"), I am particularly grateful to Keith Alger of Conservation International, who graciously agreed to an extensive interview on tropical forest conservation efforts and who agreed to review and comment on the chapter. Others affiliated with Conservation International who provided interviews and other useful help and information include Conservation

International's chief economist, Dr. Richard Rice, who provided in-depth responses to my questions about tropical forest conservation along with a set of useful references on the topic, which appear in the book; and Conservation International's Dr. Jorgen Thompsen, Director of the Critical Ecosystem Partnership Fund.

The following individuals were particularly helpful in providing specific information, answers to questions, or leads to data sources: Andy Kerr, The Larch Company, L.L.C.; and Cheryl Oakes, Librarian, and Michelle Justice, Archivist, Forest History Society; Jay Watson, Mike Anderson, Michael Francis and Jim Stritholm, all of The Wilderness Society; Nathaniel Lawrence, Amy Mall, Robert Perks, Sharon Buccino, Andrew Wetzler, and Wesley Warren, all of the Natural Resources Defense Council; Rolf Skar, the Siskiyou Regional Education Project; Frank Burch and Jim Culbert, the United States Forest Service; and Eric R. Norland, United States Department of Agriculture's Cooperative State Research, Education and Extension Service.

I wish to thank photographer Bob Herger for generously sharing the cover photograph and the following photographers and organizations that graciously provided photographs: Lesley Adams and Joseph Vale, Klamath Siskiyou Wildlands Center; Patricia Adams, United States Agency for International Development; Ronn Altig; Christine Ambrose; Frank Balthis; Gary Braasch; Justin Cullumbine of Lomakatsi Restoration Project; Daniel Dancer; Brandon Davis, Vision Paper; Katie Regan, American Lands Alliance; Tom Efird and Roxane Scales, United States Forest Service; Robert A. Eplett, California Department of Emergency Services; Charlie Ferranti, Sandi Scheinberg, and Carrie Taylor; Herb Hammond, Silva Forest Foundation; Sharon Galbreath, Southwest Forest Alliance; Tom Hamer, Hamer Environmental L.P.; Bruce Jackson, Bruce Jackson Photography; Peter Kostishack, Amazon Alliance; Vikki Kourkouliotis, National Renewable Energy Laboratory; Aurah Landau, Laura Vidic, and Laurie Cooper, Southeast Alaska Conservation Council; Benson Lee; Esther Litton; Martin Litton; Richard A. MacIntosh, Kodiak, Alaska; Cheryl Oakes, Elizabeth Arnold Hull, and Michelle Justice, the Forest History Society in Durham, North Carolina; Brett Paben, WildLaw Florida; Jay Rastogi, the Land Conservancy of British Columbia; Carlos Simpson, National Wildlife Federation; Sarah Strommen, Friends of the Boundary Waters Wilderness; Doug Thron; Larry Ulrich and Marguerite Powers; Carrie Wilber, Menominee Tribal Enterprises; and David J. Zaber.

I am grateful to the following individuals and organizations for photo leads, captions, and other information: Keith Annis, Greenpeace USA; Sheri Ascherfeld, National Office of Fire and Aviation, U.S. Bureau of Land Management; Ellen Byrne, Sierra Club Library, San Francisco; Nanci Champlin, Oregon Natural Resources Council; Lisa Boyd, California Department of Forestry and Fire Protection; Renée Green-Smith, visual arts specialist, and Terry Seyden, public affairs officer, both of the United States Forest Service in Washington, DC, and North Carolina, respectively; Mathew Jacobson, Heritage Forests Campaign; Ricardo Jomarron, Habitat Education Center, Madison, Wisconsin; Katie Miller, Forest Stewardship Council, U.S.; Anne Martin, American Lands Alliance; Bonnie Von Hoffman, California Department of Forests and Fire Protection; and Amie Brown, Western Forestry Leadership Coalition.

I also appreciate the Cooley Godward Kronish law firm for its progressive pro bono legal help and in particular for the assistance of its attorneys Adam Ruttenberg and Sanjay Beri.

My most sincere thanks, as well, to my office neighbors, Todd Helt and Michael Horton, of Telemorphic, who graciously loaned me computer equipment and helped when computer and networking issues arose.

ACKNOWLEDGMENTS TO THE 1998 EDITION

Once again, I am indebted to the many people who patiently shared their knowledge and information with me with respect to the 1998 edition, *Understanding Forests*, published by Sierra Club Books. The list includes Mike Anderson, Louis Blumberg, Pam Brodie, Michael Goergen, Bruce Hamilton, Richard Harris, Robert Hrubes, Mike Landram, John LeBlanc, Tim McKay, Pam Muick, Walter Poleman, Charles Powell, Marvin Roberson, Kim Rodriguez, Larry Ruth, Walter Sullivan, and Judith Wait. I also want to acknowledge my teachers of environmental science at the University of California at Berkeley and at Davis. Among them are professors Michael Barbour, John Holdren, Allan Knight, Robert Robicheaux, and Michael J. Singer. I am particularly grateful to author Ray Raphael, forester Herb Hammond, and forest ecologist Chris Maser for their excellent books on forestry, which I have relied upon heavily in researching this volume.

I also thank my wife, Nancy Gordon, for having somehow found the time during her busy schedule to keep my lunch box always filled as I set off to the office each morning; and for having very patiently and good-naturedly

tolerated the many times I arrived home late from work or spent weekend hours in the office.

I am also grateful to Jim Cohee, my editor at Sierra Club Books, for his belief in this book, constructive criticism of the manuscript, and confidence and exemplary patience in awaiting its arrival. Finally, I would like to warmly thank Jim Levine, president of Levine-Fricke-Recon, Inc., for providing me with an office on generous terms so that I could conduct research and write the first draft of this book in a congenial, professional setting.

FORESTS FOREVER

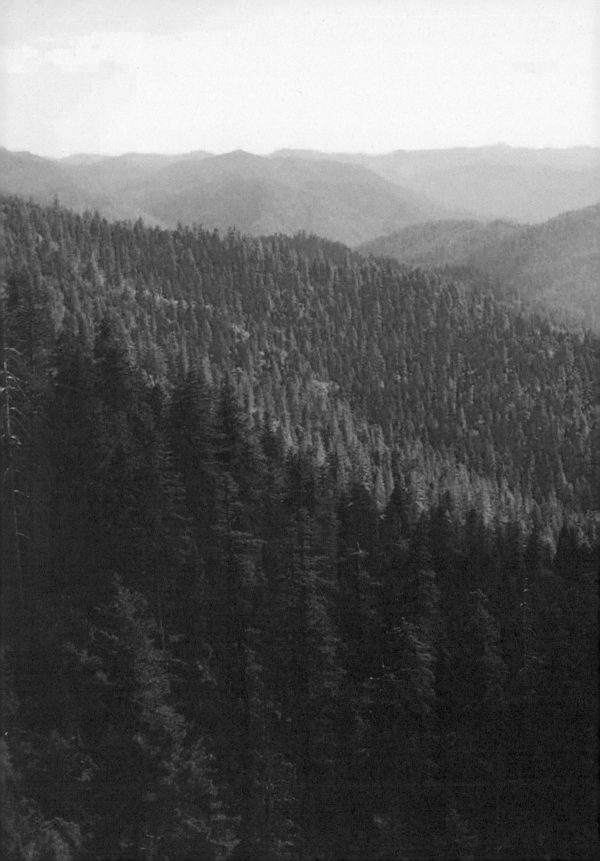

INTRODUCTION

EXPERIENCE THE MAJESTY AND BEAUTY of wild forests. Walk in the cool quiet grandeur of old growth far below its leafy canopies amongst the towering furrowed trunks of massive ancient trees. Feel the spiky needles of spruce, the softness of fir, or the flattened leaf-blades of coast redwood (*Sequoia sempervirens*). Camp on an unspoiled stream bank beneath giant trees where the water is not only cold and clean enough for brook trout and salmon, but also pure enough for people to drink. Sleep peacefully under a starry sky in the tranquility of unspoiled nature where neither the roar of traffic nor the blare of electronic media, nor the artificial lights of human settlements intrude.

We desperately need places where these experiences are still possible. As conservationist John Muir pointed out more than a century ago, wild places relieve the stress of urban living. They protect and renew us mentally and physically. Wild forests represent the climax of millions of years of evolution. It is forest from which we as a species came, forests that guided the evolution of our prehensile limbs and binocular vision, and forests we must reenter from time to time if we are to keep in touch with some essence of our primal selves. We cannot rise to our full human potential without them. We must retain as much true forest habitat among us as we possibly can or tomorrow we may have to travel hundreds, if not thousands, of miles to see a natural, healthy forest and spend a lot of money to do so. To some extent, that is already true. Nowadays people go to Alaska or parts of Canada, for example, to see the large predators, such as grizzly bear, black bear, and wolf, in abundance. Undisturbed wild places are vanishing fast (even in Alaska) and already are all too rare, remote, and vulnerable.

With the loss of wild forests go opportunities for high-quality wilderness recreation, scientific study, and subsistence hunting, fishing, and

gathering. But human gratification, scientific inquiry, and the fulfillment of our immediate utilitarian needs are only three of the most obvious among myriad reasons for taking good care of forests. More fundamental reasons — ones that led President Theodore Roosevelt and others to establish national forests and save *watersheds** — are that forests protect soil, water, wildlife habitat, climatic stability, and biological diversity. A healthy forest not only offers life-forms of awesome size and age, such as incense cedar, bristlecone pine, and bull moose, but also harbours tiny organisms, such as Nelson's hairstreak, a delicate, rust-colored butterfly with inch-long wings that lives on incense cedar. Forests are also home to magnificent songbirds, such as the brilliant Western tanager, to astoundingly shaped and variegated mushrooms, like the fluted white Helvella, to brilliant lillies, paintbrushes, columbines, and orchids, and to fascinating insects, amphibians, mammals, and reptiles. Clearly, forests must be protected and restored for their intrinsic worth, apart from their beauty and value to us, even as they promote the long-term economic vitality of local communities. Forests are complex ecological treasures that have a right to exist. We may use them, but no more ought to obliterate them than to demolish temples filled with rare, illuminated manuscripts and priceless antiquities we scarcely understand.

After a *clearcutting* operation, dismembered remains of trees young and old lie strewn about, limbs and boughs shattered. The forest understory is crushed and uprooted, severed by roads, and scourged with skid trails. Exposed soil, churned and compacted by heavy equipment, bakes dry in the sun. Wildlife is dead or has fled in terror.

Evidence of the carnage is often scraped up into brush piles and burned by loggers. The devastated site may be abandoned or a single-species, even-age tree crop may be planted where the diverse, multi-storied forest once stood. Herbicide may be sprayed on the site to kill competing vegetation. The best that can be hoped for here is akin to a tree plantation—if the "reforestation" works at all. The worst possibility— apart from species extinctions — is catastrophic erosion, loss of soil to bedrock, polluted streams, parched springs, and wasteful reversion of the land to an ecologically primitive, unproductive state; or removal of the tree canopy may simply produce a brush-choked site highly susceptible to fire and invasive species.

* Words and terms that appear in boldface italics are defined in the *Glossary*.

4

Nonetheless, many well-meaning people neither see or know about the risks of clearcutting nor understand what forests are, much less the complexities of their operation; which forests are rare or fragile; how we (and wildlife) benefit from healthy forests; and how intact *old-growth forests* differ from woodlands that have endured heavy or repeated logging. These observers may not recognize the broad implications of forest destruction or losses in quality, nor the immense difficulties in recreating an authentic forest on despoiled land. They may be swayed by assertions that ancient forests are "overripe" or "decadent" and that we must remove dead trees or fallen logs for the forest's own good, not realizing that these natural resources are absolutely integral to the healthy functioning of forest ecosystems.

Without firsthand knowledge of the effects of industrial logging, people are easily convinced that the chainsaw is the proper remedy for every forest ill, real or imagined. Meanwhile, large and healthy old trees are being cut down in the name of "forest health," "fire prevention," or "salvage logging." The public is often gullible or complacent about what is going on. Few people understand that, whereas logging companies freely use the language of reforestation or forest improvement, they typically have no interest in the challenging and expensive task of recreating real forests. By and large, timber companies are simply businesses operating in the forest for profit. Their idea of reforestation is thus to reconstitute another crop of saleable trees as quickly and cheaply as possible—unless they can make more money by simply selling their former forest land to developers. Federal and state governments still encourage or allow these practices to flourish today, because in-depth ecological knowledge and the ecological concern that springs from it are not prevalent enough among the public to force an end to these abuses.[1] Sadly, people often do not even realize what they are losing when public forests that belong to them and their children are destroyed or mismanaged by private, for-profit companies, particularly when those forests are in remote areas far from urban population centers.

Fortunately, environmental abuse, in general, and mismanagement of forests, in particular, are not insoluble problems. We as a society have the ecological knowledge and experience to conserve forest resources and to manage them sustainably. When it comes to the last remnants of our ancient forests, they absolutely *must* be preserved. That is not negotiable. In other forests, where logging is possible, it can be done selectively and

with restraint in a manner that preserves a forest's integrity, health, and future productivity. But if we expect these general guidelines to be followed, we need to marshal the public support, money, and political will to preclude forest mismanagement and wanton destruction.

Forest protection requires the adoption of commonsensical forest policies and their diligent enforcement. Equally or more important, it requires scientists, educators, public policymakers, and public servants to show the public that forest protection benefits people across the political spectrum, so that this issue cannot be used by any political faction to divide a nation expediently for its own political advantage into pro- and anti-environmental camps.

An intensive educational campaign focused on the value and, at times, fragility of natural ecosystems is not something we have the luxury to postpone. Today, threatened and endangered ecosystems and species are exposed to horrific destructive forces. Those who understand the value of forests and other ecosystems urgently need to share that knowledge and come to the defense of forests.

The purpose of this book is to explain how forests work, to discuss the fate of forests, and to suggest principles for their proper management. We can and must treat our forests better than in the past. But wisdom and knowledge are needed to guide the protection and use of forests and to reduce greatly the relentless demand for wood that drives deforestation. Since this book is meant to serve as an introductory overview, I present many topics. Yet, because the book is concise, the treatment—even of critically important subjects—is by necessity condensed. Subjects touched on include forest ecology, forest economics, forest management, forest and conservation history, forest laws and policies, tree planting as an aspect of forest restoration, timber practices, alternatives to wood, and tropical forests.

I have tried to write about highly controversial forest issues in a nonpartisan way, because I believe that the nation has neither Democratic nor Republican forests, only state, national, and private forests. The health and survival of these forests depends, to a large extent, on whether they are managed according to ecological principles and protected from destructive logging operations.[2] My criticisms of particular forest policies are, therefore, based not on ideological, political, or economic grounds, but on how compatible a policy is with a forest's ecological needs.

Since I wrote the first version of this book, *Understanding Forests* (Sierra Club Books, 1998), profound changes in U.S. forest policy have been implemented during the second term of the Clinton Administration and even more dramatically by the first and second administrations of President George W. Bush. Forest management was a hotly contested issue when I first wrote about it in the late 1970s and is even more so today. Management practices on tens of millions of acres of public and private forest are in intense dispute. Battles have raged from Maine to Alaska on the ground, in the courts, in Congress, in state legislatures, and with state forestry boards. Many of the older battles have been greatly inflamed in the early years of the twenty-first century, and many new ones have been instigated. As we will see in Chapter 4 on the history of forest conservation, the George W. Bush Administration has departed from prior policies of both conservative Republican and Democratic administrations since President Theodore Roosevelt a century ago in seeking a broad rollback of fundamental environmental laws and rules that regulate logging, mining, or drilling on national forests or other public lands. We will discuss these precedent-setting forest policy decisions in greater detail in the section of this book devoted to the U.S. Forest Service (USFS), including the following Bush Administration actions:

1. to rescind environmental laws and regulations;
2. to increase forest access by logging, mining, and oil companies;
3. to reduce federal protection for rare, threatened, and endangered species;
4. to eliminate roadless wilderness areas;
5. to reduce opportunities for public participation in forest planning and management; and
6. to reduce consultation with environmental scientists when making decisions regarding national forests.

A quick example that illustrates a number of these trends is the Bush Administration's effort to eliminate the Roadless Area Conservation Rule that was adopted by the Clinton Administration to protect 58.5 million acres of wilderness in the national forests. Another example is the Bush Administration's Healthy Forests Initiative of 2002, which led to the Healthy Forests Restoration Act of 2003. Presented by the Bush Administration as a national fire prevention measure, most environmentalists

have described it as an effort to allow the timber industry to log large, live, fire-resistant trees in remote forest areas. A third major departure from more scientifically based forest management was the Bush Administration's decision in 2003 to abrogate the Sierra Nevada Framework Agreement, a scientifically based management plan for eleven national forests in California, adopted by many stakeholders over a ten-year period with extensive public input. Instead, the Bush Administration sought to triple the logging rate recommended in the Sierra Nevada plan. The roadless rule, the healthy forests initiative, the Sierra plan, and numerous other new developments in forest policy are discussed in more detail in Chapter 5, "The U.S. Forest Service."

The Bush Administration's forest policies have produced lawsuits, letter-writing campaigns, public education efforts, and lobbying from mainstream environmental groups. Grassroots groups have used door-to-door canvassing in communities near proposed logging operations; they have perched in old-growth forest trees; they have blocked access roads to logging sites; and they have protested in small groups at Forest Service and Congressional offices around the nation. On occasions such as Earth Day or Halloween, they have performed street theater skits in costume or carried placards with messages such as "Carve Pumpkins, Not National Forests" or "R.I.P. — Old-Growth Forests." It is probably fair to say that established environmental organizations and grassroots groups alike have been enraged by President Bush's environmental policies. Yet, to date, forest protection issues have failed to fire up demonstrators in the vast numbers that have protested in the past for women's suffrage and civil rights or against the war in Vietnam. Until environmental groups can mobilize a comparable broad popular constituency—and so long as many Americans see the forest protection movement as a radical fringe movement or a *cause célèbre* of environmentalists — forests will remain under assault and at risk.

Naturally, no region in the United States has a monopoly on forest controversies, though most national forest lands are in the West. Controversial national forest timber sales are being pursued by the USFS in the Northeast in the Allegheny National Forest of Pennsylvania, the Green Mountain National Forest of Vermont, the White Mountain National Forest of New Hampshire, and the Finger Lakes National Forest of New York. Southern forests in Virginia, Texas, Louisiana, Kentucky, Florida, and Arkansas are also being threatened, as are forests in the heartland states of Missouri, Illi-

nois, Indiana, and Ohio as well as in the Great Lakes states of Michigan, Minnesota, and Wisconsin.[3] Abroad, forest battles have been joined to protect forests from chainsaw and tractor—from the tropical forests of Brazil and Indonesia, to the ancient Douglas-fir forests of British Columbia and the *boreal* forests of the vast Siberian *taiga*. These are just a small sample of important forest controversies flaring today as concerned citizens and interest groups respond to the worldwide assault on the earth's forests.

What lies behind demonstrators' willingness to risk life and limb, fines and imprisonment, time and money to stand between loggers' chainsaws and tall trees? Timber companies, forest workers, government officials, hunters, fishers, ranchers, hikers, campers, horseback riders, environmentalists, and ordinary forest users all have a huge stake in the outcomes of these confrontations. The global timber industry is a multi-billion dollar business with an insatiable drive to cut and process wood at a profit. Tens of thousands of jobs depend directly on forests; millions of acres of land are affected by decisions about forest use. The economies of many towns and regions depend on forest resources. A ban or sharp reduction in logging can force mill closures, eliminate jobs, devastate a tax base, and lead to the loss of community services. A prosperous local economy can be destroyed or whipsawed from boom to bust by forest abuse.

By contrast, forest protection and wise stewardship can lay the groundwork for a healthy, stable economy, as recreational, fish, and wildlife benefits from nondestructive forest use are generally far more valuable and far more enduring than revenue from one-shot or repeated clearcut logging operations. Brutal and short-sighted *industrial forestry* destroys forest assets rather than husbanding them so communities can enjoy forests' bountiful and sustainable yields. Over time, consistent modest yields far exceed the spoils of greedy forest mistreatment.

The outcomes of forest controversies will affect far more than wallets and balance sheets. Forests are living museums and libraries of natural history. Many of our forests, such as the old-growth forests of California and the Northwest, are *irreplaceable* biological treasures that are the last refuges of threatened and endangered species, such as the marbled murrelet and the now-famous northern spotted owl. The way we resolve forest conflicts will extend or limit the extent of our future ecological knowledge about forests and will largely determine the kinds of forests that our children and grandchildren will enjoy. Our decisions will respectfully preserve or callously despoil their natural heritage.

Forest management impacts also extend beyond the land to rivers, lakes, streams, groundwater, oceans, and even the soil and air—through forest-biosphere linkages that involve our climate and affect bird, insect, and aquatic life—for forests are crucial to the fate of dwindling stocks of wild fish, such as salmon, which spawn in forest streams and depend on healthy forests for their existence. Because of their importance in anchoring soil and absorbing rainfall, when forests are threatened, so are water supplies and water quality. Farmers and city dwellers alike thus depend on forests.

Forests saved from the sudden ravages of bulldozer and chainsaw can still be lost imperceptibly due to air pollution, acid rain, disease, and prolonged mismanagement. I recall David R. Brower, the late inspirational environmental leader, calling this piecemeal destruction of the natural world "a holocaust in slow motion." The pages that follow address both the catastrophic and the subtler, more insidious threats to forests in the United States and abroad. In so doing, the goal is not mainly to chronicle the damage, but to explain its causes and consequences and to outline potent actions that can be taken to protect and restore forests.

All else being equal, the better one understands forest issues—that is, forest resources, what threatens them, and how to surmount those threats—the greater are the chances of saving forests. Help from people of good will is urgently needed in this endeavor. Time is running out for many of the world's forests, but action now can save some of them. That action will both improve our quality of life and protect the earth's magnificent but dwindling biodiversity. Future generations will cherish the gifts our labors protect today, long after the cut lumber would be forgotten.

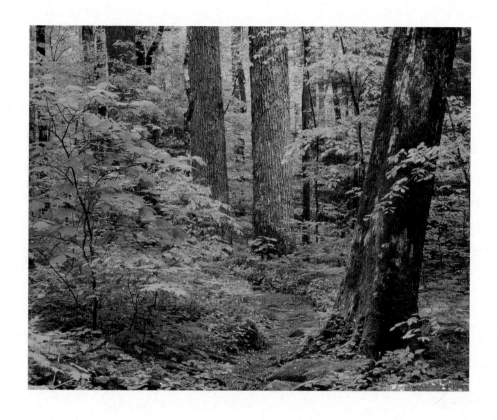

Fig. I.1. Yellow poplars, along the Joyce Kilmer Memorial Loop Trail, Joyce Kilmer Slickrock Wilderness, Nantahala National Forest, North Carolina. Photograph © Larry Ulrich.

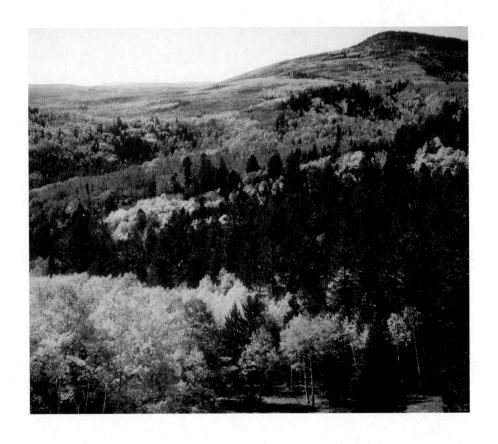

Fig. I.2. Peak fall foliage in southern Utah, featuring aspen in their rich yellows. Photograph © Benson Lee.

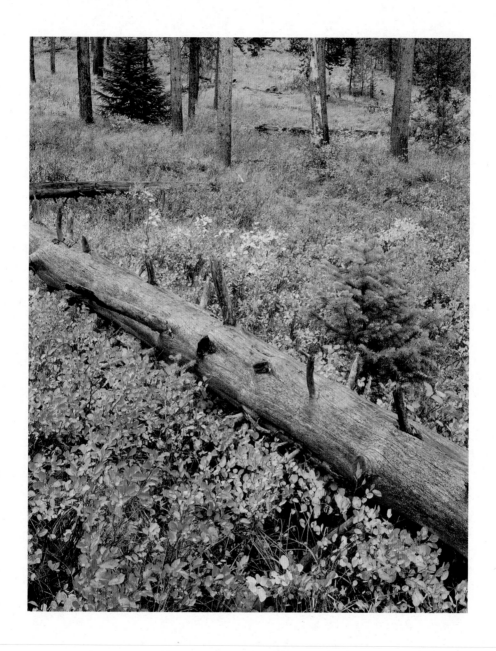

Fig. I.3. This thick accumulation of forest litter in Grand Teton National Park, Wyoming, illustrates how a multi-textured surface slows water runoff and promotes infiltration of water into the soil. Photograph © Bruce Jackson.

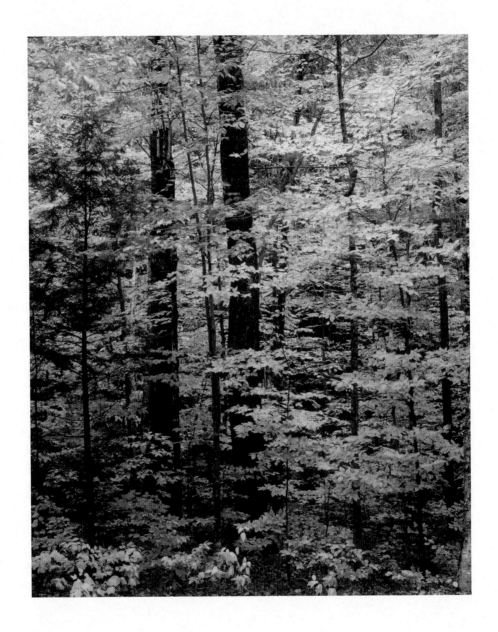

Fig. I.4. Fall foliage northwest of Conway, New Hampshire. Photograph © Benson Lee.

Fig. I.5. Fall foliage near Highway 1A in New Hampshire. Photograph © Benson Lee.

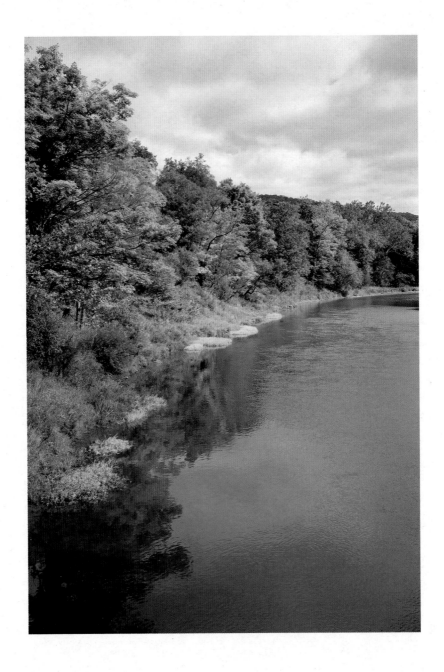

Fig. I.6. The Allegheny River runs through the Forest Stewardship Council [FSC]-certified hardwoods of the Collins Pennsylvania Forest in Kane, Pennsylvania. Photograph © 2003 The Collins Companies.

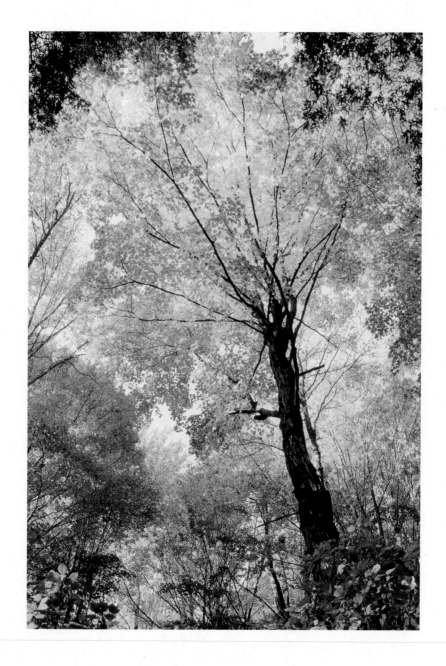

Fig. I.7. A fall canopy of maple in the Forest Stewardship Council [FSC]-certified Collins Pennsylvania Forest in Kane, Pennsylvania. Photograph © 2003 The Collins Companies.

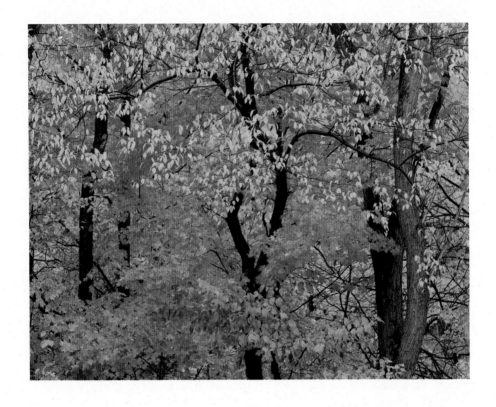

Fig. I.8. A black cherry and sugar maple forest, Bedford Reservation, Metroparks, Cuyahoga Valley National Park, Cuyahoga County, Ohio. Photograph © Larry Ulrich.

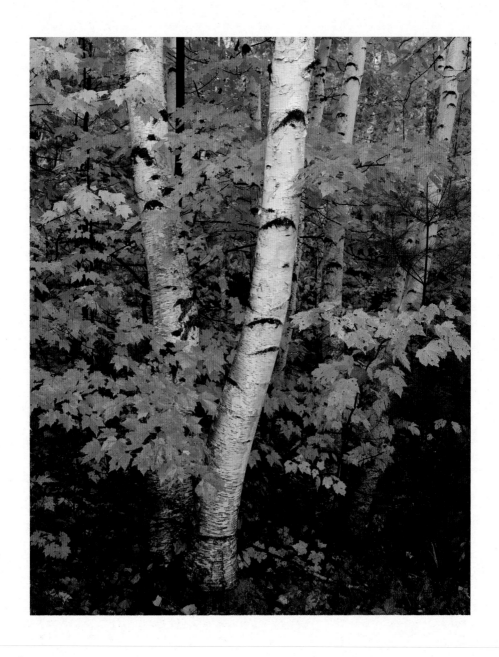

Fig. I.9. Paper birches, Wild River Valley, White Mountain National Forest, New Hampshire. Photograph © Larry Ulrich.

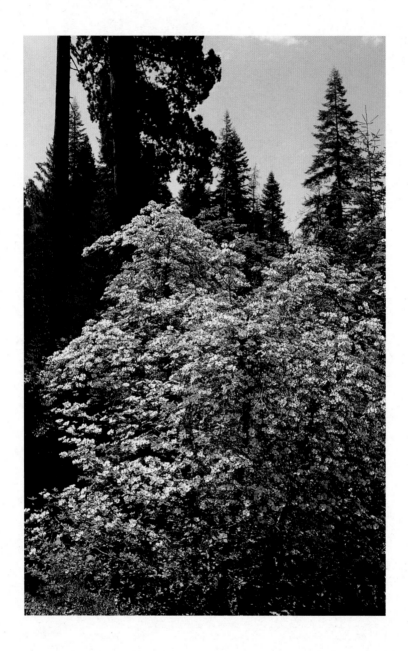

Fig. I.10. A dogwood tree flowers in the understory of the privately owned Alder Creek Grove of Giant Sequoias, inside the boundaries of Giant Sequoia National Monument, California. Photograph © Martin Litton.

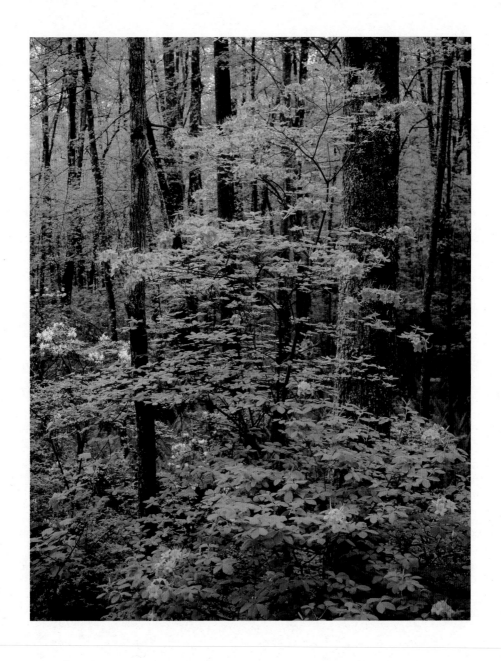

Fig. I.11. Flame and early azalea, Chilhowee Recreation Area, Cherokee National Forest, Tennessee. Photograph © Larry Ulrich.

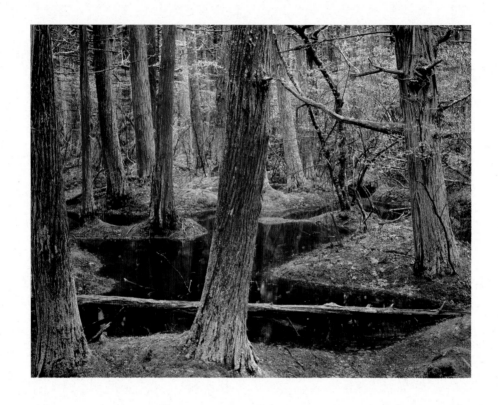

Fig. I.12. Atlantic white cedar swamp, Marconi Station Area, Cape Cod National Seashore, Massachusetts. Photograph © William Neill and Larry Ulrich.

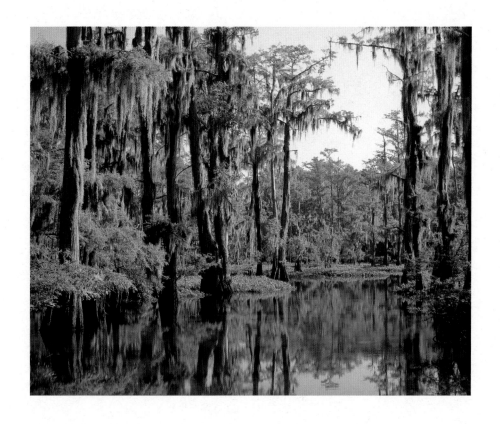

Fig. I.13. Bald cypress, Rimini Swamp off the Santee River, Sumter County, South Carolina. Photograph © Tom Blagden/Larry Ulrich Photography.

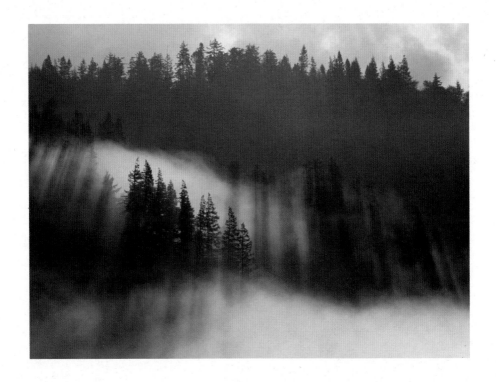

Fig. I.14. Summer fog dripping from the boughs of tall, ancient trees, near Coos Bay, Oregon, illustrates how forests intercept atmospheric humidity, provide sites for its condensation, and then deliver the accumulated moisture to the forest soil. Photograph © Benson Lee.

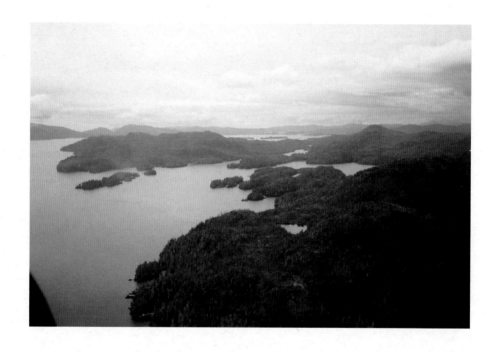

Fig. I.15. An aerial view of an old-growth forest on Gravina Island near Ketchikan, Alaska. Photograph courtesy of SEACC (Southeast Alaska Conservation Council).

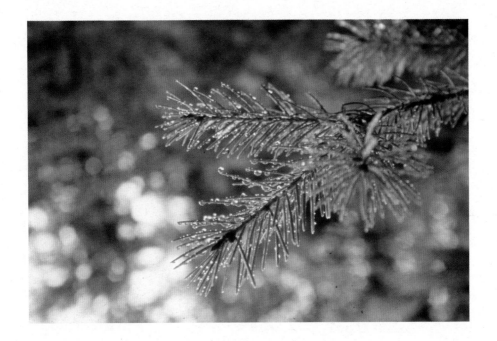

Fig. I.16. Water droplets on the needles of a Douglas-fir in the Caribou region of central British Columbia not only illustrate how tree leaves intercept moisture and provide sites for its condensation, but also how they slow raindrops, reducing the velocity of their impact on the ground, where the water percolates into the soil. Photograph © Herb Hammond.

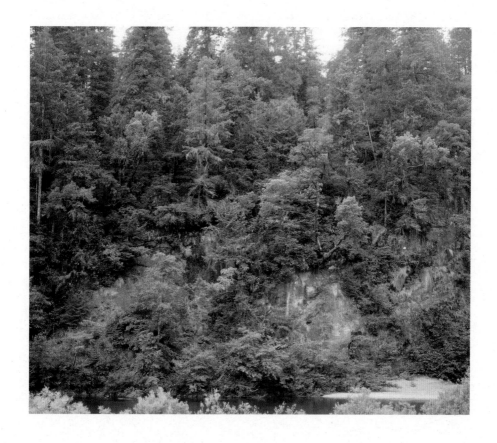

Fig. I.17. Riparian vegetation growing above the bank of the Eel River, southern Humboldt County, California. Photograph © Benson Lee.

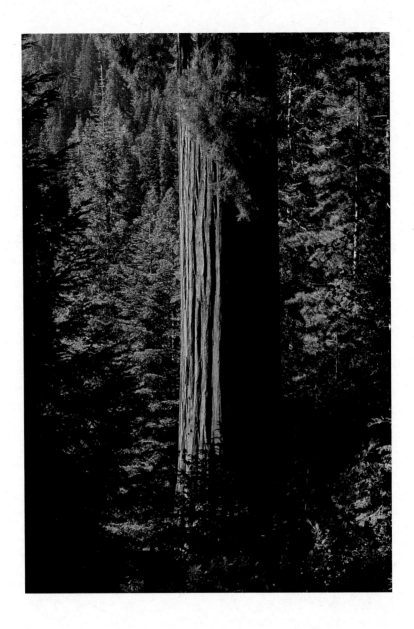

Fig. I.18. A giant sequoia is aglow, as if from an inner light, in Alder Creek Grove, a private inholding within Giant Sequoia National Monument, California. Although the scene appears natural, almost all of the Ponderosa and sugar pines that are characteristic of sequoia groves were logged off long ago, to be replaced by the usual succession of white firs and incense-cedars. Photograph © Martin Litton.

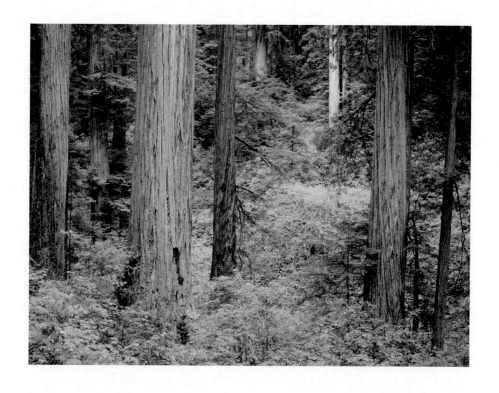

Fig. 1.19. Coast redwoods, Mill Creek Forest, Jedediah Smith Redwoods State Park, California.
Photograph © Larry Ulrich.

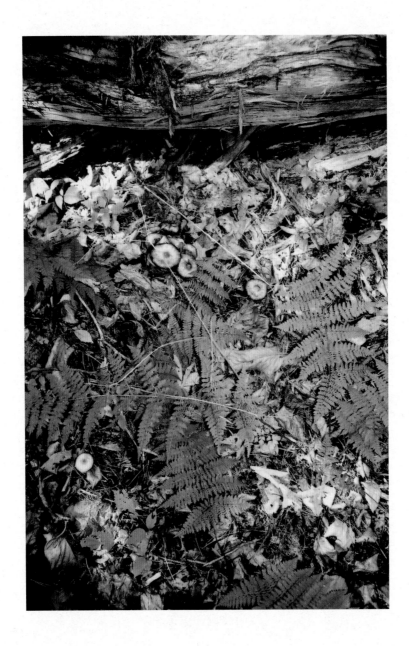

Fig. I.20. A fallen tree helps to nourish new life by recycling nutrients back to the forest soil in the George Washington National Forest, Deerfield Ranger District, Augusta County, Virginia. Photograph © 2007 George F. Thompson.

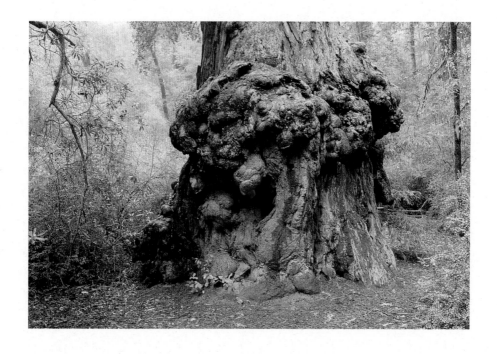

Fig. I.21. Redwood burl, Big Basin Redwoods State Park, California. Photograph © Frank S. Balthis.

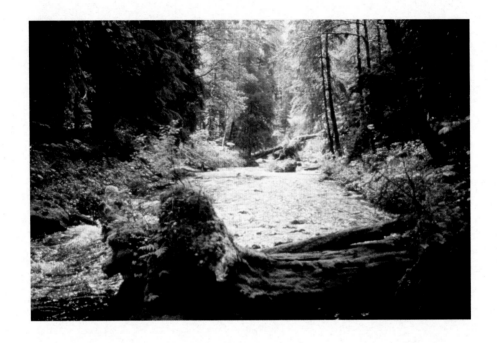

Fig. I.22. Stable vegetated banks, pools, riffles, and fallen trees in the water identify this tributary to the headwaters of the Kwinamass River as a healthy stream, located in an old-growth forest near the northwest coast of British Columbia. Photograph © Herb Hammond.

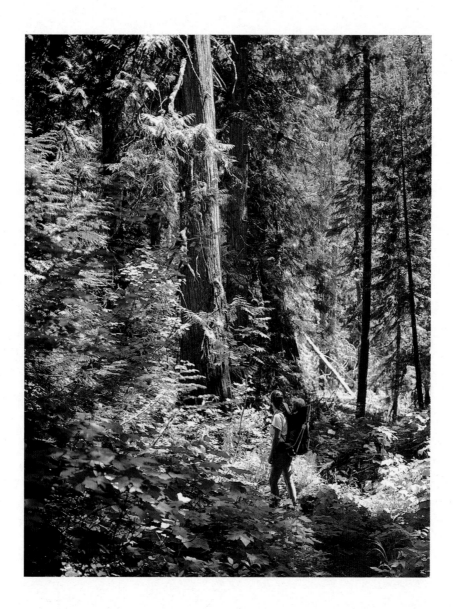

Fig. I.23. A standing snag leans at a forty-five-degree angle (right background) near a downed tree on the forest floor in Heritage Grove, an old-growth cedar grove in the Clearwater National Forest in northern Idaho. Broad-leaved plants, such as salmonberry and thimbleberry, and young trees populate the forest floor, where canopy gaps permit light to reach it. The grove is part of a mixed cedar-grand fir forest. Photograph courtesy of www.wildcountry.info.

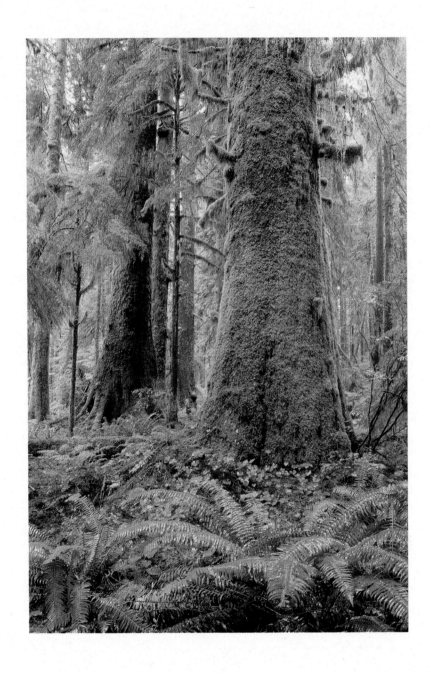

Fig. I.24. A towering old-growth Sitka spruce forest at Carmanah Creek, Vancouver Island, British Columbia. Photograph © Bob Herger.

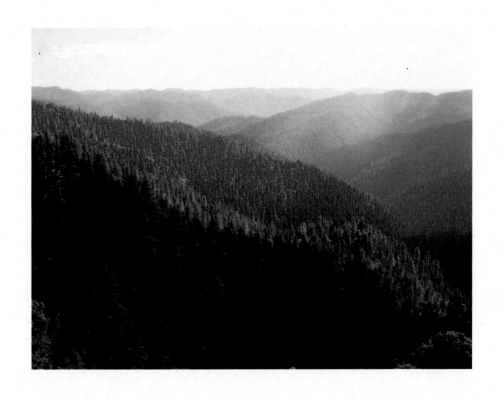

Fig. I.25. The 46,000-acre Zane Grey Roadless Area, slated for logging in the Kelsey-Whisky Timber Sale, Medford Bureau of Land Management, Oregon. Photograph courtesy of www.kswild.org.

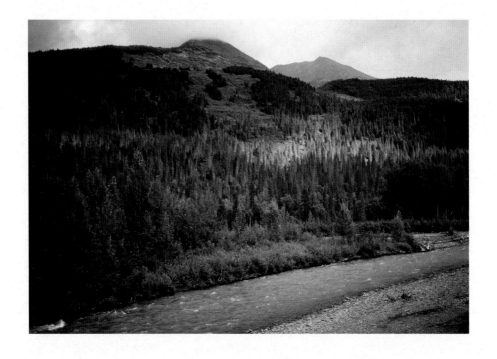

Fig. I.26. A forest killed by an infestation of pine bark beetles near the Kenai River, Alaska. Such forests are prime candidates for clearcutting in salvage logging operations. Photograph © Benson Lee.

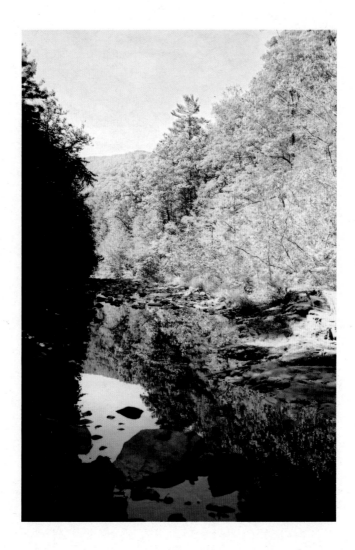

Fig. I.27. Ramsey's Draft Wilderness, about twenty-three miles west of historic Staunton, Virginia, is habitat to bear, mountain lion, and many other creatures, including native trout. Hemlock, a remnant from the last ice age, appears here, but it is threatened by Adelges tsugae *(the speck-sized woolly adelgid), an aphid-like insect from Asia. Photograph © 2007 George F. Thompson.*

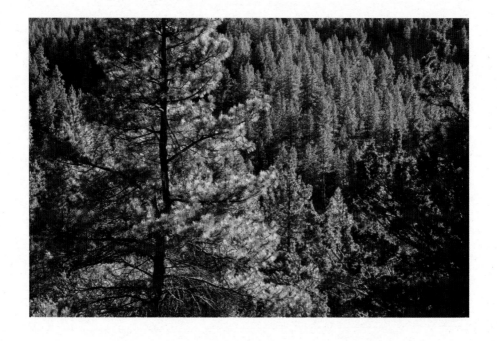

Fig. I.28. This photograph of the Collins Lakeview Forest in Lakeview, Oregon, was taken after a sustained yield cut. It remains vibrant, healthy, and mature. Photograph © 2003 The Collins Companies.

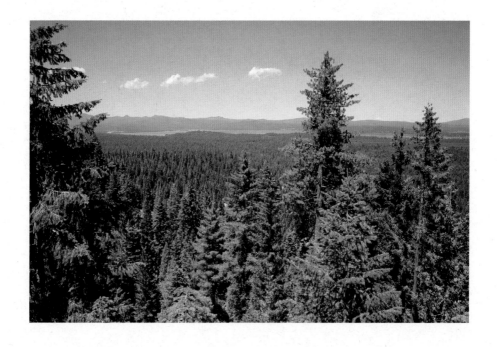

Fig. I.29. Mosquito Ridge in the Collins Almanor Forest in Chester, California, has been logged five times in the last fifty years; yet, because of sustainable practices, it remains a biodiverse, multi-layered, mixed-age, and mixed-species forest. In the distance is Lake Almanor. Photograph © 2003 The Collins Companies.

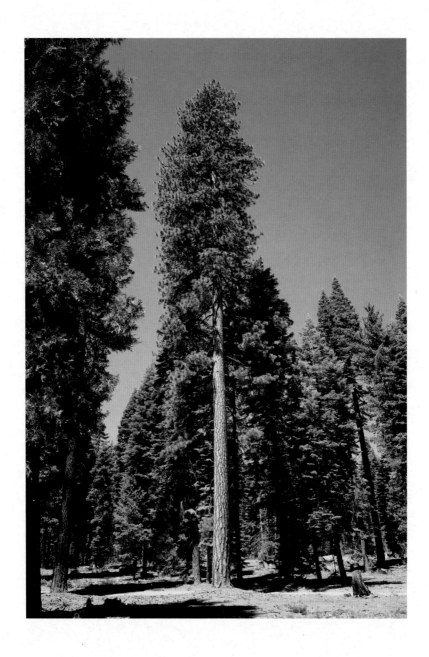

Fig. I.30. A well-managed forest allows trees to flourish and mature, as seen in the Forest Stewardship Council [FSC]-certified Collins Lakeview Forest in Lakeview, Oregon. Photograph © 2003 The Collins Companies.

Fig. I.31. Logging roads should be carefully placed and managed to assure the least disturbance to the land, as seen in the Forest Stewardship Council [FSC]-certified Collin Lakeview Forest in Lakeview, Oregon. Photograph © The Collins Companies.

Fig. I.32. A stand of Douglas-fir shows the structural diversity of an old-growth forest in the sustainably managed Wildwood Forest near Ladysmith, Vancouver Island, British Columbia. Note, also, the fire scarring on the trees, which may have occurred when the forest was under the care and management of the Coast Salish people. Photograph courtesy Jay Rastogi, The Land Conservancy of British Columbia.

CHAPTER 1.
THE BOUNTEOUS FOREST

Our inability to see whole forests, to understand
that each structure has an indispensable function. . . .
is leading us towards forest destruction.

—HERB HAMMOND, *Seeing the Forest Among the Trees* (1991)

WHAT IS A FOREST?

A forest is a totality of interdependent organisms and their interrelation-
ships, along with the places where they exist, the physical structures that
support them, and the chemical compounds they use and exchange.

"Forest" connotes both the architecture and structure of that ecosys-
tem as well as the functions and interconnection of organisms within that
structure. Thus, a forest is far more than a collection of trees. Trees are
simply a *feature* of the forest, albeit its most prominent one. By contrast, a
commercial forest is narrowly defined as land capable of producing at
least twenty cubic feet of timber per acre per year.

Forests are actually assemblages of interrelated plants and animals on
terrain dominated by tall, woody vegetation. Many scientists consider that
a savanna—a grassland with widely spaced trees—becomes a forest when
at least twenty-five percent of its surface is covered by tree crowns, though
there is no universal agreement on that arbitrary number.

While this ecological notion of forest seems straightforward, in reality
the word "forest" encompasses a large array of distinct forest types and infi-
nite gradations between them. The eastern United States, for example, is
home to such ecosystems as temperate beech-maple forest, oak-hickory
forest, pine-oak forest, white-cedar swamp forest, bald-cypress swamp

forest, boreal bog forest, and Jack pine forest, as well as northern flood-plain forest and southern riverine forest, and more. Before the virtual extinction of the native chestnut tree, the Northeast was also home to magnificent old-growth chestnut forests.

Western forests range from the spruce-hemlock temperate rain forests of the Northwest to the Douglas-fir and redwood forests of coastal and mountainous California, the mixed conifer pine-fir Sierra Montane forest, the aspens of the Rockies, and the Engleman spruce and bristlecone pines of the subalpine zones. Oak woodlands and the drier pinyon-juniper forests of New Mexico and Utah are some of the forest types that populate the Interior West. In the north are forests of white spruce, balsam fir, and pine, among others.

Even when dominated by a particular tree, the forest consists of many ecosystems and gradations between them. An oak-maple-beech forest, for example, may well include open glades, riparian areas, and rocky outcrops. Some stands of trees may be almost entirely oak, others predominantly maple, and still others an admixture, or a completely different community, due to soil, exposure, or elevational effects. Moreover, the forest may be in the process of invasion by new species, or some other change in the dominant tree type may be occurring.

Not coincidentally, the forest is a place of enormous complexity: in addition to trees, it includes soil, insects and other invertebrates, birds, mammals, amphibians, reptiles, herbs, grass, shrubs, mosses, lichens, bacteria, fungi, and viruses. Competition, predation, *respiration*, *photosynthesis*, evolution, coalescence of new life, and dissolution of the old all go on simultaneously.

So elaborate and intricate are the linkages amongst parts of the forest that forest ecologist Chris Maser refers to the forest with awe as "a trillion-piece jigsaw puzzle."[1] One way to think about a forest, therefore, is as a plexus. Derived from the Latin word for "braid," plexus means an interlaced network of parts that together form a system. The forest plexus is thus a living, multi-dimensional web interconnecting various life-forms and, through nutrient cycling, linking life with dead organisms and other mineral storehouses.

FOREST PRODUCTS

Thanks to their complexity, natural forests are the source not just of wood but of an immense array of finished and raw products. These include lum-

ber for construction materials, veneer, and furniture, paper, adhesives, waxes, turpentine, polymers, gunpowder, medicinal herbs, perfumes, sachets, charcoal, mulch, fertilizer, musical instruments, and medicines, such as taxol (from the Pacific yew) to treat cancer, quinine (from the *Cinchona* tree species) to treat malaria, and digitalis (from foxglove) for heart disease. Of course, forests also provide raw logs, firewood, burls, ferns, mosses, lichens, flowers, wreaths, fruits, nuts, cones, incense, wild mushrooms, fish, and game.

In addition, compounds once synthesized exclusively by forest plants, animals, and microorganisms are today incorporated in a large number of commonly used medicines and have provided the chemical models and insights for countless pharmaceuticals worth tens of billions of dollars. Willow bark, for example, contains acetyl salicylic acid, the active ingredient in aspirin. Medicines originally derived from forests account for forty percent of all commercially sold pharmaceutical preparations.

Apart from a cornucopia of forest products and the assorted economic benefits that forests provide, forests also offer natural beauty, sacred places, and many invaluable ecological services, whose effects extend far beyond forest boundaries.

ECOLOGICAL SERVICES

Through photosynthesis, forests both contribute oxygen to the atmosphere and remove carbon dioxide from it by storing carbon in the form of plant tissue. Forests thus tend to counterbalance global warming, which is intensified by increases in the concentration of atmospheric carbon dioxide. Some recent research, however, suggests that the absorption of sunlight by forest tree leaves may cause a net warming by decreasing the earth's reflectance, and decadent or dormant forests may also, on balance, release carbon.

Forests can affect climate locally and regionally through releases of moisture that is withdrawn from the soil by plant roots and then transported up their stems or trunks to evaporate through leaves. Since atmospheric humidity is thereby increased, droughts may be reduced or prevented. Trees also can extract moisture from the air by their contact with low fog, causing it to condense on leaf surfaces and drip to the ground, where it can add substantially to total annual precipitation. (Standing under a tall tree on a very foggy day can sometimes be like taking a gentle shower.) Trees also moderate local temperature extremes and wind velocities.

13

In addition to their influence on climate, forests purify water by filtering it through litter and soil. Much of the water we drink, either from surface or underground sources, comes from forested watersheds, including water that accumulated eons ago. Forests also increase the amount of water reaching groundwater reservoirs by slowing the rate of surface runoff (which helps prevent floods) and thus increasing the *percolation* of runoff into the soil. This helps recharge deep groundwater, raises the *water table*, and makes for more persistent streamflow during dry seasons, benefiting vegetation and wildlife. More than half of the water supplies in the western United States flow from national forests. Water from healthy forested watersheds can be used with minimal treatment by cities. When damaged forests no longer perform their hydrological functions, expensive advanced treatment plants may be needed, raising monthly domestic water bills.

Forests build and protect the soil. Trees shelter soil and soil-building organisms from the effects of direct sun, wind, and precipitation. "Soil is the basis of the forest," environmental leader David R. Brower used to say, "We have to stop treating forest soil like dirt." To forest ecologist Chris Maser (1994), "Soils are the placenta that nurtures the forest." Soil and forest litter absorb rain like a sponge and release it to vegetation and groundwater slowly. By pulling water out of wet or waterlogged soils through capillary action and releasing water vapor into the air, forests can help stabilize soils.

Forests also are important contributors to the health of aquatic ecosystems, providing food for insects by contributing leaves and other *detritus* to the water. This material serves as food for microorganisms, insects, and other life-forms in the aquatic *food web* that ultimately feed larger fish. In addition to providing food, temperate forests also shade streams and rivers, keeping temperatures low enough for cold-water species, such as temperature-sensitive native salmon and trout. The effect of temperature on stream ecosystems is profound. Cooler water contains more oxygen than warm water, and oxygen is necessary for survival, growth, and reproduction of aquatic organisms.

The favors granted by forests to streams and rivers are returned when floodwaters crest overland, depositing nourishing sediment that enriches the land. The migration of salmon from the sea to forested headwater streams is yet another pathway by which valuable nutrients are returned to the land from the water. Phosphorus, a nutrient that is relatively scarce

in terrestrial ecosystems, is brought upstream from the ocean by the salmon, along with nitrogen and other elements. Some salmon are caught by bear or eagles; others simply die after spawning and are ingested by scavengers or *decomposers*. In all of these cases, nutrients from the fish, including the scarce phosphorus, are eventually returned to the soil as animal waste products. Author Robert Steelquist refers to salmon as "swimming fertilizer sacks."[2]

The normal healthy forest also stabilizes streams, distant ocean beaches, and dunes by providing a profusion of fallen logs and branches as snags, log jams, and rootwads. These lodge in streams, creating pools and riffles and scouring the beds, introducing irregularities, or *heterogeneity*, into the habitat. The wood may eventually be washed downstream, where it may become waterlogged and decompose in bays, oceans, and estuaries, providing habitat and food for bottom dwellers and other marine and estuarine organisms.

Apart from the ecological services forests offer, they provide an abundance of opportunities for hiking, backpacking, camping, boating, fishing, skiing, nature observation, hunting, solitude, healing, and contemplation. They are sources of inspiration for art, design, literature, and music, as well as for spiritual guidance and self-discovery. Accurate forest description requires superlatives: forests contain the oldest as well as the tallest and the most massive living things on Earth. They are also the most diverse ecosystems in species per acre, especially when soil microorganisms are included.

FORESTS, BIODIVERSITY, AND ENDANGERED SPECIES

Throughout the world, forests are home to many indigenous peoples. Over thousands of years, these local stewards have often acquired sophisticated ecological knowledge of their forests and have developed countless uses for the forest plant and animal products they harvest. To destroy or gravely damage forests may not only physically or culturally annihilate native peoples, but can lead to the loss of traditional ecological lore invaluable for forest management.

Forests are reservoirs of genetic diversity. They contain more species than any other ecosystem on Earth and are like a library of genetic information that can be used by species through time to adapt to changing environmental conditions. Genetic diversity, as restoration consultant Mary Lee Guinnon puts it, is a species' "bag of tricks," which the species uses to cope with whatever condition the environment presents. Maintenance of genetic

diversity enables a species to improve its fitness and hence its chances of survival in response to altered environmental conditions. Depriving an ecosystem of its diversity, therefore, robs it of its ability to modify itself by outfitting itself with better adapted parts.

Healthy natural forests are templates that can be used as models for us to use in repairing damaged ecosystems. Maser refers to forests as "repair manuals" or "spare parts catalogs." When part of a degraded forest ecosystem is missing—when a species has become locally extinct—species can be transplanted to the affected site from a healthy forest.

As existing forests, new and old, are stressed by pollution and climate change, we will need everything that nature has to teach us about repairing damaged forests and about reconstructing new ones. Ecologist Aldo Leopold (1949) once said, "The first rule of intelligent tinkering is to save all the parts." The ancient forests are not only valuable laboratories for the scientific study of forest processes, such as succession, and the evolution of species, but they are at once blueprints and live-action instructional videos for restoring forests. Wild forests are living laboratories for studying how the natural processes of ecosystem assembly and evolution operate. Since forests differ from their youth to old age, we need to protect and conserve diverse natural forest communities of all types and ages, to assure ourselves adequate learning opportunities. The lush Appalachian Cove Forest, with its white basswood, tulip tree, and fragrant magnolias, has different lessons to offer us than do the pine barrens of New Jersey.

The value of forests as storehouses of genetic information is not limited to being a species repository—either for warehousing living curiosities or for assuring a reserve of variability that enables natural ecosystems to adapt to environmental change. Genetic material from wild plants is also of incalculable economic value for improving the resistance of domestic crops to pests and disease, potentially saving billions of dollars in crop losses or diminished productivity.

Timber companies have been slow to recognize that the multiplicity of forest life-forms constitutes what Maser wisely calls "the forest's immune system." Within the healthy forests' great diversity of interconnected organisms reside life-forms—including birds, insects, and pathogens— that can serve the forest just as white blood cells serve a human body. These forest organisms are available to proliferate when needed to deter,

mitigate, or cure the imbalances in the relative magnitudes of populations of different species that we call epidemics or pest outbreaks.

Variegated forest types are habitats for different sensitive, threatened, and endangered species. When we destroy old-growth forests, for example, we are signing death warrants for endangered, threatened, or sensitive species such as the red tree vole, the red-cockaded woodpecker, and the northern flying squirrel. Providing habitat for increasingly hard-pressed species is another ecological service that forests provide.

Unfortunately, the U.S. Congress for many years has not been supportive of efforts to protect endangered species, and on some occasions it has thwarted them. For example, the Republican-dominated 104th Congress put in effect a one-year moratorium in 1995, prohibiting the listing of additional species under the federal Endangered Species Act (ESA) of 1973, which is one of the most potent environmental laws ever passed.[3] The move was part of a broader moratorium on federal regulatory rulemaking introduced by House majority leader Representative Tom Delay of Texas.[4] Republicans cast the moratorium as an effort to make the federal government more efficient. Opponents saw it as a way of freeing businesses from new regulations, including environmental protection measures. One provision of the ESA explicitly prevented endangered and threatened species from being considered for ESA protection during the period set forth in the moratorium measure. While not successful in eliminating the ESA, the moratorium did delay protection for species awaiting listing, creating a 243-species backlog for the U.S. Fish and Wildlife Service (USFWS), the agency which lists terrestrial species. Congress also forced the USFWS to make the designation of critical habitat for endangered species a relatively low priority by depriving the USFWS "of sufficient funds to allow us to comply with all of the requirements of the Act."[5] Yet, even under the law as it had stood before these Congressional actions, the difficulty in getting a species on the Endangered Species List meant that some species died or were irrevocably set on the path to extinction before they could be listed. Whereas the USFWS in 2003 stated that it would need $153 million to comply with the ESA, the Bush Administration requested Congress to appropriate only $12 million for Fiscal Year 2004 for the entire United States.[6] Needless to say, if we want healthy forests, we had better not allow the species that comprise them to disappear.

How do forests deliver their broad range of services and goods? The answer lies in the complex way in which forests capture, transform, and exchange energy. An understanding of these processes and other fundamental aspects of forest ecology is the foundation on which sound forest policy must rest. By contrast, using economics and politics bereft of ecology as the basis of forest policy is a prescription for disaster. Therefore, the following overview of the basic principles of forest ecology serves as a prelude to the discussion of forest management practices in later chapters.

To begin, energy enters the forest as light. The forest captures this solar energy input within its leaves and uses it there to combine carbon dioxide taken from the air and water drawn from the soil to produce plant tissue. The whole process, called photosynthesis, is basic to all forest ecosystems. Through photosynthesis, the forest provides oxygen to the atmosphere and participates in the perpetual global cycling of nutrients and moisture among air, water, soil, and plants. Meanwhile, forest plant roots extract minerals from soil and rock, incorporating the elements into plant tissues. Tree leaves, stems, branches, roots, trunks, fruits, nuts, berries, pollens, and nectars feed a vast array of consumers, from tiny spores of leaf rust and leaf-cutter ants to bull moose that browse on leaves and twigs.

When dead or dying plant tissue, such as bark and tree trunks, fall to the ground, they are broken down by organisms whose specialty in life is decomposition. Mushrooms, other fungi, bacteria, termites, and beetle larvae feed on the decaying wood. In doing their job, these decomposers help produce soil and perform the critical nutrient cycling functions.

For its part, soil nourishes forest plants, supports microorganisms, provides habitat for animals, and catches, retains, and filters water, which flows through it to feed plants or percolate into underground flows known as aquifers. These underground reservoirs may discharge water to the surface in springs or flow directly into streams, lakes, and rivers.

At first glance, the forest may appear simple and virtually empty. Much of a forest's life occurs underground and is, therefore, invisible to us as we stand above it. Billions of organisms — from yeast and fungi to moles, voles, shrews, salamanders, worms, beetles, spiders, mites, centipedes, millipedes, snails, and slugs — all are busy underfoot in the leaf litter and the organic layers of soil. All actively process nutrients and make them available to higher plants and other organisms. Subterranean life helps to cre-

ate the soil and exude compounds that bind soil particles together into useful little clumps called aggregates, which retain nutrients against leaching by rainfall.

The roots of many tree species are coated and interpenetrated with fungi known as *mycorrhizae*. These intimate associates are fed by the roots and in return offer the roots some protection against root disease, stimulate root tip growth, and greatly facilitate nutrient uptake. About ninety percent of all plants are thought to have mycorrhizae. Mycorrhizae send fungal filaments called hyphae into the surrounding soil, from which they transport nutrients to the roots, which provide the fungi with sugars in return.

The hyphae thus connect the roots both to the soil and to other mycorrhizae. Exudates from roots and hyphae, along with sloughed organic matter, support a complex community of soil organisms that include bacteria, protozoa, and invertebrates. Not surprisingly, many mycorrhizae improve seedling growth and survival dramatically. Some trees, such as pines, grow on nutrient-poor soil and *require* mycorrhizae. Plant roots hold forest soil in place and in turn build more soil when they die and decompose, opening channels for water and air to enter soil. Masses of interwoven hyphal filaments known as *mycelium* are pervasive in the soil. Without their presence and activity, soil would eventually become a dusty or sandy mass of unconsolidated particles that could be easily blown away by wind and swept away by water.

As if trees knew how important soil is to the forest, they safeguard it in various ways. Trees shelter soil from the pounding of falling rain droplets and the harsh drying of wind and full sunlight. As leaves reduce droplet velocities, they also contribute nutrients leached by the rain from the leaf surface to the soil. Fallen leaves, branches, and trunks further slow the overground passage of water, increasing the seepage (infiltration) of water into the ground.

To manage this complex flow of material and energy, the forest must be information-rich — that is, well stocked with a diversity of organisms. The information is packed in the coded genetic material — vast libraries of information — stored inside each cell of each forest organism. The encoded information guides the development of the multiplicity of organisms interacting in the forest ecosystem.

The forest is also organized in other respects. One aspect of its physical organization is the forest's architecture. Most multi-species forests are

physically stratified into layers. Tall trees form the upper canopy, and shorter subcanopy trees, perhaps black cherry or dogwood, form a second layer. Shrubs, perhaps rhododendron or elderberry bushes, fit themselves underneath and among the trees; vines climb the trees or grow close to the ground; and wildflowers, herbs, and occasional outcrops of grass hug the ground.

Another important aspect of a forest's organization is the forest's food web, or food pyramid. The web is based on the *autotrophs*—plants, such as algae, which manufacture their own food from sunlight and inorganic material. Autotrophs are consumed by *heterotrophs* — literally "other-eaters," which do not perform photosynthesis themselves but survive by assimilating other organisms. Feeding is an organized activity, with herbivores, carnivores, omnivores, and detritivores each specializing (or generalizing) in their particular types of food.

PATTERNS OF CHANGE THROUGH TIME

Each forest type has one or more characteristic developmental sequences or stages, known collectively as *succession*, by which the forest becomes established in its environment. In this process, the forest adapts to the environment and simultaneously adapts the environment to itself. All the while, the successional process increases the complexity and the nutrient capital of the forest ecosystem. Nature's own system of crop rotation and natural fertilization meanwhile ensures that different nutrients and vertical soil strata (known as soil horizons) are used by forest organisms.

Like all ecosystems, forests are ever-changing. The patterns of change, however, are predictable only over large areas and long periods of time as forest ecosystems respond to natural disturbances. These include fires, earthquakes, windstorms, avalanches, landslides, floods, disease, insect plagues, invasive plants, and the effects of grazers and browsers.

The advance and retreat of glaciers provide an extreme example of successional processes. As a glacier retreats, soil and plants are removed, often leaving only scraped rock and unconsolidated mineral substrate (such as sand and gravel). These materials are low in organic matter and lack structural complexity and stability. Willows and alders might be the first trees to establish on this rugged, difficult terrain. Pioneer plants, such as alders, lupine, and ceanothus, contain nitrogen-fixing bacteria in nodules on their roots. These bacteria enrich the soil by removing molecular nitrogen from the air and incorporating it in the soil in soluble forms

suitable for plant root uptake. Pioneers also stabilize bare soil, provide shade, reduce moisture loss, and sometimes offer young trees protection against certain insects.

Once the soil has been improved by these pioneers, other plants can become established in their turn. This process continues until a dynamically stable state has been reached in which no further broadscale species replacements are likely—until the next major disturbance, such as a forest fire, again upsets the forest's equilibrium.

Wild forests periodically and naturally have wildfires, one of nature's ways of cleansing the forest of dead and dying material, opening cones and other seed stores to release seed, removing insects and disease, releasing nutrients, and—through the patchy nature of most periodic burns—introducing additional habitat heterogeneity. These fires play important ecological roles in forest ecosystems and succession. Woody debris on the forest floor is consumed as flames scorch the ground, preventing fuels from accumulating in sufficient quantities to produce hotter and more damaging blazes. A species' degree of susceptibility to fire influences its place in a forest's pattern of succession and may determine whether it dominates or relinquishes a site to another species.

The complexity of the natural forest's biological programming insures that forces needed to repair the damage done by fire will be set in motion by the fire itself. For example, fire consumes organic litter on the forest floor, and, while it releases nutrients in the form of ash, it also oxidizes nitrogen, which may be in short supply following a fire. Fortunately, the ash raises the soil's alkalinity, thereby improving its habitability by nitrogen-fixing bacteria that can restore nitrogen to the ecosystem. Plants that are able to thrive on bare ground, or in disturbed areas, sprout after fires, and begin the forest repair process. These pioneer species generally have rhizobium nodules of nitrogen-fixing bacteria on their roots, so they are soon adding large amounts of soluble nitrogen back into the soil. The new roots also hold the soil against erosion and break up compaction. Then, as the pioneer plants shed body parts, they begin building a new supply of organic materials in the soil to replace those consumed by the fire.

When fire is long delayed, fuel accumulates, so that the inevitable fire will be an inferno. It climbs up tree trunks as if ascending a ladder and burns off tree crowns, killing the trees instead of just singeing the bark. Because of the intense heat, the soil may also be damaged. It may form a crust that resists water, delays forest recovery, and leads to erosion. For

this reason, forest managers must be prepared to introduce fire as needed in forests where fuel buildup is no longer properly regulated by natural forces.

Many of the problems forest managers face today in U.S. national forests, national parks, and on private lands stem from the ecological ignorance that has guided decades of federal, state, and private fire-suppression policy. In many forests today, huge buildups of fuel threaten some forests and will necessitate expensive remedial control efforts to reduce fuel loads so that controlled burns can be conducted. In other areas, the indifference of the U.S. Forest Service and timber companies to the role played by a broad diversity of organisms in forests has led to the excessive removal of brush, downed wood, and snags (standing dead trees) that provided habitat for beneficial insects, birds, and mammals, which keep forest diseases and infestations from reaching epidemic proportion. Removal of these forest integuments—often accompanied by the application of chemical herbicides—coupled with the decisions by industrial foresters to replace natural multi-aged, multi-species, multi-layered canopies of trees with single-aged, single-species stands of commercial timber, has left woods susceptible to ruinous plagues of bark beetles, budworms, and other *vectors* (organisms that transmit pathogens).

Instead of heeding these outbreaks as warnings to begin efforts to reestablish true forests, or to begin adopting sustainable forest policies for the future, commercial timber managers typically have resorted to massive applications of pesticides. Over several decades, millions of pounds of toxic chemicals that often endanger both nontarget species and water quality have been sprayed over millions of forest acres. While these treatments temporarily address the symptoms of forest imbalance, they do nothing fundamental to redress it, and so the imbalance generally reappears in another guise, which may be misinterpreted by industrial timber managers as yet another reason for chemical control technology.

In our hubris, we have delivered multiple insults to forests by trying to manage them without conforming our actions to the principles of forest ecology. To the extent that these insults are unintentional, their common wellspring is ignorance. "Of all the myriad interdependent relationships in the forest," writes Herb Hammond (1991), "we are aware of only a few. Ignorance coupled with technological prowess makes human alteration of the forest ecosystem very risky."

Forests are at risk not only from specific actions taken by forest managers and timber companies extracting timber on the ground, but also from global environmental problems created by industrial and energy policies. Air pollution created by heavy industry, fossil-fueled power plants, and internal combustion engines produce oxides of sulfur and nitrogen that form nitric and sulfuric acid in the atmosphere. Carbon dioxide from natural and human sources also combines with atmospheric moisture to produce carbonic acid. All of these acids naturally tend to acidify precipitation falling on forests and other ecosystems.

Airborne acids eventually fall out of the atmosphere in the form of acid rain, sleet, snow, or small solid particles. They also hover in the atmosphere as acid fog, corroding high-elevation forests. Acid precipitation harms forests through direct contact with trees and other plants and through indirect effects of the acids on soils. The effects on forests differ from one forest community to another, from one tree species to another, from one ecosystem to another, because of the great variations that occur in soil and vegetation. But the price is steep: forest damage from acid rain costs the world tens of billions a year ($30 billion a year in Europe alone).

Not only are some of the effects of hyperacidity on soil cumulative, but they also are exacerbated by other potent pollutants, especially ozone, that affect leaves and by environmental stresses that can weaken a tree's resistance to pests and disease. The overall result may be to reduce tree growth and productivity, physically damage leaves, cause premature leaf fall, inhibit reproduction, alter species composition, increase susceptibility to disease or insects or climatic stress, and increase mortality.

Whereas, at high concentrations, acid rain can damage plant leaves, shoots, cuticle (a protective waxy coating), and stomata (leaf pores through which plants breath), the most serious threat from acid rain appears to be the long-term cumulative effects on soil and aquatic ecosystems, particularly lakes, where the acid may accumulate, eventually killing aquatic life. (Aquatic life is also killed by mercury, a long-lasting and toxic heavy metal released from coal-burning powerplants, that has contaminated thousands of forest lakes and streams.)

While some forest soils have a natural ability to neutralize acids, other soils are highly susceptible. In the susceptible forest, acid precipitation

increases soil acidity, and toxic sulfate and nitrate ions build up. Soil changes then result in the mobilization of toxic aluminum and iron ions in soluble form from the soil. These heavy metals are then thought to be preferentially taken up by tree roots, inhibiting the uptake of the calcium and magnesium essential for growth. The later two elements are also made soluble by acids but are then leached from the soil at an accelerated rate. These processes could be responsible for slowing tree growth.

GENETIC ENGINEERING AND FOREST RESILIENCE

Timber companies frequently use trees cloned from identical genetic stock in converting forests into tree plantations. This genetic engineering exposes such plantations to the risk of future extinction. Natural forests, with their diverse genetic makeup, have an inherent capacity to adapt to long-term environmental change. The greater a specie's natural variation, the greater the range of responses it can make to the forces of natural selection, and the greater the probability of it producing a "fit" individual, relative to its environment.

Trees of a species "propose" offspring, and subsequently the environment "disposes," deciding each offspring's fate based on whether or not it is suited to the fluctuating range of environmental conditions that determine its survival, such as temperature and moisture patterns. Because the variability of cloned trees is far more limited than that of a natural forest population, the chances of the cloned population's inability to adapt over long periods of time to changed conditions—and, hence, the chances of extinction—are much greater.

If climate warms dramatically in the next fifty or more years, as climatologists throughout the world expect and fear, the genetic variability of natural tree populations may well be required if trees are to successfully "propose" genetically modified future generations that are better adapted to the new climatic conditions and the altered fire regimes that go with them.

No one knows how millions of acres of genetically homogenous trees will fare when exposed to these new stresses. By the time we can answer this question with confidence, it may be too late to do much about it.

CHAPTER 2.
THE FOREST RESOURCE

A fallen tree is literally the soil for future generations of forests.

—HERB HAMMOND, *Seeing the Forest Among the Trees* (1991)

KINDS OF FORESTS

The world's forests can be classified according to their site, vegetation, general location, and other characteristics. For example, forests are broadly classified into northern (or boreal), central, southern, tropical, interior, coast, *montane*, and subalpine types. For vegetational classification, forests are grouped by species composition. As noted, vegetational composition ranges from pure stands of one tree species to various mixtures, such as oak-gum-cypress or aspen-birch. Specific understory plants are generally found in association with the different forest types.

Principal aspects of a site which are used for forest classification are the nature and depth of forest soil and litter, location, elevation, slope, temperature, and precipitation. Climate and soils are the principal overarching determinants of a forest type, along with the later influences of fire, competition from other plants, and predation from animals. Since individual trees, once established, cannot move themselves from unfavorable sites, they must adapt or die where they stand. *Silvics* is the study of how site characteristics and other environmental factors affect forests.

The two main forest types are those comprised of the needle-leafed and the broad-leafed trees. The broad-leafed species are almost all *deciduous* trees, such as hazel, beech, and sycamore, which lose their leaves every autumn. As if to confuse matters, however, some broad-leafed trees are also *evergreen* (nondeciduous), including the California live oak, Pacific madrone, California bay laurel, and many tropical trees. Not coincidentally,

evergreen broad-leafed trees are found in temperate or tropical areas where frost is absent or infrequent.

The northern evergreens, such as spruce, pine, cedar, juniper, and yew, are almost all nondeciduous and needle-leafed. (An exception, the tamarack [American larch], is a needle-leafed deciduous tree.) Evergreens are generally adapted to colder climates with short growing seasons, and the resinous compounds in the stems and leaves protect evergreens against frost, much like antifreeze. Therefore, even in cold climates, evergreens can maintain their needles year-round to conserve the energy that otherwise would be required to replace their leaves each year.

Particular forest types are found in zones determined largely by climate, as manifested mainly by precipitation and temperature. (Climate also influences soil formation.) Altitude exerts a major influence on local climate, so forest zones correspond to changes in altitude much as they do to the influence of latitude. Cooler mountain regions, even in middle and southern latitudes, are populated by cold-tolerant conifers.

Pure *coniferous* (cone-bearing) forests of fir, pine, spruce, and larch grow in the high, subpolar northern latitudes. These are known as taiga forests, and they tend to have poor, shallow soils and short, small-girth trees. By contrast, the moist-temperate conifer forests, such as those on the Pacific Coast (from Alaska to central California) and inland to the Rocky Mountains, produce thick layers of soil, huge trees, and dense understory growth, replete with mosses and ferns. These ecological characteristics develop in response to the voluminous annual precipitation and milder weather, with a longer growing season.

Trees of the moist, temperate forest include Sitka spruce, western red cedar, western hemlock, Douglas fir, and redwood. Because conifers grow rapidly, they are usually used for reforestation in North American commercial forestry. But when these softwoods are cut down early in their lifecycle, they have wider growth rings and more sapwood, and so their lumber tends to warp and twist in drying more than lumber from mature, old-growth timber. (This renders the immature softwood unsuitable for uses such as musical instruments that demand high-quality wood and less suitable for construction, where strong, straight lumber is required.)

Immediately to the south of the pure coniferous forests in the northern hemisphere are transitional forests of mixed broad-leafed trees commingled with coniferous species. In the eastern United States, these forests include sugar maples, yellow birches, American beech, inter-

spersed with two conifers, the white pine and eastern hemlock. Still farther south in the temperate zone, the conifers become sparser and eventually disappear, giving rise to forests comprised entirely of broad-leafed deciduous trees. Examples include eastern hardwood forests of beech-maple or maple-basswood and oak-hickory forests with their northern red oaks, scarlet oaks, and white oaks, and the bitternut, shagbark, and pignut hickories.

Moving into the warm temperate latitudes, a gradual shift occurs in forest type to broad-leafed evergreens. These trees are dominant in tropical forests, which are extremely rich in species diversity. While we may think of all tropical forests as jungle, the tropics actually have very distinctive forest types, including equatorial rain forest, dry tropical forest, monsoon forest, mangrove forest, montane forest, and others, each with unique ecological features and communities of species. In addition to the widely distributed forest types, there are isolated and rare forest forms. The pygmy forests of coastal California, for example, are created by unique soil conditions. Swamp forest and palm oases, too, result from unique hydrologic conditions.

ANCIENT AND OLD-GROWTH FORESTS

No single characteristic defines an *ancient forest* or an old-growth forest. The two terms are roughly synonymous, although "ancient" is more applicable to forests of great antiquity, with some trees many hundreds or thousands of years old, whereas an old-growth stand might be a "mere" 200 years in age or even less in some forest ecosystems that begin showing signs of decadence after 120 years. When one says "old growth," the image that pops into mind is often a stand of ancient giant sequoias, some more than 2,000 years old, with trunks large enough at the base for a car to drive through. Red cedar, Alaska yellow cedar, and bristlecone pine, however, get even older than redwood — 3,000 years, 3,500 years, and more than 4,600 years, respectively. In an insightful comment, holistic forestry expert Herb Hammond observes, "ancient forests seem to embody all aspects of the various phases of a forest," meaning that shrubby forest openings, young saplings, and mature, dying, and dead trees are all simultaneously present.

The presence of large, old trees is not sufficient to qualify a site as an old-growth forest. David Middleton (1992) defines an old-growth forest as "a structurally complex forest, hundreds of years old, that has not been

directly altered by humans." That may be an apt definition if "alteration by humans" means the influence of industrialized society, but the definition ignores the fact that old forests were typically very much influenced (over long periods of time) by the activities of their aboriginal human inhabitants, especially their regular use of fire to manage forests. One need not withhold an "old growth" designation from forests just because they were profoundly influenced by aboriginal peoples, however, since humans, too, are part of nature and forest ecosystems.

By contrast, the words "structurally complex" *are* key to defining "old growthness." Complexity is expressed as variations in size, shape, age, and species—of other forest organisms as well as trees. Patchiness in the distribution of vegetation is another manifestation of complexity, as is the presence of a multi-level forest canopy rather than a homogeneous monolayer.

For a coniferous forest, the four main distinctive structural characteristics that develop over time and convert it to an old-growth ecosystem are: (1) presence of the multi-level forest canopy, (2) large, old living trees [large for the site and old for the species], (3) dead standing trees (snags), and (4) downed trees. In addition to these four basic attributes, an old-growth forest exhibits wide variation in tree size and age and in irregular breaks in the canopy caused by broken or fallen trees. These breaks then allow light to penetrate to the forest floor and provide growth opportunities for young trees.

Each of the components of the old-growth ecosystem has important functions that help sustain the forest as a whole. For example, large downed logs decay slowly on the forest floor and release their stored nutrients over periods as long as 400 to 500 years. During that time, they build soil fertility, provide food and shelter to numerous organisms, offer rooting media for new trees and other plants, slow down surface runoff, trap and collect soil and nutrients, and, after being honeycombed by bark beetles and other wood borers, serve as spongy water storage tanks for forest life during seasonal dry spells.

While it may appear forlorn and scraggly, the snag is actually, in Middleton's words, "an animal apartment house" that provides nesting, roosting, feeding, and denning opportunities to numerous species for many generations during the century or so that it may remain upright. The old-growth forest has an abundance of snags compared to a younger forest, and it also contains a relatively large amount of fallen wood. The dead, dying, and wounded trees that provide variation and irregularities within

the forest are produced over centuries or millennia by the accumulated effects of disturbances cited in Chapter 1.

OLD-GROWTH REMNANTS: WHERE THEY ARE, WHY THEY ARE PRECIOUS

Along the Pacific Coast of North America, the remaining uncut but rapidly vanishing old-growth forest is found distributed from northern California to Alaska. Redwood and Douglas-fir old growth grows as far north as Oregon. Douglas-fir ranges into Washington, and Sitka spruce-western hemlock old growth can grow from northern Oregon to British Columbia and southeastern Alaska. The ancient forest in this region contains other large and impressive trees, such as the grand, noble, and Pacific silver firs.

Inland old-growth and native forest are also found in Montana, Idaho, Colorado, Wyoming, Arizona, and New Mexico. Despite its value and scarcity, approximately two to three billion board feet of old-growth timber—60,000 to 100,000 acres—was still being cut annually in the Northwest, Southwest, northern Rockies, and Tongass National Forest of Alaska in the late 1990s.

Of the 850 million acres of original native forest in the lower continental United States at the time of the first European settlements in the late sixteenth and early seventeenth centuries, little ancient or virgin forest survives. At best, only a few percent of the original forest has escaped the lumberman's ax and saw, and only ten million acres of old growth are protected from cutting nationwide. Most of the old growth now in harm's way, however, is in the Pacific Northwest and Alaska. Well over ninety percent has been logged, and for some desirable species the loss of old growth has been much greater. At the logging rates of the mid-to-late 1990s, all remaining unprotected Pacific Coast old growth will be gone by about 2025.

Throughout the eastern United States, less than one percent of the aboriginal old growth has been saved from logging—probably less than a million acres—and it is found mostly in the Great Smoky Mountains, the Adirondacks, and a few relatively small sites in the East. Some of these parcels are twenty-five acres, others fifty acres, and occasionally larger, such as a stand of 1,700-year-old bald cypress on the Black River of Cape Fear, North Carolina. Today, when people speak of old growth in the East or Southeast they are probably referring to *second-growth forests* that may be 200 years old or less and that have acquired some, if not many, old-growth characteristics.

Population growth and demand for "natural areas" from an increasingly urbanized populace are putting severe pressure on old growth as well as on forests of all types, but people are especially drawn to old-growth forests precisely because they are the last and most impressive examples of wild forest. Through the cumulative impacts of their numbers, hordes of well-meaning, admiring people nonetheless gradually destroy the objects of their affection. In addition, if we reserve only a few examples of old-growth wilderness, chances are most Americans will find these ancient forests remote and expensive to reach. We, therefore, need to maintain as many geographically dispersed and representative samples of our original forests as we can to help assure their accessibility and to minimize their ecological fragmentation.

Timber interests and their allies have often made the bogus argument that because "trees are a renewable resource," cutting old-growth forest is a perfectly acceptable and harmless activity. Usually it *is* possible to replant trees after a forest has been clearcut. And, in due time, some of these trees *will* grow large. Seldom, however, do logging companies really make an effort to recreate the ecosystems they cut. And, even if they did, the history of modern industrial forestry is far too short for us to have demonstrated an ability to recreate old-growth forest conditions. These may include tons of mycorrhizae and *epiphytes* per acre (in a Northwestern ancient forest, for example), nitrogen-fixing lichens, as well as insects and birds for pollination, snags for habitat, and ancient, downed "nursery trees" for shelter, habitat, water management, and soil building.

"Old-growth soil with untold thousands of organisms is the most biologically rich part of the ancient forest," notes Hammond. But without the diversity and complex interactions of the fully developed old forest, soil fertility will not recover to its antecedent condition after logging. With simplification of the forest by industrial forestry, and with habitat fragmented by large clearcuts, forest genetic diversity, soil fertility, and water-holding ability will all decline, and forest life will not be as vigorous or robust as in a natural old-growth forest. In permitting our scarce remaining old-growth ecosystems to be destroyed, we may lose links in the great chain of forest life that is essential to the re-creation of future forests.

CHAPTER 3.
WHERE HAVE ALL THE FORESTS GONE?

There is no clear institutional leadership on forest issues at the global level.

—WORLD RESOURCES 1994–1995: *A Guide to the Global Environment*

The destruction of the world's forests is one of the major concerns of our age. Each year the world loses some 37 million acres of forests. According to United Nations' estimates, almost 40 percent of Central America's forests were destroyed between 1950 and 1980. During the same period, Africa lost 23 percent of its forests and the Himalayan watershed 40 percent.

—LESTER R. BROWN, PRESIDENT, WORLDWATCH INSTITUTE;
FOREWORD TO JOHN PERLIN'S *A Forest Journey* (1989)

Polite conservationists leave no mark save the scars upon the Earth that could have been prevented had they stood their ground.

—DAVID R. BROWER (1912–2000), ENVIRONMENTAL LEADER

LESSONS FROM HISTORY

The early European arrivals in North America acted as if the forests, wildlife, fish, and soil were limitless and impervious to abuse. This was the same mistake made 5,000 years ago in Mesopotamia: deforestation there increased the erosion of saline mountain soils and salinized the arable land, thereby reducing food production and contributing to the empire's decline. The Greeks, Romans, and other southern Europeans learned similar lessons as they, too, deforested and eroded their lands, depleted their soils, and killed their wildlife. So it was in ancient North Africa, China, and elsewhere.

The world's forests, which once covered forty percent of the earth, have been greatly reduced since humans first began cutting them down thousands of years ago. Only twelve percent of the earth is still covered by *intact* forest ecosystems. The World Resources Institute (WRI), in a 1997 scientific assessment of the world's forests, found that only twenty percent of the world's original forests were still "*frontier forests*" — meaning that they were still large, natural, and intact.[1] Even more shocking, WRI's team of ninety scientific experts found that, outside of the most remote and largely inhospitable boreal forests (e.g., parts of Siberia and far northern Canada), fully three-quarters of the world's remaining frontier forests are "threatened and may be significantly degraded in the next five to ten years."[2] Today, regretfully, global deforestation is still occurring rapidly. The root causes are soaring demand for wood, paper products, and land, which make logging profitable or a necessary step in preparing forest land for farming or ranching. The destruction of intact natural forests by loggers is often facilitated by foreign investment in timber exploitation, government corruption, illegal logging, and misguided economic policies that undervalue natural forests; sometimes, too, logging concessions are bestowed for political reasons to secure the support of powerful special interest groups. Conservationists and their allies have found it very difficult to deter the powerful political and economic forces in favor of logging. As a result, from 1990 to 2000, more than half a million square miles of forest were deforested globally—an average of 53,000 square miles a year—according to WRI data. Strong and determined multinational efforts to protect threatened forests — and to restrain the profligate consumption of wood that contributes to it—are urgently needed today to prevent the devastation of the world's remaining natural forests. Existing international efforts have not been equal to the task thus far and probably will not succeed without relentless pressure from concerned citizens.

How fast is global wood consumption growing? World consumption of wood for fuel and materials is increasing at a rate that is roughly proportional to the rate of world population growth, and has risen 2.5 times to 3.4 billion cubic meters from 1950 to 1991.[3] And world paper consumption, which was barely twenty-two million metric tons in 1930, grew tenfold between 1930 and 1990 and increased by a third again to 324 million metric tons, just from 1991 to 2001.[4]

Rising demand for lumber and plywood has made tropical wood a disastrously profitable commodity. For this reason, and also to provide land for ranching and farming, half of the world's tropical rain forests have been lost within the last half of the twentieth century alone. Central and South America, North America, Africa, and Asia have all sustained major forest losses. Ecologically unique tropical forest ecosystems, such as those of Madagascar, the Philippines, and Hawaii, with many rare endemic species, have been plundered for their timber. Apart from the social, economic, ethical, and scientific reasons not to do this, there are also significant public health reasons: "The cure for dreaded diseases such as AIDS and cancer," wrote Worldwatch Institute leader Lester Brown, "may reside in some plant as yet undiscovered that grows in the rain forest—if [the plant is] destroyed, humankind will be forever denied such help."[5]

Rapid forest losses are not confined to the tropics. Chainsaws are consuming the great northern forests of Siberia at twice the annual rate of deforestation in the Brazilian Amazon. Some seventy-six nations have lost all of their frontier forests, according to the World Resources Institute. Logging old-growth forests has been particularly savage and unremitting in British Columbia and elsewhere in western Canada. More than fifty percent of the old growth of coastal British Columbia has already been logged. Nineteen of the twenty primary watersheds on Vancouver Island have already been clearcut. (A primary watershed is one that opens directly to the sea.) Government logging plans target much of the country's old growth for extinction. If history is a guide, Canadians may well repeat, albeit more rapidly, the mistakes the United States has made with its forests over the past four centuries.

One need not be an ecological purist to be profoundly concerned about forest losses. The gross environmental impacts from such losses range from the merely costly to the catastrophic. Deforestation over large land areas can produce drought, flooding, desertification, soil degradation, erosion, and, thus, siltation. In turn, siltation can cause severe damage or ruin to streams, rivers, wildlife, wetlands, reservoirs, lakes, canals, dams, and harbors. The effects of deforestation also extend far beyond the cutover land to rivers, bays, and oceans. For example, in the Pacific Northwest and parts of Alaska, salmon catches in rivers have declined steeply as spawning streams fill with debris and silt, depriving people, bears, eagles, and orcas of important food sources.

U.S. forest cover was inexorably reduced by logging over the centuries of European settlement. From the billion or so forested acres found in what is now the United States, including Alaska, a low point in forest area of 567 million acres was reached sometime about 1900. Since then, the area of land in forest has increased to 749 million acres in 2003, due to the reconversion of marginal agricultural land to forest.[6] Thus, comparing the original expanse of American forest land in 1600 across what is now the fifty states to U.S. forest area in 2003, we find that the United States has about 300 million acres of forest less than in 1600, depending on which expert's estimate you accept.[7]

The change in forest acreage is, of course, a poor measure of what has been lost in the American forest since European settlement. Although more than 700 million acres of land may still have trees standing on them, they are rarely if ever equal in ecological function, species richness, and abundance to the primeval forest that the first settlers found. New England forests had oaks measuring up to thirty feet in circumference, white pines of similar girth standing 250 feet high, and sugar maples fifteen feet around the base, in addition to their hickories, elms, chestnuts, and other species.[8] Such forests were replete with an almost mythic abundance of wildlife.

As Donald Worster wrote, "According to one estimate, a typical forest area of ten square miles supported as many as five black bears, two to three pumas and an equal number of gray wolves, 200 turkeys, 400 white-tailed deer, and up to 20,000 gray squirrels."[9] As the forest habitat was cut down, much of this original plethora of wildlife, especially the large predators, was driven off or killed by hunters. Streams and rivers were degraded by loss of their protective forest canopy, by erosion from cutover banks and deforested lands, and by the trampling of livestock and the pollution of industry. In the process, native amphibians and fish, such as salmon, trout, and alewives, as well as water-dependent mammals, such as beaver, mink, otter, and muskrat, were lost from forest ecosystems. Even as some semblance of scrubby forest struggled back into existence in places after repeated land clearings, the forest was not the same. Large carnivores that regulated the populations of smaller mammals were now gone; forest songbirds were scarce; countless small animals that normally conditioned the soil were likely to be absent or rare. The industrious grey squirrels that had once filled the woods with their chattering and scolding

had also contributed to forest regeneration by forgetting to harvest buried acorns and hickory nuts. When these natural reforestation agents were eliminated, fewer trees of these species sprouted to join the ranks of their elders. With the alteration in species came a different kind of forest.

Whereas losses in forest cover stabilized nationwide around 1900, some regions continued to lose net forest cover until 1920 or later. Even today, certain regional forest types, such as California's oak woodlands, are declining in acreage. If one considers *native* forest rather than forest area per se, then forest losses in some regions are continuing to the present, since timber companies often reforest with different species (or different proportions of species) than a site originally had. Nationwide, however, U.S. forest acreage in the 1990s was about the same as in 1920, although much of what passes for forest is a faint shadow of its former grandeur and, in many places, is scarcely better than a tree farm. The 749 million acres of U.S. forest acreage in 2003 represented a recovery in area of about 180 million acres over the nadir of forest acreage that occurred around 1900.

Forest removal began relatively slowly at first in what is now the United States, constrained by early settlers' small numbers and technological limitations. Thus, it took settlers a full two-and-a-half centuries, from 1600 to 1850, to accomplish the first forty percent of the deforestation they eventually inflicted. But the rate of deforestation increased so quickly after 1850 that, in the next fifty years, far more land — 150 million acres — was deforested than in the previous 250 years.

Although U.S. wood growth in the aggregate now exceeds wood removals by more than seven billion cubic feet, that statistic disguises the fact that, even while standing timber volume was increasing and the total area in forest has been largely unchanged in the United States for decades, certain ecosystems have been more heavily depleted or damaged, while others have had an opportunity to recover.[10] During the 1980s, for example, bottomland hardwood forests in the South were converted to agricultural use so rapidly and extensively that, by 1985, only a million of the original twenty-four million acres of bottomland hardwoods remained in the lower Mississippi River Delta. Similarly, hidden in the overall statistics, softwood cutting on commercial timber lands substantially exceeded growth from the late 1950s or early 1960s well into the 1980s.[11]

And although temperate-zone forests increased globally by about five million acres between 1980 and 1990, the aggregate estimates of timber

acreage obscure localized regional devastation, the destruction of certain rare forest ecosystems, and qualitative changes in forest condition for those forests that survive. In Europe, more than a fifth of the trees have moderate to severe defoliation, most probably caused by air pollution, drought, nutrient loss, and insect damage. Aggregate forest loss data also typically do not highlight the losses in old-growth versus other forests. Today, only about one percent of Western European forests can still be considered old growth (greater than 200 years of age in this case and harboring "a natural range" of indigenous species). Similarly, in the lower forty-eight United States, only one percent of the aboriginal forest land remains "frontier forest," as defined by the World Resources Institute.

The colonists who arrived in what is now the United States found a largely unspoiled natural environment with wild forest covering more than one billion acres. Much of the plains and some of the forests were intensively managed with fire by the original Native American inhabitants. Their periodic fires, and those ignited by lightning, kept the Great Plains west of the Mississippi in grasses and herbs, instead of allowing forest establishment. Native Americans also kept eastern forests of oak, elm, ash, and hickory open and healthy by burning them frequently. These early American forest stewards not only hunted and gathered in the forest and farmed in clearings, but also "outplanted" desirable plants to use for food, basketry, and other crafts. For example, they might plant oak or hazel near villages or migration routes to harvest acorns and nuts at their convenience. Some tribes, especially in Central and South America, practiced shifting slash-and-burn agriculture, but forests generally were the Native American's gardens and orchards, as well as enormous storehouses of fish, fowl, and meat. As long as forest damage from farming or tree cutting was small in scale, local, and of limited duration, and as long as the forests were not subjected to wholesale abuse, the forests recovered and their magnificent bounty was endless.

Before the colonial era, there was, of course, no commercial logging in North America. In those days, logging meant that a tribe might cut a few trees to create small farm plots or to build small wood buildings. At times, a Native American would go into the woods, carefully select a tree, and, after an appropriate ritual to propitiate its spirit, laboriously cut the tree down with a stone hatchet to build a dugout or remove its bark to build a canoe. Belief in the sanctity of the natural world was not unique to Native American culture. Certain groves, and even large parts of forests, have

been regarded as sacred in Africa, Europe, India, and China since ancient times. Groves were sacred temples for the Druids, for example, and sanctuaries for the pantheistic ancient Athenians. The Chinese have preserved groves of sacred trees near temples since Confucian times, and, before the British came to the Uttarahkand region of India, no one was allowed to harm the vegetation of Uttarahkand's sacred areas in any way. In their wisdom, religion and folk custom created early forest nature preserves in various cultures.

By contrast, early European settlers of the New World appear to have been blind to the miraculous and sacred dimensions of forest life. They neither managed the forests sustainably nor valued them as ecological phenomena. They saw only game, lumber, and firewood to be taken and land to be cleared. Steeped in a Protestant work ethic and a utilitarian materialism, they viewed the wilderness as a hostile adversary to be tamed and replaced with the blessings of "civilization." The construction of their towns and cities and the development of their industries required a continual supply of timber and fuel. That meant incessant forest clearing, so the settlers industriously hacked and hewed the forest to build their villages, roads, ships, farms, and factories. From the days of earliest settlement until 1880, by far most of the wood cut was used for fuel, while the rest went for building materials or was cleared to create farms.

Deforestation first began in the East, localized initially in coastal regions and around towns and cities. Anyone who could swing an axe took what he could, giving little or nothing back to the land. As those lands were cleared and settled and the more accessible forests were converted to agricultural uses, the settlers pushed steadily west, leaving stumps and fields behind them. For 100 years after the nation's founding, it was federal policy to dispose of public land freely or cheaply to homesteaders, miners, and grazers, to encourage settlement and promote economic development. Much of the nation's forests, ranges, and mineral wealth were thus put into a multitude of private hands.

At first, only a small percentage of the forests were cleared. After all, they covered roughly a billion acres. But eventually, as cities developed, huge areas were cleared. By the 1860s, a commercial timber industry had come into being, and the wood chips and sawdust really began to fly. Eager for abundant supplies of trees after the Civil War, the timber industry discovered the white pine forests of Michigan, Wisconsin, and Minnesota, and logged them as fast as they could, leaving only "stumplands."

From the onset of the logging in the Great Lakes region after the Civil War, it took only a few decades to remove three-quarters of the area's standing timber.

The new timber industry next moved south to log the pine forests that stretched from Virginia through Texas. By the 1920s, timber companies had reduced the forests there, too, and then they were off to the Pacific Northwest. Under the influence of abundant rainfall, the region's ancient Douglas-fir, spruce, and hemlock grew two to three times as tall as the trees of the eastern hardwood forests. The giant trees were a lumberman's dream, but the legacy of destruction the industry had left behind across the nation was beginning to catch up with it. An era of forest regulation was beginning. Some forest treasures were placed off limits to the timber industry in parks and temporarily, as it turned out, in national forests. (Clearcutting of the national forests began in earnest in the decades after World War II.)

As noted, net losses of U.S. forest land ceased around 1900, and U.S. forest area increased slightly to 1920, at which point the amount of land in forest cover stabilized. This was caused by the gradual abandonment of farmland in the East and South, beginning in the 1880s, and by a tapering off in forest-to-farm conversions. Many of these abandoned farms naturally reverted to forest, and the forest-to-farm conversions largely ended in the 1930s. Thus, U.S. forests increased by forty million acres from 1920 to 1930. Net forest losses nationwide also stopped because of technological changes. Coal and oil replaced wood as fuel, and vehicles replaced draft animals. Consequently, much less farm land was required for pasturing stock and raising forage. Improvements in agricultural technology also led to large increases in agricultural productivity, which meant less farmland was needed. Improvements in lumber mill efficiency made it possible to get more usable wood from each tree as lumber mills acquired smaller, more exact saws and, in the late twentieth century, obtained "smarter" automated cutting equipment.

To sum up, the trend toward the progressive deforestation of the United States came to a halt through a combination of technological change and economic forces, albeit bolstered by conservation sentiment and forest conservation legislation (described in later chapters). Although the nation was still converting about 500,000 acres of forest every year to farms and urban uses in 1992, the conversion of forests to other uses between 1992 and 2002 was more than counterbalanced by an

overall increase in land converted to forest from other uses. Thus, U.S. forest acreage in 2003 — 749 million acres — was twelve million acres larger than in 1992.[12] In addition to tree plantations and reforestation efforts, many small, marginal farms in the Northeast have been abandoned during the past fifty to 100 years and have reverted from field to forest or brush. The percent of land in forests in the Northeast has, therefore, increased in many areas, reaching close to sixty percent for Connecticut, New York, and Pennsylvania.

In the 1930s, a cooperative forest-fire control program launched by the U.S. Forest Service involving state agencies and private timber owners also began reducing forest losses. Its success alleviated timber growers' fears that their timber would be destroyed before it could be sold, and the program thus contributed to their willingness to risk retaining standing timber.

As recently as the 1940s, timber was still so cheap that it cost less to buy a stand and cut it than to plant an equivalent acreage in seedlings, not to mention raising them to commercial size. Only when lumber prices rose in the 1960s, in response to diminished supply, did reforestation begin to be widely practiced on commercial timber lands.

THE PRICE FORESTS HAVE PAID

Although some of our replacement forests are healthy, others show signs of neglect, mismanagement, and the ravages of diseases and pests of European and Asian origin, such as gypsy moth infestations and Dutch elm disease.[13] Still others bear damage inflicted by multiple pollutants, especially ozone and, to a lesser extent, acid rain. The symptoms include leaf loss, discoloration, and abnormalities; reduced growth, branch dieback, increased susceptibility to illness and pests; and, eventually, premature death.

Whereas trees planted by timber companies and private landowners helped to defray forest losses from lumbering, the second-, third-, and fourth-growth forests produced in the United States have tended to be vastly inferior in native biodiversity, volume, and size to the original old-growth forests that stood on the lands just eighty to 100 years earlier. Much of the replacement forests today in the East and South are simplified and crowded brushy stands of small, narrow-girth trees. Gone are the chestnuts and elms, victims of diseases from abroad. Some oaks and maples are now being attacked by fungi. Beech, dogwood, sycamore,

white ash, balsam fir, and hemlock are threatened by disease and pests, too. Exotic plant species from Europe and Asia have also invaded and displaced native species, changing the forests in fundamental ways. High-grading—culling the best trees by selective cutting—has dispatched many of the finest seed trees. In addition, the new woodlands are often fragmented in small, disconnected lots, with a high ratio of edge to interior. This changes the habitat and reduces the niches suitable for deep-forest songbirds and other forest species. Simultaneously and tragically, many migratory songbirds are losing their southern hemisphere habitat to deforestation.

Even though today's second- and third-growth forests are not the equals of earlier old growth, many wildlife species can thrive in these forests and have rebounded from low population levels at the turn of the twentieth century. Populations of beaver, elk, pronghorn antelope, wild turkey, and whitetail deer have all boomed as hunting has been regulated more scientifically, based on game population surveys, and forest habitats have increased and been protected in national and state wildlife refuges and on certain well-managed private lands. Unfortunately, other nongame species, such as the red-cockaded woodpecker, have not thrived, and still others have gone extinct.

Forest protection in the future thus needs to involve more than just continued vigilance to safeguard scarce old-growth forest from logging, and more than just holistic, sustained-yield forestry to maintain the health of productive timberlands. It must also include restoring populations of sensitive, threatened, and endangered species and the nursing of deteriorating forests, old and new, back to health by controlling incursions of invasive species that threaten to overrun native ecosystems, even in protected national parks and wilderness. In Chapters 10, 11, and 13, I discuss how to accomplish some of these goals.

WHERE THE TREES ARE

Of the 749 million forested acres in the United States in 2003, about two-thirds were productive timberlands; the remainder were unproductive or off-limits to logging because of park, wilderness, or protected watershed designations. Who owns and controls America's forests? Although they are 192.4 million acres in size, our national forests contain only ninety-seven million acres of timberland — eighteen percent of the country's total. Commercial timberland is forest that is producing or capable of

producing at least twenty cubic feet of industrial wood per year and that has not been withdrawn from production by law or regulation. Another sixteen percent of U.S. timberland is in other federal, state, county, and municipal ownership. Thus, the public owns and, in theory, manages thirty-four percent of the nation's commercially productive forest land.

Timber companies hold a surprisingly small proportion of the nation's commercial timberlands — only twelve percent. Roughly fifty-four percent of the commercial forests remains in the hands of farmers, other citizens, and Native American tribes. Despite the small share of timberland that is owned by the forest industry, these industrial lands produce about a third of the nation's timber harvest—more than twice the output of the national forests. This is largely because industry in the West managed to acquire the nation's most productive timberlands before the national forests were established.

OUR WOOD SUPPLY

The nation in 2002 consumed eighteen billion cubic feet of timber and produced about fifteen billion, but that in itself doesn't imply a timber shortage or an impending shortage in the United States. First, to account for the shortfall: nearly five billion cubic feet was imported in 2002, mostly from Canada. Meanwhile, the nation exported 1.7 billion cubic feet, so *net* imports were roughly three billion cubic feet, which, when added to domestic production, equal our total domestic consumption.[14]

These statistics need to be understood in a broader context, however — that of timber growth rates in our forests compared with wood removed from forests. In 2003, net annual domestic wood growth (the increase in wood volume minus mortality) was almost twenty-four billion cubic feet per year in the Unied States. Saleable wood removals from U.S. forests were only sixteen billion cubic feet, so more than three billion cubic feet of wood was added to the standing stock of U.S. timber after accounting for the removal of logging residues and other unutilized wood.[15] In fact, the volume of growing standard timber in 2003 in the United States (eighty-five billion cubic feet) was twenty-eight percent greater than in 1953.[16] Therefore, forest protectors can take heart: we are not facing an impending timber shortage. Moreover, wise stewardship can further enhance and perpetuate our forest resources.

CHAPTER 4.
CONSERVATION EFFORTS

How would you feel if you knew that the oldest living beings on Earth had all been converted into money and you would never again see them, and your children would never have a chance to see them?

—CHRIS MASER, *Sustainable Forestry* (1994)

STARTING IN THE MID-1860s, early conservationists, such as George Perkins Marsh (1801–1882), who witnessed widespread forest destruction, were becoming alarmed about the possibility of future national timber shortages and about the increasingly pervasive damage that humans were inflicting on nature.[1] A few far-sighted and public-spirited citizens, scientists, naturalists, and sportsmen were now finally starting the slow process of convincing the government that the fate of the nation's forests was cause for concern. They aroused the scientific community and the press and eventually brought their fears of future timber famines to Congress and state legislatures. Initially, those bodies took little effective action until private citizens (outside government) took responsibility for waking up their elected representatives and making a case for conservation.

EARLY FOREST CONSERVATION EFFORTS

Few of these conservationists defended the forests for their intrinsic value. One exception was the conservationist, explorer, and scientist John Muir (1838–1914). As a boy, Muir had helped his family clear wild forests in Wisconsin to farm; but, as a man, speaking from personal knowledge gained in long, solitary journeys on foot through the forests of the United States and Canada, Muir urged the protection of forests for their beauty, wildlife, and natural power to heal and uplift the human spirit. Like naturalist and philosopher Henry David Thoreau (1817–1862), Muir repre-

Fig. II.1. John Muir, one of America's most famous conservationists, was an eloquent and passionate early champion of forest protection, wilderness preservation, national parks, and reverence for nature, particularly in the Sierra Nevada. Muir founded the Sierra Club in 1892. Photograph courtesy of the Forest History Society, Durham, North Carolina.

Fig. II.2. Theodore Roosevelt (left), as President of the United States, was a leader in the conservation and preservation of wild lands and cultural monuments in the United States. Here, he is pictured with conservationist John Muir in Yosemite National Park, California. Yosemite Falls, the highest waterfall in the United States, is in the center-left background. Muir led the campaign to establish Yosemite as a national park in 1890. The border is part of the original photograph. Photograph courtesy of the Forest History Society, Durham, North Carolina.

Fig. II.3. Gifford Pinchot, erstwhile protégé of John Muir, was the first Chief of the United States Forest Service. Once in charge of the public domain, however, Pinchot quickly became a proponent of the multiple-use of forests rather than forest preservation, and he thus opened the door to industrial forestry on public land. Photograph courtesy of the Forest History Society, Durham, North Carolina.

Fig. II.4. German émigré forester Bernard Fernow, head of the United States Bureau of Forestry, advocated sustained yield management of America's public forests as early as 1891. Photograph courtesy of the Forest History Society, Durham, North Carolina.

Fig. II.5. Aldo Leopold in Arizona, circa 1911. Leopold, whose "land ethic" was greatly influenced by the emerging science of ecology, is widely considered one of the most important environmental thinkers of all time. He began his career in 1909 as a Forest Assistant in the U.S. Forest Service (USFS), and through his efforts convinced the USFS in 1924 to create the nation's first formally protected wilderness, the Gila Wilderness Area in New Mexico. Like John Muir, Leopold's writings inspire millions of readers today. Photographer unknown. Courtesy of the University of Wisconsin-Madison Archives.

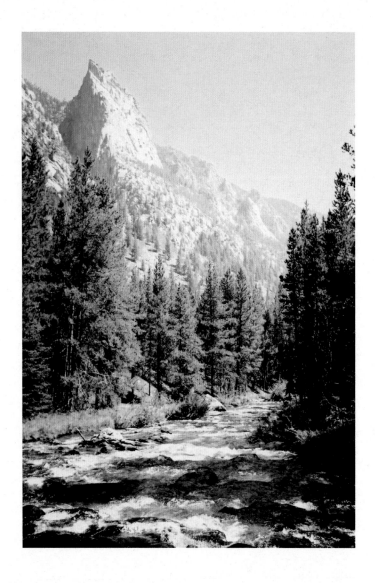

Fig. II.6. Bob Marshall worked tirelessly to create wilderness areas in the United States, and he especially loved Montana. Today, one can share in the experience of wilderness because of the efforts of Bob Marshall and others. Here is an example of wild lands worth saving: looking east at Silver Run Plateau and Lake Fork Canyon along the Lake Fork Trail No. 1, Absaroka-Beartooth Wilderness in Custer National Forest, part of the Greater Yellowstone Ecosystem, near Red Lodge, Montana. The trail follows this beautiful mountain creek through a lodgepole pine forest to a series of alpine lakes. Moose and bear frequent the area. Photograph © 2007 George F. Thompson.

Fig. II.7. A 1935 photograph of Bob Marshall, of the U.S. Bureau of Indian Affairs, during one of his many hiking treks to the wilds of Montana. Marshall was a cofounder of the Wilderness Society in 1935, along with other famous conservationists: Harold Anderson, Harvey Broome, Bernard Frank, Aldo Leopold, Benton MacKaye, Ernest Oberholtzen, and Robert Sterling Yard. In commemoration of his conservation efforts, "The Bob" in Montana was officially designated a national wilderness area in 1940 after Mr. Marshall's death in 1939. Photograph by Mable Mansfield, courtesy of The Wilderness Society, Washington, DC.

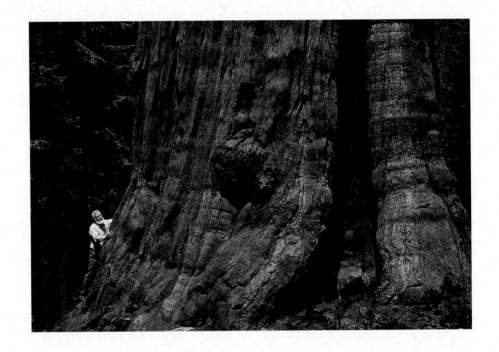

Fig. II.8. Martin Litton, a giant of the American conservation movement and stalwart defender of America's old-growth forests, communes with the Amos Alonzo Stagg Sequoia, the fifth largest tree on Earth and one of the giants that Litton has worked to protect in Giant Sequoia National Monument, California. Photograph © Martin Litton.

sented the antithesis of the materialism and utilitarianism that dominated much of the early American conservation movement.[2] Muir's writings were a brilliant fusion of natural history and reverence for nature. By the 1870s, Muir and other conservationists, such as forester Dr. Franklin B. Hough and U.S. Secretary of the Interior Carl Shurz, were calling insistently for federal action to protect forests.

Several states also awakened to the need for forest conservation in the 1860s and 1870s, but they usually became active only after timber companies had already ravaged their lands. State forest protection efforts were generally limited to establishing commissions of inquiry to document the extent of forest destruction or to creating weak state forestry associations, few of which had trained staff or adequate financial resources. These early ineffectual efforts bear a curious resemblance to contemporary efforts by multi-national organizations to protect tropical forests.

Early conservationists shared some of the Progressive Movement's concerns about monopolies.[3] By advocating government control of forests, conservationists sought to protect the public domain from the thrall of the timber magnates and robber barons who had seized control of other extractive industries and were consolidating public resources in their own hands.

EARLY FOREST LEGISLATION

Congress first responded to pressure for forest conservation in 1872 by creating Yellowstone Park in Wyoming and then by passing the ill-fated Timber Culture Act of 1873 to encourage homesteaders to grow and protect trees. The act gave homesteaders an additional 160 acres of land if they promised to grow trees on forty acres, but it led to widespread land fraud and was repealed. The Timber and Stone Act of 1878 followed, allowing settlers to buy 160 acres of forestland for $2.50 an acre. Upon repeal of the Timber Culture Act, the Forest Reserve Act of 1891 was adopted. While the Timber Culture Act and the earlier Homestead Act of 1862 had transferred public lands into private hands, the Forest Reserve Act marked a transition in public land policy "from disposal to retention" of the public domain.[4] The act authorized the President to set aside (in reserve) millions of acres of land from "public entry," which meant sale to the public, in order to protect watersheds and establish parks. President Benjamin Harrison used his new authority promptly to designate reserves, and by 1897, during President Grover Cleveland's term, forty million acres had been set aside.

Bernard Fernow, an émigré German forester who headed the U.S. Bureau of Forestry, urged Congress as early as 1891 to manage the new forest reserves for a continuous (sustained) yield of timber. He was the principal author of the Forest Management Act, known as the Organic Act of 1897. The act established the purposes of the forest reserves: to protect watersheds and provide a timber supply for the nation. The act also established management principles for the reserves. Fernow had the foresight to recognize as early as 1902, in his book *Economics of Forestry*, that timber companies did not, and would not for the foreseeable future, have sufficient economic incentives to manage their timber on a sustainable yield basis. He, therefore, advocated government control of forests.

The federal forest reserves were transferred from the Department of the Interior to the Department of Agriculture's Bureau of Forestry in 1905 after a long campaign by then-Bureau head Gifford Pinchot, an intimate friend of President Theodore Roosevelt and an early protégé of Muir. The reserves became the core of the nation's national forests. The Bureau of Forestry was renamed the U.S. Forest Service (USFS) in 1905, and the reserves were renamed the national forests in 1907.[5]

Forest conservation first became public policy in the United States not out of a love of forests for their own sake. Instead, the federal conservation movement began as a modern, rational, and scientifically oriented reaction to the unregulated and wasteful destruction of forests and other natural resources so common in early America. By contrast, conservationists were for "regulated exploitation" of resources and were thus against the kind of wanton resource abuse epitomized by the senseless slaughter of bison and the extermination of three billion passenger pigeons.[6] In the eyes of USFS Chief Forester Pinchot, forest trees were a crop to be rationally managed, and the national forests were to be put to prompt, efficient, and businesslike *use*, albeit a conservative use, that ostensibly preserved their permanent value.

Pinchot was animated by the high-minded and overarching goal of insuring the continued prosperity of the nation's agricultural, lumbering, mining, and livestock interests through an ample supply of timber. "The object of our forest policy," Pinchot declared, "is not to preserve the forests because they are beautiful . . . or because they are refuges for the wild creatures of the wilderness. The forests are to be used by man. Every other consideration comes secondary."[7] In his narrowly utilitarian focus,

Pinchot was nonetheless egalitarian rather than elitist: he wanted the forests to be used "for the permanent good of the whole people and not for the benefit of individuals and companies."[8] Conflicts between the needs of an ecosystem and the needs of people, however, were to be resolved for the benefit of humans. Thus, when Pinchot spoke of "conflicting needs" with regard to nature, he was referring not to any inherent right of nature to exist versus a human need for resources, but instead to conflicts among competing resource users, as in his admonition that, "where conflicting interests must be reconciled[,] the question will always be decided from the standpoint of the greatest good of the greatest number in the long run."[9] Unfortunately, lacking Muir's deep ecological insights, Pinchot often could not recognize what the greatest good would be in that "long run" for the greatest number. Because he was far more committed to using the national forests than to protecting them as ecosystems, Pinchot opened the national forests to livestock grazing which caused much ecological damage. He also effectively opposed the establishment of wildlife preserves in the forests and betrayed the trust of John Muir by siding with those who, over Muir's fervent opposition, were to build a dam at Hetch Hetchy in Yosemite, the first dam to be sited in a national park. It would be decades before the Forest Service reluctantly and selectively embraced the idea of wilderness preservation and longer still before the idea of removing the O'Shaugnessy Dam and restoring Hetch Hetchy Valley began gaining support among resource managers.

EXPANDING THE PUBLIC DOMAIN

By 1907, Roosevelt, under Pinchot and Muir's influence, had exercised the authority granted him by the Forest Reserve Act to set aside 100 million additional acres as national forests, mostly in the West. The Weeks Act of 1911 extended the forest reserves to the East, where most of the timber had already been cut. The act was passed to accomplish flood and fire control and watershed protection, as well as out of a desire to secure recreational opportunities on public lands. In 1916, a year after the establishment of Rocky Mountain National Park and more than half a century after the establishment of Yellowstone, the National Park Service (NPS) was established to manage the nation's thirteen national parklands. Under the leadership of the service's first director, Stephen Tyne Mather, the NPS began an era of rapid growth.

As the federal government began protecting forest reserves in the late nineteenth century, a parallel nongovernmental wildlife conservation movement was launched and sustained by the amateur efforts of private citizens, generally men of wealth and position. George Bird Grinnell, a hunter-conservationist appalled by the slaughter of birds for the plume trade, founded the National Audubon Society in 1886. Although the protection of birds was its initial mission, that concern led the society to work for the protection of diverse bird habitats, including forests. In time, the society's agenda broadened, and, in 2007, the organization has more than 600,000 members.[10]

Another private organization that helped form early forest policy was The Boone and Crockett Club, a small but influential hunting club of conservation-minded sportsmen, founded in 1887 by Theodore Roosevelt and a number of fellow big game hunters, including Grinnell. The membership eventually included USFS Chief Pinchot and renowned wildlife ecologist Aldo Leopold, foremost exponent of the seminal land ethic concept, which asserted an ethical obligation of land stewardship.[11] While promoting rifle hunting, the Boone and Crockett Club lobbied for the enactment of the first game laws, such as those protecting migratory birds, and for the establishment of national forests, wildlife refuges, and national parks.

The power of the inspired and committed citizen working on behalf of nature is epitomized in the accomplishments of John Muir. Working independently as a writer and public speaker, Muir collaborated with his publisher, Robert Underwood Johnson, the editor of *Century* magazine, to campaign relentlessly for forest protection. In 1889, *Century* issued a call for protection of all forests on federal land and for a national *forest plan*. Muir's lyrical nature writing and advocacy, coupled with Johnson's publishing and lobbying, launched a successful campaign for the eventual creation of Yosemite National Park in 1890. Some of the land was already under the state of California's ineffectual guardianship; Muir helped draw new boundaries to protect 1,500 square miles of unparalleled beauty surrounding Yosemite Valley in the heart of the park.

In 1892, Muir and twenty-seven other Californians founded the Sierra Club. It was part alpine club and part conservation organization and was modeled after the Appalachian Mountain Club.[12] One of the group's guiding precepts was Muir's firm belief that bringing people into the wilderness would create converts for conservation. This conviction pro-

vided the impetus for the club's wilderness and mountaineering outings, Sierra Nevada trail building, and educational programs. The club, however, was not just dedicated to promoting the exploration and enjoyment of mountains; club leaders wanted to protect the forests and other natural features of the Sierra Nevada.

In the Sierra Club's early years, Muir worked closely with Johnson and with Harvard botanist, Charles Sprague Sargent, a pioneer of the forest conservation movement. Sargent had conducted a survey of the nation's forests in 1880 and for years thereafter had advocated creation of a federal forestry commission to survey Western forests. Finally authorized in 1894, the Western Survey, on which Sargent also labored, provided the justification that President Grover Cleveland needed in 1897 to set aside by administrative action more than twenty-one million acres of public land as forest reserves.

With the fame that Muir's writings and successes in protecting Yosemite brought, Muir, Johnson, and Sargent used their influence to lobby Department of Interior secretaries and other powerful government officials for forest protection. In 1903, President Theodore Roosevelt invited Muir to camp with him in Yosemite, and Muir's eloquence and passion in defense of nature made an enormous impression on Roosevelt, beautifully chronicled in *John Muir and His Legacy* by Stephen Fox. Following their trip, Roosevelt had the Sierra Nevada forest reserve extended as far north as Mount Shasta. During his presidency, Roosevelt created or enlarged thirty-two forest reserves totaling seventy-five million acres, in addition to numerous wildlife reserves, parks, and national monuments.

THE PROTECTION OF WILDERNESS

Although the nation had set aside millions of acres of public forested lands, the idea of leaving these lands alone and unmanaged—allowing natural processes to rule the ecosystems without human intervention, structures, roads, or motorized vehicles—was still a novel one. The concept of protecting land as "primitive" or wilderness areas arose spontaneously when two virtually simultaneous objections to wilderness destruction were raised not long after World War I in the American Southwest. Landscape architect Arthur Carhart had been hired to design a road in the White Mountain National Forest of Colorado so the USFS could build vacation cabin sites on the shores of Trapper Lake. Instead, Carhart convinced the USFS that a road and cabins would damage the

47

wilderness lake, and the project was set aside. At about the same time, ecologist-to-be Aldo Leopold was working as a forester for the USFS and was given the assignment of assessing the timber of the Gila National Forest for logging. Unhappy with that prospect, he persuaded the USFS to protect half a million acres of the Gila as a designated primitive area off limits to logging.[13]

Another milestone in the protection of nature had occurred earlier at the state level when, in 1885, New York State established the Adirondack Forest Preserve and at a state constitutional convention adopted a provision declaring that it would be kept "forever wild." Adirondack Park today contains 200,000 acres of aboriginal old growth and more than a million acres of maturing second-growth forest. Whereas the park is six million acres in size, more than half is private property; some of this land has been developed and additional development is possible. A core area of 2.7 million acres of parkland are owned and protected by the state.[14]

Through the involvement of Sierra Club members in outdoor activities, the club became inexorably drawn more deeply into protecting forests and other natural resources. To date, the Sierra Club, joined by other conservation and environmental organizations, has fought many successful battles for the establishment and enlargement of national parks, national forests, national monuments, wilderness areas, and wildlife refuges, and against the establishment of major dams in parks and other scenic areas. By the 1950s, the club was broadening its outdoor activities and areas of concern beyond California to other states. Gradually, as the conservation movement of the 1950s and 1960s metamorphosed into the environmental movement of the later twentieth century, the club became a "full-service" environmental organization engaged in virtually every type of environmental issue, from protection of forests, deserts, prairies, air, soil, and water to energy, agricultural, toxics, and trade policies. Today, the club has more than 750,000 members in fifty-seven chapters and 370 groups. It has a staff of more than 400 people and has an influence on international as well as national environmental issues.

Other national, regional, and conservation organizations have also played pivotal roles in the protection of forest and other natural resources using a variety of techniques. The Wilderness Society, founded in 1935 by forester and plant pathologist Robert Marshall, along with Aldo Leopold, Robert Sterling Yard, and Benton MacKaye, was dedicated to "fighting off invasion of the wilderness" and promoting an apprecia-

tion of its values. The society battled on the legislative front as well as in the courts for protection of wilderness and for proper management of the national forests. In the late 1940s, Wilderness Society director Howard Zahniser reintroduced the idea of a national wilderness protection system and began campaigning for it. (The idea was first articulated in 1921 by regional planner Benton MacKaye, founder of the Appalachian Trail, who began advocating for the trail in that year.) After years of effort, beginning with the first introduction of the wilderness bill in 1957, Zahniser's campaign and early legislative drafting culminated in the 1964 Wilderness Act, which was finally approved by Congress after sixty-six drafts. Initially, the act was opposed by both the U.S. Forest Service and the National Park Service because it conflicted with their road-building and wilderness development agendas.[15] The act established the National Wilderness Preservation System and protected more than nine million acres of wilderness in more than fifty wilderness areas in more than twelve national forests. In 2007, the system included more than 700 areas totalling more than 107 million acres, with more than fifty-seven million acres in Alaska. All of this land by law must remain "forever wild," without roads, unlogged, and in as natural a condition as possible.

The National Wildlife Federation, founded in 1937, is yet another enormously important and broadly based national conservation organization that has traditionally included many hunters and outdoor enthusiasts in its ranks. Along with Defenders of Wildlife, the organization stressed the protection of wildlife and related issues.[16] Other private conservation organizations, such as The Nature Conservancy and the Trust for Public Land, concentrated on the acquisition of ecologically important and threatened lands, especially those critical to preservation of endangered species and biodiversity. the Natural Resources Defense Council has functioned as a public interest environmental law firm, as has the Sierra Club Legal Defense Fund, now Earthjustice. These groups, along with Environmental Defense, have provided the environmental movement with invaluable legal, scientific, research, and policy expertise, greatly contributing to the professionalization of the environmental movement. Many other groups too numerous to mention have also provided vital service in defense of forests. To a large extent, the robust, nongovernmental conservation movement was necessitated by the frequent and widespread failures of governmental agencies to prevent the deterioration of native ecosystems and to protect wildlife.

As early as 1897, the Organic Act had codified into law the idea that the national forests (then known as forest reserves) were not to be managed exclusively for any one industry or to yield a single product, but for a variety of benefits. This multiple-use principle was later recodified and elaborated in the Multiple-Use Sustained-Yield Act of 1960, which requires that the renewable resources in the national forests be managed in a balanced and coordinated way so that no single use excludes others and so that the productivity of the land remains unimpaired. The USFS supported the act's passage in the hope that it would preclude the large-scale designation of forest lands as wilderness, a single use that would have prevented logging. (The act does, however, require the USFS to recognize wilderness preservation as a legitimate use among other forest land uses.) The sustained-yield provisions of the Multiple-Use Sustained-Yield Act prescribe that the national forests must be managed so as to make possible a nondeclining rate of timber production indefinitely. Other activities in the forest, such as mining, grazing, recreation (including wilderness enjoyment), and hunting, were also recognized by the act as uses to be sustained through prudent long-term management.

Unfortunately, as I will discuss in Chapter 5, the multiple-use doctrine was more often honored in the breach than the observance. The term "multiple-use" can be used to mask extremely damaging forest practices. For most of the post-World War II period, timber extraction has been the dominant use of the national forests to which other uses have had to yield. The USFS has received timber production quotas from Congress that often result in logging rates far in excess of what can be sustained. A veritable tug of war has typically taken place over the years between Congress, the White House, and the USFS over how much of the service's roadless areas ought to be preserved as wilderness and how much ought to be logged. (Congress, the environmental community, timber interests, and the USFS also spar over timber production quotas.) All parties to these contests are spurred by conflicting pressures from pro-wilderness environmental forces and anti-wilderness timber industry interests. In 1976, during the administration of President Jimmy Carter, the USFS formally addressed the question of how much wilderness to save from the chainsaw in its first Roadless Area Review and Evaluation (RARE I), which inventoried roadless areas and made recommendations for their management. RARE I proposed that only twelve million of the USFS's fifty-six million roadless acres should be

protected as wilderness. After a legal challenge from environmentalists, the RARE I study was invalidated in federal court for failing to assess adequately the plan's environmental impacts.

In 1978, a second USFS plan known as RARE II proposed wilderness protection for sixteen million acres, but it also increased the acreage designated for possibly destructive multiple uses. RARE II became mired in additional litigation and eventually was found to be in violation of the National Environmental Policy Act for failing to consider wilderness adequately as a use for some of the roadless lands. Thus, RARE II also was never implemented. The Carter Administration came to a close without bequeathing a formal wilderness protection plan for roadless areas in the nation's national forests. President Carter did, however, sign the Alaska National Interest Lands Conservation Act of 1980, which gave federal protection to millions of acres of forested (and other) wilderness lands.[17]

Despite the absence of a comprehensive successor to RARE II for determining the fate of roadless areas, for the past two decades Congress has sporadically added wilderness to the National Wilderness Preservation System while opening roadless areas to development, all on an ad hoc basis, responding expediently to a host of political pressures, including those from the White House. Logging has been somewhat constrained by the 1973 Endangered Species Act. It requires that all species at risk of extinction be listed as endangered or threatened, according to their degree of peril, and that their habitat must be protected. It also requires that a recovery plan be implemented for listed species. By 1998, private landowners were being allowed by the federal government to adopt voluntary Habitat Conservation Plans that permitted them to proceed with developments that caused some destruction of critical habitat on their property in return for protecting more habitat than required by law elsewhere. Roadless areas were finally given a nationwide reprieve from logging when, on January 5, 2000, President Bill Clinton signed the Roadless Area Conservation Rule, designed to protect 58.5 million acres of inventoried roadless areas in the national forests from road building, commercial logging, mining, and drilling. The George W. Bush Administration first exempted the Tongass National Forest from the rule, however, and then, on May 5, 2005, completely reversed the Clinton Roadless Rule. On September 19, 2006, the Bush Administration's action was overturned by a U.S. District Court, which reinstated the rule in response to lawsuits by twenty conservation groups and the attorney

generals of California, New Mexico, and Oregon. (See Chapter 6 for more of the history of the Roadless Area Conservation Rule.)

FOREST PLANNING AND MANAGEMENT

The National Forest Management Act of 1976 (NFMA) ostensibly was passed to provide more specific direction to the USFS in managing the forests, consistent with the mandates of the Multiple-Use Sustained-Yield Act.[18] The NFMA indeed does reaffirm the principles of multiple use and sustained yield. However, because the USFS was very much in the thrall of the timber industry and its Congressional allies during the post-war period, the NFMA in practice—as implemented by the timber industry's friends—allowed the USFS to abandon sustained-yield selective management and to permit clearcutting, by creating broad exceptions to the Multiple-Use Sustained-Yield Act. The NFMA, however, and contemporaneous legislation—the Federal Land Policy and Management Act of 1976 and the Forest and Rangeland Renewable Resources Planning Act of 1974—stressed the use of resource inventories for forest and range planning and management. These conservation laws decrease the chances that nontimber values will simply be accidentally overlooked, and they increase the chances for systematic resource management.

Among its positive features, the NFMA requires the USFS to prepare an interdisciplinary Forest Plan for managing each national forest and stipulates that a reforestation plan must be included in every national forest timber sale, so that cutover lands can be restocked "with assurance" within five years of the final harvest. The NFMA prohibits logging "where soil, slope, or other watershed conditions" will be "irreversibly damaged" and requires each sale to include a *Sale Area Improvement Plan* that often outlines mitigation measures required to counter logging impacts. Under the NMFA, forest planning is to be comprehensive and integrated for multiple uses, not exclusively for harvesting timber. Logging rates are not to exceed sustainable limits. Nevertheless, laxity in interpretation and laxity in enforcement have been problems: flagrantly unsustainable timber exploitation has continued under the Act's aegis, even though the importance of other nontimber uses, such as recreation, watershed, fish and wildlife, was formally recognized and accorded more attention.

The Ronald Reagan and George H. W. Bush administrations that followed President Carter were largely hostile or indifferent to additional wilderness designations, although dozens of wilderness bills passed Con-

gress, despite lack of administration support. The Clinton Administration, as noted, was much more supportive of wilderness protection.

In the next chapter, I provide an overview of the USFS's programs and policies as they impact forest conditions. In Chapter 5 (and also in Chapter 7), I describe the USFS's actions during George W. Bush's presidency. Whereas the agency under President Clinton had been more ecologically oriented than in the preceding forty years, under President Bush it once again was redirected to facilitate logging at all costs. Thus, although millions of acres of land still remain roadless today, their fate is as controversial as ever.

CHAPTER 5.
THE U.S. FOREST SERVICE

The forest is not a factory for goods and services. It is a living entity which we have an ethical obligation to respect and perpetuate, even the parts which seemingly have no present use to human beings.

—TIM FOSS, "NEW FORESTRY: A STATE OF MIND" (1994)

THE AGITATION FOR CONSERVATION that began in the 1860s eventually produced important results, although some took a century or more to arrive. The results came in the form of the protective national forest legislation, discussed in Chapter 4, and in the accretion of 193 million acres of national forest land. Outside the national forests, tens of millions of acres of land were given protection as federally designated wilderness, and thousands of miles of rivers were included in the nation's Wild and Scenic River System. Millions of additional acres of national parks, national monuments, national wildlife refuges, and national grasslands were also protected from development under various federal agencies. A loosely similar system of state forests, state parks, and state wildlife refuges also evolved. Yet, despite this enormous increase in public lands set aside for conservation, their management was often far from what good stewardship dictated—or what the American people may have expected.

INSIDE THE U.S. FOREST SERVICE

The U.S. Forest Service (USFS), established in 1905, is now a powerful, complex, far-flung super-agency of 33,000 employees that controls hundreds of billions of dollars worth of timber, land, and other resources. Overall, the USFS uses its annual net spending ($5.5 billion in Fiscal Year 2006, compared to $4.13 billion in Fiscal Year 2008) to manage 155 national forests in forty-four states, Puerto Rico, and the Virgin Islands,

including nine million acres of wetlands and riparian areas, along with twenty national grasslands totaling four million acres. The forests include 35.2 million acres of designated wilderness and more than 4,400 miles of national wild and scenic rivers, plus some 23,000 recreational facilities.

These lands contain globally significant biological resources, including more than 10,000 plant species, more than 3,000 animal species, more than 400 of the nation's 1,312 (as of 2007) federally listed threatened or endangered plant and animal species, and some 2,900 species designated as "sensitive" because their welfare is in doubt. Thus, the fate of many threatened and endangered species depends on the caliber of the USFS's habitat management. The 193 million acres of national forests and grasslands also provide domestic water worth billions of dollars for sixty million people in the continental United States, and they constitute 8.5 percent of the nation's land area.

In addition to timber, these lands also provide grazing for livestock, sport and commercial fishing, sport and subsistence hunting and gathering, as well as valuable energy and mineral deposits. National Forest System lands hold an estimated fifty billion tons of coal, plus oil, gas, geothermal energy, precious metals, and other minerals. The USFS has leased some six million acres of its lands for energy production and has 150,000 mining claims on its property. The USFS also permits roads, highways, trails, transmission lines, telecommunications facilities, and ski resorts in the national forests and allows hunting, boating, and fishing. In 2003, more than thirty-seven million Americans used motorized off-highway vehicles, many on USFS land. Given the growing intensity of commercial, industrial, and recreational use, it should be no surprise that the ecological condition of most national forest land has deteriorated and that many species of wildlife now lead a precarious existence.

THE FOREST SERVICE'S MISSION AND GOALS

During its tenure, the USFS has mirrored as well as molded the public's view of forests, grasslands, and other natural resources. Originally set up to protect forested watersheds and provide a reserve of timber for the nation, the USFS in its early years adopted a custodial approach to public land and resources in reaction to the flagrant abuses of the public domain evident in the 1880s. The USFS sought to curb these abuses and instituted some modest controls on grazing. Sometime after World War II, the USFS began to treat the national forests as if it were a cornucopia of

resources that could provide a vast array of goods and services to the public without suffering degradation. For the next thirty years or so, the USFS did little to acknowledge how a massive extraction of resources might affect the land's ecological health.

Where trees grew in sufficient size and number, the USFS's primary goal in the post-war years was to manage the marketable timber. That meant surveying it, protecting it from fire, cutting it, and, to some extent, regenerating cutover lands. "Taming the wilderness" was a goal that resonated with many wild-land managers in the service's early years. Thus, transforming natural forests, with diverse mixtures of tree species, ages, and sizes, into tidy plantations of rapidly growing, single-species stands of trees was regarded as a laudable achievement without significant drawbacks. And it was made profitable for timber companies by government subsidies for road building, firefighting, brush removal, and timber sale administration, as well as congressionally mandated timber production quotas that often disregarded market demand for lumber.

Similarly, the USFS's dominant goal for the grasslands under their care after World War II was to provide ranchers with inexpensive grazing. Thus, its rangelands were managed primarily for cattle and sheep, rather than for the health and diversity of the native animals and vegetation, soil fertility, or water purity. If "managing for animal units" meant that native perennial grasses were replaced with annual nonnative grasses, or that natural streams were trampled into muddy ditches, or that native birds and insects grew scarce, that was simply a cost of accommodating the rangeland customers, who were primarily Western ranchers. Consequently, the ecological health of the nation's rangeland continued to decline in much of the West, following the tremendous overgrazing and deterioration of the late 1800s. The numbers and species diversity of native plants and wildlife all decreased dramatically (as they have elsewhere on the nation's prairie), and natural ecological processes, such as soil-building, were impaired.

As recently as the 1980s and early 1990s, the USFS was still focusing primarily on cutting and raising timber and on fighting fires. (Even today, the service spends nearly $2 billion a year on fire-suppression and related aviation activities.) For decades, the USFS's "Smokey Bear" public relations campaign convinced Americans that forest fire was an unmitigated evil that the service should control at all costs, using bulldozers to plough firebreaks and aircraft to drop chemical fire retardants. Not much

thought was given to the beneficial affects of fires on forest and grassland ecosystems, which had evolved with fire and which required fire for ecosystem health.

In the absence of fire, trees and brush grew in dense concentrations, sucking moisture out of the soil and drying up creeks and springs to the detriment of wildlife numbers, species diversity, and soil condition. Some species that required the heat of fire for germination did not reproduce at all, and others were crowded out by the dense brush and trees. So much fuel accumulated on some lands that, when fires inevitably occurred, they burned with such unnatural ferocity that they were capable of killing large, normally fire-resistant trees and of damaging the soil by baking the life out of it. Meanwhile, the public was also shielded from the reality that large wildland fires are fundamentally uncontrollable forces of nature, as was graphically illustrated in Yellowstone National Park in 1988 by the huge fire caused by lightning and in New Mexico's Bandelier National Monument in May 2000 when a *controlled burn* set by the National Park Service turned into a large, uncontrolled wildfire known as the Cerro Grande Fire that charred 46,000 acres and burned 235 homes in the Los Alamos area, along with some historic buildings that once housed part of the Manhattan Project.[1] Whereas wildfires can sometimes be coaxed away from populated areas, true confinement and control depend upon wind abatement, rainfall, outdoor temperatures and moisture, and fuel depletion.

MANAGEMENT CHALLENGES — AND DEFICIENCIES

Given the manifold responsibilities of the USFS and the position of public trust that it enjoys, the service should observe the highest standards of integrity, honesty, candor, and professionalism. However, some actions and statements of the service are troubling.

For example, the Report of the Office of Inspector General for Fiscal Years 2002 and 2003 concluded that the USFS "does not operate as an effective, sustainable, and accountable financial management organization, as evidenced by the restatement of the fiscal year 2002 financial statements and the extensive *ad hoc* effort to achieve the fiscal year 2003 unqualified audit opinion." The accountant's report noted that most of the issues it had identified were "longstanding and pervasive weaknesses impacting the Forest Service's ability to accurately and timely report to the Congress and the public what it accomplishes with appropriated

funds and to be fully accountable for those funds."[2] Although the USFS under its chief, Dale N. Bosworth, is endeavoring to correct these deficiencies, these developments raise the question: might an agency that, by the federal government's own account, exhibits serious management deficiencies in handling financial resources also turn in a less-than-stellar performance in handling the nation's natural resources?

This question has serious ramifications. Officially, the USFS is the lead federal agency in natural-resource conservation in the United States and presents itself as a global conservation leader. Almost all forests and rangelands in the United States are affected, even those beyond the national forests, through the agency's research, cooperative agreements with other federal agencies and states, and its other land management programs. The service's mandate is exceedingly broad: it includes conducting scientific research; providing technical and financial assistance to states, private landowners, and other nations; providing outdoor recreational opportunities; augmenting water supplies; and even helping to meet national energy resource needs. Ironically, despite domestic forest mismanagement, the USFS is increasingly active in exchanging scientific and technical information internationally to assist other nations in managing their forests and ranges, ostensibly to minimize damage to global ecosystems.

The USFS's domestic work is not limited to timber management: the service is responsible for the management of national forest ecosystems, vegetation, watersheds, grazing lands, minerals and geology, forest products, recreation, wilderness, cultural and heritage resources, fish and wildlife habitat, and native plants. It has responsibility for many sensitive, threatened, and endangered species and their habitats. Thus, along with other agencies, the USFS is involved with projects such as grizzly bear recovery, gray wolf reintroductions, and restoration of the California condor and black-footed ferret. The service nowadays also conducts some riparian area restoration, rangeland improvement, and watershed protection. The Research and Development Division performs forest resource inventory and monitoring functions, resource valuation-and-use studies, and vegetation management and protection research, as well as wildlife, fish, watershed, and atmospheric sciences research. The USFS manages twenty-two experimental forests (down from seventy-one in 2003) and also provides technical and financial assistance to nonindustrial state and private timberland owners. Through its State and Private Forestry Divi-

sion, the USFS conducts programs in conservation education, cooperative forestry, urban and community forestry, forest health management, cooperative fire protection, and fire and aviation management. In addition, the service performs some watershed restoration and emergency watershed improvement work to combat erosion; conducts forest conservation education programs; and gathers scientific data on soil, water, air, and weather. When not engaged in all these activities or arranging timber sales, a large part of USFS work is still fighting forest fires and, to a lesser extent, reducing wildland fuel through manual brush removal and controlled burning.

The USFS's scientific research encompasses the forest environment, forest protection, forest resource analysis, forest management, forest products and harvesting, and ecosystem management, including large-scale ecosystem studies. The ecosystem management research is conducted at a landscape level (meaning at a large scale, including all of an area's ecological features, such as rivers, streams, wetlands, grasslands, and forests) in an effort to learn how to manage natural resources in an integrated manner, rather than resource by resource. This landscape-level research originally was intended, among other goals, to identify ecosystems threatened by climate change and to model their probable response. From 1994 to 1996, for example, a study of alternative sustainable management scenarios for the entire Sierra Nevada ecosystem was prepared. Now in its fourth major revision cycle, the study is currently called the Sierra Nevada Forest Plan.

The USFS also routinely conducts silvicultural examinations on vast areas of forest land, which are then used to prepare management prescriptions and conduct "*timber stand improvement*" work. In Forest Service parlance, "timber stand improvement" means mostly pre-commercial thinning (two-thirds of the quarter million acres "improved" in 2003 were given this treatment—the cutting of trees with no commercial value in a young stand so that the trees remaining have more room to grow to commercial size). The USFS also tries to combat insects, such as the gypsy moth, and other tree diseases that threaten standing timber.

MANAGEMENT OF ECOSYSTEMS VERSUS "CONSERVATION THROUGH USE"

The USFS is formally committed to using an "ecosystem approach to management" that "integrates ecological, economic, and social factors to maintain and enhance environmental quality to meet current and future needs."

The service is thus pledged to ensure "sustainable ecosystems by restoring and maintaining species diversity and ecological productivity . . ."[3]

Words and phrases such as "sustainability," "restoration," "maintaining and improving conditions," and "enhancement of habitat" appear frequently in USFS statements and literature. However, by the service's own account, only a third of the national forest system's watersheds are in good condition. For a variety of reasons, the USFS admits that, after about 100 years of its management, only twenty-seven percent "of inventoried forest and grassland watershed were in fully functioning condition as a percent of all watershed," despite annual budgets that have grown over the years to billions of dollars. Similarly, the service acknowledges that only half of its riparian and wetland areas "currently meet standards and guidelines of land and resource management plans."[4] Why? How did this disparity happen if the USFS is truly managing its lands to protect them from loss and injury, while maintaining and enhancing their condition?

Logging is an integral part of what the USFS calls "conservation through use." The service's official mission is to "Sustain the health, diversity, and productivity of the Nation's forest and grasslands *to meet the needs of present and future generations*" in perpetuity (emphasis added).[5] It is important to understand that the primary frame of reference here is the satisfaction of human needs to which the other ecologically oriented elements of the USFS's mission are subordinated when deemed necessary by the service and those who dictate its policies. This issue was at the core of the 2000 Planning Regulation, which stated that ecological sustainability was the "guiding star" of forest management. This precept was eliminated in the 2004 Planning Regulation, which stated that ecological, economic, and social sustainability were all inseparable and co-equal. Thus, the service's primary purpose is not, as many people might assume, the preservation, protection, and maintenance of ecological integrity for its own sake. The mission statement is not expressed in terms of preserving natural forest ecosystems and their ecological functions, or of perpetuating the natural distribution, diversity, and abundance of native species.

What the USFS means by "sustaining the health, diversity, and productivity" can only be understood by observing the service in action and by studying USFS policies and regulations to see how the agency's operational guidelines interpret the words "health, diversity, and productivity." "What ultimately counts," says Chief Bosworth in his introduction to the USFS's 2004 to 2008 Strategic Plan, "is what happens on the ground."[6]

The case of the seventeen-million-acre Tongass National Forest in south-eastern Alaska is an instructive example of what some USFS critics see as a "disconnect" between Forest Service rhetoric about conservation and the reality of Forest Service actions "on the ground." Biggest of all our national forests — about the size of Georgia — the Tongass is also the largest old-growth temperate rain forest left in the United States. This colossal, majestic greenbelt stretches south of Ketchikan across the Alaskan panhandle, from the islands and misty fjords of the Gulf of Alaska to its interior border with British Columbia. But clearcut logging has been sanctioned and encouraged here by the federal government, which, in 1954 and 1960, through the USFS, gave two large timber companies fifty-year logging concessions at bargain-basement prices. The companies took advantage of their concessions to clearcut forest lands and export the logs and pulp to Japan, South Korea, and Taiwan, paying "less than the price of a cheeseburger for a 500-year-old tree," according to Timothy Egan of *The New York Times.*[7]

In the process, the companies did enormous damage to the forest: the Ketchikan Pulp Company, owned by Louisiana-Pacific, also dumped its poisonous pulp-mill effluent in Ketchikan's Ward Cove in violation of state and federal permits, where it left a potent legacy of toxic pollution in the cove's sediments.[8] The casualties of the Tongass clearcutting include silted salmon streams in southeast Alaska, where world-class king salmon spawn, and once-forested but now-denuded timber crags where wolverine, gray wolf, and grizzly recently roamed.

One of the two large Tongass timber concessionaires, the Japanese-owned Alaska Pulp Company, abandoned its operations in 1993. The USFS subsequently cancelled Alaska Pulp's fifty-year timber concession to cut two billion board feet of Tongass timber by 2011. Ketchikan Pulp pled guilty to violating federal water pollution laws with discharges from its Ketchikan mill, which ground logs into pulp for export. The company announced in 1996 it would have to abandon its Tongass operations because USFS regulations would make further work there unprofitable. The company's opponents said it was unwilling to make the investments needed to correct its water-pollution violations.

Alaska's two senators at the time, Frank Murkowski and Ted Stevens, both tried to obtain federal subsidies to continue the Tongass logging, but they could not persuade the 104th Congress to go along. From the

standpoint of the public treasury, the decision came not a moment too soon. The USFS's Tongass National Forest timber program has lost some $850 million since 1982, according to Taxpayers for Common Sense, including a loss of almost $48 million in 2004 alone. The losses occur because the revenue from Tongass timber sales typically does not cover the cost of the sales, which include management costs and allowances for timber road construction. (These findings are not inconsistent with earlier studies of USFS Tongass timber sale losses by the U.S. General Accounting Office, which found that timber sales in the Tongass cost taxpayers more than $102 million just from 1992 to 1994.) Nonetheless, the USFS, during George W. Bush's tenure, continues the logging of the Tongass.

Despite Louisiana Pacific's exit from the Tongass, other smaller firms have continued to bid on, and clearcut, old growth there. To facilitate the logging, the George W. Bush Administration in its first term exempted the Tongass from President Clinton's Roadless Area Conservation Rule, which had protected 58.5 million acres of public wilderness land in the national forests from road building, logging, and other development. As of 2005, the USFS was preparing more than fifty timber sales in the Tongass, which would likely involve additional roads. However, the USFS already has an approximately $900 million backlog of deferred road maintenance and capital improvement needs in Alaska, including the Tongass National Forest.

Why is public money being used to log in a wilderness of global significance that belongs as a natural heritage to the American people? Is this an appropriate use of agency resources and discretion? One argument the USFS uses to defend subsidizing timber sales in general is the claim that timber sales are important sources of rural employment. But data obtained from the USFS and cited by the nonpartisan budget watchdog group, Taxpayers for Common Sense, revealed in 2005 that each direct timber job created in the Tongass National Forest in 2002 cost $170,000 —quadruple the average U.S. 2002 household income—hardly a sensible way to create rural employment today in America.[9]

Whereas Tongass timber cannot be profitably cut on a large commercial scale in an ecologically sustainable manner, fishing and tourism in Alaska and elsewhere could provide more jobs and revenue than could the continued destruction of the old-growth forest. But, unlike logging, they could do so indefinitely. Thanks to the actions of the USFS, however, the hitherto roadless Tongass now has 5,000 miles or so of roads that

open the wilderness to degradation and rob it of the characteristics that make it unique. Only 818 miles of the 5,000-mile Tongass National Forest road system, however, are open to passenger cars. The public, therefore, gets little chance to use this extensive road network. Yet, by allowing timber companies to deduct road construction costs from timber sale fees that the companies owe the USFS for Tongass timber, the service is bestowing public funds on timber companies. The public, therefore, gets to subsidize the very companies who are degrading and destroying large areas of public property.

INDUSTRIAL FORESTRY ARRIVES IN FORCE

Management of the public forests was not always as ecologically brutal and flagrantly dismissive of the public interest as it has been in the Tongass and elsewhere during the post-World War II era. At one time, trees in the national forests were selectively logged at a moderate pace rather than clearcut, and it seemed as if the national forests might be treated as a public trust. Commercial timber companies in the early decades after the USFS was established in 1905 did not want timber to be sold from the national forests at all, since the federal timber would compete with supplies they were still selling from their own private holdings. Thus, as late as World War II, only two percent of the nation's timber came from national forests. But, about 1950, a turn-about occurred. Much privately owned timber had been cut during the war, and, by its end, private timber was scarce. This aroused the commercial timber companies' interest in the national forests.

During the first half of the twentieth century until this development, the USFS had mainly practiced multiple-use and sustained-yield management. Thereafter, given the scarcity of private timber, the USFS shifted more decisively toward industrial forest management. This meant aggressive roadbuilding, intensified logging, clearcutting at the expense of long-term forest sustainability, and management of the national forests for timber as the dominant forest use, rather than managing for multiple uses. Whereas only 1.5 billion board feet per year of timber had been cut in the national forests in the early 1940s, and whereas the cut was still only 3.5 billion board feet in 1950, the timber industry and Congress then insistently began pressuring the USFS to increase its harvest rate steeply. In response, the service abandoned its previous insistence on selective logging under sustained-yield guidelines and began wholesale

clearcutting. This ended the era of forest custodianship and marked the beginning of aggressive exploitation of the national forests.

As larger mandatory timber harvest quotas were imposed and as more timber sales were ordered by Congress and were put out for bid, the rules for timber appraisals and sales were made less and less protective of the forest. By 1970, increased timber-industry pressure on the USFS had succeeded in raising the annual cut in the national forests to 13.6 billion board feet—almost four times the 1950 level. The cut remained above ten billion board feet through 1990, a level the service contended was sustainable. Since then, the cut has declined almost every year (except 1998) to 1.7 billion board feet in 2003, largely due to litigation aimed at halting the abuse of the national forests.[10]

BELOW-COST TIMBER SALES PROLIFERATE

During most of the half-century-long period following World War II of aggressively expanded timber cutting, the USFS accepted even very low offers for its commercial timber. Its priority was to take public timberland and turn over the trees to private timber companies at public expense, often "trading" the value of trees for industry-constructed roads. USFS costs for managing timber sales and expediting timber removal for logging companies frequently far exceeded the government's proceeds from the sale. As a result, public timber was often sold at an outright loss, and valuable opportunities for multiple use were simultaneously foreclosed, even though the economic value of nonextractive uses—such as recreation, fish, and wildlife—exceeds the value of the timber, grazing, and mining in eight of nine USFS regions. Recreation, hunting, and fishing in national forests contribute more than thirty-seven times more income to the U.S. economy and produce thirty-two times more jobs than does logging! In addition, commercial logging on the national forests has often cost more than a billion dollars in federal funds a year — money that could be better spent on forest restoration, on retraining forest workers, and on helping communities adapt to the inevitable end of dependence on the subsidized liquidation of public forests. The Wilderness Society has estimated that such below-cost timber sales cost the public a total of $21 billion dollars between 1975 and 1985 alone. These costs were mostly for logging-road construction and for timber-sale management and administrative expenses. Private timber owners were also penalized by this process: undervalued public timber dumped on the market through government

subsidization artificially depressed timber prices and reduced the value of private holdings.

What if, instead of squandering public resources and money, the USFS had truly protected our forests, streams, and endangered species and allowed natural forest conditions to persist while allowing only very limited and light-impact selective logging, as is done elsewhere? (See Chapter 11.) What if, as those forests had grown and increased in value, the USFS had instead applied the $21 billion that taxpayers spent on timber company subsidies to forest restoration and ecological land management?

With all the demands on the national forests nowadays, is continuing to manage the forests primarily for timber production the lands' highest and best use today? This is a particularly salient issue, given the disparity in revenue realized from nontimber resources on the national forests compared with the net revenues from timber sales, and considering the disproportionate damage done to the national forests by industrial forestry.

Recreational fishing on USFS-managed rivers, streams, lakes, and ponds, for example, generates several billion dollars a year in secondary economic activity related to tourism and retail spending. Tens of millions of days annually spent by hunters and/or lovers of nature vastly overshadow in importance the revenue earned from the service's most ecologically destructive activity: managing clearcut timber sales.

According to the U.S. Department of Agriculture's *Agricultural Statistics* for 2004, the total value of all timber cut and all miscellaneous forest products gathered on national forests in 2002 was a mere $167 million, including timber gathered at no charge.[11] The USFS likes to report that its programs generate receipts of a billion dollars per year from timber sales, recreation fees, and other land uses. This statement, however, masks the scant gross revenue that timber sales generate, and the substantial direct and indirect costs that render many sales as money-losers—without even imputing any dollar cost to the resource damage done.[12]

A DIFFUSION OF RESPONSIBILITY: IRRESPONSIBILITY BY DESIGN

Critics of the U.S. Forest Service believe that its foresters, who have the on-the-ground responsibility for supervising timber sales, often lack the professional prestige and administrative power to protect the forests from more senior (and, therefore, more powerful) pro-industry political appointees who oversee the service at the Department of Agriculture or elsewhere. These high officials may themselves be former timber-industry

lobbyists or officials, or they may simply be more responsive to timber industry demands, or to a Congress that reflects the industry's desires more than the public interest.

For much of the post-war period, management authority has been diffused within the USFS along an internal chain of command and to outside contractors, who perform much of the necessary field work. It then becomes difficult to assign responsibility for mismanagement. Also by administrative design, foresters in federal service during the 1950s and 1960s had been intentionally relocated every two to four years by the USFS to discourage "entrapment" by the local community, be it pro- or anti-logging. Foresters thus tended not to develop deep roots in local communities near the forests they manage. Since the 1970s, however, this unwritten policy has been significantly altered: rangers were often admonished to "spit and whittle" with locals to cultivate a sense of belonging and rootedness.

YARDSTICKS OF WOOD

During the 1980s and much of the 1990s, in the waning years of a political era when many influential and senior officials from the West sat in Congress, the USFS was primarily evaluated by Congress on its effectiveness in "getting out the cut," meaning fulfilling congressionally adopted timber-production quotas. Would it not be wiser for the service's budget to depend on good stewardship—on how well the service cares for the ecological quality and health of the forests, including wildlife, sensitive habitats, and aquatic resources, such as streams, wetlands, lakes, and rivers? The fulfillment of timber-harvest quotas should not be the standard for measuring the USFS's performance. In fact, commercial logging should stop on national forests until a trustworthy steward is in charge, capable of ecologically oriented sustainable forestry—and able to resist all political pressures to mismanage resources for commercial profit. The scant 1.8 percent of the nation's annual timber supply produced by logging in the national forests could easily be replaced by more efficient use of wood, wood recycling, and greater use of wood substitutes, such as kenaf and hemp.[13] (See "Alternatives to Wood" in Chapter 13.) Might it generally not be preferable only to log federal forests to provide or protect nontimber benefits, such as improved wildlife habitat and reduced fire risk?

Whereas some current mismanagement practices can be altered by better leadership, other weaknesses in the USFS are likely to be remedied only when the economic interests of those controlling the forests are aligned with the public's long-term interest in the forest's welfare.[14] This could happen if USFS employees' compensation were tied to increases in "forest capital," as reflected by improvements in forest health, structure, and quality, as well as by increases in the volume of standing timber.

PRE-EMPTING THE WILDERNESS

In reaction to increasing development pressure on the nation's remaining wild lands during the post-World War II era, Congress responded to insistent conservation lobbying by passing the Wilderness Act of 1964. The act securely set aside some wild and pristine public lands beyond timber industry saws and out of reach of mining and drilling interests. Unfortunately, since then, USFS officials have kept millions of acres of pristine wild lands that are eligible for wilderness protection off the agency's official maps of roadless lands. These maps are used by Congress in delineating and establishing new federally protected wilderness areas.

In an ideal world, a new inventory of roadless areas should, therefore, now be conducted by an objective, scientifically appointed advisory board composed of forest and wildlife ecologists. All roadless areas, and even areas where the impact of roads has been slight, should be off limits to logging and, where possible, given wilderness status. This would prevent the USFS from further disqualifying potential wilderness with unneeded roads and clearcuts.

A simple executive order by an environmentally concerned president could also create an array of new ancient forest national monuments, just as President Clinton in 1996 created the new Grand Staircase-Escalante National Monument in the desert canyonlands of Utah. Coastal rain forests in the Tongass National Forest and biologically diverse ancient forest in the Siskiyou National Forest are but two examples of ancient forests that would be eminently suitable for national monument status.

ROAD BUILDING RUN AMOK

In 1964, the same year in which it passed the Wilderness Act, Congress incongruously also passed the National Forest Roads and Trails Systems Act, which put the USFS in the business of building and funding logging

roads for timber companies to reduce their logging costs. Over the years, the USFS has built 436,000 miles of permanent and temporary national forest roads. The length of the permanent roads alone is fourteen times the circumference of the earth and more than twice the length of the national highway system!

These roads have taken millions of acres of forest out of timber and wildlife production. The USFS estimated in 1985 that the roads it planned to build through 1995 would sacrifice twenty million acres of forest to road surface. For generations, USFS-sponsored road-building has destroyed the wilderness character of tens of millions of additional acres of public land, since, as noted, much road construction has been in areas that otherwise would have been candidates for wilderness designation and permanent protection.

In a flagrant abuse of public trust—because it preempts the deliberations of democratically elected officials—the USFS has often hastened to push roads into areas that were candidates for congressional wilderness designation and permanent protection, precisely to foreclose their eligibility for wilderness protection. James Furnish, former Deputy Chief of the USFS during the Clinton Administration, was Forest Supervisor of the Siuslaw National Forest in northwestern Oregon in the late 1990s. When he took that job, he discovered that the forest's largest roadless wilderness area had recently been "carved up" by a timber sale shortly after a new Oregon wilderness bill had lifted temporary logging restrictions there. "They took the biggest roadless area on the Siuslaw," Furnish said, "and they deliberately neutralized it by creating a timber sale and constructing roads right in its midst. The only plausible explanation for locating the sale there was to eliminate its wilderness potential." The USFS as an agency wanted to harvest timber and realized that roadless area designations were being used to prevent logging. Their way of beating the nemesis of roadless areas was to knock them out. "Based on my history with the agency," Furnish added, "this was a pattern that was repeated over and over again. Naturally there was no written policy to scuttle roadless areas, but it was basically unwritten policy to screw them up. The USFS was smart enough not to put any of this down on paper, but this *ad hoc* policy was the best way to protect areas for future timber harvests."[15]

In recent years, the pell-mell rate of road construction seems to have moderated. New road construction rates on the National Forest Road System have ranged from nineteen miles in Fiscal Year 2002 to 101 miles in

Fiscal Year 2004, while an annual average of 468 miles of Forest System Classified Roads have been decommissioned during that time. Unfortunately, road decommissioning has not been a major priority of the George W. Bush Administration, and the annual road decommissioning rate in 2002 had fallen to 734 miles, about a third of the 2,000 miles of unneeded existing road that had been returned to forest in 1994.[16]

TAXPAYERS RECEIVE A $10 BILLION SURPRISE

The USFS's creation of an immense network of roads throughout the national forests has not only fragmented the forests, jeopardized wildlife, and annihilated wilderness, but also produced an enormous maintenance liability. Taxpayers not only subsidized the construction costs, but now must pay huge maintenance costs, for roads that largely benefited logging companies. (Logging companies used to do much of the road maintenance, but, as logging activity has slowed, maintenance has declined.) Fewer than 4,800 out of 383,000 miles of permanent USFS roads are open to all passenger cars without restriction, and no more than 80,000 miles of permanent roads can be used by passenger cars under specified conditions. Of these latter roads, more than 60,000 miles are typically single-lane roads that passenger vehicles need to negotiate slowly and that are subject to restrictions. Nearly 300,000 miles of the classified USFS road system exclude passenger cars and all but high-clearance vehicles. By contrast, logging trucks and other high-clearance vehicles can travel 220,000 miles of permanent USFS roads. (Another 80,000 miles of classified USFS roads are closed to all vehicular traffic.) Most Americans had no idea that enormous road-building and maintenance costs were even being incurred, let alone that they would have to pay for them without being even able to use most of the roads.

Apparently, this gigantic road-building enterprise was never coherently presented to Congress either. Money for road building is simply authorized annually by Congress. No one really tallied the unintended costs as the road system burgeoned. "This is a good example of budget 'creep,'" a high former USFS official commented privately. "When you get your head out of the hole to look around after about 30 years, all you see is roads everywhere, and [you] realize that there are indeed negative consequences that were not envisioned back in the sixties." Nor was a comprehensive Environmental Impact Statement ever written for the road-building program since the passage of the National Environmental Policy

Act of 1970. Yet, a program of this magnitude surely should have been comprehensively reviewed and deliberated rather than simply augmented with annual appropriations. The USFS instead built roads year by year, without explaining their cumulative ramifications—perhaps without fully understanding them. Yet, by its mandate, the USFS is supposed to do its business "in the most effective and efficient manner possible, providing the best possible value for the American people."[17] By contrast, the service has incurred more than a *$10 billion liability* for road and bridge maintenance in the national forests.[18] A 2004 Office of Management and Budget evaluation of the USFS's Capital Improvement and Maintenance Program, as cited by the nonprofit Taxpayers for Common Sense, found that the service "has been unable to demonstrate that it can maintain its current infrastructure needs."

Many who have critically examined the USFS's road-building program believe that all federal subsidies for construction of logging roads by private companies should be stopped and that the service should remedy existing problems with its infrastructure before contemplating its further expansion. Much more attention also needs to be paid by the USFS to decommissioning unneeded but ecologically damaging roads, such as those actively eroding into spawning streams and rivers, and to returning the forest estate to optimum health. When an agency accrues a $10 billion liability which it has no plausible means of covering, legitimate concerns might be raised as to whether the congressional oversight committees have been sufficiently vigilant in reviewing the agency's spending.

The USFS is continuing to aggravate its current problems by spending tens of millions of dollars a year subsidizing timber companies to build new roads in the national forests. The agency currently pays for these subsidies through Specified Road Credits that reduce the price of timber sales to logging companies to defray their road design and construction costs, thereby artificially lowering the cost of the timber. It is also still paying timber companies under now-discontinued Purchaser Road Credits that could be applied to future timber sales and Temporary Road Credits that support the construction of temporary logging roads. As Taxpayers for Common Sense noted, "There is little or no public benefit from these programs. A 1997 study by the Congressional Research Service found that timber access was the primary purpose for 97 percent of new roads and 87 percent of road reconstruction from 1990 through 1997."[19] Nonethe-

less, the USFS defends these roads by claiming that the "recreational benefits" (e.g., hunting, fishing, hiking, etc.) justify the public expense.

DECLINING LOGGING RATES HELP FOSTER A REFORESTATION GAP

In contrast to earlier cuts of thirteen billion board feet per year, the annual cut on Forest Service land in 2002 fell to 1.7 billion board feet. Yet, the USFS was still focused more on logging than on reforestation. For example, the USFS allowed 248,000 acres of forest land to be logged in 2003 but only "reforested" 164,000, of which slightly more than half was performed by allowing "natural regeneration."[20] Thus, the agency reforested only two acres for every three it had cut.

A huge backlog of untreated or poorly treated land awaits reforestation, and vast areas of forest watershed, mined land, and rangeland await restoration. The magnitude of the problem would not necessarily be readily apparent from USFS data, however, because of the fragmentary nature of the records kept. For example, the service maintains a database listing annual "Restoration Needs." A naive reader might logically assume that the yearly acreage of lands requiring restoration was based on a comprehensive survey or statistical sampling of all USFS lands. That is not the case. As a senior USFS employee explained to me, "'Reforestation Needs' is just an annual estimate of the number of acres of national forest lands *that have been diagnosed* to be in need of a reforestation treatment. The diagnosis is made by a silviculturist and generally compares the quantity of inventoried timber on site with the timber objectives set forth for the site in management plans or project-level documents. *The number of acres that can be diagnosed in any given year varies from place to place with the financial and human resources that are available* to perform this work (emphasis added)." Thus, what the USFS terms "Reforestation Needs" is *not* the totality of reforestation needed but only the portion of those lands that the USFS decided to survey for reforestation in a given year. The true magnitude of the reforestation backlog and of the more demanding land and water restoration backlog is probably unknown, but certainly it is much larger than acknowledged.

Whereas the USFS is currently incapable of dealing with its maintenance backlog, it has also allowed a backlog of unmet reforestation needs to accumulate. According to one agency official in the USFS's Washington, DC, headquarters:

> Annual appropriations have been insufficient to keep pace with burgeoning resource recovery needs, including reforestation . . . With no offsetting increase in annual appropriations to cover this work, we lack the financial wherewithal to address these collective resource needs.[21]

The quality of the reforestation and mitigation work done by commercial contractors on public lands depends on the standards to which the USFS is willing and able to hold its contractors and on the dedication of the timber companies, which often operate under lax federal supervision. It also depends on the adequacy of the money bid in the timber sale to cover all concurrent reforestation work. In years when timber bids are low, for example, due to an economic recession and low timber demand, the funds generated from sales may not be adequate for reforestation. The USFS then must seek the additional money from Congress, which may or may not appropriate such funds. If money does not arrive in a timely way, more time is allowed for the establishment of brush, which tends to increase eventual reforestation costs, since the larger the brush becomes, the harder it is to control. The USFS is also responsible for reforestation on previously cut but unrestored lands in the national forests. This backlog work also depends on the availability of adequate funds, which must be appropriated by Congress and are subject to political considerations. Moreover, the USFS tends to be relatively uninterested in the reforestation of "low-productivity" but potentially ecologically valuable forest sites—those where timber production is under fifty cubic feet per acre per year—since these sites are unlikely to produce enough revenue to cover the cost of their repair. Economic considerations thus take precedence over potential ecological concerns.

Even when a commitment is made to reforest, the effort may fail for any number of reasons, ranging from inadequate site preparation, management, and/or planting personnel, to failure to protect the seedlings from animals, drought, or frost. Sites are typically only subject to one- and three-year post-logging survival exams, which mainly determine whether the trees are still alive. Systematic long-term ecological evaluation of reforestation efforts and their effects on watersheds and regional ecosystems are rarely, if ever, conducted. Post-fire reforestation is also accorded a higher funding priority than conventional post-logging planting so that, when intense fire seasons occur, much logged land is not reforested.

The Knutson-Vandenberg (KV) Act of 1930 gives the USFS the right to require deposits from timber companies to ensure proper reforestation. In practice, however, the amount of the deposits may be inadequate to remedy problems arising from extraordinary events, such as droughts, fires, and insect invasions. The act generally provides only the minimum funding necessary for reforestation, which need not cover the costs of necessary follow-up "stand-tending activities." Furthermore, the USFS often applies the KV monies for activities, such as road building, which have nothing to do with the act's intended purposes.

Reforestation, however, does occur. In contrast to conditions in 1900, when virtually no reforestation or long-term forest management was practiced, approximately 152,000 acres of land were reforested in Fiscal Year 2004, according to preliminary data. Yet, these numbers leave much to be desired: at the end of the year, nearly 900,000 surveyed acres were still in need of reforestation. Using this limited USFS data set, since 1991 the service's annual acreage of reforested land has *declined* by seventy percent (from 505,000 acres in 1991) and has also fallen as a proportion of the surveyed acreage found to be in need of reforestation.

CUTTING FORESTS, PLANTING TREES

Reforestation by timber companies under USFS leases has generally been a pretext for the conversion of diverse native forest to single-species tree farms. Moreover, a third to a half of all the money earmarked for reforestation and mitigation of timber sale damage using the KV Act fund is instead used by the USFS to pay for administrative expenses and does not reach the forest floor.

In contrast to reforestation, the USFS should be devoting more attention to forest restoration (see Chapter 12). Among the restoration actions needed on national forest lands are the closure and revegetation of logging roads and trails, especially in sensitive areas. Areas to target for restoration should include riparian zones and wetlands, ungulate (moose, elk and caribou) winter range, and large-mammal reproduction areas. Also badly needed is restoration of under-represented habitat types, such as Ponderosa pine in Colorado, and habitat for sensitive species, including those not officially listed by the U.S. Fish and Wildlife Service, for reasons discussed in Chapter 6 having to do with the difficulties in getting recognition for threatened and endangered species under the Endangered Species Act of 1973.

Much of the work to restore native vegetation and species diversity on public forests should be accomplished with the help of existing Youth Conservation Corps (YCC) personnel or similar groups and with the aid of a new National Environmental Restoration Corps (NERC). Other useful tasks would be to stabilize and recontour disturbed slopes and soils and to conduct prescribed burning of wooded lands where necessary to reduce fire risk caused by past logging or by misguided fire-suppression policies. The NERC and the YCC could also restore streams to a more natural condition by stabilizing and revegetating banks with native plants and by removing barriers to native fish spawning runs. Part of the process of restoration is also to control the spread of noxious nonnative species on public lands. If left untreated, invasive plant species can make pests of themselves, outcompeting and killing native plants on which native wildlife depends and dominating a landscape. Japanese honeysuckle and other exotic vines, for example, can blanket a forest floor, cloaking native trees in a strangling embrace. Rampant infestations of nonnative thistles and other thorny plants can render rangeland unsuitable for grazing or recreation. Water hyacinths and other waterborne weeds can choke lakes and streams. The USFS in 2003 described invasive species as "the single greatest threat to forest and rangeland health"[22] People whose employment was affected by logging curtailments could be given hiring preferences to work on these and other important federal restoration priorities.

In recent years, the USFS has accomplished some impressive restoration of watersheds. To date, this is neither as widespread nor as common as it ought to be. The fact that it is occurring, however, and that, increasingly, far-sighted professionals within the agency recognize that this must become the agency's dominant activity in its second century are cause for some guarded optimism.

1995: THE U.S. FOREST SERVICE VOWS TO REINVENT ITSELF

During the last years of the Clinton Administration, the USFS was reporting that it was "redoubling its efforts to ensure that all commodity production on Forest Service lands is done in an environmentally acceptable manner. Where commodity production cannot be achieved in such a manner, commodity outputs are being adjusted downwards." Consistent with these policy announcements, but not necessarily because of them, the service had been reducing its reliance on clearcutting as a standard

timber harvest method. Since 1988, when 283,000 acres were clearcut, the total acreage clearcut had by 2003 fallen to 23,000 acres.[23]

Under the USFS's draft renewable resources program plan for 1995 (prepared decennially under provisions of the Forest and Range Renewable Resources Planning Act of 1974, as amended), the service committed itself to the challenging mission of fundamentally reinventing itself at the behest of President Clinton, who directed the agency to "achieve sustainable forest management by the year 2000."[24] To that end, the USFS's long-term strategic plan outlined a set of laudable goals. Ecosystem protection and ecosystem management were to be cornerstones of national forest policy for at least the next decade. The restoration of ecosystems was also to have been a major USFS goal. Another principal goal was to provide multiple benefits for people *within the capabilities of ecosystems*—that is, consistent with the maintenance of an ecosystem's health and diversity. But the lofty goals have yet to be fulfilled.

Observers of the USFS had seen a palpable move during the 1990s toward a more environmentally responsible land stewardship under the leadership of then-USFS Chief Forester Mike Dombeck. Dombeck helped create a new agenda for the agency that emphasized sustainable management of resources and ecosystem and watershed health. A former college professor and former Acting Director of the U.S. Bureau of Land Management, Dombeck became Chief of the U.S. Forest Service in January 1997. During his four-year tenure, he made a priority of protecting forest health, increasing roadless areas, and deemphasizing commercial timber sales. In attempting to learn more about Dombeck's achievements for this book, I discovered that, after his departure, files describing those accomplishments had vanished from the USFS Website. Users were greeted with the message: "The file you requested is not available."

2000: THE COMMITMENT TO SUSTAINABILITY WAVERS

Since the Bush Administration took office in 2000, the USFS once again seemed to retreat from Dombeck's laudable agenda in favor of reasserting its past close affinity with timber industry interests. As we shall see more clearly in Chapter 6, the USFS has taken numerous stands opposing the protection of roadless areas and forest conservation, all counter to the approach pioneered by Dombeck.

Among specific priority actions planned in 1995, the service had proposed to establish old-growth forest management areas and riparian

conservation areas and to obliterate thousands of miles of USFS roads each year until the year 2000.[25] Not much is being said in the USFS today about these objectives. Likewise, declining timber harvests were projected, along with a reduction in clearcutting from eighteen percent to four percent of the total acres cut. As of 2003, timber harvests had declined (as noted), but the clearcutting goal had not been reached (even by official tallies): about ten percent of the logging on USFS land was still being done by clearcutting or similar methods.

MEASURING PROGRAM SUCCESS

A look at the USFS's performance report for 2003 raises some doubts as to how well the service is doing in meeting its broad sustainability goals. Referencing the USFS's *Fiscal Year 2004 Strategic Plan*,[26] the service states,

> For fiscal year (FY) 2003, because no approved annual performance plan existed, there are no annual performance measures. Instead, for this performance and accountability report, the Forest Service used the revised targets reflected in the agency's 2003 Program Direction as FY 2003 performance indicators, since they are based on the appropriate funding rather than on the budget request sent to the President.[27]

Furthermore, in a section of the report subtitled, "Quantitative Measures of Performance," the agency states,

> Forest products activities and their outputs are *presumed* to be within sustainable limits because the levels of most outputs today are significantly less than the historical levels (emphasis added). If the Forest Service is to achieve, 'products and services . . . for subsistence commercial, and noncommercial uses within sustainable limits,' the agency must establish how sustainability will be defined. Processes designed to assess sustainability are under development, but, in the meantime, periodic assessments of inventory and monitoring data must serve as indicators of sustainability.[28]

Translating all of that into plain language, the agency acknowledges that it is required to operate in a sustainable manner, but it has not devel-

oped any definitive method for ascertaining what that means operationally. Even were the USFS interpreting "sustainability" to mean "sustaining ecological processes" rather than merely "sustaining the output of commodities," such as timber, and services, such as camping, the service here is clearly making the illogical assumption that, because resources may not have collapsed under the weight of a particular practice for a period of time, the practice must therefore be indefinitely sustainable—whether the output be ecological services or cubic feet of wood.

The agency has had a similar difficulty in demonstrating that its programs are cost effective, as various mandates require. Currently, an "estimated 40 percent [of the USFS's] total appropriations are devoted to planning, analysis, and resolution of legal and administrative challenges. . . ."[29] Elsewhere the agency notes, "the Forest Service may be able to develop and report objective measures to provide performance information about program efficiency, *but it is not able to demonstrate the cost effectiveness of agency programs.*" It is, therefore, puzzling to read the claim on the very next page of the same report that "the Forest Service brought *cost-effective sustainable forestry* to a diversity of landowners in FY 2003" through development of nearly 22,000 forest stewardship plans for private and public forest landowners.[30]

The USFS also recorded the protection of 300,000 forest acres in 2003 through its Forest Legacy program. This, however, was only forty-three percent of the acreage planned for protection that year and represented less than a tenth of a percent of all USFS land. In 2003, the service also intended to increase its own accountability, expand its research and evaluation efforts, increase the use of prescribed fire as a management tool, augment efforts to enroll private forest landowners in USFS forest stewardship programs, and curtail resource extraction where necessary to protect ecosystems. All of these ambitious goals sounded encouraging, of course, and friends of the nation's forests have been watching the USFS eagerly in hopes that the laudable goals would be matched by effective implementation and avoidance of further abusive forest practices. USFS insiders recognize, however, that the problems the service has in measuring its own performance and achieving financial accountability have plagued it for many years and that the agency is still struggling to develop simple, cheap, and effective systems for managing its vast and diverse resources.

PROPOSALS FOR REFORM

Many proposals for reform of the USFS have been advanced over the years. The proposals range from minor modifications in existing programs to calls for sweeping changes in mission and management, divestment of lands, or even abolition of the agency. A comprehensive in-depth survey of these proposals can be found in Elizabeth Beaver, et al., *Seeing the Forest Service for the Trees: A Survey for Changing Forest Service Policy.*[31] Several of the most important of these proposals are summarized below, based on *Seeing the Forest Service for the Trees*'s survey.

Some critics of the USFS have proposed selling off or auctioning all or part of the service's public lands to states or private interests. Taken to its logical conclusion, this would mean abandoning the goal of holding public lands in trust for present and future generations. Wealthy corporations and individuals would simply be able to acquire public lands and put them to exclusively private uses. One proponent of selling public forest to private enterprise is the Competitive Enterprise Institute (CEI), a Washington, DC, think tank backed by large corporations and associated with anti-environmental views. The CEI contends that private enterprise would manage the forests more profitably and efficiently. No doubt industry in the short-term could profit more from the lands than the USFS, but, of course, the profits often come from extracting immediate private profits at the expense of the resource's ecological health and long-term future returns to the public.

Among other proposals for making the USFS more responsive to market forces are those, presented by the Seventh American Forest Congress, which advocate that all costs associated with sales of timber and other forest products be reflected in the prices charged for those products, so that the sale costs are borne by the purchasers or other beneficiaries, without any public subsidization.[32] Forest economist Randall O'Toole argues that, without this crucial step, neither changing the regulations under which the USFS operates nor putting new managers in place will fundamentally improve resource management. His diagnosis is that a powerful system of economic incentives currently induces the USFS to mismanage forests, because these policies augment the agency's budget.[33] O'Toole advocates "divorcing" the service from dependence on congressional appropriations, stripping all subsidies from USFS budgets, and charging timber purchasers as well as everyone else the true costs of their activities. (To date, this has not been done.) With spending on timber sales newly constrained by mar-

ket forces, the modest fees charged millions of recreational users for their environmentally benign forest use would then become a much larger part of each national forest's budget, and recreational users would then have a commensurately larger say in each forest's planning and management. O'Toole also recommends using this approach to reform other resource management agencies besides the USFS.

A number of proposals tendered in recent years are designed to fundamentally change the emphasis of the USFS from timber production to guardianship of national forest ecosystems and ecological health. Thus, the proposed National Forest Protection and Restoration Act of 1999 would have prohibited all commercial logging on the national forests and would have suspended or terminated existing logging contracts as expeditiously as possible.[34] The bill had 112 House co-sponsors in the 107th Congress, where it was known as H.R. 1494. It was reintroduced in the 109th Congress as H.R. 3420 by Representative Jim Leach (R-IA) on July 25, 2005; it had fifty-nine co-sponsors. The bill would have redirected timber sale subsidies to fund the investigation of wood-free alternative products for paper and construction materials and to fund grants "to entities involved in the development and production of the most environmentally sound nonwood alternatives" In addition, the bill would have established a Natural Heritage Restoration Corps to repair ecological damage caused by prior national forest policies and would have required the USFS (as well as the U.S. Bureau of Land Management and the U.S. Fish and Wildlife Service) to develop and implement Natural Heritage Restoration Plans. The restoration plan notion somewhat resembled the recommendation of a distinguished scientific panel, appointed by the Secretary of Agriculture in 1997, which analyzed the need to reform the USFS and which recommended that the service use bioregional strategic plans to achieve future desired ecological, economic, and social conditions.[35] The General Accounting Office also weighed in with a call for the USFS to conduct and incorporate in its forest-level planning broader-scale assessments of ecological and social issues that transcend forest boundaries.[36] Aligned with the tenor of the proposed Forest Protection and Restoration Act, the Sierra Club has also gone on record against commercial logging on the national forests. In addition, various other observers have proposed that the USFS budget be altered to prohibit the agency from planning, designing, and constructing new roads in national forests and to prohibit logging in either roadless areas or old-growth forests.

A predecessor to this bill, the Act to Save America's Forests, H.R. 4145, introduced in 1996 during the 104th Congress by Congressman John W. Bryant (D-TX), would have transformed the USFS into the world's largest ecosystem protection and restoration organization. The Act to Save America's Forests evolved gradually out of a bill introduced in 1989 by Congressman John Bryant (D-TX), the Clearcutting Prohibition Act (H.R. 2406), which was inspired by the forest advocacy work of Texas attorney Ned Fritz and was later reintroduced in modified form by Bryant in 1991 as the Forest Biodiversity and Clearcutting Act (H.R. 1969). Through amendments to the Forest and Rangeland Renewable Resources Planning Act of 1974, the bill would have required the conservation and restoration of native biodiversity in forested areas and would have banned clearcutting and other even-aged timber management systems on the national forests and certain other federal lands. Logging and road construction would have been restricted on federal land in roadless areas, ancient forests, special areas, and watershed protection areas.

Despite endorsement by more than 600 scientists and sponsorship by 133 Representatives and six Senators in 2003, the Act to Save America's Forests failed to pass in the Republican Congresses of 2003-2005. Senator Robert G. Torricelli (D-NJ) first introduced the Act to Save America's Forests in the Senate in 1997 during the 105th Congress as S. 977. The act was reintroduced in the Senate as S. 1897 on October 18, 2005, by Senator Jon S. Corzine (D-NJ); Representative Anna Eschoo (D-CA) and numerous cosponsors reintroduced the act in the House early in 2006. A national campaign on behalf of the act has been spearheaded for several years by Save America's Forests, a nonprofit forest advocacy group based in Washington, DC.[37]

The Wilderness Society—long a knowledgeable and constructive critic of the USFS—has also advocated that the USFS be reoriented to focus primarily on guaranteeing the health, integrity, and sustainability of its ecosystems. As outlined in The Wilderness Society's proposal, protection of biological diversity, pure air and water, and backcountry recreation would be the service's foremost goals; the USFS would only be allowed to produce commodities, such as timber or forage, for sale or lease when those activities did not conflict with the agency's new ecosystem management mission.[38] This proposal is compatible with a proposal from the Seventh American Forest Congress, which recommended that national forests should be managed to sustain ecosystem structure, functions and processes.[39]

A similarly sweeping set of changes was envisioned for the USFS by Earth First! co-founder Dave Foreman, now of The Wildlands Project. Foreman and colleagues have called for the national forests and other public lands to be reorganized into a system of large wilderness preserves to be buffered by surrounding zones of managed private lands. The public lands would be connected by public and private wildlife corridors to protect biodiversity and recreate large regions of wilderness in which nature could thrive.

Some reforms affecting the USFS have been implemented in recent years. For example, states and counties have traditionally received a percentage (e.g., twenty-five percent) of the revenue from national forest timber sales within their borders as payments in lieu of taxes to help defray the costs of local schools and roads. This policy was developed to compensate a county for revenue lost due to the existence of federally owned land within the county. The effect of these payments has been to create a solid state and county constituency for timber sales. The Secure Rural Schools and Community Self-Determination Act of 2000, however, gave counties the very attractive option of adopting a new funding formula based on "historic" payment levels associated with past high timber sales revenues.[40] Instead of receiving a percentage of actual receipts, counties can receive a percentage of the state's highest revenues received during any three years between 1986 and 1999. This widely adopted modified compensation mechanism effectively disconnects local revenues from timber sales receipts and presumably reduces state and county pressure in favor of logging.

CONCLUSION: WHITHER THE FOREST SERVICE?

Clearly, there is much to love and much to hate about an agency as multifaceted, massive, venerable, and controversial as the USFS. Writing about the service today is a slightly schizophrenic exercise—like writing about Dr. Jekyll and Mr. Hyde. On the one hand, there is the ever-present good Dr. Jekyll, the official persona that the USFS presents to the public on its Website, in reams of official reports and manuals, and in educational programs reaching thirty million Americans a year. The USFS depicts itself as devoutly committed to improving and protecting the national forests and their watersheds and to producing a myriad of other public benefits. Against these pronouncements, however, stands the presence of the bad Mr. Hyde—that is, the mute testimony of the abused lands and aquatic resources under the USFS's protection. The service, meanwhile, is sensitive

to its public image and the controversy that its stewardship has aroused, so much so that, in the "Message from the Chief" that introduces the *Forest Service Performance and Accountability Report — Fiscal Year 2003*, Chief Dale N. Bosworth felt compelled to state, "the natural resource and land management work of the USDA Forest Service continues to be held in high regard." The chief goes on to describe the service's new emphasis on what it has called, "four major threats to the nation's forests in the 21st century: fuels and fires, invasive species, loss of open space, and unmanaged outdoor recreation." Of these, the service calls invasive species, "the single greatest threat to forest and rangeland health," estimating the economic damage and control costs at $137 billion a year. "The impetus behind the Chief's Four Threats," the report stated, "is the Forest Service's Office of Communications, which has been developing "the information and supporting communications products." How much of the new emphasis on invasive species is driven by program needs, and how much by public relations consideration? One public relations effect of this agency reorientation may be to divert public attention exclusively toward the agency's work on the four threats.

Those who remain optimistic about the USFS and its potential for reform have looked at long-term trends in agency behavior and values and have taken heart that the agency has at least officially acknowledged the need to provide sustainable management of ecosystems and has in small ways begun the tremendous task of restoring the nation's forest estate. A former top USFS official recently confided, "There is a growing willingness on the part of the Forest Service to admit that restoration is necessary" and that the service is "really moving in the direction of making that its main job."

In the next chapter, we will see to what extent the USFS under the overall management of President George W. Bush is emphasizing ecosystem protection.

CHAPTER 6.
NEW DEVELOPMENTS IN U.S. FOREST POLICY

Forty-four percent of the [U.S. Fish and Wildlife Service] scientists who responded to the survey said they have been asked by their superiors to avoid making findings that would require greater protection of endangered species. One in five agency scientists reported being directed to alter or withhold technical information from scientific documents. And more than half of the respondents—56 percent—said agency officials have reversed or withdrawn scientific conclusions under pressure from industry groups.

—ZACHARY COILE, "WILDLIFE SCIENTISTS FEELING HEAT," (*San Francisco Chronicle*, 2005)

It is inconceivable to me that an ethical relation to the land can exist without love, respect and admiration for the land, and a high regard for its value.

—ALDO LEOPOLD, AS CITED IN THOM J. McEVOY, *Positive Impact Forestry* (2004)

REVOCATION OF THE ROADLESS AREA CONSERVATION RULE

By the time the Clinton Administration took office in 1992, the U.S. Forest Service (USFS) had been managing the national forests for eighty-seven years. Millions of acres of public land were badly scarred with bald, eroding clearcuts or fragmented by hundreds of thousands of miles of roads, many in ill-repair. Most of the nation's pristine old-growth forests had been trucked off to sawmills. Industrial forestry practices were driving many endangered species to extinction while the condition of many threatened species grew more perilous. Wild salmon and other native fish populations were dwindling or vanishing in streams and rivers badly degraded by silt-laden runoff caused by erosion from logging activities

and associated roads. Mining operations and widespread livestock grazing within the national forests were continuing to aggravate these problems.[1] Environmental groups, therefore, adopted the position that whatever wild land was left in the national forests needed immediate protection from logging—at least until it could be considered for inclusion in the National Wilderness Preservation System.

Sensibly, the Clinton Administration agreed to study granting a higher level of protection to the nation's remaining roadless areas, often the last refuges of exceptional wildlife. These lands are among the most beautiful, ecologically sensitive, and unspoiled left in the national forests. Within these rare, remote areas, away from the incursions of motor vehicles, natural evolution and other ecological processes still operate with a minimum of interference. Here, one can still experience nature's serenity and enjoy a sense of what America's forest primeval once was like. If one day we are able to restore great swaths of the national forests and other damaged lands, then our roadless natural areas will provide us with reference ecosystems to emulate and with the native plant seeds and propagules and wildlife broodstock vital for the recolonization efforts.

With imminent threats to these irreplaceable ecosystems looming in the form of additional roads and timber sales, then-Forest Service Chief Mike Dombeck in February 1999 imposed an eighteen-month moratorium on the building of new roads in inventoried roadless areas of the national forests, with some exceptions for forests with recently revised forest management plans. The USFS then began a public rule-making process of unprecedented scale to consider the Roadless Area Conservation Rule (RACR) that would ultimately protect 58.5 million acres of roadless national forest land in thirty-nine states from logging and road building. The rule was not only designed to safeguard natural ecosystems and precious wilderness recreation areas — along with some of the nation's cleanest water—but also intended to protect habitat for 1,600 sensitive, threatened, or endangered species.

Far from an impulsive decision, the RACR was the culmination of a rule-making process that elicited millions of favorable public comments, and took more than 600 meetings. Never has there been such massive public involvement in a federal rule-making process. When the RACR was finally published in early January 2000, it was probably the most important forest policy decision of the outgoing Clinton Administration. The

Sierra Club called the RACR "the greatest land-protection victory in a generation." The 2.2 million favorable comments submitted by the public strongly suggest that it was among the most popular environmental rules ever promulgated. Yet, the sounds of cheering had scarcely faded when, on his first day in the White House, President George W. Bush blocked the RACR from going into effect by ordering all federal agencies to suspend for sixty days the implementation of any regulations that had been published in the *Federal Register* but had not yet gone into effect.[2] This action—taken despite the public's overwhelming and democratically expressed support for wilderness protection—froze all pending or recently completed federal regulations, including land, air, water, and ocean regulations, regardless of their merits or urgency.

Throughout its first term, the Bush Administration was an intransigent, though at times a clandestine, foe of the RACR. Although President Bush was sworn to uphold the nation's laws, his administration's Justice Department failed to defend the RACR against industry challenges in court and, as early as May 2001, signaled that it intended to nullify the rule, while at the same time it was publicly professing to uphold it.[3] Then, just before Christmas of 2003, the Bush Administration formally decided that it would "temporarily" exempt Alaska's Tongass National Forest from the RACR. Subsequently, the USFS abandoned the RACR altogether, making its position public on July 16, 2004, in a proposed new rule, Special Areas: State Petitions for Inventoried Roadless Area Management, that in a single bold stroke sought to strip away all the protections afforded by the RACR to national forest wilderness throughout the United States.

The new proposed rule placed numerous hurdles in the path of further roadless area protection, by leaving nothing more protective for these wild lands than the forest plans under which they are administered (fifty-nine percent of which, according to The Wilderness Society, allow road building in inventoried roadless areas) and a tortuous, costly, and uncertain administrative process, fraught with peril to the wilderness. The process allowed each state governor eighteen months in which to petition the USFS to specify rules for the national forest roadless area in their state, and these suggested rules could be either more protective or more lax than the requirements of the applicable forest plans. In effect, this placed clever roadblocks in the way of roadless area protection. First, it required a governor to initiate new action to protect a state's roadless wilderness.

That in itself was a significant barrier, as it required forest defenders to pressure their governor to respond favorably and file a petition with the U.S. Department of Agriculture (USDA)—which would then have to accept it and ultimately rule favorably upon it. The new rule thus put the fate of roadless lands into the hands of state governors—many of whom are indifferent or even hostile to wilderness and do not want to offend politically powerful state mining and timber interests.

If petitions were not filed by a governor, management of that state's roadless areas would then have been subject to existing forest management plans, most of which, as noted, allow road building and logging in roadless areas (although they can also protect wilderness). As an added deterrent to the filing of petitions, the state that did petition for roadless area protection was required to pay for the petition and to assist federal agencies in preparing required environmental studies. However, even if a governor filed a petition asking for roadless area protections *and* if the USDA approved the petition, protection could only come after a time-consuming, rulemaking process. The Bush Administration thus intentionally left the nation's wildest forests highly vulnerable to logging, mining, and road building, undoing the Clinton's Administration most important effort to save some unspoiled public forests.

Public reaction to the abandonment of the RACR was so intense that the USFS extended the deadline for receiving public comments. By November 2004, even before the deadline was reached, the service had received more than a million comments, preponderantly favoring retention of the RACR. In an interesting footnote to this decision, when the Environmental Protection Agency (EPA) was given its chance to comment on the rollback of the roadless rule, senior officials prevented the staff from objecting. Public Employees for Environmental Responsibility revealed in November 2004 that, although EPA staff had expressed serious concerns about the rollback, all objections were stricken from the EPA's final concurrence letter to the USFS, on the orders of a Bush Administration political appointee.

The Bush Administration's exemption of the Tongass National Forest from the RACR will have an impact on the Tongass's old-growth forests. Some nine million roadless acres in the Tongass alone are now at risk from logging and other commercial activities. The USFS is targeting its planned Tongass timber sales on what the Natural Resources Defense

Council (NRDC) calls "the biological heart of the Tongass — with the grandest, oldest trees."[4] These trees, including ancient sitka spruce, hemlock and yellow cedar, are found in ecologically rich and valuable intact forest habitat. As of February 2006, more than 100 sales scattered throughout 2.5 million acres of the Tongass forest were being planned. But, as noted in Chapter 4, the Bush Administration's effort to repeal the RACR was invalidated by a federal court that overturned the repeal. The court, however, let stand the administration's exemption of the Tongass National Forest, leaving it vulnerable to logging and development.

CONFLICTS OF INTEREST WITHIN THE BUSH ADMINISTRATION

Soon after his inauguration, President Bush began appointing personnel sympathetic to the timber, mining, oil, and gas industries to powerful public land management positions. For example, on March 9, 2001, President Bush nominated former mining, oil, and gas industries' lobbyist J. Steven Griles as Deputy Secretary of the Interior. In this high post, Griles had broad authority over the management, leasing, and development of federal lands, including Bureau of Land Management (BLM) lands, national wildlife refuges, the National Park Service, and national monuments.[5] Many of the other administration appointments followed the same pattern of turning over critical public resource management posts to representatives of the extractive industries most responsible for damaging the resources and least likely to conserve them.

Thus, President Bush named former timber industry lobbyist Mark Rey to become Undersecretary of Agriculture, a position that gives him powerful control over national forests policy. Before his appointment, Rey represented industry groups, such as the National Forests Products Association, American Forests Resources Alliance, and American Forest and Paper Association. Just before being tapped by the Bush Administration, Rey also held senior positions on the staff of two of the Senate's most antienvironmental figures: Senator Larry Craig (R-ID) and Senator Frank Murkowski (R-AK), who later became Alaska's governor.

Another problematic appointment was President Bush's 2003 choice of Mark Rutzick to become a senior advisor to the National Oceanic and Atmospheric Administration on natural resource and endangered species issues. He was, according to the NRDC, "the timber industry's top lawyer in its fight against the Endangered Species Act."[6]

The Bush Administration has made no secret of its dislike for the Endangered Species Act (ESA), because of the way that its protection of threatened and endangered species interferes with logging, mining, and oil and gas drilling on public land. The administration revealed its attitude in various ways: just months after he was sworn in, President Bush advocated relaxing rules for listing threatened and endangered species under the act.[7] He also starved endangered species and critical habitat programs for money; thus, the president's Fiscal Year 2003 budget provided no contingency funding to implement new court orders that were about to result from citizen suits enforcing the ESA. Predictably, the U.S. Fish and Wildlife Service (USFWS) found that, for the summer of 2003, it did not have enough money to meet court-ordered deadlines for protecting endangered species and their habitat. Critical habitat designation protects habitat that is essential to the welfare or survival of federally listed threatened or endangered species, most of whom are imperiled by devastating losses and fragmentation of their habitat by development. The designation of specific critical habitat allows the government to limit or block development and other activities, within a specific area, that would be harmful to the protected species' recovery. However, in the summer of 2003, once the USFWS had spent its $6 million annual budget for critical habitat designations, it announced that it could no longer designate additional critical habitat for already-listed species, even though it is legally required to grant such petitions under the ESA.[8] While the USFS said in 2003 that it needed $153 million to address the existing backlog of species to be listed and critical habitats to be designated, the Bush Administration requested only $12 million for Fiscal Year 2004.

Kieran Suckling, an expert on endangered species issues with the non-profit Center for Biological Diversity, explained the fine points of the Bush Administration's endangered species strategy:

The Administration always asks for enough money to implement court orders existing at the time of its budget request. Indeed, the language of the budget request indicates that it calculates the needed budget request based on existing court orders. But that is a problem because it ensures that when court orders are rendered (sometimes just months after the budget request has been submit-

ted) it instantly breaks the bank. This is a win-win situation for the Administration because (1) it gets to tell the courts it can't obey the ESA [Endangered Species Act] because it lacks the money, and (2) by purposefully keeping the program on the edge of bankruptcy, it gets to argue that every new suit to protect endangered species is breaking the bank. [For example] . . . in 2002, the Administration sent its Fiscal Year 2003 budget request to Congress, noting that it was just enough to cover existing court orders and that there was a good chance that there would not be funds for new court orders. On March 13, 2003 Congress approved 100 percent of the budget request but also noted that it didn't think the administration asked for enough money to meet its legal obligations. It invited the administration to submit a supplemental budget request. The administration refused to ask for more money. Instead, it held a press conference in April announcing that it could not comply with court orders to designate critical habitat. Thus while the budget request was technically, and by the skin of its teeth, sufficient to meet court orders known at the time of the request, it was clearly engineered to collapse immediately afterward. That is exactly what happened. Congress offered extra money to avoid the trainwreck. The Administration refused it [preferring] the train wreck.[9]

Consistent with its opposition to granting endangered species sufficient habitat to assure their recovery, the Bush Administration in late 2004 settled a suit by the National Association of Homebuilders brought under the ESA against the National Marine Fisheries Service. The suit claimed that the National Marine Fisheries Service had done an inadequate economic analysis (required under the ESA) for critical habitat designations. Instead of mounting a vigorous legal defense against the suit and defending the habitat needed by federally listed wildlife, the Bush Administration capitulated, sided with the home-builders, and removed protection for up to ninety percent of critical habitat of salmon and steelhead in the Pacific Northwest and up to half of the previously identified critical habitat in California.

Other examples of the administration's flaccid support for the welfare of endangered species abound. In 2002, the gray wolf's status was changed from endangered to threatened (a decision recently reversed by

a federal court in Portland), and, on July 14, 2004, the Interior Department proposed entirely eliminating federal protection for the gray wolf. The USFWS, in February 2003, denied endangered species status to the California spotted owl, an old-growth forest species, citing a lack of evidence that the bird's habitat was sufficiently threatened. Yet, the California spotted owl population is declining at four percent per year, according to the USFWS.

The Bush Administration had also been reassessing the status of the old-growth-dependent marbled murrelet, at the timber industry's request. Its private-contractor assessment team weighed in during May 2004 with a conclusion that undoubtedly displeased both the Bush Administration and the timber industry: the murrelet is genuinely endangered. The Bush Administration nonetheless chose to assist the timber industry at the murrelet's expense by arguing that murrelets living along an 800-mile stretch of the Pacific Coast south of Canada should be lumped for purposes of ESA designation with populations in British Columbia and Alaska. This obfuscated the risk to the U.S. murrelet population and left the Bush Administration an opening to delist the species in spite of its dire status.

And despite the USFS's inclusion of the unmanaged use of off-road vehicles as one of its four priority threats (see Chapter 5), the service still permits off-road vehicles to roam across thousands of square miles of habitat for endangered grizzly bears in the Idaho, Kootenai, and Lolo national forests of Montana.[10] Many environmentalists believe that the Bush Administration is currently laying the groundwork for removing the grizzly bear from the list of endangered species. As evidence, they cite the fact that the USFS is rewriting management plans for six national forests surrounding Yellowstone National Park to provide for the creation of a "primary conservation area" around the bear's core habitat where protection would be maintained—but in order to loosen protection elsewhere. The result would be greater access to the national forests near Yellowstone, opening up bear habitat in the Greater Yellowstone Ecosystem for oil and gas drillers, miners, and loggers whose activities would have been impaired by the presence of an endangered species. What the grizzly bear really needs, however, is continued protection, so that fragmented populations can expand their range and interbreed with other isolated bear populations. Thus, the Yellowstone grizzly population should be allowed to expand its range over wildlife corridors that would allow it to interact with the bears of Glacier National Park and elsewhere.

Although the USFS had previously called for the black-tailed prairie dog to be listed as a federally threatened species, the service in February 2004 decided—in deference to ranchers, who view prairie dogs as pests —to allow prairie dogs to be poisoned on national forests and national grasslands. Also in February 2004, the Bush Administration issued a budget proposal that called for reduced funding for endangered species' recovery efforts by nearly $10 million.

Finally, the USFWS has acknowledged that the Pacific fisher, another old-growth forest species, is endangered and deserves federal protection. Yet, the USFWS had to announce, on April 2, 2004, that it had no money to protect the fisher and, therefore, wanted to make the animal a "candidate" for future listing.

THE BUSH ADMINISTRATION'S HEALTHY FORESTS INITIATIVE

The Bush Administration launched a program in 2002 called the "Healthy Forests Initiative," portraying it as an urgently needed fire protection response to a new national fire emergency. The initiative was introduced following the costly and extensive wild fires of 2000 and 2002. After nightly news reports of raging wildfires, loss of life, and property damage, television viewers could be excused for believing that a genuine emergency had suddenly arisen requiring a drastic new approach to forest fires, one that might even justify the suspension of environmental safeguards and limits on time-consuming public participation in forest management.

The facts, however, tell a different story. Indisputably, in 2000, the nation did experience its most severe fire season in decades when some 8.4 million acres burned in 122,000 fires.[11] In 2001, however, only 3.6 million acres burned—far below the national average for the previous eighty years (about fourteen million acres). Large national annual variations in the extent of burned area are common. The size of the acreage burned in 2000, while unusually large relative to the average acreage burned during the previous decade (3.8 million acres), was less than the average annual acreages burned in the four decades from 1919–1959 (24.4 million acres). Similarly, while the 6.9 million acres that burned in 2002 was substantially above the annual average during the preceding ten years (4.2 million acres), it was not unusual: fire seasons in which acreages similar to the 2002 total also burned had occurred as recently as 1996 (6.7 million acres) and 1988 (7.4 million acres). Moreover, the

number of fires in 2000 (122,000) and in 2002 (88,000) were not at all unusual. In fact, the number of fires in 2002 was less than the average number of fires occurring in every decade from the 1920s through the 1990s. These averages ranged from a low average rate of 97,599 fires per year from 1899–1929, to a high average rate of 163,329 fires per year from 1980–1989. Indeed, during the 1990s, fewer acres burned annually on average than during the 1920s–1960s, and again through the 1980s.[12]

To seasoned conservationists, the Healthy Forests Initiative was suspicious from the start. On the one hand, the administration said the initiative was necessary for protecting public lands from wildfires. But much of the activity proposed was to be conducted far from developed areas in remote, roadless, hitherto protected areas where the timber industry would be allowed to log large, live, fire-resistant trees. This would be done without environmental reviews, on the strength of USFS assertions that the logging was necessary to prevent fires — but if that were the real goal, why were loggers not restricted to removing flammable understory vegetation near heavily settled areas? Nor did the initiative require loggers to remove flammable logging slash and other debris after logging operations. Thus, the practices that the initiative promoted actually can intensify forest fires and divert fire prevention resources from the defense of populated areas to logging in remote ones. The Bush Administration's rationale for permitting the removal of large, fire-resistant trees was to make certain timber sales were attractive enough to logging companies to compensate them for thinning densely growing, small and unprofitable flammable trees and brush. It was a good example of public forest management on the cheap.

The Bush Administration also claimed that it needed to reduce public interference with forest thinning, arguing that environmentalists were putting people, homes, and communities at risk from wildfires by delaying federal fire prevention work through excessive appeals and litigation. This specious theory was put to rest, however, by a May 2003 Government Accounting Office study that showed that less than three-tenths of one percent of all thinning projects were taken to court and that ninety-five percent of all thinning projects proceeded speedily.[13]

In yet another rationale for "streamlining" logging under the Healthy Forests Initiative, the administration sought authorization to end ESA consultation with the USFWS on timber sales of up to 1,000 acres,

thereby disengaging the scientific expertise of the government's most knowledgeable wildlife agency from the species protection process on these sales. The initiative also allowed the federal government at times to bypass the preparation of Environmental Assessment (EA) Reports and Environmental Impact Statements (EIS), to reduce interagency consultation, and ironically, to limit the already infrequent public appeals of fire-related thinning activities.

Another USFS rule adopted as part of the administration's Healthy Forests Initiative allows the service to skip routine review of salvage logging operations under the National Environmental Policy Act of 1970 (NEPA) and the National Forest Management Act of 1976 (NFMA) when an "economic emergency" exists. Using this rationale to circumvent NEPA and NFMA, the USFS in mid-2004 declared an economic emergency on Oregon's Siskiyou River National Forest—scene of the 2002 Biscuit Fire that burned a perimeter of 500,000 acres—and approved several salvage logging sales there. According to Rolf Skar of the Siskiyou Project, "The administrative appeal process for those sales was axed and the sales were fast-tracked for auction and preparation. Ironically, at least one of these . . . sales received no initial bidders—and many went for a single, minimum bid price."[14] The USFS has now used the economic emergency clause in lots of salvage projects, though not without challenges. A federal district court judge in January 2002 ruled that the USFS illegally excluded the public from the planning of a "salvage logging" project in the Bitterroot National Forest of Montana and issued an injunction halting the logging. That timber sale would have resulted in the logging of 29,000 acres of roadless old-growth forest and sensitive fish habitat. Later, those areas were dropped from the sale in an out-of-court settlement with environmentalists that nonetheless allowed 15,000 burned acres to be logged. Salvage logging sales were also blocked on the Kootenai National Forest in Montana in 2003 by a federal judge when it became clear that the USFS had not inventoried the forest's old-growth timber in at least fifteen years. Logging would have violated the forest's management plan, which requires the conservation of at least ten percent of the forest's old growth.

As part of the Healthy Forest Initiative, President Bush in September 2002 ordered the USFS and other land management agencies to use "Categorical Exclusions," to exempt logging projects that are designed to reduce fire risks from the NEPA requirement that these projects be

reviewed in an EA or a more detailed and comprehensive EIS. "Categorical Exclusions" were originally designed to permit small projects having little environmental consequences, such as routine maintenance of ranger stations and campgrounds, to proceed without having to go through either an EA or an EIS, as otherwise required under NEPA. In 2002, the USFS was seeking to formulate a Categorical Exclusion regulation that would have exempted timber sales under a certain acreage from environmental review. By July 2003, the service finalized more drastic Categorical Exclusion rules that greatly broadened the number and range of logging projects that it can categorically exempt from environmental review and public participation. Previously, if small projects otherwise eligible for Categorical Exclusions were to take place under "extraordinary circumstances," such as in a roadless wilderness or a Research Natural Area, or in the presence of threatened or endangered species, the projects were *not* eligible to receive Categorical Exclusions. The new 2003 rule allows Categorical Exclusions even in many of these cases. Thus, Categorical Exclusions can now be granted even in roadless areas; for the logging of up to 250 acres of dead or dying trees; and for the logging of up to fifty acres of live trees. The public can neither comment on nor appeal these projects as originally provided under NEPA and NFMA.

With the Healthy Forests Initiative as a precedent, Bush Administration allies introduced new legislation in Congress called the Healthy Forests Restoration Act (HFRA) of 2003 to make the Initiative's provisions and restrictions permanent. The act was finally signed into law, on December 3, 2003, after $23.8 million in lobbying by the timber industry and millions in additional campaign contributions to Republican congressional representatives. As with the administration's Healthy Forests Initiative of 2002, the HFRA was depicted by the administration as a national fire-prevention measure. Its critics charged that it was again designed to expedite commercial logging and to take advantage of public fear and confusion over the precise nature of fire threats. The law used fire prevention arguments to rationalize reducing public participation in forest planning, to justify the weakening of environmental safeguards set up to review purported fuels reduction projects, and to circumvent the ESA by allowing federal land managers to act in the name of expediting fuels reduction projects without consulting the USFWS.

Not surprisingly, the HFRA does not specifically provide additional funding or brush-clearing assistance for communities at high risk of fire

from nearby forests. Instead, as with the Healthy Forests Initiative, the act again allows logging companies to remove large, live, fire-resistant trees in remote forest areas far from residential areas on the pretext of reducing hazardous fuels. In the name of fire prevention, the act limits the rights of citizens to appeal logging sales and other USFS decisions, and it requires judges to act more swiftly than before to process appeals filed to stop the logging. These measures collectively reduce long established and hard-won environmental protections. An interim rule adopted by the USFS in early 2004 for implementing the HFRA also sets up barriers to the appeal of many logging projects once a final decision has been reached.[15] Unlike the HFRA's predecessor, the Clinton Fire Plan, which concentrated fire-prevention resources on the "Wildland-Urban Interface Zone," close to buildings and communities, the HFRA reallocates resources to a much broader zone, up to one-an-a-half miles away from the community edge.[16] Thus, any increase in resources for firefighting and fire prevention under the Bush law is more than offset by this reallocation to remote forest areas.

NO INTERAGENCY CONSULTATION

Although the USFS has repeatedly asserted that it wants to increase its accountability, Chief Forester Bosworth seems to want to reduce scrutiny of the service's compliance with endangered species, clean water, and other federal laws. A January 2004 memo from Bosworth, as reported by Public Employees for Environmental Responsibility, expressed his desire to eliminate consultation with other federal agencies on all land management actions that the USFS regards as unrelated to the agency's "four threats" agenda. (These threats are fire, invasive species, off-road vehicles, and loss of open space.) The USFS had already issued the 2004 final rule declaring that no consultation is necessary to review possible violations of the ESA, provided the Forest Service's actions are being taken to reduce fire risks. So less consultation seems to be better from the service's standpoint—even when an action *is* related to fire, one of the agency's identified threats.

Interagency consultation ideally is a valuable safeguard that can reduce the likelihood an agency will take harmful or illegal actions that result in lawsuits or will harm the environment. In June 2004, USFS Employees for Environmental Ethics sued the service over its extensive use of sodium ferrocyanide fire retardant, allegedly without consulting with the USFWS

or conducting environmental reviews. Some 11,000 air tanker loads of the chemical are dropped on the national forests yearly—although the chemical, when exposed to sunlight, breaks down to hydrogen cyanide and kills fish indiscriminately.

THE ROLE OF ENVIRONMENTAL SCIENCE IN THE BUSH ADMINISTRATION

The Bush Administration has raised questions about its regard for objective environmental science by·seeking to reduce obligatory consultations with wildlife biologists and other government natural scientists who normally would provide scientific advice about the effects of timber sales on wildlife, habitat, water quality, and on other non-timber resources. In previous administrations, scientists at the USFWS, for example, had often exerted a moderating influence on forest management policies sought by timber companies.

The Union of Concerned Scientists (UCS), a nonprofit organization, prepared reports in February and July 2004 on the manipulation, suppression, and distortion of scientific evidence by the Bush Administration. Along with these reports, UCS released a related statement called, "Restoring Scientific Integrity in Policy Making."[17] By February 2004, sixty-two scientists, including twenty Nobel Prize winners, had signed the statement. The document criticizes the administration for systematically skewing the presentation of scientific opinion to make it appear more favorable to the administration's positions about global climate change and other critical environmental and public health issues. The statement concluded that the administration was stacking science advisory panels, thereby undermining "the quality and independence of the scientific advisory system and the morale of the government's outstanding scientific personnel." Among other things, the letter chastised the administration for allegedly suppressing the results of scientific research and manipulating its presentation to the public in reports and press releases. On the topic of the ESA, the statement noted, "The administration is supporting revisions to the Endangered Species Act that greatly constrain input into the process of identifying endangered species and critical habitats for their protection." By March 2005, the statement had 6,392 scientific signers.

In another indication of the Bush Administration's desire to subject scientific research to political scrutiny, the White House Office of Man-

agement and Budget finalized a new set of "peer review" guidelines in December 2004. The guidelines require that a broad array of significant governmental scientific research must now be reviewed by outside committees that include industry representatives.

PUBLIC PARTICIPATION

While the Bush Administration has reduced the scope and impact of public participation in forest planning, it has also quietly laid off or reassigned most of the USFS's highly praised Content Analysis Team, whose job it had been to summarize public comments on proposed USFS actions so that public input could be considered in USFS decision making. Forty-seven of its sixty-five employees were cut in 2004. The work will now be done by private contractors. Replacing the specialized career employees operating under civil service protection with outside firms is likely to make their work more susceptible to political influence, for private contractors are, of necessity, directly beholden to agency managers for payment and their next contract. The trend to diminish the public's voice in the management of public lands can also be seen in the U.S. Bureau of Land Management (BLM), which in February 2004 proposed to give ranchers more grazing permits on public lands and to restrict public participation in the permitting process by limiting the public's right to intervene on ESA issues. Similarly, the USFS in 2004 indicated that it, too, wanted to limit public input on its grazing permits, extending their duration, shortening the permitting process, and limiting the consideration of alternatives to proposed permits.

THE SIERRA NEVADA FRAMEWORK AGREEMENT

Another major departure from scientifically based forest management was the Bush Administration's decision in 2003 to destroy the Sierra Nevada Framework Agreement, a carefully designed management plan for eleven national forests in California. The plan had been adopted by many stakeholders over a ten-year period of negotiations with extensive public input. Developed under the Clinton Administration, the plan would have reduced logging by half on 11.5 million acres of the Sierra Nevada and would have decreased grazing by twenty percent to protect rare species, such as the California spotted owl and the northern goshawk, and their old-growth forest habitat. Instead, relying once again

on the pretext of reducing wildfire danger, the USFS plans to triple the level of logging recommended in the Sierra Nevada plan and to reduce the forest canopy in old-growth stands from eighty to fifty percent, logging even where spotted owls are known to nest. Large fire-resistant trees up to thirty inches in diameter at breast height would be removed in the process. (The previous limit had been twelve to twenty inches). To help win public support for the revised plan, the USFS hired a San Francisco public relations firm known as One World Communications. For $90,000, the firm advised the USFS to present the new plan as a program of wildfire reduction around small communities, which it did, and to identify it with the catchy phrase, "Forests with a Future," while keeping the PR contract secret. Two members of Congress then called for the U.S. Inspector General to investigate this use of public funds, but he refused, saying nothing illegal had taken place.

Unfortunately, California is not alone in being asked to sacrifice the environmental quality of its national forests to meet the Bush Administration's higher timber production goals. The administration also plans to double logging in the West at large, on top of the logging increases of 2000–2004, according to assurances privately given by USDA Undersecretary Mark Rey to the Intermountain Forest Association, a timber industry group, as reported in December 2004 by the NRDC.

MINING AND DRILLING IN THE NATIONAL FORESTS

During May 2002, the Bush Administration cancelled a moratorium on mining on 1.2 million acres in and around the Siskiyou National Forest in Oregon that had been imposed to allow time for the area to be studied for national monument status. Instead, mining will now be allowed on ninety percent of the ecologically diverse area, home to rare plants and animals, including some 300 species found nowhere else. The decision follows a USFS decision in February 2002 to allow exploration for lead mining in the Mark Twain National Forest and large increases in the leasing of Western public lands for oil and gas drilling. In March 2002, for example, the USFS proposed opening 140,000 acres of roadless land in the Los Padres National Forest to oil and gas drilling. In late January 2004, the USFS frustrated environmentalists in Alabama by issuing a forest plan allowing drilling and mining in ninety percent of Alabama's national forests — without public review or comment. The BLM, under the Bush Administration, is also issuing thousands of permits for oil and

gas drilling on federal lands at record rates. In June 2004, the BLM held the largest Utah BLM lease sale ever, both in terms of acres leased and total bids received, auctioning off more than 200,000 acres of public land in Utah for oil and gas exploration—all for less than $10 million. Was all this public land really only worth the price of a Silicon Valley chateau? Not very likely. Unfortunately, in addition to these fire-sale prices, these public land transactions often leave a legacy of environmental destruction from roads, service buildings, bore holes, drilling pads, and drilling fluids. Moreover, the bonds the BLM requires to guarantee capping of wells cover only a fraction of the cost of capping and restoring the site. Nonetheless, the Bush Administration early in its first term cancelled a modest increase in the forty-year-old bond rates, leaving taxpayers with a growing liability for cleaning up after derelict drillers.

CONCLUSIONS

The Bush Administration has aggressively pursued policies that degrade and destroy the nation's natural resources. These resources are now blatantly being managed for the timber, mining, oil, and gas industries that profit from the extraction of natural resources from public land. On balance, the preponderance of official actions taken by the USFS and other resource management agencies also suggests that the federal government is actually subverting its environmental laws. For example, instead of standing up for federal environmental statutes with vigor and conviction, the administration has made sweetheart deals with industry that circumvent environmental laws and regulations painstakingly crafted over decades—often with exhaustive public input—to protect public lands from abuse.

The Bush Administration is thus engaging in what has come to be known as "sue and settle" tactics: failing to defend vigorously environmental laws and regulations against industry attacks and instead negotiating compromise solutions that weaken those environmental safeguards. Overall, the administration's policies are not, properly speaking, conservative in the traditional sense of conserving and protecting our resources. They reveal a contempt for independent scientific advice and management and a disregard for environmental protection. Invaluable and irreplaceable natural resources that belong to the people of the United States are instead being transferred to private timber companies for exploitation, regardless of the environmental consequences and at far less than their

true value, while the costs of logging, mining, and drilling on the public's lands are shifted to ordinary taxpayers. The difference between the true value of the public's resources and the revenues charged for them amounts to a loss of the nation's patrimony, orchestrated by the agencies entrusted with protecting these treasures. History will likely judge this as a radical betrayal of the public trust.

We will now shift from this review of contemporary forest policy to a discussion of contemporary forest management practices and ecological approaches to forestry that hold the possibility of forest preservation, restoration, and sustainable management.

CHAPTER 7.
FORESTRY AND LOGGING TECHNIQUES

When we see land as a community to which we belong, we may begin
to use it with love and respect.

—ALDO LEOPOLD, *A Sand County Almanac and Sketches Here and There* (1949)

FORESTRY NEW AND OLD

Forestry is the management of a forested area and all of its resources for
the achievement of human goals. That generally means producing bene-
fits for people and should include protection and restoration of forest
ecosystems. Forest stewardship usually means protecting the forest against
fire, insects, disease, erosion, landslides, and possibly avalanches. True
stewardship of natural forests *requires* the preservation of natural ecologi-
cal functions and processes. By contrast, industrial forestry tends to
employ a capital-intensive agricultural model emphasizing the commodity
production of trees, rather than protection of the forest as an ecosystem.

To maximize the output of wood fiber per acre (for timber, pulp, or
fuel), the industrial forester generally operates on a shorter planning
horizon than the forest steward or the forester practicing sustainable
forestry, which is described later in this book. It is common for industrial
forest operations to operate on twenty- or thirty-year cycles when fast-
growing trees are being grown as a crop for pulp. The sustainable forester
may plan on a much longer basis, thinking fifty, 100, or even 200 years
into the future. The industrial forester, with some exceptions, resorts to
heavy machinery, chemical controls of vegetation and wildlife, and inten-
sive, even at times harsh management practices, as the priority of the
industrial forest operation is to maximize revenue from the land through
timber sales. Perpetuating a complete range of the natural forest's ecolog-
ical processes is generally not a high priority in industrial forestry—so

long as the absence of ecological health or diversity doesn't cost the landowner any timber revenue in the short-term. However, industrial forestry may well include objectives other than timber production, including the protection of fish and wildlife, water resources, recreation, biodiversity, and unforested ecosystems lying within the forest boundaries. Industrial forestry need not ignore or damage these other resources and values, although it often does.

By contrast, **sustainable forestry** aims at delivering a continual yield of forest products and services by protecting the whole forest as an ecosystem and limiting extraction of its products to their incremental growth between extraction cycles, so that the forest is constantly able to renew itself without an overall loss in quantity or quality. Regularly taking more from a forest than its incremental growth is rather like deficit spending—a form of raiding the "capital " or stock of forest products so that the ecosystem declines over time. Yet, as noted, both industrial and sustainable forestry may include a common range of management goals, beyond the production of timber. How concerned the forest owner is about fish and wildlife, water, range, biodiversity, and recreation varies from person to person.

FOREST AND TIMBER HARVEST PLANS

Ideally, forestry on anything but the smallest scale should be conducted according to a formal plan. A forest management plan is a written document that explains the overall timber management strategy for a whole forest, such as even-aged management (which requires clear-cutting) or all-age management (which is compatible with selective cutting), and it outlines management goals, such as the commodities and amenities to be obtained or protected, and the methods for accomplishing the goals. It also describes the different stands of the forest and provides a history of significant management activities. As described by Thom J. McEvoy in *Positive Impact Forestry*, "Management plans that involve periodic timber sales should also include stand maps with existing and proposed access routes; timber inventory data, including growth estimates; wildlife habitat assessments; and an objective for each stand that is to be treated."[1] By contrast, a **timber harvest plan** (THP) describes a particular timber removal operation. Unfortunately, long-term forest plans are generally required only on the national forests and for certain other federal lands, such as those of the U.S. Bureau of Land Management, as well as for large timber harvest operations in California.[2]

Apart from the states of California and Washington and, to a far lesser extent, Oregon and Maine, forest management plans are ordinarily not required on private forest land, unless the land is enrolled with a public agency in a special forestry assistance or tax abatement program. Forest practice legislation and enforcement needs strengthening in most states, and citizen involvement is necessary to provide on-the-ground oversight to insure that THPs and other rules are followed.

TIMBER SALES AND ENVIRONMENTAL IMPACT

Good forestry requires both a broad ecological knowledge of forests and related ecosystems as well as specific knowledge of logging technology, since forestry today is largely mechanized and computerized. For a large timber sale, the land is often surveyed from the air; the resulting photometric data are scanned into a computer and reproduced on a map. However, someone always "cruises" a representative portion of the timber sale area on foot to measure and assess it so that the yield of the logging operation can be accurately computed.

Where forest-level planning is required, the timber lessee or owner must submit a proposed forest management plan or THP to environmental review by the state or federal resource management agency in charge, unless the project qualifies for a Categorical Exclusion (as discussed in Chapter 6). The plan specifies the proposed timber removal method and related issues and accounts for environmental impacts. If a significant environmental impact is deemed likely, an Environmental Impact Statement (EIS) may be required, although in California, an approved THP is regarded as satisfying the requirements of the state's Environmental Quality Act. Forest management plans for national forest land and large California timber sales require a public review and comment period before logging permits can be granted.

If a timber forest manager, owner, or logging contractor wants to provide a forest with maximum protection and is not in a hurry to turn every last tree into money, timber can be gradually extracted from forests by the selective cutting of individual trees or groups of trees. In a well-executed selective harvest, trees are felled precisely, sometimes with the help of jacks and cables, so as to minimize damage to trees left in the stand. Damage to a tree is costly: it can provide an opportunity for disease or insects to breach the tree's defenses, and, even if it does not, it can reduce the tree's value as lumber by thousands of dollars. Between the relatively light

immediate physical impact on the forest of single-tree selection and the extreme impact of clearcutting (discussed in detail in Chapter 9) lie various timber removal methods on a continuum of increasing impacts, from patch cuts to shelterwood cuts to seed cuts. We will discuss each in turn.

LOGGING METHODS AND TOOLS OF THE TRADE

Good forestry requires the use of ecological knowledge, knowledge of silvicultural and logging techniques, and site-specific judgment to match timber removal methods correctly with management goals and local conditions. In general, the ecological circumstances that justify removing a large proportion of a forest's standing timber are few, although this approach is common in industrial forestry.

In industrial forestry, the location of the timber sale, the site slope, the soils, even ambient temperature and the size of the trees to be cut all influence the choice of tree removal technology. These systems should be designed to minimize disturbance to the soil, waterways, and remaining trees. To avoid compaction of soil and consequent damage to soils and tree roots, it is best to remove trees when the ground is frozen. In areas where the ground does not freeze, all but the coarsest well-drained soils should be dry before logging begins. Wet soils are more susceptible to compaction, which reduces soil pore openings, which in turn hold oxygen that is vital to the health of numerous soil organisms that perform essential ecological functions of benefit to the trees, even as they build new soil.

Entire books have been written on the subject of logging technology and systems for felling, prebunching, bunching, cable *yarding*, grapple skidding, and other extraction techniques, as well as on the topics of draft horse logging, design of logging trails and landings, culvert installation, and logging road construction. These technologies will not be discussed in detail in this book. Suffice it to say that large and medium-size trees are cut with chainsaws; on plantations of small trees, a mobile logging machine known as a feller — capable of seizing a whole tree trunk and cutting through it like a giant pruning shear — is sometimes used. Whole trees are sometimes removed from the forest, but, because most of a tree's nutrients are concentrated in its leaves and small branches, treetops and limbs should be (and usually are) left in the forest to keep removal costs down and to avoid excessive depletion of soil nutrients. Once trees are cut, they are handled in a variety of ways, depending on whether they are intended for lumber, pulp, or fuel, and on other factors, including

their types, sizes, and quantities. Thus, whereas some logging operations remove whole trees intended for use as power plant fuel, trees destined for the sawmill are typically limbed and topped by chainsaw and bucked (cut) into sections. The trunks are then dragged (skidded) or lifted out of the forest for loading on trucks. Sometimes, in preparing a tree for a pulp mill, the whole tree is limbed and topped on a landing. The bole might then be chipped and blown into a waiting truck.

Modern logging operations typically are highly mechanized. They use large, heavy equipment, including Caterpillar-type (tracked) logging tractors, mobile yarders (a truck-mounted steel boom equipped with cables for dragging logs), bulldozers, log loaders, logging trucks, support vehicles for mechanical maintenance needs, and fixed cable "yarding" machinery (to drag cut logs from the timber stand to the loading "yard").

SELECTION CUTS

In a planned single-tree selection cut, certain trees are chosen for removal by a forester according to specific criteria derived from long-term forest management goals. For example, a conceptually simple strategy for improving a commercial timber stand is to remove defective and diseased trees to allow the remaining trees more room to grow. In practice, considerable knowledge may be needed to develop the removal criteria and identify the trees that meet it. Another goal might be to rectify the mistakes of past mismanagement—for example, the propagation of trees ill-suited to a site; the exclusion of fire to the point that hazardous fuels have accumulated and are waiting to create a huge conflagration; or allowing the intrusion of unwanted, invasive species that are crowding out native species desirable for wildlife or commercial harvest.

Yet another strategy is to identify the most vigorous, fastest growing, highest quality trees of greatest future value and to thin other trees that are in competition with these trees for light, water, and nutrients. If several trees are touching each other in the canopy, they are in competition for available light. Favored trees can be given more room to grow by felling their neighbors. A tree is typically "released" by cutting competing trees on at least two sides of the crown. Significantly more growth is sometimes produced by releasing the canopy on all four sides. Sometimes a desired shade-tolerant (late-successional) tree may be growing beneath a canopy of less desired species and the owner may decide to thin the canopy to allow the understory tree access to light. This needs to be done

only by knowledgeable people, for thinning is a stress for the remaining trees and, if the trees are suffering from other stresses, thinning shock can damage or kill the remaining trees.

Another harvest guideline might be to harvest only trees below or above a certain size and commercial value. Taking the biggest and best trees is known as "high-grading." Removing the smaller trees according to a plan to favor a later, higher-value crop of trees is known as timber stand improvement. When trees reach certain critical diameters at breast height (dbh), they "graduate" into more valuable commercial classifications. For example, when a young tree reaches a diameter of about six inches, it becomes a pole and can be sold for pulp, firewood, posts, or poles. At ten to sixteen inches in diameter, the tree may be accepted as saw timber, depending on the local mill's criteria. When it has reached eighteen to twenty-six inches in diameter, it has reached the veneer timber stage. Perfectly straight, defect-free premium logs of this grade can be worth several dollars per *board foot*, often 1.5 to 2.5 times what an ordinary grade one sawlog would bring.[2]

Still another silvicultural strategy is to leave some of the largest and best trees standing to seed future generations. No matter what the timber harvest selection strategy is, selective timber management by single-tree or group-selection cutting generally requires the exercise of more judgment and skill than does wholesale tree removal. It can be quite difficult during a selective cut in a crowded forest to avoid injury to the remaining trees. For these reasons and because the forest needs to be reentered for successive cuts more frequently than with clearcuts, selective logging tends to be more labor-intensive than clearcutting. (The repeated entries with heavy equipment take a toll on the forest that needs to be considered.) The use of selective cutting versus clearcutting may be especially necessary in hot, dry forests where unshaded seedlings might dry out and die following a clearcut or a series of patch cuts. With single-tree selection cuts, the next generation of young trees will benefit from the shade cast by the remaining trees. Naturally, however, this makes the regeneration of shade-intolerant pioneer species impossible and early-successional shade-intolerant species difficult to impossible.

Despite its advantages, selective cutting is sometimes misapplied, resulting in "high grading"—removal of the best trees from the forest. This is akin to reverse genetic selection, with the worst, least commercially desirable trees left on site to seed the next generations. As the best trees

are culled again and again over time, forest quality inexorably deterio-rates. Another significant problem with selective cutting is that it is fre-quently used to cull all the commercially undesirable species from a forest, leaving nothing but a *monoculture* of the most marketable or valu-able species, such as sugar maple. This result is known as "type conver-sion" or "stand conversion." Conversely, a timber operator might selectively remove all commercially desirable trees, leaving only trees of low commercial value. Finally, because trees provide each other with pro-tection against wind, sometimes the selective removal of trees from a tim-ber stand can leave the remaining trees vulnerable to *windthrow.* This is a concern on windy sites where thin soils prevent deep rooting. A silvicul-turalist can identify sites where windthrow is likely to be a threat by observing the pits and hummocks left on the ground by past generations of windthrown trees.

Selective cutting may present a different kind of problem in areas that have serious infestations of root rot or bark beetles, or where most trees have been killed by fire or insects. By retaining sources of further infec-tion, selective cutting may prolong infestations. If continued commercial timber production is the main goal in the short-term, clearcutting may be necessary to control infestations, and the timber owner may also need to clearcut to salvage the dead timber en masse. Another forest-scale problem is the extent of, and impact of, the road building that may accompany selec-tive cutting. Because much of the forest is left intact, more roads may be required to reach and remove the trees that are selectively cut than for other methods of tree removal, such as the *patch cut.* Much logging-related environmental damage to streams, fish, and water quality is directly attribut-able to roads because of the erosion they cause. In good logging, timber operations are carefully planned to minimize the number, size, and ero-sional impacts of roads. Temporary bridges may then be used to cross streams, and nontoxic, biodegradable lubricants derived from vegetable oil are used for crankcase and saw lubricants and fuel additives. Biofuels and lubricants may be more expensive than toxic petroleum-derived fuels and oils, but they are less hazardous to operators and to the environment into which they are invariably released during normal equipment operation.

PATCH CUTS

An alternative to selective cutting is the division of the forest into sections of equal size known as blocks, and the sequential cutting of the blocks at

regular intervals, leaving a patchwork of open spaces surrounded by forest. Each even-aged patch of timber will form part of a distribution of age groups, from young to older trees, across the forest landscape. As each block reaches the age at which cutting has been prescribed, the patches are cut one after the other and replanted sequentially. The goal is to create a stratified age-class distribution of stands in the forest, so that the timber volume taken in each cut is replaced by new growth of the younger forest blocks. This simplification of the forest's age structure allows a regular quantity of commercially marketable timber to be taken from the forest periodically. While the timber acreage is eventually evenly apportioned among a range of age groups (classes), the distribution pattern of the trees, segregated by age across the landscape, is highly unnatural.

Still, a patch cut forest is likely to be environmentally preferable to a clearcut, because the patch cut forest contains trees of different ages versus the uniform age of trees regrowing in a clearcut forest. Patch cutting also permits more forest heterogeneity, as it allows some young, intermediate, and old habitat to remain available to wildlife while the next swath of forest grows to harvestable size. The usefulness to wildlife of the residual forest, however, depends on the size, shape, age, and connectedness of the forest fragments that remain.

A major disadvantage of patch cutting is the "*edge effect*" it creates, where forest meets grassland or newly exposed clearcut. By excising a block of trees from a forest, for example, a patch cut exposes the remaining forest on all four sides to wind, drying, and invasive species. Large numbers of adjacent bare patches also fragment the remaining forest habitat and impair the survival of certain interior forest species, especially migratory songbirds in eastern U.S. forests. The creation of new forest edges there, for example, provides the brown-headed cowbird with an opportunity to destroy populations of smaller songbirds by laying its own eggs in their nests. Cowbird chicks hatch sooner and are larger than their songbird hosts and out-compete their songbird nestlings for food. Native to open country, the cowbird normally ranges only half a mile into closed forests, but new forest edges make large additional territory available to the cowbird, to the songbirds' detriment.

SHELTERWOOD CUTS

A *shelterwood cut* removes most of a forest area's trees but leaves a thinned overstory to protect the young seedlings from overexposure to either sun,

wind, frost, or some combination of these influences. The retained over-story improves seedling establishment and growth by modifying their **microclimate**. Once the new generation of trees grows large enough not to need extra protection, loggers return to remove the older shelterwood canopy. This then leaves an even-aged tree plantation, so shelterwood cutting is essentially a clearcut performed in stages. As such, it has most of the drawbacks and advantages of a clearcut.

A *seed tree cut* resembles a clearcut even more closely than does a shelterwood cut. All trees are removed except a few mature ones, which are left to provide seed for regeneration of a new tree crop. The seed trees provide little in the way of shelter, and, once their purpose has been accomplished, loggers typically reenter the site to remove them, leaving an even-aged collection of seedlings or young saplings.

Perhaps ten or fifteen years after tree planting or the natural regeneration of a clearcut, loggers return to a site for what is called "precommercial thinning." Trees and shrubs competing with chosen specimens of desired species are cut down. Finally, at a time when, according to calculations based on timber growth rates and tree age, the standing timber has reached a volume that maximizes the owner's return on investment (or sooner if ready cash is needed), trees are once again cut. If the final operation is a clearcut, the whole cycle starts over. Generally, the more often this is done and the shorter the rotational period, the smaller the trees produced.

The industrial forestry procedures described here — single-tree and group-tree selection cutting, shelterwood cutting, seed tree cutting, patch cutting, and clearcutting — while common in the West, vary greatly from region to region and across ecosystems. In the case of northeastern U.S. hardwoods held in small-scale private ownership, for example, trees are rarely clearcut for a number of reasons that render clearcutting economically and silviculturally unjustified. Instead of containing towering species with thick trunks and relatively condensed crowns, such as Douglas-fir, redwood, Sitka spruce, or Ponderosa pine, a stand of northeastern U.S. hardwoods might initially consist of many crowded, relatively thin-stemmed trees. Due to the high relative ratio of treetop-to-bole volume, limbing all but the largest specimens (as would probably be required after clearcutting) would not be cost-effective. In addition, the small size of the landholding, the owner's presumed lack of capital or short planning horizons, plus the presence of difficult (broken) or mountainous terrain might make the use of expensive heavy machinery infeasible. Finally, even

if clearcuts were made, hardwood planting generally produces poor results, and the creation of large clearcut forest openings would invite predation on the new seedlings by white-tailed deer and rabbits.

HERBICIDES AND OTHER BRUSH-CONTROL METHODS

Next to clearcutting, the most controversial forestry topic is probably the use of herbicides to control brush, herbs, and weeds that compete with trees. Plant competition can be so severe, in fact, that it can prevent tree establishment or make growth slow and survival problematic. Because herbicides are effective control agents and can be cheaply applied to the forest by air, they are economically attractive to forest managers. Environmentalists are generally arrayed against foresters on the subject of herbicides. Many professional foresters believe that the broadscale application of herbicides is safe for wildlife, humans, and commercial tree species. They contend that scientific evidence indicates that low-dose applications of herbicides do not make wildlife ill, kill soil organisms, damage soil structure, or bioaccumulate in animal tissue.

Following their application, herbicides are rapidly absorbed by vegetation or adsorbed onto soil and dust, where they are generally soon deactivated. Herbicide effects on a particular site depend on the compound's toxicity, persistence, mobility in soil, potential for bioaccumulation (if any), exposure pathways, and consequent exposure risks. Although laws and regulations prohibit the discharge of herbicides into surface water, an unplanned infusion of herbicides into streams and wetlands can easily occur if a heavy rain falls soon after spraying; if an accidental spill takes place; if wind gusts carry spray from aircraft onto water; or if equipment and containers are emptied into waterways during cleaning. In high concentrations, herbicides can damage or destroy fish and other aquatic life and produce illness in humans. Nowadays, much more care is taken in the application of herbicides than in previous decades. Spraying is usually done during dry weather to prevent contamination of runoff, for example. However, personnel who spray herbicides on forest land are not necessarily trained or licensed. No federal license is required for the application of herbicides (except 2,4-D) on private land, and regulations vary from county to county and state to state.

The effects of herbicides on soil are complex. Because herbicides kill broadleafed vegetation, they cause an increase in the availability of nutrients released from the dead and ruptured cells. Depending on climate

and on when new vegetation gets established, excess nutrients may then be leached from the soil by precipitation and lost to plant roots. Spraying kills broadleafed native species of trees and brush, such as alder and ceanothis, that are natural soil repair agents. These trees host nitrogen-fixing bacteria attached to their roots. The bacteria enrich the soil with soluble nitrogen suitable for plant uptake. When tree and shrub roots that support fungi are killed, the microflora of the forest soil changes, and the fungal community and the organisms that live upon it are reduced. In its stead, the bacterial population of the soil increases, along with a more bacteria-dependent food web.

Despite astute public relations by defoliant manufacturers and timber companies, some phenoxy herbicides widely used by timber companies can be dangerous to humans and wildlife. One phenoxy herbicide in particular, 2,4,5-T, was implicated in cancer, blood disorders, rashes, miscarriages, and birth defects. Aside from its intrinsic toxicity, 2,4,5-T was also frequently contaminated during manufacture with dioxin, an ultra-toxic compound. Since the use of Agent Orange in Vietnam (from 1962–1971) aroused public concerns about herbicide effects, some of the more toxic and persistent herbicides have been taken off the market. 2,4,5-T was banned in the United States in 1979. The closely related compound 2,4-D is still legal in the United States, but those who apply it must be trained and certified. Moreover, because of the 2,4,5-T controversy, 2,4-D is no longer used in California.

The U.S. Forest Service (USFS) is a major user of herbicides and, according to the U.S. Department of Agriculture, in 1994 applied about 100,000 pounds of herbicides, algicides, and plant growth regulators for purposes ranging from site preparation and weed control to conifer release. 2,4-D is still the herbicide most heavily used by the USFS—more than 35,000 pounds in 2003. Other heavily used herbicides in 2003 were glyphosate, Picloram, and Triclopyr.

Herbicide application is only one of many methods to reduce competing vegetation. All have their pros and cons. Whereas manual control of brush (by hand labor) eliminates the tops of plants, the roots and shoots survive in the soil to resprout later. From the standpoint of forest preservation, this is a benefit, but the brush then competes with commercial trees for space, light, nutrients, and moisture. In contrast to the manually controlled plant, the roots of the herbicide-treated plant die and cease to compete with the trees—just what the commercial forester wants.

If, instead of using hand labor, brush control is done with heavy mechanized equipment, it may compact soil, harm tree roots, and cause erosion. Manual brush control does not have these disadvantages, but it is much more labor intensive and likely to require repeat treatments. In some cases where native brush is thick, it may be ripped out by bulldozer and brush rake. The ground may then be harrowed with a heavy duty scarification plow to open it for planting. Although manual brush control is invariably less damaging to the land, mechanized or herbicidal brush control is usually adopted, because these methods are cheaper.

Controlled (or prescribed) burning is another alternative to herbicides. Whereas forest burning does not introduce synthetic toxins into the environment, it can deplete soil nutrients by destroying organic matter (humus) in the soil and by oxidizing nitrogen during combustion. Burning is also sometimes used to dispose of logging debris. Grazing is widely used to manage low-growing vegetation, but it may have some undesirable ecological effects. Sheep and cattle can damage desirable species and introduce diseases to wildlife.

As noted, good forestry depends on the choice of appropriate silvicultural and harvesting methods combined with a thorough understanding of forest ecology and a knowledge of the requirements of the tree species being grown and harvested. Good forestry also requires a continuous and enduring commitment to the land following logging to insure long-term erosion control and long-term survival of regeneration plantings. Roads and drainages often require maintenance over long periods of time to prevent uncontrolled erosion, including landslides and damage to natural *watercourses*. The owner or manager who is only interested in money and fails to perform required maintenance is likely to do irreparable harm to the forest.

CHAPTER 8.
OF OLD GROWTH, SPOTTED OWLS, AND SALVAGE LOGGING

Love the forest. Appreciate the forest. Give thanks
that the forest sustains us.

— HERB HAMMOND, *Seeing the Forest Among the Trees* (1991)

THE FATE OF OLD-GROWTH FORESTS and the northern spotted owl in the
Pacific Northwest has been the focus of a bitter and longstanding dispute
between environmentalists and the timber industry. In response to envi-
ronmentalists' challenges to old-growth forest logging, U.S. District Court
Judge William L. Dwyer ruled in 1991 that the federal government had
failed to protect the spotted owl as required under the Endangered
Species Act (ESA). Logging over the past century and a half had already
destroyed all but about ten percent of the owl's original habitat. Judge
Dwyer, therefore, issued a comprehensive ban on further logging in fed-
eral forests until their management plans were brought into compliance
with the ESA. This and prior decisions would virtually halt logging of the
ancient forests on federal lands for more than five years.

To meet conditions set by Judge Dwyer, the federal government con-
vened a special study group in 1993 to assist it in resolving the Pacific
Northwest forest crisis. Known as the Forest Ecosystem Management
Assessment Team (FEMAT), the group was directed to use an "ecosystem
approach" in delineating forest management alternatives. FEMAT's
efforts cost more than $3 million and, including its subteams and four-
teen advisory subgroups, utilized the services of 600 to 700 people. The
team gathered and assessed scientific evidence regarding the biology and
survival prospects of the owl and developed candidate alternative policies
for the management of the more than twenty-four million acres of feder-
ally owned forest land in Oregon and Washington.

President Clinton then convened a high-level forest "summit conference," on April 2, 1993, in Portland, Oregon, where he helped to lay the groundwork for a 1994 forest management compromise agreement to protect habitat for the endangered northern spotted owl and other rare old-growth forest species and to blunt the economic impact of a logging reduction. President Clinton from the outset had committed his administration to the goal of crafting a balanced, comprehensive, scientifically sound, ecologically credible, and legally responsible long-term forest management solution to the conflict. In July 1993, when FEMAT produced its analysis and outlined ten possible management options, the Clinton Administration announced its "Forest Plan for a Sustainable Economy and a Sustainable Environment," based on Option 9 of the FEMAT alternatives.[1] Many forest activists opposed Option 9 for not protecting all spotted owl habitat and for creating old-growth reserves that are not sustainable. Pro-industry critics assailed the plan for protecting too much owl habitat. Although the impetus behind the plan was to restart the stalled flow of federal timber from the Northwest's national forests and to provide for a sustained timber harvest to benefit the region's economy, the plan did represent an increased emphasis on ecosystem management that would help preserve old-growth, late successional, and aquatic ecosystems—a fundamental shift away from a single-minded management for timber.

After an Environmental Impact Statement (EIS) was done, the Forest Plan was formally presented to Judge Dwyer on April 14, 1994. The EIS requires that any logging done must be consistent with certain ecosystem management criteria. These criteria require that the effects of timber operations on endangered species must be considered in the aggregate across the entire landscape of old-growth timber holdings on federal lands in the Northwest. Examining the effects of logging on a particular local site would not be sufficient to meet this test. In return for an expected eventual end to logging on the last remaining six million acres of old-growth forest, and a reduction in the allowable cut in the region's national forests, the 1994 Northwest Forest Plan promised $1.2 billion in federal funds over a five-year period to retrain timber workers and restore forest land in the affected region. The plan went into effect on a limited basis in 1994 and provided for the resumption of some logging in the Northwest's old-growth forests, but at levels far below those of the 1980s.

On July 27, 1995, to the profound dismay of environmentalists, President Clinton — despite his own avowed objections — reluctantly signed into law a $16.3 billion education spending bill with a totally unrelated rider — an amendment containing logging provisions he had previously vetoed. The new law specifically exempted salvage timber sales in the national forests of the Pacific Northwest from federal environmental laws, such as the ESA and the Clean Water Act, and barred citizens from challenging the salvage sales in court or by administrative appeal. Characterized by supporters as "emergency legislation," the new provisions doubled "salvage logging" rates on federal lands damaged or threatened by fire, disease, or insects.

True *salvage logging* is the removal of diseased, dying, and dead trees, but, under the rider, timber companies and the U.S. Forest Service (USFS) used salvage logging as a pretext to enter roadless old growth and clearcut thousands of acres of healthy trees. The salvage logging rider, in effect, created a loophole in environmental laws big enough to drive a thousand logging trucks through, and a federal court soon broadened the law's purview far beyond President Clinton's expectations. Vice President Al Gore later admitted that signing the salvage logging rider was one of the biggest mistakes of the Clinton Administration, but the damage was done. According to calculations by salvage logging critics, salvage logging under the rider may have cost taxpayers as much as a billion dollars in subsidies from the USFS to multinational timber firms before the rider expired at the end of 1996. However, the new law defined "salvage" logging so broadly that industry argued that up to a billion *board feet* of healthy, live timber could be cut under the legislation. Whereas "salvage logging" rates were to be doubled in damaged federal forests, the bill also expedited logging on vast healthy forests that provided spotted owl habitat. The new bill thus undermined the administration's much-touted Pacific Northwest Forest Plan and increased logging activity.

A decade after the signing of the Northwest Forest Plan, with forest disputes still roiling in the Pacific Northwest, the George W. Bush Administration capitulated without a fight to a series of timber industry suits over implementation of the protective 1994 agreement.[2] In one instance, for example, it reached a conciliatory out-of-court settlement with Douglas Timber Operators, the American Forest Resource Council, and the Association of O & C Counties (the plaintiffs), agreeing to do away with a mitigation program that required the U.S. Bureau of Land Management (BLM)

and the USFS to protect old-growth, forest-dependent species when allowing logging in mature and late-successional forests. Prior to the settlement, the USFS and BLM had to survey proposed timber sale areas in the Pacfic Northwest for rare plants and animals. Where the species were found, buffer zones (where no logging was allowed) were required to protect these populations from the impacts of logging. Now, with the "survey and manage" requirement waived, timber companies can plead ignorance about harm they may be doing to endangered species or to any of some 300 rare species not yet on the federal endangered species list.

As a result of another change in the Northwest Forest Plan made by the USFS, loggers no longer have to abide by the plan's Aquatic Conservation Strategy (ACS). Intended to protect threatened and endangered salmon in the Northwest, the ACS had required that loggers assess the impacts of logging and roads on individual salmon streams. Now, they need only assess the impacts of logging on streams at the scale of the watershed in which the logging takes place. This allows the USFS to assess impacts once they have been diluted to undetectable or insignificant levels.

In 2003, the Bush Administration settled another timber industry lawsuit by agreeing that logging in the Pacific Northwest could be twice the timber volume taken in recent years under the Northwest Forest Plan — despite the need for habitat protection for old-growth species.[3] The Bush Administration's practice of settling suits in favor of industry has allowed industry to decide which environmental legislation and prior agreements it wishes to be relieved of simply by filing suit against enforcement of the offending legislation. It need not actually prove its case in court.

In retrospect, the results of the Northwest Forest Plan a dozen years after its signing have at best been mixed. Some 156,000 acres of owl habitat in the Northwest (western Washington, western Oregon, and northwestern California) have been degraded, including 17,000 acres of clearcuts, according to the U.S. Fish and Wildlife Service.[4]

The plan established old-growth forest reserves and designated other areas as "matrix" forests containing some remaining old growth amidst other forest types. Unburned old growth in the reserve was protected from logging, but burned old growth was subjected to salvage logging. Old growth in the matrix zones was left eligible for logging under the plan, provided that wildlife surveys were performed and required buffer areas were protected. Because the USFS and BLM failed to implement properly the ACS and abandoned the "survey and manage" require-

ments of the plan, conservation groups successfully sued to block much of the old-growth logging that the plan mandated.[5]

SALVAGE LOGGING BEYOND THE NORTHWEST

Salvage logging controversies were not confined to the Northwest. The Lake Tahoe Basin Management Unit in Northern California, for example, contains a rapidly deteriorating fire-prone forest comprised largely of dying fir trees, with some native pine. Like many contemporary forest problems, it is a legacy of earlier mistreatment.

Located not far from the shores of scenic Lake Tahoe, the trees were weakened by six years of drought and, by the summer of 1995, were quickly succumbing to two of their ancient insect enemies, the pine bark beetle and the fir engraver. Lake Tahoe, the deepest and largest mountain lake in North America, was also one of America's clearest before extensive development in its basin. Visibility in the lake is declining fast now — by a third in less than forty years — due to excessive nutrients (nitrogen and phosphorus) that enter the lake by atmospheric deposition (in rain and on dust particles) and on eroded soil particles generated mainly from the construction of buildings, roads, and trails, as well as from logging.[6] These nutrients then produce elevated concentration of algae in the lake water column, and, along with slowly sinking particles of fine dust, they diminish the lake's famed clarity.

Before the Gold Rush of 1849, the Lake Tahoe Basin watershed had been cloaked in a magnificent, fire-resistant forest of tall and well-spaced pines — vanilla-scented Jeffreys and thick-barked sugar pines with giant cones — along with incense cedar, white fir, and red fir. Periodic surface fires had kept the more heat-sensitive firs from being more numerous than the pines. Land survey data taken in the mid-1800s show that the ratio of fir to pine was approximately one to one. But once the valuable pines in the watershed were clearcut for mine timbers or charcoal and a period of fire suppression began, a crowded, predominantly fir forest emerged. The ratio today is five fir to one pine. Michael G. Barbour, Professor of Plant Sciences at the University of California, Davis, described what happened: "In the absence of fire every twenty-five to fifty years, the overstory canopy became more continuous, shading out pine saplings but not the more shade-tolerant fir saplings. Tree densities of modern Tahoe Basin forests are three to five times what they were prior to 1800. This crowding makes trees susceptible to periodic droughts and to catastrophic crown fires."[7]

Citing the possibility of an uncontrollable wildfire in the Lake Tahoe Basin Management Unit (a unit within the national forest system), the USFS decided to rely on commercial logging, rather than controlled burns, to manage the unhealthy forest. In the greater Tahoe area (outside the lake basin itself), Sierra Pacific Industries, among other companies, bought the right to cut dead and dying timber in a salvage operation that allowed the cutting of some surviving pine trees that are overly dense and susceptible to disease and crown fires. Neither logging too near the lake nor a catastrophic wildfire, however, is good for Lake Tahoe, since both cause polluting runoff. The ecological integrity of both forest and lake must be protected. The Tahoe National Forest deserves nothing less than the highest standards of ecologically oriented forest management for the region. Relying primarily on commercial logging and fire suppression to meet the forest's management needs is unlikely to protect and enhance the area's extraordinary ecological values.

Salvage logging as practiced often contrasts with the high-minded ecological rationales used to justify it. For example, the USFS authorized an extensive salvage logging of 130 million board feet on the Boise National Forest in Idaho following a 1992 fire. The logging was ostensibly to restore the forest's health, and, on its completion, the USFS expressed satisfaction with the quality of the work. No EIS or administrative review had been required. But after months of investigation and on-site inspection, local environmental activists reported that logging operations were conducted in off-limit zones, "healthy trees were improperly cut damaged lands were not properly replanted," creeks with imperiled species were adversely impacted, and helicopter landing pads were built beside sensitive streams.

Timber industry lobbyists and their allies in Congress sought legislation in 1996 to extend the 1995 salvage logging legislation and make it permanent. Fortunately, their efforts failed and the rider mercifully expired. However, as we have seen, salvage logging was reborn or, some might say, rose from the ashes again, thanks to the efforts of the Bush Administration and the passage of the Healthy Forests Restoration Act of 2003.

CHAPTER 9.
CLEARCUTTING

Clearcutting might be economically efficient, but the attempts to justify it with ecological arguments fall short. . . . Soil nutrients are depleted when the entire [above ground] forest biomass is carried off on a logging truck or burned in the aftermath of a clearcut.

—Ray Raphael, *Tree Talk* (1982)

No forestry topic evokes stronger emotions than clearcutting. Clearcutting is the removal of all trees on a site and the consequent loss of forest conditions, such as the influences of the forest canopy and roots on the soil and forest floor. Environmentalists generally abhor clearcutting. Foresters and commercial timber operators use it frequently and regard it as a legitimate forest management practice. The debate often obscures two separate and important issues: the first is whether a particular site should be logged at all; the second is, if the logging is acceptable or necessary, what logging method is appropriate for the site? With this distinction in mind, we will now explain why clearcuts are done and what their ecological effects are. The arguments for clearcutting are generally framed in economic terms, while those against are usually based on ecological concerns.

Most large commercial timber companies find it more profitable to clearcut a coniferous forest than to log it selectively. Hardwoods are more frequently logged selectively, as already discussed. Since clearcutting does create a uniform habitat, it allows a timber operator to control brush and replant efficiently. Timber management activities, such as thinning and herbicide treatments, can then be efficiently conducted after clearcutting to reestablish the next generation of trees. The size of a clearcut and length of *rotation* (the time between clearcuts on the same parcel) is critical to

assessing the clearcut's ecological impact. A clearcut the length and width of a mature tree, for example, creates an opening in the forest that natural forest processes can readily fill. A clearcut of more than twenty acres, however, creates a sudden forest void that is much more difficult for the forest to repair.

Various costs and the projected net revenues of a clearcut versus those of a selective cut are weighed by a timber company contemplating clearcutting. The first obvious economic incentive for clearcutting is that more saleable trees can be taken to market right away at the same time. Even though more trees are cut than in a selective cut, the clearcutting operation might be less expensive, since no effort need be expended to select trees and protect them during removal of their neighbors. In a coniferous forest, however, reforestation after a clearcut may be more costly than reforestation after selection cutting. (This would not be true, however, in cutting hardwoods that naturally regenerate by resprouting from stumps.) The higher costs of regeneration in a softwood-dominated forest are due to the fact that clearcutting removes all trees, whereas, in selective cuts, young trees of intermediate sizes and ages are left standing and have a headstart on newly planted seedlings. On a clearcut site, therefore, a timber manager must wait longer to the next commercial harvest than with a selection cut.

Clearcutting is also attractive to timber companies because it produces trees of the same age in the generation following the cut. The management of clearcuts is convenient for timber companies because forest operations can be done concurrently throughout an even-aged site, and clearcutting makes it possible to produce a new generation of trees of uniform size and quality that are easier to mill. While the motives behind clearcutting are usually economic, once a decision has been made to log a forest, sound ecological arguments, *in some instances,* can be made for managing by clearcutting versus other tree removal methods. What are these circumstances?

SPECIAL CASES WHEN CLEARCUTTING *MAY* BE WARRANTED

Commercial foresters recommend the use of clearcutting for salvaging logs from forests killed by insects or fire and when extensive root disease or infestation by dwarf mistletoe exists. Failure to remove the diseased or infested material may lead to rapid transmission of insects or diseases to the next generation of trees. Clearcutting may also be necessary for the

removal of single-species stands of invasive exotic trees, such as eucalyptus. If the goal is to convert an area from eucalyptus to native trees, it would make no sense to selectively cut the eucalyptus. Because of the vigor with which eucalyptus grows and reproduces, the area would soon again be covered with eucalyptus. Selective cutting simply would not achieve the desired objective.

Arguments can be made for clearcutting relatively flat and erosion-resistant temperate land that was previously planted with single-species of commercially managed, single-age trees. Such lands already resemble plantations or farms more than forests, and, so long as there is no real prospect of their restoration to forest and so long as their soils are not damaged by abuse, most of the harm has already been done by the initial forest removal operation. As will be explained later, however, monoculture tree plantations are usually more susceptible to insects and pathogens than are forests.

Timber managers wanting to grow a species that requires direct sun for establishment or for vigorous growth may also opt for clearcutting and attempt to justify their decision on ecological grounds, whereas the underlying motivation is basically economic. The industry contends — although some independent experts strongly contest — that forest clearing is necessary to establish certain shade-intolerant species, such as Douglas-fir. This assumption, however, does not justify clearcutting.

Openings in a forest canopy can be made for new plantings by selective cutting, and Douglas-fir will grow there, just as new firs sprout naturally in sunny patches of forest floor when a mature fir tree falls. Granted, the new recruits will be fewer in number than were the entire area cleared. Patch cutting as the chosen alternative to clearcutting, however, entails an ecological price, due to forest fragmentation and edge effects, as discussed elsewhere.

WHEN CLEARCUTTING SHOULD NOT BE USED

Even foresters who might sanction clearcutting as an acceptable industrial forestry technique recognize that clearcutting is totally inappropriate on steep, unstable mountainsides where erosion, landslides, or avalanches are a problem. Nor should clearcutting be done in very high-elevation subalpine forests where the ***thermal island effect*** of tree trunks are required for good seedling establishment.[1] In general, forests situated in any harsh climate — for example, very hot and dry, or frost-prone

lands—need forest cover for successful regeneration and likewise should not be clearcut. Nor should drainages be clearcut when dissected by many small streams susceptible to siltation and nutrient overenrichment. Whereas buffer strips can be created along larger streams and rivers, streams and wetlands may be so numerous and pervasive in some areas that buffering is impractical. Naturally, these areas, too, should not be clearcut. Clearcutting also should not be done where it will deprive endangered species of needed continuous forest cover or where the visual impact of the cut will be unacceptable.

Forests that will not regenerate well by other methods following logging are, in industry's view, also candidates for clearcutting. These difficult-to-regenerate sites include so-called "stagnant forests." The stagnant forest is a *climax forest* that has been undisturbed for many centuries in cool, wet northern climates and may be undergoing deterioration associated with old age and the long-term absence of natural disturbances. Because of large forest litter accumulations and the slow rate at which litter decomposes under cold conditions, soils become acidified and simultaneously insulated from summer warmings. The effects can be the eventual degradation of the soil into permafrost and very slow forest growth. Foresters in the past have advocated clearcutting such forests, but poor regeneration often results. Ecologists argue that, whereas these forests may be stagnant from an economic point of view, they should be protected and studied because we know little about both the ecological processes taking place within them and the species dependent on those processes.

THE BROADER CASE AGAINST CLEARCUTTING

Many, if not most, environmentalists believe that no valid ecological argument can justify completely removing a forest or large timber stand in a single operation. This view usually rests on a love and respect for nature and is often passionately held. Adherents of this position are unlikely to alter their convictions. Nor would a lumbermill owner likely relinquish the belief that the transformation of forests to lumber by the most efficient means available is in society's best interest. Beyond these polarized positions, two basic and pragmatic objections to clearcutting need to be considered: the first is based on the kind of forest to be logged; the second pertains to the damage clearcutting does.

In the case of the first objection, opponents of clearcutting maintain that clearcutting should not be used to eliminate increasingly scarce old-

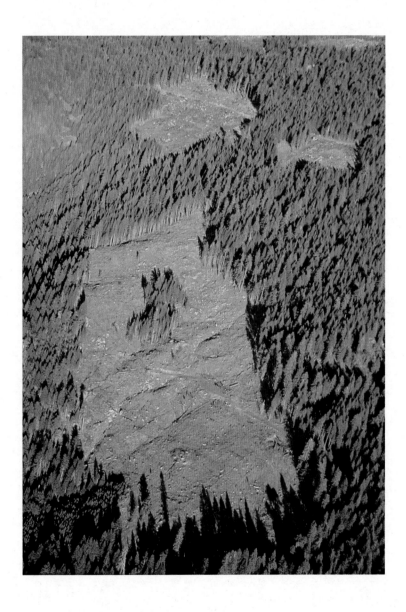

Fig. III.1. An aerial view of a small clump of trees surrounded by bare and stony mountain soil after the U.S. Forest Service (USFS) approved a logging operation known as a patch cut. The wildlife clump, as the USFS calls the small group of trees, will be all that remains for wildlife once the logging company later returns to remove methodically the sheltering forest that still surrounds the patch cut. The patch cut is thus a very large clearcut on the installment plan. Photograph © Martin Litton.

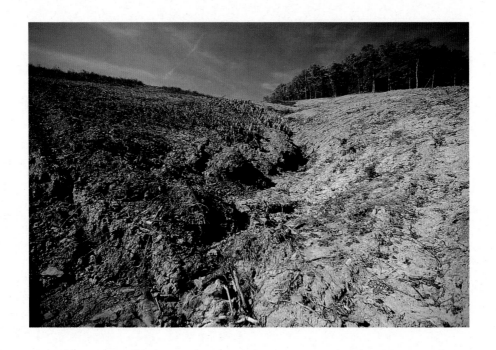

Fig. III.2. Eroding soil sloughs off a barren hillside as a result of a savage clearcut, where once a tranquil forest stood in Floyd County, Kentucky. Photograph © Daniel Dancer.

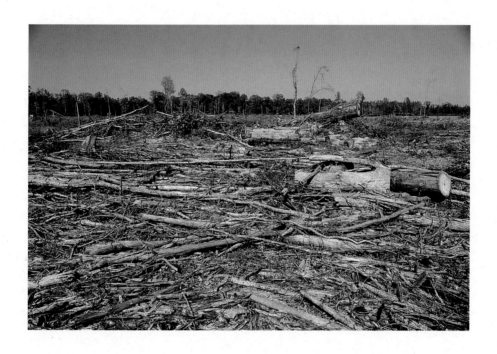

Fig. III.3. A clearcut on private lands in Itawamba County, Mississippi. Photograph © Daniel Dancer.

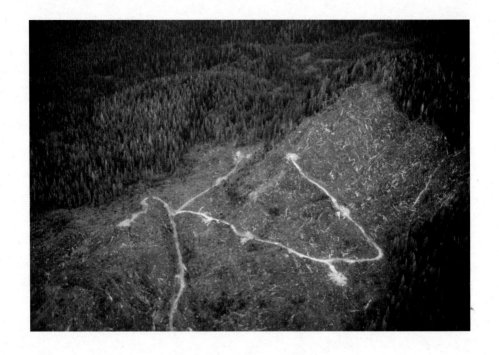

Fig. III.4. Clearcuts on steep mountain slopes in the Tongass National Forest, Alaska, the largest old-growth temperate forest left in the United States. Photograph © Benson Lee.

Fig. III.5. An aerial view of the west side of the Western Divide in the Giant Sequoia National Monument, California, showing a forest disfigured by angular clearcuts, sometimes euphemistically known as patch cuts in U.S. Forest Service terminology. This had been habitat for eagles, spotted owls, fishers, and, longer ago, condors—all old-growth forest species. Photograph © Martin Litton.

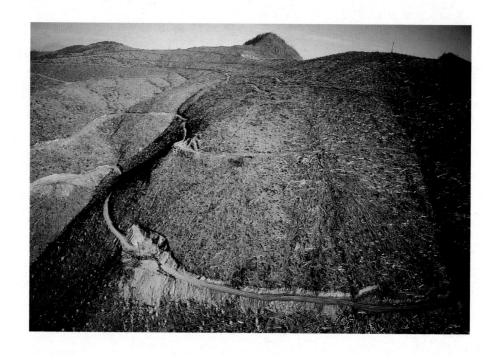

Fig. III.6. A former old-growth fir and hemlock forest on a ridgetop peak near Mount St. Helens, Washington, that was clearcut by a commercial timber company in the 1980s, following the 1980 eruption of the volcano. Clearcuts still continue near Mount St. Helens and in the Cascade Mountains of Oregon, although mostly in smaller plot sizes and, with increasing frequency, on second-growth forest because of the diminished remaining old growth. Photograph © Gary Braasch.

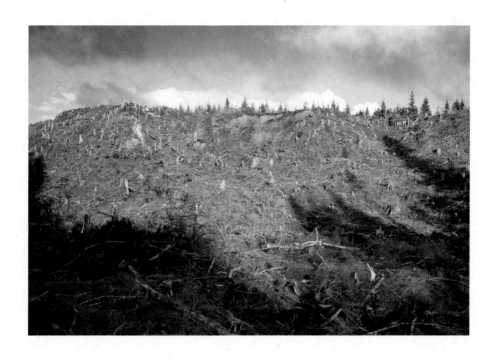

Fig. III.7. Clearcut, in the Hoh Valley, Olympic National Forest, Washington. Photograph © John Ganis, from Consuming the American Landscape *(Dewi Lewis Publishing, 2003).*

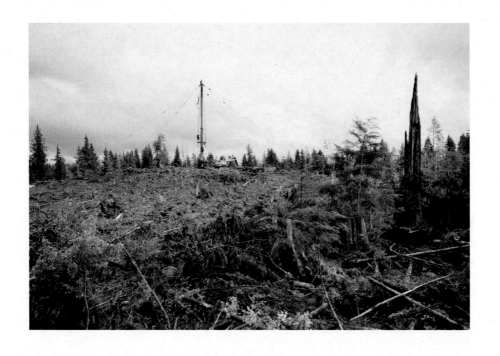

Fig. III.8. Logging yards, old-growth forest, Hoh Valley National Forest, Washington. Photograph © John Ganis, from Consuming the American Landscape *(Dewi Lewis Publishing, 2003).*

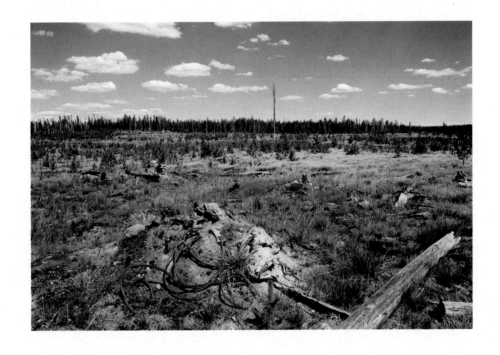

Fig. III.9. Logging cables in a reforested clearcut, Targee National Forest, Idaho. Photograph © John Ganis, from Consuming the American Landscape *(Dewi Lewis Publishing, 2003).*

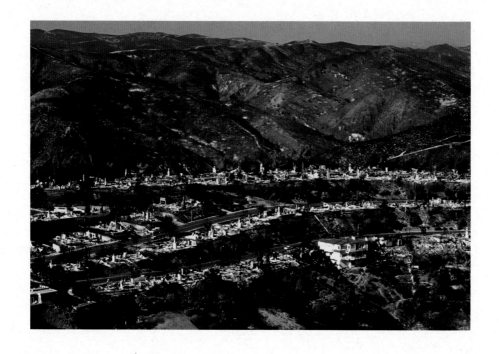

Fig. III.10. A firestorm burns to the coast of San Diego County, California, in 1993. Miraculously, one Laguna Beach home survived. Photograph © Robert A. Eplett/California Office of Emergency Services.

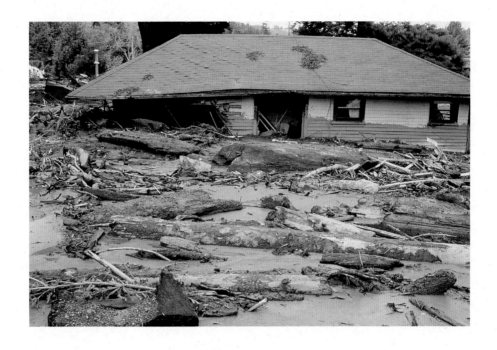

Fig. III.11. This house in Stafford, California, was buried by a landslide caused by a clearcutting upslope. Photograph © Doug Thron.

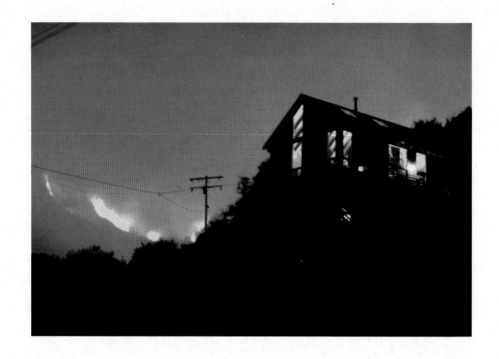

Fig. III.12. Homes are threatened near Malibu, California, by the Topanga Canyon Fire of 1993. Firestorms in Southern California that year burned 193,000 acres, killed four people, injured 162, did $1 billion in damage, and destroyed 1,078 structures. Photograph © Robert A. Eplett/California Office of Emergency Services.

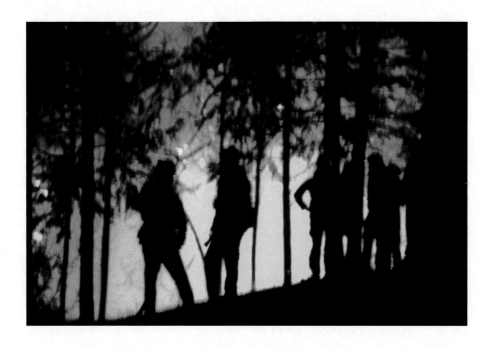

Fig. III.13. Fire fighters are silhouetted by raging flames of the 1992 Old Gulch Fire in Calaveras County, California. Photograph © Robert A. Eplett/California Office of Emergency Services.

Fig. III.14. A "regenerated" Ponderosa pine stand that has been mechanically thinned and then spot-burned to remove surface and ladder fuels in Meadow Valley, Plumas National Forest, in northeastern California. This procedure is typical of forest fire protection measures prescribed for the Sierra Nevada. Photograph courtesy of the U.S. Forest Service.

Fig. III.15. Slash burning after clearcutting on a California timber company's lands. Photograph © Doug Thron.

Fig. III.16. A pine retention treatment in the South Fork Little Butte Creek timber sale on the Dead Indian Plateau, Medford Bureau of Land Management, Ashland Resource Area, southwestern Oregon. In an effort to create a healthier forest, the understory, mid-story, and some overstory (mostly Douglas-fir and Ponderosa pine) were removed to emulate missed fire cycles. Only larger Ponderosa pines were retained. Many of the leaves blew down in the first year (middle left of the photo). Photograph courtesy of www.kswild.org.

Fig. III.17. A second- or third-growth red fir forest in Meadow Valley, Plumas National Forest, in northeastern California. The stand has been thinned, but surface fuels have not yet been burned off. Following the burn, the larger trees in the area will show some scorching. Photograph courtesy of the U.S. Forest Service.

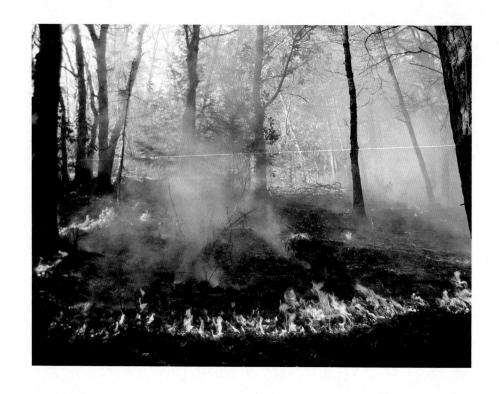

Fig. III.18. At a site outside of Ashland, Oregon, not far from Emigrant Lake, members of the Lomakatsi Restoration Project burn a small patch of the forest floor in an oak woodland ecotype to reduce duff and leaf litter buildup, to recycle nutrients, and to stimulate native forbs and grasses. Photograph courtesy of the Lomakatsi Restoration Project.

Fig. III.19. This stand has been thinned and given a prescribed burn. It is part of the proposed 6,426-acre Meadow Valley Timber Sale in the Plumas National Forest in the Feather River Basin of California. The sale is one of the first logging proposals by the U.S. Forest Service (USFS) under the amended Sierra Nevada Framework. Logging would reduce the forest canopy to thirty-to-forty percent in defense zones and to fifty percent in threat zones. Logging would be possible in remote areas of the forest, allowing the removal of large fire-resistant trees. The Sierra Nevada Forest Protection Campaign (SNFPC) says the logging will degrade some of the Sierra's last old-growth forests and could increase fire danger by opening the forest canopy to the growth of ladder fuels and by cutting down big trees.

Some of the proposed logging would occur in spotted owl, northern goshawk, and bald eagle habitat, near existing and proposed wilderness, and in a proposed Wild and Scenic River corridor. Thirty-inch trunk diameter limits and snag retention requirements in the existing USFS plan would be waived. The USFS has proposed using the sale as an opportunity to study the impacts of clearcuts on the California spotted owl and northern goshawk's habitat and population dynamics. The SNFPC says that the USFS should prioritize fuels reduction closer to communities and not unnecessarily disturb the habitat. Photograph © Christine Ambrose.

Fig. III.20. An old-growth stand on the Kaibab Plateau within the Kaibab National Forest in Arizona near Grand Canyon National Park. The North Rim of the plateau was designated the Grand Canyon Game Preserve by President Theodore Roosevelt in 1906. Roosevelt called for the area to be "set aside forever for the use and benefit of our people as a whole and not sacrificed to the shortsighted greed of a few," but the East Rim Timber Sale is within the preserve's boundaries. Much of the East Rim logging is to occur in remote areas of the forest, including the border of the Saddle Mountain Wilderness, and it will result in the removal of large, fire-resistant old-growth trees. Some 2,300 acres of old-growth trees are to be cut in the East Rim Timber Sale. The U.S. Forest Service maintains that the logging will reduce fire risk and improve forest health. According to the Southwest Forest Alliance, a coalition of conservation groups, "The old growth left on the Kaibab National Forest is especially important because it represents the best opportunity to restore old growth on a landscape scale." Commenting on the timber sale, a spokesperson for the Grand Canyon Chapter of the Sierra Club said, "For more than two decades we have witnessed the incremental destruction of a rare ecosystem a few thousand trees at a time." Some ninety-five percent of the American Southwest's old-growth forests has already been cut. Photograph © Sharon Galbreath.

Fig. III.21. A forty-four-inch diameter stump from an old-growth Ponderosa pine logged on the North Kaibab National Forest, Arizona, where 6,000 more old-growth trees are due to be logged in the Dry Park Timber Sale, destroying critical wildlife habitat. The Southwest's largest concentration of northern goshawks is found in the Kaibab forest, and the U.S. Forest Service in 1992 developed management guidelines that were to protect them. Instead, the Southwest Forest Alliance says, "On the North Kaibab National Forest, minimum canopy densities contained within the Goshawk Guidelines have instead been applied as maximums. This has destroyed the integrity of old-growth stands by logging large openings around and within each group. A highly fragmented landscape of stunted trees, dwindling grasses, and eroding soils is the result. Squirrels, goshawks, and other species may out of necessity nest in these logged areas, but it is marginal habitat and their long-term survival is doubtful." Photograph © Sharon Galbreath.

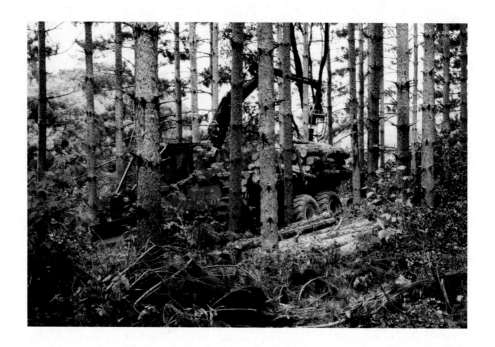

Fig. III.22. Timber sales and ecological forest management were important practices in the Lake Wisconsin Watershed Restoration Project, a 1,872-acre landscape (now known as the Merrimac Preserve) bounded by the Wisconsin River and ancient Baraboo Hills west of Merrimac in south-central Wisconsin. Timber sales were designed to help phase out undesirable species, including pine plantations (such as the one pictured here), and the income from pulp and sawlogs defrayed some of the costs of restoration. Here, a Valmet 524 "Woodstar" rubber-tired articulating skidder with an extending boom loads eight-foot pulp and sawlogs for the trek to the staging area, where the logs are sized and then loaded onto semi-trailers for the over-the-road haul to the mill. "Prescribed fire is a primary tool in restoration ecology and land management," recalls Dr. Thomas C. Hunt, who directed the restoration project for the land's former owner, Wisconsin Power & Light Company, "but, on the Merrimac site, fire and the red and white pines were not compatible. Since relic stands of white pine inhabit the area, some pines were left to establish big-tree character and to provide a canopy for eagle nesting." Photograph by Dr. Thomas C. Hunt.

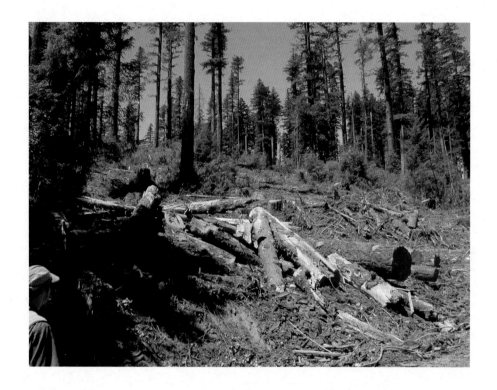

Fig. III.23. A classic regeneration harvest of an old-growth forest in the Mount Wilson timber sale on the Medford Bureau of Land Management Glendale Resource Area in southwestern Oregon. This forest had an overstory of Douglas-fir and an understory of yew, rhododendron, and madrone. The idea here was to do a regeneration harvest, leaving six-to-eight trees per acre larger than twenty inches in diameter at breast height. By leaving that structure, some of the forest ecosystem functions will be retained. Photograph courtesy of www.kswild.org.

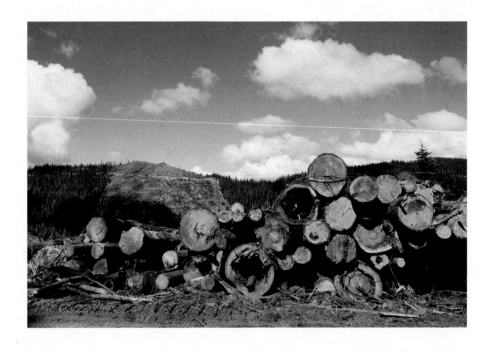

Fig. III.24. A log landing and clearcut across a ridge, Willamette National Forest, Oregon. Photograph © John Ganis, from Consuming the American Landscape *(Dewi Lewis Publishing, 2003).*

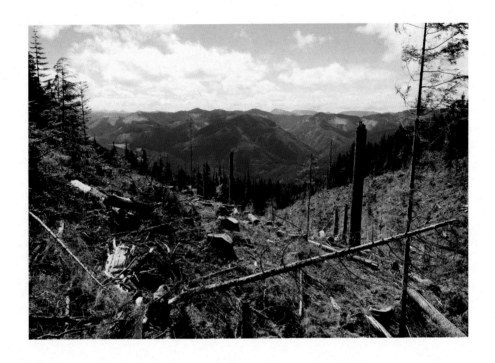

Fig. III.25. Site of a federal timber sale, Willamette National Forest, Oregon. Photograph © John Ganis, from Consuming the American Landscape *(Dewi Lewis Publishing, 2003).*

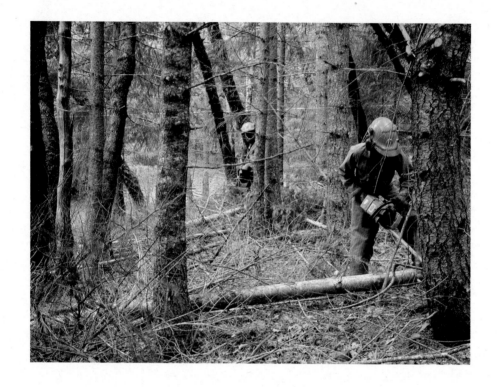

Fig. III.26. Lomakatsi Restoration Project workers thin Douglas-fir trees within the drip lines of native "legacy" black oaks in Trinity County, California, to help restore this stand to its historic pine-oak composition. Oak woodlands are among the most endangered ecotypes in California, to a significant extent because of encroachment by conifers due to the suppression of fire. Photograph courtesy of the Lomakatsi Restoration Project.

Fig. III.27. A wasted life. This young Giant sequoia (Sequoia gigantea), only six-to-eight inches in diameter, was too small to be hauled away, but it was large enough to get in a logger's way at Black Mountain Grove in a part of what was Sequoia National Forest but is now Giant Sequoia National Monument, California. Although coast redwood (Sequoia sempervirens) can grow by stump or root sprout, Giant sequoias never do. The attempts at sprouting seen here are the tree's last throes, and the sprouts were dead within a month. Photograph © Martin Litton.

Fig. III.28. The Baldpate Roadless Area of the Superior National Forest in Minnesota has been proposed for logging in the U.S. Forest Service's Big Grass Timber Sale, but the sale was temporarily halted by a federal judge until a full Environmental Impact Statement is completed. As pointed out by American Lands Alliance, the sale in the Kawishiwi Ranger District is part of a narrow corridor that connects the two units of the Boundary Waters Canoe Area Wilderness. Logging it would threaten wildlife, such as the endangered Canada lynx, boreal owls, and many other species. Photograph courtesy of Friends of the Boundary Waters Wilderness.

Fig. III.29. This mature hardwood forest is slated for logging in a below-cost timber sale on the Chequamegon Nicolet National Forest in Wisconsin. This stand is one of hundreds included in the 7,700-acre sale, which includes forest stands critical for the pine marten, a state endangered species, as well as the northern goshawk and red-shouldered hawk. The stand has been protected temporarily by an injunction granted in response to a lawsuit by the Environmental Law and Policy Center of Chicago on behalf of individuals and the Habitat Education Center of Madison, Wisconsin. The plaintiffs alleged that selective logging here every ten-to-twenty-five years simplifies the forest's structure, damages interior forest conditions, harms sensitive wildlife, and gives the forest insufficient time to recover. Photograph © David J. Zaber of the Habitat Education Center.

Fig. III.30. Kenaf grower Ernest Brasher (left) and Vision Paper's Michael Allison (right) inspect Brasher's kenaf field near Charleston, Mississippi. Kenaf fibers are an important alternative to wood pulp for the production of smooth, soft, high-quality paper. The cultivation of kenaf is one way to reduce the consumption of forests for paper production. Photograph courtesy of Vision Paper.

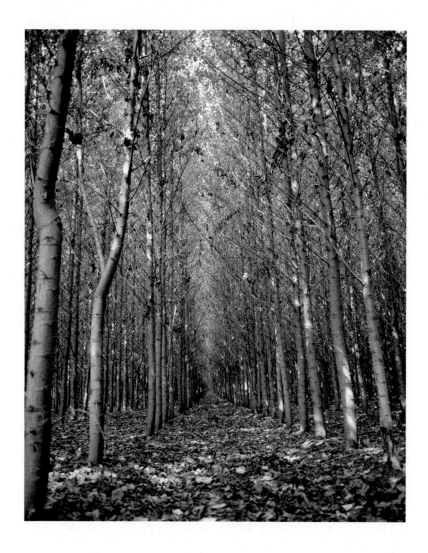

Fig. III.31. A commercial hybrid-cottonwood plantation in the state of Washington, where fast-growing trees are raised to provide wood pulp for paper production. Short-rotation wood crops such as these are also studied at the U.S. Department of Energy's National Renewable Energy Laboratory in Golden, Colorado, where researchers are interested in their potential as biofuel or biofuel feedstock (raw material used in preparing processed fuel, such as alcohol or biogas). Biofuels have an advantage over fossil fuels: their combustion adds little net carbon dioxide to the atmosphere, since the carbon dioxide released during the wood's combustion process exactly equals the carbon dioxide extracted from the air by the tree during its growth. Photograph © Warren Gretz of DOE/NREL.

Fig. III.32. Students from the Seattle Preparatory School plant Western red cedars in 2007 for the Green Seattle Partnership at South Portage Bay Park in Seattle. Photo courtesy of Green Seattle Partnership.

growth forest. In the space of a few hours or days, a clearcut can destroy old-growth ecosystems that may have taken millennia to develop. Once old growth is cut, it will not return for hundreds of years — if ever. Critics of clearcutting also maintain that clearcutting permanently damages forests so they will be unable to produce sustained yields of timber after one or more cycles of clearcutting. The science of forest ecology offers us some insights into these issues.

Forest ecology teaches that nature at times brusquely disrupts and even destroys forests by hurricane, tornado, earthquake, avalanche, volcanic eruption, fire, flood, disease, insect infestations, and combinations of these events and processes. This does not mean, however, that clearcutting mimics natural processes. Whereas natural catastrophes in forests may *kill* trees, they rarely *remove* trees en masse from the forest. However, forests have evolved the capability of regenerating after even violent catastrophic events. Thus, disruptive as clearcutting is to forest processes, *under certain circumstances and given sufficient time,* nature is quite capable of repairing local damage and of recreating a mature, intact forest. The fears about forest health and welfare following clearcutting are in these cases essentially fears about forests' recuperative powers.

Some clearcut lands will naturally regenerate rapidly as a forest, especially the highly productive lands in regions of ample rainfall, such as the Pacific Northwest. Adjacent, undamaged forests and the soil bank of the clearcut site then serve as sources of seed. Lower quality timberland, however, may not regenerate after a clearcut and may require expensive and problematic reforestation efforts. Recovery after clearcutting depends on a number of site-specific factors, since its impacts depend on where, when, and how it is done. (The "how" refers not only to the tree felling and log removal methods, but also to the clearcut's size and shape.) Clearcutting unquestionably has complex effects on soil, water, wildlife, microclimate, and biodiversity. Some of these effects act upon each other to compound forest damage.

Once a site is clearcut and replanted with one or a few species, diversity is greatly reduced. Habitats and ecological niches for a vast variety of creatures are eliminated. Their losses, in turn, affect the populations of the species dependent on them, and the damage cascades through the ecosystem and beyond. The complex natural forest has now been reduced to a much simplified system of a single, or very few, species. This monoculture (or near-monoculture) is ultimately more susceptible to attack by

disease and pests than in a natural forest. For example, without old stand-
ing dead trees, woodpeckers that normally thrive on forest insects will be
virtually absent from the new plantation, so a bark beetle invasion may
wreak havoc with the new trees. And because the trees are all the same
age and similar height, the movement and reproduction of insect and dis-
ease vectors from tree to tree is easier and quicker. Because the trees are
grown in full sunlight, they may have more branches (depending on spac-
ing) than those grown in the partial shade of a forest canopy and, there-
fore, will be of lower quality for lumber.

Deforestation exposes the ground directly to the sun, wind, and rain. It
thus modifies the humidity, light, temperature, and wind speed affecting
the seedlings. Seedlings are exposed to a harsher environment, with more
extremes of temperature — both heat and frost — moisture, drying, and
wind. Isolated individual clearcuts do not significantly affect climate, but
their cumulative effects may do so. Moisture transpired by trees humidi-
fies the atmosphere and can contribute to cloud formation or intensify
rainfall. Deforestation of thousands of square miles — as in the tropics
and in the United States — can also affect regional climate by influencing
the reflectance of solar radiation from the earth's surface and the carbon
dioxide concentration of the atmosphere.

Heavy logging equipment often used in clearcutting tends to disturb
and compact the soil. Compaction makes it harder for tree roots to pene-
trate the soil and reduces soil pore spaces which contain oxygen needed
by soil microorganisms that make organic and inorganic matter available
for uptake by trees and other vegetation. Once land is stripped of trees
and other ground cover, the tree roots no longer hold soil in place. Slop-
ing clearcut sites are then vulnerable to rapid erosion and slope failure
after heavy rains. But erosion damage doesn't stop there. It affects streams
and rivers, where heavy loads of silt and debris in runoff clog the spaces
within spawning gravels and impair or prevent the hatching of fish eggs
and the survival of fry. Eventually, silt in stream beds can raise stream lev-
els, cause floods, and undercut banks. That, in turn, can cause landslides,
adding even greater sediment loads to a stream. Raised to new heights by
sediment in their channels, flood-stage streams can then undermine and
topple even giant trees in the floodplain. Disturbance can also be translo-
cated further downstream as sediment and debris move in the streambed
to the lower elevations of the watershed.

Bereft of trees, a landscape may lose more of its precipitation to runoff. Stream flow then may become more seasonally variable, prone to high flows in spring and low flows during the summer dry season. Water quality may be affected if suspended sediment and nutrient loads are increased through erosion. Loss of forest cover to clearcutting also exposes the ground to warming earlier in the spring, leading to earlier and more complete melting of snowpacks. This can lead to a spring flush or spate of water instead of a steadier flow of longer duration. In winter, loss of tree cover that kept snow shallow in spots may make it harder for deer and elk to find food in early spring.

Whereas erosion removes nutrients, back on the logging site the soil's nutrient capital is further reduced by the physical removal of the cut tree trunks and frequently by the burning or removal of slash. The most serious effects are caused by whole tree removal. Less harm is done to the soil's *nutrient bank* if branches and treetops are left on site to help rebuild the soil. Not only do the woody debris have habitat value for wildlife that play important roles in nutrient cycling and seed dispersal, but logs and other large chunks of decaying, downed wood also serve the forest as "slow-release fertilizer."

Some effects of clearcutting can be mitigated by leaving quantities of downed wood on the ground after the cut to help soil recovery and provide wildlife habitat. Similarly, snags (dead, broken, and misshapen trees) should be left standing for cavity nesting birds. While these snags and logging debris may look untidy, they are ecologically useful. On national forests, the number of snags left per acre is prescribed in timber harvest plans.

MINIMIZING DAMAGE WHEN REMOVING TREES

Since much of the damage from logging is caused by roads and yarding areas, selective cutting may not be the method of choice in steep mountain areas or elsewhere. Ground-based logging under selection *silviculture* usually requires an extensive network of temporary roads known as skid trails on which logs are dragged out of the woods, usually by Caterpillar tractors. This equipment, when used on certain soils and under certain conditions, may cause severe damage to the roots of remaining trees. Although other log removal methods exist, they, too, have environmental costs, and not all of the alternative systems are compatible with selective cutting operations.

Gentler logging methods exist than simply dragging a tree out of the woods by tractor. While horses do less damage to the woods, they are not powerful enough to remove the largest logs. In some areas, trees are removed on top of the snow to minimize damage. Lifting logs out by helicopter minimizes damage to the soil and other trees but is costly (up to $40,000 a day). In addition, it consumes thousands of gallons of fossil fuel a day, requires cleared landing pads, and is easily restricted by rain and fog.

Balloon logging uses a balloon instead of a helicopter to suspend the logs in the air, but, like cable and skyline yarding, it requires cable rigging to guide the balloon. Skyline yarding, or the suspension of logs entirely off the ground from an aerial cable system, reduces ground damage but roughly doubles the cost of tractor logging, as it requires frequent re-rigging of cables each time operations move through a timber stand. "High lead" yarding suspends only one end of the log off the ground by an elevated cable on a boom or spar and drags the other on the ground to a landing area. Cable yarding requires large landing areas and wider roads for mobile yarders than for trucks, as well as the nonselective cutting of trees beneath each cable to facilitate passage of the logs. Both cable and balloon systems cause much less damage to the ground than dragging the logs along skid trails, but they are difficult or impractical to operate on selective cuts because of the obstruction of the remaining forest. A compromise solution sometimes used is to clearcut "alleys" within the logging area, along which cables are set. Because of the erosion that cable logging can produce in steep forested slopes, and because nonselective cutting may be inappropriate on some sites, it is not always preferable to logging by tractor. In short, there is no panacea: no logging method known is without environmental impacts. Contrary to what one might expect, if cable yarding and helicopters are disqualified for a particularly steep site, a clearcut might do less soil damage than selective skidding of logs on a multitude of trails. However, if the slope is so steep and the soil so unstable that erosion from these skid trails would be a problem, clearcutting is probably ill-advised as well, and the site should not be logged at all.

SITE PREPARATION AND REPLANTING AFTER CLEARCUTTING

Clones of a single conifer species are often planted following clearcutting in converting the site to a commercial forest. As part of the process, the ground may be treated with herbicides to suppress all broad-leafed plants and hardwoods that would compete with the desired commercial tree

crop or harbor rodents that eat seedlings. The alternative of simply clearing brush in small patches immediately around seedlings is generally rejected by timber managers because of the speed with which uncontrolled native brush can invade from the surrounding area. What is good for a single-species tree crop may not be good for the forest or its wildlife, however. Apart from its effects on the soil, elimination of brush species deprives wildlife of forage, berries, seeds, and cover. Foresters who clearcut generally make a number of optimistic assumptions: they posit that the roots of native brush will survive all but the most intensive removal operations; that wildlife will eventually reinvade from adjoining areas; and that soil organisms and the soil fertility dependent on them will naturally recover after clearcutting. These assumptions may easily prove flawed, to varying degrees, especially when the cumulative impacts of clearcutting within a region are considered over time.

During the establishment of a commercial tree crop, young seedlings may need to be protected against predators. In some cases, the industrial forester's solution is to control small mammals, such as gophers or mountain beaver, by poisoning or trapping. The bark of young commercial species is also sometimes coated with distasteful or toxic chemicals. Deer and elk hunting may be deliberately increased in the area to reduce browsing. These species may initially increase in numbers in and around clearcuts and patch cuts as more sunlight on the forest floor stimulates the development of succulent new growth; but, when monocultures of trees become well established and the now homogeneous forest canopy closes, the resulting habitat is generally less desirable for them than before logging. Historically, many commercial forestry operations have shown minimal regard for wildlife, soil fertility, native plants, or erosion, and they tend to ignore the roles of soil organisms, small forest animals, and other noncommercial "components" of the forest ecosystem. Those organisms, however, are important to soil aeration and to soil nutrient content and water-holding capacity.

Following clearcutting and the extensive erosion that often occurs on slopes, the initial crop of tree seed or seedlings may fail to thrive. Then, without the shelter of trees to shade it and to slow evaporation, the impoverished soil may dry out and be overgrown with brush. This is enough to greatly delay the reestablishment of a healthy forest.

When followed by replanting, clearcutting is in essence an attempt by foresters to skip normal successional processes that nature developed to

take the forest progressively from natural catastrophe back to ecological climax vegetation. By planting preselected trees after clearcutting and extirpating competing native vegetation and a whole spectrum of other life essential to a healthy forest, logging sites are not allowed to repair themselves naturally and replenish their lost nutrients, so as to insure the forest's reestablishment and long-term survival. Cyclical clearcutting and associated management practices are thus likely to produce a steady degradation of forest, with unpredictable long-term environmental consequences. Successive clearcutting is, therefore, not a sustainable process with respect to maintainence of soil quality or tree yields. The deleterious effects, however, may take three or more generations of clearcutting to become obvious. Since professional forestry itself has only been practiced for a relatively few generations of trees, much of the inevitable harm is not yet apparent.

In the forests of Germany, where professional forestry had its beginnings in the late eighteenth century, the planting of conifer stands and their clearcutting on "short rotation" was widely adopted by landowners attracted by the possibilities of short-term economic gain from fast-growing softwoods. The short rotation on these pine and spruce forests was not unlike the rotation periods used on commercial forests in North America today. The late Gordon Robinson, a forester and proponent of sustainable forestry, described what this practice accomplished in Germany in only a century and a quarter:

> Deciduous hardwoods and true fir became nearly extinct . . . By the time of the First World War it had become clearly apparent that something was very wrong. Trees were stunted; many died before they even approached the size of the original forest trees. Soils had become impoverished, and trees suffered increasingly from storms, insects, and diseases.[2]

This is the *direction* in which short rotation, single-species commercial tree cropping is heading in the United States. Could we be making the same mistakes with our forests that the Europeans made with theirs a hundred years ago? Some of the economic forces driving us in this direction are described in Chapter 10.

CHAPTER 10.
FORESTS, MONEY, AND JOBS

The [timber] companies had been quietly trimming payrolls
for decades as advancing technologies made labor-saving possible.

—ALAN THEIN DURNING, *Saving the Forests* (1993)

Three years into a drastic curtailment of logging in Federal forests,
Oregon, the top timber-producing state, has posted its lowest
unemployment rate in a generation, just over 5 percent. What was
billed as an agonizing choice of jobs versus owls has proved to be
neither, thus far.

—TIMOTHY EGAN, *The New York Times* (1994)

GOOD FORESTRY IS RARE

Timber company managers are motivated to keep timber company own-
ers and investors happy by maximizing owners' equity and by boosting the
company's stock price, if it is a public company. Apart from obeying the
laws of the land, timber managers—with some laudable exceptions—are
apt to pay little attention either to the health of the forest ecosystem or its
wildlife, fisheries, and watershed—unless protecting these resources hap-
pens to be part of their company's management plan.

The same incentives that militate against moderate cutting also deter
forest restoration. The forest owner who is only interested in monetizing
the timber resource and regards the forest merely as a capital asset in an
investment portfolio is not motivated to perpetuate the forest when doing
so reduces profits. Businesses like easy money. And what could be easier
than mining the natural forest capital accumulated over centuries in trees
and soil—capital in which one invested nothing? Moreover, cumulative

ecological damage from overcutting and from excessive removal of downed wood may not show up for decades or more—long after most company executives and most U.S. Forest Service (USFS) administrators are gone. Timber companies, therefore, have economic incentives to sacrifice the future forest for present dollars by minimizing investment in such stewardship activities as soil improvement, erosion control, and ecological protection. Their sights are instead set on timber market conditions, rates of return on investment, tax code provisions, and ways to operate at least cost and effort. Again, with some noteworthy exceptions, timber companies are generally focused on how the company's profit-and-loss statement will look next quarter or, at most, in five or ten years. Against these compelling commercial imperatives are arrayed the dictates of a manager's personal code of behavior, the codes of ethics of the professional societies to which he or she may belong, and the scrutiny of those peers. Often the commercial pressures prevail.

Whereas growing diverse natural forests to biological maturity takes generations, an owner meanwhile must care for the land and pay taxes on it. However, the returns on a selectively cut, well-managed forest that is logged on a sustained-yield basis are likely to be only one to two percent per year of the timber's total cash value. Since that is far less than can be made from a Treasury bond or other competing investment, not many timber companies —even those who claim otherwise—will operate their lands on a sustainable basis, and those public companies that attempt to do so are susceptible to hostile takeovers by more aggressive companies. So it was for the Pacific Lumber Company of Northern California, once known for its conservative forestry practices, but after it was bought by MAXXAM, Inc., MAXXAM greatly accelerated its logging on what had been Pacific Lumber's land to raise cash to pay back the loans used for the buyout (see Chapter 13). Fears of suffering a fate such as Pacific Lumber's have driven other timber companies to increase their logging rates in order to better their earnings.

Even growing a commercial crop of trees (as distinct from recreating a forest) may easily take thirty to eighty years, although some construction-grade wood can be grown in only fifteen years. Wood fiber for pulp, however, may be had far more quickly than dimensional lumber. Timber prices have to be high indeed for timber investments to compete with earnings that could be had by clearing the land, selling the trees and land, and investing the proceeds to compound for half a century at the prevailing rate of interest.

As author Ray Raphael explains in *Tree Talk*, his tour de force on forestry, "Because of interest computations, economic maturity of the timber occurs long before biological maturity of the trees."[1] This means that trees will be cut before the forest is mature and even before the trees have attained "their maximum annual growth increment" — the point in a tree's life cycle when wood fiber productivity is greatest. Other natural forces tend to push timber companies to hurry trees to market. The sooner the trees can be cut, the less likely that insects, disease, fire, and predation will cause damage to the trees before the timber matures and can be sold. In addition to illustrating the maxim, "haste makes waste," the profit-maximizing, short-rotation, timber-removal cycle disrupts the forest more often than would a longer rotation calibrated to maximize timber volume.

Because of the distant, less certain payoff from reforestation and the more certain, immediate return from logging and selling timber, most commercial timber investment is for expediting logging and other costs of doing business, with only a scant few percent of spending devoted to reforestation and forest management. On top of all the "perverse incentives" that encourage forest destruction, timber sale conditions and forestry regulations on public forest lands are poorly enforced. Although reforestation, erosion control, and stream corridor protection are mandatory, forests routinely are badly damaged during logging, inspections are often inadequate, and potent sanctions for poor performance are lacking or rarely applied.

In *Tree Talk*, Raphael summarizes why timber companies destroy forests: "The whole economic edifice is entirely rational—but it is based on a logic that has nothing at all to do with silviculture [the growing of trees]."[2] The alternative to "economics first" timber management is sustainable forestry, which legitimizes investment in slowly accruing forest capital.

JOBS AND FOREST PROTECTION

While timber companies and their allies like to depict efforts by environmentalists to save ancient forests as the main cause of job losses in the timber industry, this is not the case. Overcutting of timber resources, mechanization of timber harvesting, automation at lumber mills, market forces, and the export of raw (unmilled) logs all have had a much greater impact on jobs in the timber industry than the campaign to protect old growth.

Regardless of the number of board feet cut in the Pacific Northwest, employment per board foot cut there declined by more than a third in the mid-1990s. This had nothing to do with owls and everything to do with technological change in the timber mills. Earlier studies had projected that, even without environmental restrictions, timber-related jobs in the Douglas-fir region of Oregon and Washington would drop by more than half from 1970 to 2000. Conservationists had estimated that job losses from automation by 2030 will cost 25,000 jobs in Washington and Oregon, three times the loss from reductions in timber harvesting. USFS research has found that the relative importance of timber employment in Washington, Oregon, and California from the early 1970s to the late 1980s fell by fifty percent.[3]

Any industry based on a finite diminishing asset, such as old-growth timber, must inevitably run out of raw material and shut down. Timber-dependent communities must adjust to the inevitable and develop economic alternatives. Second-growth timber can be milled where available. Wood products can be manufactured from renewably grown lumber. High value-added manufacturing, such as furniture making, employs up to twenty-five times more people than does logging. Communities have also invested in recreation and ecotourism and in establishing sustainable forest reserves to provide long-term sources of revenue.

Following the national forest moratorium on old-growth logging in Oregon in the early 1990s, as described earlier, timber industry spokesmen tried scare tactics and whipped up the emotions of loggers and others to scapegoat environmentalists. Not only did the economic blackmail fail, but time belied the threats: the state remains a robust timber producer, mills have shifted to smaller timbers grown on private tree farms, and many displaced workers are being successfully retrained and are finding skilled work as mechanics, cabinetmakers, and health care personnel. High-technology corporations, such as Sony, continue to be drawn to the state for its attractive quality of life.

Destroying all the old-growth forest would save only a relatively few timber jobs for a few scant years. At that point, the old-growth-dependent jobs would be gone—at a gigantic environmental price—and the workers would still be without permanent, sustainable jobs. The sooner the issue of economic conversion and worker retraining is honestly faced, the better local communities will be in the long run, by still being able to offer

high-quality recreation and an attractive quality of life. The solution is not to destroy the last old tree in the forest, but to assist timber industry workers in finding sustainable jobs. As Alan Durning points out in *Saving the Forests,* "Their jobs . . . are no more a reason to continue deforestation than jobs in weapons plants are a reason to go to war."[4]

CHAPTER 11.
SUSTAINABLE FORESTRY

The essence of a sustainable forest is the ability to continually
harvest the interest without having to touch the principal.

CRAIG BLENCOWE, "BUILDING UP THE FOREST" (1996)

INSTEAD OF FOCUSING UNIQUELY on commodity timber production, a new
movement known as sustainable forestry, begun in the mid-1980s, empha-
sizes protecting a forest's ability to conduct its natural ecological
processes and functions. The aim is to maintain indefinitely the forest's
capacity to produce a stable yield of timber as well as other goods and
services. This enables a forest to meet economic and environmental goals
simultaneously. Naturally, sustainable forestry requires providing forest
ecosystems with adequate protection during logging so they can recuper-
ate fully afterwards. All the forest's natural resources must be safe-
guarded, especially the soil (the basis of the forest), the water, any
indigenous human population, and the integrity of the forest gene pool.
Furthermore, the survival of the forest's diverse wildlife, even small and
seemingly insignificant creatures, must be ensured, because every living
thing naturally found in the forest has an ecological role that contributes
to the functioning of the forest.

Even if the forester does everything just right, there is still no guaran-
tee that yields can be sustained "in perpetuity." Thus, some experts are
unconvinced that sustainable forestry is possible. Extracting resources
from the forest over long periods may ultimately have an unforeseeable
deleterious effect that lowers yields; therefore, sustainability must be
regarded as a presumption and a goal rather than a guarantee. Moreover,
forest growth rates vary with the forest's age and successional stage and its
response to natural disturbances — for example, wind, fire, avalanche,

insects, and disease. Thus, a *sustained yield* may be impossible under all these circumstances. For example, when a forest's growth rate slows, a yield that was sustainable in one phase of the forest's life may become unsustainable.

In striving toward the goal of sustainable forest management, which some foresters prefer to term simply "good management," it is important to recognize that even good logging techniques may nonetheless inflict long-term cumulative forest damage. So even in the absence of major disturbances, sustainable forestry requires *more* than technically sound "good logging" practices: no matter how excellent logging practices are, enough of the forest must be left in place to allow natural forest processes to continue. If good logging practices do this and protect soil structure, fertility, and forest creatures, then logging yields are probably sustainable. By contrast, using sustained yield to refer to forest practices that merely produce a constant annual increment of wood fiber for a while, either in a plantation-like setting or without protecting a forest's natural ecological processes, is clearly misleading. To take the most obvious example, if the annual volume of wood removed exceeds the annual volume grown, the annual removal of that amount will eventually destroy the forest, even though the forest's yield may be constant until the day before the timber runs out. A less obvious example of what sustained yield does not mean is a forest that is managed so that only one product or crop would be sustained. Concurrently, however, other forest outputs and services would be declining or impaired. Thus, the forest ecosystem would be degraded. Finally, even the yield of the favored single product is likely to diminish if soil nutrients are depleted or other damage is done to the forest's components or processes.

An example of holistic forestry provided by Herb Hammond in his superb book, *Seeing the Forest Among the Trees,* offers strong evidence that sustainable forest management is possible, at least over a sixty-year period.[1] Hammond tells the story of the 132-acre Wildwood forest near Ladysmith on Vancouver Island, British Columbia. Wildwood had 1.5 million board feet of timber in 1935, and forester Merv Wilkinson began managing the property in 1938. He made his first cut in 1945 and, over the next sixty years, removed a total of 1.5 million board feet during twelve environmentally sensitive selective loggings that protected old growth, fallen trees, soil, snags, and wildlife. "Today," Hammond reports, "Wildwood is a diverse, intact forest ecosystem . . ." The forest now contains 1.65 million board feet of timber—more standing timber than it had in 1935.[2]

Another example is the Menominee tribe's 234,000-acre forest near Neopit, Wisconsin. This forest is managed by Menominee Tribal Enterprises to sustain a diversity of species and to improve the forest by removing the worst trees and saving the best. Slow-growing, crowded, old, and diseased trees are preferentially selected for removal, gradually improving the quality of the standing timber. Approximately one percent of the forest has been cut annually for the past 140 years, forestry analyst Hans Burkhardt reports.[3] "This level of harvest," Burkhardt writes, "yields a forest in which lumber is of consistently high quality and quantity, forest inventory is high and nondeclining, and associated plant, wildlife, and natural systems are flourishing and healthy." Whereas most of the management relies on natural regeneration, a few clearcuts are sometimes made and some planting is done. Natural regeneration in the Menominee forest also includes shelterwood cuts to mimic natural disturbances in the forest necessary to the regeneration of certain pioneer species, such as white pine, that normally regenerate in quantity only after a fire or severe windstorm. In the shelterwood process that the Menominee managers practice, the forest canopy is thinned so that light can reach the forest floor, and the soil is scarified by tractors dragging heavy chains to expose mineral soil for the arrival of new seed from the remaining overstory trees. Some protection from sun, wind, and heat is provided by the remnant canopy. After the young trees begin growing, the sheltering overstory is carefully removed.

Another example of successful sustainable forestry is the work of forester Craig Blencowe of Fort Bragg, California, documented in *Working Your Woods*.[4] In one forest that Blencowe carefully managed over a twenty-five-year period, timber volume tripled, important forest values were protected, a sustained yield of trees was achieved, and more timber was harvested over that time than stood on the land when management began in 1972.

Yet another example of a sustainably managed property is the Collins Pine Company's 94,000-acre Almanor Forest, in Northern California. There, after generations of management, the company still has 1.5 billion board feet of high-quality timber, as it did in 1941. Although Collins Pine has never clearcut the forest, it has harvested more than two billion board feet of softwood lumber and veneers—enough for more than 200,000 average-sized homes. The company uses a home-grown forest inventory system in which every tree on some 580 one-acre plots has been marked,

measured, and tracked for decades. Every decade, the company takes a timber inventory and determines how much the timber has grown. The forest manager is careful not to cut more timber than has grown in the previous ten years. A company forester observes the condition of the trees and culls those infected with disease, those whose growth has slowed for other reasons (as indicated by a flattening of their tops) or those that are being shaded (as revealed by the sparseness of their crowns). Many trees that an ordinary commercial forestry operation would cut are left to die in place to benefit wildlife that require snags for dens or perchs, and a generous supply of woody debris is left on the forest floor to enrich the soil and benefit the mice, moles, and voles that feed larger predators. Each year, the forest yields a dependable thirty million board feet of timber. The multi-species, multi-aged, mixed conifer forest includes Ponderosa pine, white pine, sugar pine, incense cedar, and Douglas-fir, interspersed with healthy natural meadows, rivers, streams, and a lake. The whole ecosystem remains healthy enough to support great blue heron rookeries and populations of black bear, bobcat, cougar, spotted owl, osprey, pileated woodpecker, beaver, and even wolverine. Simultaneously, the dependable supply of logs from the forest helps to maintain the company's local sawmill in Chester, California, which employs 235 workers.

The aesthetically pleasing and ecologically sound results obtained by Collins Pine Company demonstrate that forests can provide jobs from generation to generation while offering people recreational opportunities and simultaneously protecting wildlife, natural habitat, soil, streams, and trees. "Sustainable forest" should not, however, be confused with "natural forest." The property has some 640 miles of logging roads, and the presence of tree stumps and log skidders and the exclusion of fire attest to the land's extensive management. No one would mistake the area for a wilderness. Given its concern for sustainable forest management, it is not surprising that Collins Pine Company became the first privately held forest-products company to be certified for its environmentally and socially responsible management by Scientific Certification Systems under accreditation from the Forest Stewardship Council.

GOOD MANAGEMENT, ECONOMIC SUSTAINABILITY, AND "NEW FORESTRY"

Naturally, if a forester annually harvests less than the forest's annual net growth and follows other sound management procedures, the forest's timber volume will inexorably increase until some natural phenomenon halts

the process by increasing mortality and loss of biomass from the ecosystem. Blencowe (like other sustainable forestry practitioners) manages forests by harvesting less than the growth in forest volume over each harvest cycle until the forest inventory attains a predetermined maximum target volume. He then begins to harvest at regular intervals a volume equal to the forest's net growth in the preceding period. This yield can be indefinitely sustained without ever reducing the forest volume below the target level. His goals, however, include improving the quality of the working forests that he manages, for maintaining inventory volume does not in itself guarantee maintenance of forest quality. Blencowe, therefore, uses each of his harvests as a management opportunity "to retain the biggest, best quality and most-vigorous trees in the post-harvest inventory to build future inventory." To implement that management philosophy, he marks inferior and diseased trees for removal (while preserving snags as needed), and he thins suppressed trees to create space for the highest quality trees to be retained (and for their progeny). Blencowe is not alone in believing that some of the biggest and best of all tree species should be left in the forest to improve the forest's future productivity. The sustainable forester's initial emphasis, therefore, should not be on what to remove from the forest, but on what to leave.

Whatever the selection criteria, the benefits of thinning need to be weighed against the risks of damage to the soil and to the main stems of remaining trees. Pre-existing stress on the trees being thinned also needs to be considered. If the trees are suffering from stress due to disease, pests, drought, or even a particularly heavy set of seed, the thinning could be injurious or fatal and should be delayed.[5]

With an eye to forest economics, forest ecologist Chris Maser points out in *Sustainable Forestry* that sustainable forestry is not only essential to the forest, but also to a sustainable forest-products industry, which, in turn, is a prerequisite for a sustainable society:

Sustainable forestry is the opposite of plantation-management practices today. In plantation management, costs are hidden and deferred to the next rotation or next human generation. In sustainable forestry . . . there are no hidden, deferred costs; it is pay-as-you-go forestry that more closely follows Nature's blueprint for maintaining a self-repairing, self-sustaining forest.[6]

To increase the chances of having sustainable forests, ample supplies of dead wood should be left in the forest, along with a sufficient volume of living trees. Downed logs, limbs, and treetops left on the forest floor help to restore soil nutrients; dead standing timber provides birds with habitat for nesting and roosting; and trees lying across, or lodged within, streams create pools and other needed aquatic habitat. Where logging is taking once-continuous forest and threatening to create isolated forest patches, forested corridors must be left standing between forest remnants to permit species to migrate seasonally and in response to climate change. Minimal but permanent roads, in contrast to temporary poor-quality lanes, help to reduce erosion, according to Maser and others. Damaged areas, especially stream buffers, should be revegetated with native plants, and nonnative species should be controlled when possible. Along with increasing numbers of forest ecologists, Maser believes that clearcutting and sustainable use are incompatible, and he, therefore, advocates a permanent end to clearcutting.

THE IMPLICATIONS OF CONSERVATION BIOLOGY

The science of conservation biology provides many useful guidelines that can assist forest managers in determining what forest stands *not* to cut. Conservation biology, broadly speaking, is the interdisciplinary application of biological sciences, especially ecology and genetics, to maximize the survival of natural habitats and ecosystems along with their natural processes and associated biodiversity. Two core principles of conservation biology apply not only to the establishment of natural preserves, but also to the management of natural areas, such as forests: first, that large preserves are essential to the survival of the most broadly representative biodiversity, and, second, that habitat fragmentation inexorably leads to species' extinctions. Forest managers thus need to minimize the distance between forest fragments produced by logging so that forest species can commute between otherwise isolated habitat areas and benefit from the resources of the larger area. Similarly, as noted earlier, forested connective corridors should be left to link islands of forest habitat, so species can move freely across whatever is left of their natural range after logging, without incurring unnaturally high rates of predation or other risks due to the removal of protective cover and habitat. Corridors should "encompass complete ecosystem types," as Herb Hammond explains, and they should include

not only riparian corridors, but also alpine corridors and "cross-valley corridors" that provide a representative assemblage of the local ecosystems along an elevational gradient, from valley floor to uplands.[7]

Conservation biology teaches that, because of the interdependence of species, predators are essential to the natural functioning of wild forests and other ecosystems. Because the large carnivores often require large territories in which to range, forest planners need to consider those predators' needs when deciding how much forest to spare from logging. Conservation biology also has drawn attention to the unnaturally high rate of species extinctions resulting from human disruption of ecosystems. The findings of conservation biology imply that forests containing endangered, threatened, or sensitive species and unique habitats—and particularly those areas rich in biodiversity or essential to the life cycle of a large concentration of a particular species—must be accorded high levels of protection from disturbance in order to protect rarity and shield depleted populations from further stress and to avoid squandering biological abundance where it still exists. Thus, a conscientious forest planner must leave certain areas fully protected. These include old-growth areas and ecologically sensitive zones, such as those with steep gradients and thin soils, as well as high-elevation terrain and riparian zones. Floodplains, wetlands, and riparian zones are of great value to wildlife and are important sources of biodiversity; riparian zones must be off-limits to logging because they are especially erodible, fragile, and may be difficult to revegetate, once disrupted.

SUSTAINABLE MANAGEMENT OF PREVIOUSLY CUT FORESTS

Sustainable forest management in the context of timber production must account for previous and current site conditions. As stated earlier, the sustainable forest manager's general goal must be to maintain all forest processes, structures, and species, as well as to perpetuate a naturalistic mature forest.[8] Usually, the naturalistic sustainable forest will also be multi-age and multi-species. (Occasionally, a natural timber stand will happen to be of uniform age, as when a lodgepole pine stand is fully destroyed in a large fire or windstorm and new trees all begin life at about the same time.) As long as forest management activity does not degrade long-term forest quality, it may qualify as sustainable. However, it must permit natural forest structure, be it simple or complex, to persist and evolve, thereby retaining most species' habitats.

Whereas various techniques may be adopted to help reproduce a multi-aged, multi-species naturalistic ecosystem, some enduring principles do apply to all sustainable forestry management.[5] The first principle, as already discussed, is that timber harvest rates must be limited and — on average — be less than or equal to the net volumes of wood produced during the growth cycle between loggings. Local studies of growth, regeneration, and mortality are necessary to establish the allowable cut. Monitoring must be conducted to verify results over time. Limiting the timber removal rate in this manner precludes the gradual elimination of the forest itself, an inevitable consequence of cutting the forest faster than its natural replenishment rate. With these restraints on timber removal, the forest canopy can be preserved, protecting wildlife and reducing soil erosion. Also, with retention of the canopy, forest fragmentation tends to be minimized.

A second, related sustainability principle is to establish a rotation age for the forest that permits trees to stand long enough to grow large for their species and old enough for the forest to exhibit (and perpetuate) old-growth structure and other natural conditions. Limiting harvest rates, setting a long rotation period (that mimics natural stand longevity), and managing for structural diversity (a consequence of the multi-age, multi-species stand composition) are not only good sustainable forestry practices, but also serve to preclude large-scale, short-rotation clearcutting.

At the core of sustainable forest management guidelines are certain proscriptions: do not simplify the forest ecologically; do not take more from the forest than the forest can provide and still remain healthy; and do not allow short-term expediency — the desire to minimize management costs and maximize timber production — to reduce the forest's long-term productive capacity. In essence, while gathering some of the forest's bounty, do no intrinsic harm to the forest.

One implication of these dicta is the need to consider the ecological consequences carefully before marking a tree for cutting. The effects of tree removal on the illumination of the forest floor and understory trees, for example, need to be considered. Too little light will suppress tree growth; too much light will produce a short, bushy tree with many knots. Trees with nests of birds such as owls, ospreys, and eagles should be left standing. Logging on fragile soils or in landslide- or erosion-prone areas must also be avoided. A tree can never be uncut, and removing the wrong

one can cause enduring ecological damage to a site. Just as the selection of trees for removal requires careful attention, so forester Merv Wilkinson points out in *Restoration Forestry* that patient observation is needed to identify trees for retention as "parent trees" for seeding future generations: "A tree needs to be observed over several seasons before it is selected, to see that the cones are abundant, well-developed, and not misshapen. Undeveloped cones signal that an aging tree has lost vigor."[9]

Burning of slash has historically been used as a common waste disposal technique, often without considering the ecological needs of the forest or the ecological impacts of the fire. Slash burning, however, is not desirable unless it is consistent with a program of controlled burns scheduled under conditions beneficial to the forest ecosystem. Although fire occurs naturally in forests and may be prescribed under some management regimes, burning of slash under conditions likely to produce hot fires may impair forest recovery. The fire's heat can damage the soil by baking it so hard that a surface crust forms; even at lower temperatures, fire can reduce soil fertility by eliminating all litter and humus.

For controlling live vegetation in a sustainable forest management system, manual brush control and mulching are preferable to the use of heavy machinery or herbicides. Broadcast spraying of broad-spectrum herbicides should generally be avoided because of toxicity to beneficial species. Pinpoint applications of short-lived herbicides by handpainting particular stems is generally considered acceptable, however. To reduce fire hazards from accumulated ladder fuels, the EBC Company of Willits, California, has pioneered the development of inexpensive systems for removing brush, limbs, and trees under nine inches in diameter and converting them to useful products, such as kindling and firewood. Founder Ed Burton and co-designer Phil Jergenson have built brush bundlers, electric shears, electric- and gasoline-powered wheelbarrows, wheelmounted solar panels, and a solar wood drier so that woodlot owners, ranchers, arborists, and homeowners can efficiently cut, bundle, haul, and dry "smallwood" for sale or domestic use, all using solar-powered electric chainsaws, small electric tractors, and other quiet equipment.

Natural regeneration, if occurring, is generally preferable to artificial planting of either seeds or seedlings. Naturally regenerated trees tend to be more disease-resistant than artifically planted stands. When natural regeneration for some reason is unreliable, then seeding with locally adapted native seed is preferable to nonlocal seed, and it is especially

preferable to the seeds of genetically engineered "supertrees." These specimens may grow quickly, but they are likely to be genetically homogenous and, therefore, probably lack sufficient genetic variability to respond to future climatic and other stresses. Seeding versus planting seedlings or other container-grown plants allows for more natural *microsite* selection and natural root development. Nursery stock may suffer root deformity or damage if improperly grown or handled, and, even under the best of circumstances, container-grown specimens will experience transplantation shock, which retards development. According to Wilkinson, "A tree that has been transplanted needs eight to ten years to be completely clear of shock."[10]

In keeping with the goal of preserving all essential habitats to protect biodiversity, sustainable forestry principles include retention of sufficient quantities of snags and downed logs. Just how much to retain is a matter of debate among expert foresters and also varies from ecosystem to ecosystem. But the forest needs some diseased, dying, "defective," and dead trees to maintain all of its ecological functions. Although the "defective" tree may be marred (from the mill operator's perspective) by a cavity or peculiar branching structure, the tree may be perfect for wildlife. Likewise, even when smaller trees are being thinned, some thickets should be left for wildlife to mimic the forest's natural variability.

If selective logging of single trees or small groups is adopted, tree removal must be done without construction of an overly extensive road system that causes habitat fragmentation or impinges on riparian areas. The down side of removing many trees in small groups dispersed throughout otherwise largely unbroken forest is that the resulting edge effects can degrade large areas of the uncut residual forest. Some interior forest species are known to avoid forest areas within 300 feet of sizeable clearings. Roads also present barriers to wildlife and provide veritable thoroughfares for the entry of insect pests, nonnative invasive plants, and fungal diseases.

Selective cuts also must not be made to "high grade" the forest by removing the biggest and the best specimens, leaving only smaller, inferior trees to reproduce. From the vantage point of maximizing long-term forest quality, it makes sense to leave the largest and best specimens standing and to remove the worst, working in harmony with natural selection rather than against it. To maintain or encourage the attainment of old-growth characteristics and multi-age structural diversity, a restriction on

cutting trees larger than a specified breast-height diameter may be made part of the sustainable-management plan in some settings for an appropriate period (until sufficient numbers of trees reach the desired size).

In selective logging, it is also necessary to avoid too-frequent entries into the forest with heavy equipment. The sustainable-yield forester will not only want to manage growth and regeneration, but also to log in the least damaging and least visible ways. For example, to minimize forest damage through soil compaction, horses are generally preferable to tractors for log removal. When machinery is used, it should be the lightest equipment that will do the job (above some minimal threshold of efficiency). Similarly, rubber-tired vehicles are likely to be less damaging than those with metal treads.

If clearcutting is generally taboo and selective cutting may lead to high grading and forest fragmentation, what can the sustainable forest manager do? Selective cutting can avoid the pitfalls of high grading and fragmentation, if trees are properly selected according to a sensible strategy. In general, but with clear site-specific exceptions, the strategy should be to focus management efforts on removing suppressed (crowded) and inferior trees (culls), on reducing excessive fuel loadings, on lowering the density of species made overabundant by fire suppression, and on salvaging damaged or diseased trees while leaving some as snags and downed logs. Stands can be thinned in various ways to relieve crowding without destroying the forest canopy. For example, small openings that do not harm forest wildlife can be created by removing trees that are overtopped by a neighbor or that themselves are overtopping a potentially more vigorous or superior tree. (If openings are no greater in diameter than the height of the trees, they will mimic the openings created by natural mortality.) A skilled forester can also identify trees that are destined to be "shaded out" because of their relatively slow growth.

A strategy that might make little sense would be to harvest arbitrarily all trees greater than a certain diameter in size, since this might, for example, result in the cutting of trees that were rapidly increasing in value, that were faster growing and better adapted to their site than the trees left standing, or that met both these conditions. Another poorly considered selection strategy would be to fail to recognize that trees about to grow into a new and more valuable diameter-dependent commercial classification—from sapling to pole; from pole to sawtimber; or from sawtimber to the higher-grade veneer log—are about to increase rapidly in value

in a relatively short period and should generally be retained by their owner to take advantages of the higher prices that the better grade of wood commands.

Tree falling can be done carefully with the help of *jacks* to avoid damaging neighboring trees, and a well-planned skid trail and road system can minimize forest damage during logging operations. Road construction should be competently planned and supervised so that road widths are minimized and roads are laid out on well-drained stable soils following natural contours whenever possible, preferably with curves kept to gentle grades when possible.

Although the costs of careful, selective tree cutting and removal may be higher than demolishing a forest in a single clearcutting operation, other management costs are likely to be lower in selective forestry. The healthy, selectively managed forest will require neither replanting nor the extensive pre-commercial thinning operations needed in response to dense regrowth after clearcutting. Nor will it need expensive slash burning and herbicide applications. Because trees under a properly managed canopy will be obliged to "reach for the light," they will tend to grow tall and straight. Under selective sustainable management, a relatively intact forest will also be available for nonconsumptive uses and for the periodic harvesting of various nontimber products. Judicious single-tree selection and small-group selection are consistent with protection of the whole forest, its watershed, its soil, its natural diversity, and the regional environment. Therefore, this management system is truly compatible with multiple use of the forest and with production of a limitless flow of timber now and in the future. Another important advantage is that forest inventory and quality can often be increased for many years before they stabilize—and, so long as the forest is managed sustainably, valuable products can continually be removed to provide owners with steady income and workers with steady employment.

THE CONTROVERSY OVER "NEW FORESTRY"

A movement known as New Forestry arose primarily in the 1980s out of the frustration some U.S. Forest Service (USFS) personnel experienced with prevailing management practices in the National Forests. Proponents of New Forestry characterize it as a method of maintaining a forest's physical structure and ecological functions by mimicking the way natural processes, particularly fire, produce disturbance and remove trees, especially in the

Pacific Northwest. Various timber-management strategies are, therefore, employed in New Forestry in response to differing local conditions and differing interpretations of New Forestry doctrine.

New Forestry theory acknowledges that the entire forest ecosystem is important, that habitats for all species should be maintained, and that the negative effects of industrial forestry must be mitigated. New Forestry practice is to retain some forest canopy and canopy layers intact and to minimize road construction. Buffers of uncut timber are left along watercourses to protect them from siltation and bank erosion. Some trees of each species are left uncut, including some high-quality trees to seed future generations. Prescribed numbers of standing dead and downed timber are also left for wildlife habitat. A site logged according to New Forestry guidelines will, therefore, be more heterogeneous than a traditional clearcut site, will still provide some shade and shelter, and will exhibit nutrient-cycling processes. New Forestry is nonetheless based on clearcutting and even-aged forest management. Within that paradigm, New Forestry systems offer techniques for dispersing, shaping, and sizing clearcuts and for blunting their ecological impacts. Under one New Forestry management system, for example, as few as eight green trees might be left standing per acre.

Critics of New Forestry see it as an *apologia* for clearcutting and a screen behind which to conduct USFS "business as usual." They charge that, whereas the ecological principles espoused by the scientific founders of New Forestry are laudable, practitioners may be less high-minded and may give only token observance to ecosystem values. Some highly qualified forestry experts, however, are enthusiastic about New Forestry and regard it as a tremendous improvement over traditional industrial forest practices.

FOREST CERTIFICATION

Forest certification is an international movement, begun about 1990, dedicated to furthering sustainable forestry by labeling wood and other forest products produced on well-managed forests in ways that are both environmentally and socially acceptable. As of 2004, about 100 million acres of land worldwide had been certified under the accreditation of just one organization, the Forest Stewardship Council (FSC), headquartered in Germany. In Canada, the Canadian Standards Association has accredited seventy million acres under its guidelines, and the Programme for the Endorsement of Forest Certification, a European organization head-

quartered in Luxembourg, has accredited another 136 million acres. In the United States, the timber industry has self-certified seventy-five million additional acres, as will be discussed later in this chapter. Nonetheless, these certification systems combined account for at best a tiny percentage of all U.S. wood sales—less than one percent in 2001, according to Ted Kerasote.[11]

A modest but growing number of timber producers and wood-product distributors, however, are seeking certification, and many industrial users and consumers avidly seek out certified products. Metafore of Portland, Oregon (formerly known as The Certified Forest Products Council), acts as an information clearinghouse for customers seeking wholesalers and retailers of certified wood products. Major corporations, such as Home Depot, Lowe's Home Improvement Center, FedEx Kinko's, and IKEA participate in the certification movement. So does an eighty-nine-member United Kingdom buyers group that uses $4.8 billion worth of wood products every year and accounts for more than a quarter of all wood demand in Britain.[12] Some timber wholesalers, such as EcoTimber of Berkeley, California, buy their wood mostly from certified timber producers. The display of a certification label can be an advertising asset and may eventually translate into higher prices for participating companies.

To obtain certification, participating forest owners and managers pay a fee and submit to inspections and audits by an independent certifier.[13] They also agree to follow forest-management practices consistent with the principles, criteria, and standards prescribed by the certifying organization. The standards are designed to protect the ecological integrity of a forest, including forest functions, ecological processes, wildlife habitats, biodiversity, water quality, and recreational opportunities. The standards include a long checklist of "dos and do nots." Among other things, participating landowners must adopt a forest management plan that balances economic goals with protection of the forest ecosystem. They must also respect the interests and welfare of local residents, communities, and workers and must protect sites with important cultural significance.

To guarantee that certified forest products are indeed genuine, a chain of custody must be kept for certified forest products, starting from the forest through shipping, scaling, and milling and on to the marketplace. The product is thus tracked through processing, manufacturing, distribution, and even printing. Because of the potential for abuses and the challenges of enforcing proper certification globally under widely varying conditions,

reputable certifying organizations themselves are accredited by the FSC and others. The FSC, however, is the only organization whose certifiers mandate the formal tracking of the production of wood and other forest products from the forest to the consumer and who guarantee that the wood is from a well-managed forest or plantation. All FSC-endorsed certifiers have detailed evaluation criteria that a landowner must satisfy to achieve certification. Following established FSC protocols, forest practices are examined to ensure their consistency with basic principles of sustainable forestry. For companies that manufacture or trade certified products, the FSC's chain-of-custody process is essentially an inventory control system that segregates and identifies products that are known to have originated in an FSC-certified forest.

The FSC is an international consortium of regional nonprofit forestry groups founded in 1993 by diverse stakeholder groups from twenty-five countries. The international headquarters of FSC is in Bonn, Germany, and the U.S. headquarters is in Washington, DC. Three independent certification organizations are currently accredited by FSC—Scientific Certification Systems (SCS) of Emeryville, California; SGS Systems and Services Certification, Inc., of Rangely, Maine and Rutherford, New Jersey; and the Rainforest Alliance's Smart Wood Program of Richmond, Vermont. Smart Wood certification is conducted in California by the Institute for Sustainable Forestry, a nonprofit group based in Redway, California. SCS is a for-profit entity that has working partnerships with forestry consulting firms around the world.

Unfortunately, certification by the FSC is no guarantee of ecological purity. Circumstances arise in which clearcutting and herbicide and pesticide use are permitted in particular regions, although the FSC requires that alternatives to these harsh techniques must at least be considered. The FSC also certifies some forest plantations; so much wood in the southern hemisphere is produced on timber plantations that excluding them from certification would have fractured the political coalition whose cooperation made the FSC possible. However, Principal 10 of the FSC's ten governing principles for forest management (which apply worldwide to all FSC-certified forests) stipulates that, although "plantations can provide an array of social and economic benefits and can contribute to satisfying the world's needs for forest products, they should complement the management of, reduce pressures on, and promote the restoration and conservation of natural forests."

FOREST STEWARDSHIP COUNCIL (FSC) PRINCIPLES AND CRITERIA

The FSC has developed a set of principles and criteria for forest management that is applicable to all FSC-certified forests throughout the world. The rules consist of ten principles and fifty-seven criteria that address legal issues, indigenous rights, labor rights, multiple benefits of forests, and environmental impacts surrounding forest management.

PRINCIPLE 1: COMPLIANCE WITH LAWS AND FSC PRINCIPLES

Forest management shall respect all applicable laws of the country in which they occur, and all international treaties and agreements to which the country is a signatory, and comply with all FSC Principles and Criteria.

PRINCIPLE 2: TENURE AND USE RIGHTS AND RESPONSIBILITIES

Long-term tenure and use rights to the land and forest resources shall be clearly defined, documented, and legally established.

PRINCIPLE 3: INDIGENOUS PEOPLES' RIGHTS

The legal and customary rights of indigenous peoples to own, use, and manage their lands, territories, and resources shall be recognized and respected.

PRINCIPLE 4: COMMUNITY RELATIONS AND WORKERS' RIGHTS

Forest-management operations shall maintain or enhance the long-term social and economic well being of forest workers and local communities.

PRINCIPLE 5: BENEFITS FROM THE FOREST

Forest-management operations shall encourage the efficient use of the forest's multiple products and services to ensure economic viability and a wide range of environmental and social benefits.

PRINCIPLE 6: ENVIRONMENTAL IMPACT

Forest management shall conserve biological diversity and its associated values, water resources, soils, and unique and fragile ecosystems and landscapes and, by so doing, maintain the ecological functions and integrity of the forest.

PRINCIPLE 7; MANAGEMENT PLAN

A management plan—appropriate to the scale and intensity of the operations—shall be written, implemented, and kept current. The long-term

objects of management, and the means of achieving them, shall be clearly stated.

PRINCIPLE 8: MONITORING AND ASSESSMENT

Monitoring shall be conducted—appropriate to the scale and intensity of forest management—to assess the condition of the forest, yields of forest products, chain of custody, and management activities and their social and environmental impacts.

PRINCIPLE 9: MAINTENANCE OF HIGH-CONSERVATION-VALUE FORESTS

Management activities in high-conservation-value forests shall maintain or enhance the attributes which define such forests. Decisions regarding high-conservation-value forests shall always be considered in the context of a precautionary approach.

PRINCIPLE 10: PLANTATIONS

Plantations shall be planned and managed in accordance with Principles and Criteria 1–9 and Principle 10 and its Criteria. While plantations can provide an array of social and economic benefits and contribute to satisfying the world's needs for forest products, they should complement the management of, reduce pressures on, and promote the restoration and conservation of natural forests.

As forester Robert Hrubies, Ph.D.,Vice President of SCC, notes, "certified forestry is not perfect forestry."[14] Certified forestry does, however, conform to nine or ten operant principles of good forest management. The FSC avoids using the term "sustainable forestry," regarding it as too politically loaded. According to Hrubies, the term not only is meaningless and unprovable, but also has often been co-opted by people who would not necessarily even qualify for certification. Instead of sustainable forestry, the FSC uses terms such as "responsible forestry" or "well-managed forests" to refer to forests that are managed in environmentally, socially, and economically acceptable ways.

The timber industry's answer to the FSC is an organization with much laxer standards known as the Sustainable Forestry Initiative (SFI), established by the American Forest & Paper Association (AF&PA). The SFI has granted certification to almost all its timber industry members, despite their pervasive acceptance of clearcutting, herbicides, and pesticides.

Although the SFI requires that its members subscribe to a laudable set of sustainable forest management principles, many of the implementing guidelines for these principles do not set rigorous performance standards that must be met in the field; instead, these guidelines call on member companies to do what they regard as appropriate. For example, with regard to the objective of broadening the practice of sustainable forestry, the guidelines states: "Each AF&PA member company will define its own policies, programs, and plans to implement and achieve the AF&PA Sustainable Forestry Principles and Guidelines."[15] The guidelines with respect to clearcutting are tolerant, stating:

> AF&PA members will develop and adopt. . . appropriate targets for managing the size of clearcuts. Where the average size of clearcut harvest areas exceeds 120 acres, AF&PA member companies will reduce the average size to no more than 120 acres, except when necessary to respond to forest-health emergencies or other natural catastrophes.[16]

The SFI also does not require labeling of certified products, chains-of-custody, or annual forest monitoring. Land managers today will often opt for dual certification—from an FSC-certified group and from the SFI—so they cannot be accused of having an environmental or industry bias.

Unfortunately, although many consumers tell pollsters they are willing to pay more for certified lumber, their purchasing decisions appear to be governed largely by price. Thus, producers of certified lumber have had to bear the costs of certification themselves without being able to pass the costs on to consumers. Nonetheless, these companies enjoy intangible benefits in consumer goodwill and name recognition, which conceivably may translate into somewhat higher stock prices for publicly held firms. The demand for certification, however, is still too weak to support broadly higher prices for most certified lumber products. Moreover, in Japan and mainland Asia, consumer knowledge of, and interest in, certified lumber is even less than in Europe and the United States. If forest certification is to come into its own quickly enough to reduce significantly the rapid destruction of forests, particularly in the tropics and the boreal regions, certification will need to impact a far larger share of the timber market than is now the case. Fostering this growth will be a major challenge to the environmental movement and certification organizations.

Although the sustainability principles outlined in this chapter provide useful guidelines for managers of real forests, some tree-bearing land has long since ceased to qualify as forest. How should these areas be managed? Naturally, tree farms *per se* are no worse than asparagus fields, citrus groves, or any other kind of farm crop, all of which produce valuable products and have environmental impacts. But farms should not be confused with forests, and a sustainable yield of farm products should not be confused with proper sustained-yield forestry. Timber companies that claim to manage timber sustainably but convert natural old-growth or even healthy secondary forests to industrial tree farms misrepresent the facts. Whether or not the yield is sustainable, it is usually but a single crop, and, moreover, the immature timber hurriedly produced on these farms is not equivalent in strength and density to older, forest-grown timber. Changing a natural hardwood and conifer forest to a more profitable pine or spruce plantation may also have a deleterious affect on soil, through the accumulation of a more acidic humus. Being more acidic, the litter is more resistant to decomposition by soil microorganisms; that is, it decomposes more slowly. Thus, nutrients in the humus are less available for incorporation in the soil and eventual uptake by trees and other plants. All-important soil microflora and invertebrates are likely to be reduced. Perhaps the timber companies engaged in blurring the distinctions between tree farms and forests have beguiled themselves into believing their own rhetoric about sustainability.

Without doubt, natural forest values are lost on managed plantations, which seem strangely sterile and far less attractive to humans and wildlife than wild forests. Yet, the appeal of plantations to timber companies and to some local communities is understandable. Plantations can produce three to thirty times as much wood fiber as natural forests through the use of selected fast-growing species or hybrids (sometimes consisting of clones of particularly productive specimens) and through intensive management, which may include fertilization, irrigation, and the use of herbicides and pesticides. The availability of timber and fuel from plantations may also reduce demands for fuel and lumber from natural forests. However, a tree farm is more uniform in structure and, often, in DNA, than is a forest. It is also less effective in protecting and purifying water; it is more prone to erosion; and it has a less complex litter-soil-invertebrate matrix.

Furthermore, since fast-growing trees are usually harvested on a shorter rotation than in a natural forest and because entire trees are frequently removed, the nutrient capital of the soil may be rapidly depleted, and a sustained yield will eventually prove impossible to maintain, unless fertilizers are added. As succinctly described in Lamb and Gilmour's *Rehabilitation and Restoration of Degraded Forests*, the potential benefits of tree plantations, including limited biodiversity benefits, can be increased by planting a compatible mixture of species and then by surrounding the plantation with a buffer of restored forest or by retaining interspersed strips of old-growth or restored forest within the plantation.[17] Lamb and Gilmour point out that the benefits, including financial gains, of using multiple species "result from better site use, improved tree nutrition, and reduced insect or pest damage."

SUSTAINABLE FORESTRY PRINCIPLES AND GUIDELINES OF THE AMERICAN FOREST & PAPER ASSOCIATION (AF&PA)[18]

Preamble

The forest products industry has a strong record of stewardship of the land it owns and manages. Forest industry lands include some of the most productive forests in the world. Innovative programs to create habitats and landscapes, and to enhance the diversity of flora and fauna, offer excellent examples of how industry foresters employ modern forest science in the protection of locations that are unique in their geological, ecologic, or historic value. At the same time, these forests are meeting the needs of society for homebuilding and other building products, as well as for printing, packaging, and sanitary products. Many companies have effective programs to extend their technology and stewardship knowledge to nonindustrial private landowners, who own most of the forestland in the United States.

These Sustainable Forestry (SF) Principles, including Implementation Guidelines, constitute the AF&PA members' commitment to sustainable forestry and the measures by which the public can benchmark this commitment. AF&PA members are actively implementing these principles and practices. Their objective is to achieve a much broader practice of sustainable forestry throughout the United States. In this way, they will perceptibly improve the performance of member companies and will set new standards for the entire forest industry as well as for other forest landowners.

Sustainable forestry is a dynamic concept that will evolve with experience and new knowledge provided through research. AF&PA views its Principles and its Implementation Guidelines as the latest of many steps in a progressive evolution of U.S. industrial forestry practices. Through this step, AF&PA members seek to meet the needs of humanity for essential wood and paper products while protecting and enhancing other forest resource values.

PRINCIPLES FOR SUSTAINABLE FORESTRY

America's managed forests make a vital contribution to the nation and to the world by providing economic, consumer, environmental, and aesthetic benefits indispensable to the nation's quality of life. A vital forest-based economy provides wood and paper products, employment, and a viable tax base. Accomplishing sustainable forestry on private land requires a partnership among landowners, contractors, and the companies that purchase wood.

AF&PA members, therefore, support on the forestland they manage — and will promote on other lands — sustainable forestry practices. Moreover, AF&PA members will support efforts to protect private property rights and the ability of all private landowners to manage sustainably their forestland. This support stems from the AF&PA membership's belief that forest landowners have an important stewardship responsibility and commitment to society. In keeping with this responsibility, the members of the AF&PA support the following SF principles:

1: SUSTAINABLE FORESTRY

To practice sustainable forestry to meet the needs of the present without compromising the ability of future generations to meet their own needs by practicing a land stewardship ethic which integrates the reforestation, managing, growing, nurturing, and harvesting of trees for useful products with the conservation of soil, air and water quality, wildlife and fish habitat, and aesthetics.

2: RESPONSIBLE PRACTICES

To use in its own forests, and promote among other forest landowners, sustainable forestry practices that are economically and environmentally responsible.

3: FOREST HEALTH AND PRODUCTIVITY

To protect forests from wildfire, pests, diseases, and other damaging agents in order to maintain and improve long-term forest health and productivity.

4: PROTECTING SPECIAL SITES

To manage its forests and lands of special significance (that is, biologically, geologically, or historically significant) in a manner that takes into account their unique qualities.

5: CONTINUOUS IMPROVEMENT

To continuously improve the practice of forest management and also to monitor, measure, and report the performance of our members in achieving our commitment to sustainable forestry.

CHAPTER 12.
RESTORATION FORESTRY

No big conservation project is adequate in today's world without a major restoration component. There is simply too little land left in near-prime condition, human influences are everywhere, and some ecosystem types are virtually gone.

—Reed F. Noss, "Wilderness Recovery: Thinking Big in Restoration Ecology" (1993)

WHY RESTORATION IS VITAL

Enormous areas of the world's forests that once seemed indestructible have now been fragmented or obliterated. More than 2.2 billion acres of forest have already been cut or otherwise degraded globally and, within a decade, wrote Lamb and Gilmore, "most of the world's forests will probably have been subject to some form of harvesting at least once."[1] Broadly speaking, the destruction of the natural environment today is proceeding at a pace that far outstrips nature's ability to restore itself. This is everywhere apparent, not only in the clearcutting, high-grading, and conversion of natural forests to tree farms, but also in the erosion of topsoil; the desertification of land; the acidification of rain and, hence, of soils, lakes, and streams; the diversion and damming of rivers; the filling of wetlands; the plowing of native grasslands; the spread of noxious invasive species; and even the collapse of vast ocean fisheries. Consequently, over the past 400 years in the United States alone, more than 500 species of the nation's plants and animals have become extinct. Thousands more are now rare, threatened, or endangered. Little wonder that butterflies, amphibians, and songbirds are vanishing along with the natural areas and open space that we loved but took for granted. Unfortunately, most of the ecological destruction will be greatly exacerbated by rapidly accelerating climate change.[2]

Fortunately, the twentieth century has also witnessed the birth of a promising new approach to nature that entails more than its preservation or conservation; instead, this new approach—planned, proactive restoration—attempts to repair environmental damage and guide natural habitats closer to their healthy, pre-disturbance condition. Clearly, this practice is quite challenging, and, as yet, the rate of genuine forest restoration is only a small fraction of the deforestation rate.[3] Nonetheless, as global population swells within the next few decades to nine billion people, restoration is clearly necessary—merely setting aside our remaining unspoiled land will not be enough. Land managers everywhere will need the science and technology of restoration ecology—and the managerial skill to employ them successfully. That often means allowing for the needs of local resource users, since their support can be critical to restoration project success.

ASSESSING EACH SITUATION

Healthy forests tend to regenerate naturally after disturbances such as fire, windstorms, ice storms, avalanches, insect attacks, disease, and grazing or browsing. Thoughtful analysis is required before deciding whether or not an active restoration effort is necessary; sometimes natural recovery processes will suffice. All that may be needed is protection of the area from additional unnatural disturbance or removal of obstacles to recovery.[4] But if disturbance is persistent and removes or severely damages essential components of the ecosystems—soil, moisture, or plants and animals required for the operation of forest processes—then the forest may be unable to recover unassisted. The restorationist may then need to reintroduce selectively missing, threatened, or under-represented species, particularly animals that have been regionally exterminated or plant species whose seed tends to disperse slowly.

How one goes about restoring a forest depends on many factors. These include:

• How and why the forest was damaged;

• The current site conditions (Is adequate moisture available? Is soil structure intact? Is topsoil present? Are sources of seed and wildlife present on site or in adjoining areas from which they can repopulate the site?); and,

• The forest's natural successional path before disturbance.

A review of all these issues—in conjunction with an examination of the related complex human social, cultural, and economic expectations—will help to determine realistic goals for the restoration. Ideally, all these site-specific conditions and factors would be considered in the context of the ecological needs of the larger landscape within which the project is implemented. Thus, for example, the restoration may be designed to help provide connectivity between existing healthy but fragmented natural forest areas, or it may provide needed habitat for species that are endangered on adjoining degraded lands.

Whatever the environmental problems being addressed, confronting them through restoration implies directing the development of the affected ecosystem toward an earlier, healthy, and natural set of baseline conditions as reflected in the composition and structure of the ecosystem and its processes. A related goal is often to return the ecosystem from intensive management to more autonomous control by inherent ecological processes—for example, from dependence on planting trees and other vegetation to reliance on natural regeneration and the actions of animal and plant seed dispersers. Ideally, the ecosystem will then be able to continue restoring itself. The restorationist's overarching goal is the re-creation of a fully functioning ecosystem that contains a species composition and diversity comparable to similar local ecosystems.[5] "A restoration approach based on ecological integrity," notes DellaSala et al., "incorporates the advantages of historical models while recognizing that ecosystems are dynamic and change over time."[6] Once forest health and forest processes are restored, the forest will evolve over time through an orderly sequence of relatively predictable natural changes known as forest succession. The restoration must be designed to allow resumption of whatever succession is natural for the ecosystem. This implies that the reintroduction of certain species may need to be done in a particular sequence so that some plants do not exclude others from the ecosystem before they are able to become established. Otherwise, native species may be unable to recreate their normal geographic distributions, abundance, and age-distribution. For trees, a normal age-distribution usually means the forest would contain young, medium-age, and old trees in approximately natural proportions for the species and site. (Following a catastrophic natural disturbance, however, in which all trees are killed, the trees replacing them would most likely all be approximately the same age.)

In a forest, complete restoration would mean:

• Reestablishing a full range of forest life-forms in their natural patterns of distribution and abundance;

• Recreating (where absent) naturalistic physical structures, such as the forest canopy, understory, drainage and hydrological patterns, and natural ecosystem properties, such as soil tilth, fertility, and stability; and

• The reestablishment of forest processes, such as natural selection, succession, nutrient cycling, and fire.

In short, for restoration to be completely successful, all components of a forest need to be reassembled and put into good working order or be progressing toward it. In real-world practice, time, resources, and ecological knowledge are limited, and any intervention that moves the forest toward healthy natural conditions is considered restorative. Eventually, however, the long-term heavy lifting is generally done by nature itself, especially when it comes to rebuilding soil and recycling nutrients.

Restoration success may be evaluated with respect to a historic ecosystem, whose baseline characteristics were measured, or to a similar contemporary natural ecosystem. Evaluation can be accomplished using complex metrics that strive to synthesize many aspects of the ecosystem or by simple measures of selected variables, such as species composition, biological diversity, and percent canopy coverage and sizes, ages, distribution, and density of trees (or other species).[7]

Naturally, restoration is not synonymous with merely planting trees. Restoration forestry requires other procedures chosen according to the site's predisturbance condition, the ecological conditions prevailing in the restoration area, and the manager's goals for the site. Attention may need to be paid to soil, hydrology, or invasive species. If forest damage has been severe and sources of seed are depleted (both on living plants and in the *soil seed bank*) and no adjacent intact forest exists, then restoration may require some reseeding or replanting of trees as well as other ecosystem components, such as shrubs and other understory plants. The reintroduction of absent wildlife and the control of exotic species may also be necessary.

As noted, the basic aim of forest restoration is to help a forest return to a state of ecological health in which all natural processes once again function properly, collectively managing the ecosystem and controlling its development.

TWO CHEERS FOR RESTORATION

The benefits of forest restoration are many. Restored forests may prevent extinction of endangered species and may provide suitable habitat for the recovery of threatened or rare wildlife. Forest restoration may also provide important economic and ecological benefits. For example, it may prevent mud slides and flooding or may eventually reduce logging and recreational pressure on nearby natural forests.

Not all communities and interest groups living near degraded forests will favor forest restoration. Some individuals or communities may fear that forest restoration may prevent continuing use of the forest for hunting and gathering. If the environmental, social, and economic needs of these forest users are not considered, and if these interest groups are not given a stake in the success of the project, their opposition can easily delay or block a project.[8] Ideally, a restoration project will be designed to provide some benefits to local residents, either in the form of future sustained-yield harvests of forest goods and services or in other environmental, economic, or social benefits. Employment opportunities for rural residents, for example, might result from the restoration itself; from the monitoring, protection, and maintenance of the project; or from resulting ecotourism. As noted by DellaSala et al., "Ecological restoration . . . must become an important component of an ecologically sound [and] socially just, forest economy." In turn, local residents may have unique local and traditional knowledge of forests to contribute to the restoration project.[9]

SETTING RESTORATION GOALS AND OBJECTIVES

Because forest restoration requires that natural hydrological regimes must be restored, issues of surface and groundwater quality and quantity may need attention. Aquatic systems not only deliver water through a forest, but they also interconnect the parts of the forest ecosystem. A real forest is not merely land covered with trees but often is a mosaic of other habitats, such as wetland, meadow, prairie, bog, or fen. These, too, may well need to be restored. Clearly, forest restoration is more than merely recovering the land with trees.

Forest restoration may involve various activities, such as fencing (to protect sensitive riparian zones) or perhaps the removal of fencing and other artificial structures where they are unneeded or harmful to wildlife. Restoration may also require erosion control, road removal or minimization, noxious-weed control, control of invasive species or pathogens, and fuel abatement through controlled burning. Prescribed burning is only one technique a restorationist may need to employ in order to reintroduce (mimic) natural disturbance regimes. A native plant nursery may also be needed to raise seed and bare-root stock for revegetation. Alternatively, wild locally adapted plant material may need to be collected.

Generally, in North America, the forest ecosystems most likely to engage restorationists' attention are those in which the major recent disturbances have been caused by fire or human intervention—typically road building and logging. Native Americans, however, altered North American forests over thousands of years by fire and by planting and harvesting edible and other useful plants. These interactions between preindustrial indigenous people and forests have occurred since time immemorial. Restoration is, therefore, not intended to return an ecosystem to a condition predating all human contact, even if that were possible.

Other types of problems that may require restoration are losses of forest components (trees, brush, herbaceous vegetation, litter, snags, downed wood, wildlife, soil organisms and microbes), loss of soil productivity, invasion by exotic species, loss of biological diversity, erosion, and sedimentation of waterways.

In its planning and design phase, the restoration effort should also make provision for monitoring, evaluation, and adaptive management—the use of feedback from evaluation to modify techniques and treatments.[10] Clearly, the best available science and technology should be employed; treatment areas need to be prioritized; and local legal requirements need to be met. Forest restoration normally begins with an ecological inventory and assessment in which resources are studied, site conditions are mapped, and ecological damage is described and analyzed. The data gathered in the inventory and assessment phase are used in the establishment of appropriate restoration goals and objectives. The management prescriptions written to achieve these goals and objectives must include not only management practices, but also the development of a long-term monitoring and assessment plan by which a program's success can be gauged. Naturally, sometimes it is impossible to determine what

species were present on a particular site or the sizes of particular populations of plants and animals. One must then use imperfect knowledge or knowledge of similar ecosystems in other locales to simulate baseline data toward which the restoration manager will strive. Naturally, restoration is not always possible: species may have become extinct, soil may be badly damaged and infertile, the climate or microclimate may have changed, and exotic species may have become so well established that they are virtually impossible to eradicate. Moreover, some exotic species change soil chemistry and nutrient availability in ways that may make reestablishment of the original flora difficult or virtually impossible.

ON-SITE RESTORATION TECHNIQUES AND PROCESSES

Sites that have been high-graded by selective logging to remove one (or more) commercially valuable species from the ecosystem may need to be replanted with local stock of that species (unless the species can regenerate naturally from the seed bank—for instance, seeds and propagules already in the soil). Decisions regarding whether to use seed, seedlings, or older plants need to be made on a site-specific basis, with consideration given to the requirements of the species desired as well as soil, climate, and other conditions. (These issues are thoughtfully discussed in Lamb and Gilmour.) Eroding areas, such as stream banks and active landslides, may first need to be stabilized mechanically or protected before other treatment. Stream and stream bank stabilization may be done with logs, root wads, wattling, erosion-control fabric, boulders, and other types of bank armor.

Along with mechanical stabilization, local species found on stream banks before disturbance may need to be planted to ensure quicker revegetation under the threat of erosion or because successful natural revegetation by desired species is unlikely, perhaps due to exclusion by competition. Whereas fast-growing, short-lived species, such as alder, may provide a quick response to eroding stream banks (and will provide streams with needed inputs of leaf litter), in coniferous forests long-lived species that grow along waterways may also need to be interplanted along the banks so that, over the long term, the waterways will benefit ecologically from large fallen trees that create pools for fish habitat.

Actively eroding roads may need to be recontoured, and erosion control devices may need to be installed, repaired, or improved. Unneeded

roads should be closed, ripped with heavy machinery if necessary, and then planted. Other hardened and impermeable compacted soils may also need to be broken up. Trees and other species may need to be reseeded, and, where soils are lacking in natural microorganisms, the inoculation of some seed species or seedlings with nitrogen-fixing bacteria and mycorhizzal fungi may be advisable to improve rates of plant establishment. When the need for erosion-preventing ground cover is so urgent as to preclude starting plants from seed, shrub and tree seedlings may need to be planted. Sometimes, however, where the main problem in the forest is the exclusion of fire and trees are unnaturally crowded, the forest may need to be thinned and the understory may need a controlled burn to reduce hazardous fuel levels. This may improve the understory vegetation and boost populations of deer, elk, small mammals, and songbirds.[11]

FOREST PLANTATIONS

In some parts of the world and under some forest ownership patterns, there is little constituency for, and scant possibility of, genuine forest restoration. In these circumstances, some forest benefits can be obtained through forest plantations, although forest plantations can also produce serious and complex harmful effects.[12] In addition to producing fuel, lumber, food (including fruits, nuts, mushrooms, and honey), and other forest products, such as latex, well-managed forest plantations can provide some ecological services, such as soil protection, soil improvement, watershed rehabilitation, carbon sequestration, and increased biodiversity relative to deforested areas. They may also serve as buffer zones around natural forest areas, from which plants and animals may in time recolonize the plantation, adding considerable biodiversity. Although, in general, plantations are vastly inferior to natural forests in their biodiversity and in their resistance to pests and diseases (because of their uniformity), plantations are typically quite productive and efficient in producing desired tree species.

Forest plantations can be improved from an ecological perspective by interspersing the plantation with strips of natural or restored forest; by planting multiple species rather than a single species; by allowing colonization of the understory by native plants; and by allowing buffer areas to remain unharvested when tree crops are cut.[13] Plantations are particularly important in tropical forest areas undergoing rapid deforestation, as I will discuss in Chapter 13.

SIX ARGUMENTS FOR RESTORATION—WHY RESTORATION IS URGENT

1. Forests and other damaged natural resources are often unstable and actively deteriorating. They will not wait in suspended animation until we get around to restoring them. If ecological deterioration is not arrested, repair almost always becomes progressively more expensive and difficult. For example, when a pernicious invasive species first enters an ecosystem, control or extirpation may be relatively easy. Ultimately, however, it may be very difficult and costly. To cite another example, if the erosion of a steep slope induced by clearcutting goes unchecked, it can cause severe gullying and the loss of topsoil down to bedrock. Successional processes may thereby be set back 1,000 years, and revegetation may be virtually impossible.

2. A failure to restore damaged resources also may lead to damage of pristine resources. For example, failure to stabilize an eroding clearcut may invite landslides that topple adjacent trees or stifle creeks with sediment, plugging the spaces within gravel spawning beds used by salmon and trout. Similarly, failure to restore a site contaminated with toxins from drilling, logging, or other industrial operations may pollute a pristine aquifer or surface water resources with hydrocarbons or difficult-to-remove heavy metals.

3. Failure to arrest deteriorating ecological conditions through protection of remnant habitat and restoration of adjacent habitat can also lead to the extinction of rare, threatened, and endangered species that depend on the habitat being lost. If old-growth features are not allowed to develop in disturbed forests under management, marbled murrelets, spotted owls, Pacific fishers, northern goshawks, and other imperiled old-growth-dependent species discussed earlier will remain confined to the increasingly fragmented old-growth ecosystems that remain. To cite another example, native songbirds are threatened by loss of riparian gallery forests in the western United States. In many states, only tiny remnants of the native riparian forests remain. Natural riparian forest habitat must be restored to expand the habitat available to these species if we expect to see a rebound in their abundance and distribution. Similarly, restoration of native prairie is important to the survival of endangered prairie wildflowers and forbs and prairie-linked insects, birds, and mammals.

4. Degraded resources left unrestored are more susceptible to being irretrievably lost to development, since their natural values are diminished or less evident. Thus, in their degraded condition, these lands have fewer defenders. For example, a clearcut area from which all valuable timber has been removed (and on which it may take decades or longer for valuable timber to grow) is a tempting candidate for commercial or residential development. Land values along polluted rivers also are likely to be depressed and may invite unsightly and ecologically damaging development, such as scrap yards and waste depots.

5. The science and technology of restoration needs to be actively developed, tested, practiced, and refined now so they are capable of meeting the ever-increasing challenge of global ecosystem repair. Adequate technology will be unavailable when needed unless it is supported, nurtured, and developed today. All indications are that the need for restoration is growing rapidly throughout the world and across all resource systems.

6. Restoration and conservation are intimately related. Often the first step in both restoration and conservation is identical: eliminating the source of the ecosystem disturbance. In addition, restoration activity has educational value for society, and the resulting increase in environmental knowledge and awareness also benefits conservation initiatives. The ultimate test of ecological understanding is not whether we can conquer nature, but whether we can take degraded ecosystems and from them reestablish complex, naturalistic, and healthy ecosystems. By developing and disseminating this subtle knowledge of how to reconstruct ecosystems, we can contribute to a social and political climate in which all environmental activity is better supported. Society should not be forced to choose between restoration and conservation any more than a person should be asked to choose between eating and breathing. Both are essential. If degraded ecosystems near large urban population centers are sufficiently enhanced through restoration to become attractive destinations for millions of people, the demands and impacts of a growing population on natural ecosystems can be reduced, leading to further recovery of natural systems that then can serve as models (reference ecosystems) and provide native plant germplasm and wildlife broodstock for recolonizing degraded areas.

CHAPTER 13.
SAVING FORESTS

The world's forest economy functions—or malfunctions—as it does because its current structure benefits powerful groups Overcoming their concentrated economic and political power will require concerted campaigns, tireless grassroots organization, and ingenious political strategies.

—ALAN THEIN DURNING, *Saving the Forests* (1993)

This is not about protecting the environment. We have the most stringent environmental protections of any timber company in the state. This is part of a radical political agenda based on lawlessness and the desire to destroy our way of life.

—ROBERT E. MANNE, PACIFIC LUMBER COMPANY PRESIDENT AND CEO

(FROM THE COMPANY'S WEBSITE, MARCH 18, 2003)

THE STRUGGLE OVER THE HEADWATERS FOREST

The Headwaters Forest Complex in northwestern California, inland from Humboldt Bay, was once an unspoiled natural paradise containing some of the earth's oldest, tallest, and most awe-inspiring life-forms. Groves of 900-year-old coast redwoods, with giant trees more than 250 feet in height, sheltered marbled murrelets in mossy treetop boughs. Thick forest soils provided pure water in which king and coho salmon spawned. This forest was once part of a primeval two-million-acre forest of coast redwoods. Now, it holds some of the last ancient redwood forest left within the Humboldt Bay ecosystem. Only about three percent of the original, vast ancient forest remains intact and untrammeled by loggers. The Headwaters remnant is particularly unique, as it is upland rather than along river valleys. The area contains several distinct ancient groves within a larger matrix of clearcut old growth and cutover second-growth lands.

The Pacific Lumber Company, originally a family-owned firm founded in 1863, owned this land for 122 years and, by the mid-twentieth century, was practicing selection logging. It had large areas of undisturbed forest and often spared old trees and enough vigorous younger ones to protect the forest soil and to provide trees for successive generations. The firm was financially sound and profitable, demonstrating that economic success and good environmental stewardship are compatible. With its "no clearcutting" policy, its long-term forest management approach, and its ample employee retirement plan, Pacific Lumber was regarded as a model timber company. But as large redwood and Douglas-fir trees grew rarer during the 1980s and redwood lumber appreciated in value, the well-run, prudently managed company—which had gone public in the 1960s—now became an irresistible takeover target for corporate raiders interested in quick profits. This, however, put at risk seventy-five percent of the world's privately owned redwoods—the fraction that still stood on Pacific Lumber's property.

Free-market forces arrived in the mid-1980s when Charles E. Hurwitz, Chairman and CEO of MAXXAM, Inc., a Houston-based conglomerate, led a hostile takeover bid for Pacific Lumber. MAXXAM's leveraged buyout of Pacific Lumber was backed by the sale of $750 million in junk bond debt arranged by notorious junk bond dealer, Michael Milken, of the Drexel Burnham Lambert brokerage. Pacific Lumber thus became a wholly owned subsidiary of MAXXAM in 1985.

The New Regime

Once in control of Pacific Lumber, MAXXAM loaded the company with debt, boosted Pacific Lumber's logging rate by 100 percent or more, and began rapidly clearcutting the ancient old-growth redwoods of the Headwaters.[1] MAXXAM also sold off some Pacific Lumber Company assets and converted the employees' fully funded pension fund to an annuity with Executive Life, which went bankrupt a few years later in "one of the largest taxpayer-funded bailouts in insurance industry history."[2] According to a report to the State Water Resources Control Board, MAXXAM "removed $55 million of pension assets from the company immediately after purchase."[3] While MAXXAM added its debts to Pacific Lumber's balance sheets, it undertook a series of complex financial transactions over the years to relieve itself of liability for those debts in the case of a default.

As MAXXAM's forestry practices and obsession with short-term profits rapidly became apparent, grassroots activists and national environmental groups quickly began mobilizing to save the Headwaters with its ancient trees, marbled murrelets, salmon spawning streams, and biodiversity. Some forest activists optimistically expressed hopes of protecting as much as 60,000 acres. Their on-going campaign has involved a broad range of tactics, including lawsuits, shareholder referenda, ballot initiatives, passage of federal and state legislation, a citizens' jobs-and-restoration plan, meticulous reviews of logging plans and advocacy before government agencies, monitoring of logging-related sediment discharges to local streams, and nonviolent direct action, including sit-ins, road blockades, and rallies. The complex campaign has brought together Humboldt County's property owners with nearby activists from Mendocino County who were committed to creating a sustainable second-growth timber economy in the region and who were reinforced by ancient forest defenders from the San Francisco Bay Area, Oregon, and other states.

Earth First! started the campaign to save the Headwaters with the first of its many public actions on October 22, 1986, and it mobilized other groups to join the campaign. The main legal defense of the forest was conducted by the Environmental Protection Information Center (EPIC) of Garberville, California, a grassroots watchdog and legal action group. EPIC filed its first lawsuit against MAXXAM in May 1987 over the failure of MAXXAM's logging plans to consider the cumulative impacts of logging old growth on the endangered marbled murrelet. EPIC subsequently filed a second lawsuit and was joined in its third suit by the Sierra Club.[4] These defensive actions were necessitated by the federal and state governments' failure to enforce their own environmental laws concerning the protection of endangered species and the many beneficial uses of the state's once-clean rivers and streams. Tragically, the controversy that ensued illustrates the awesome price that forest defenders are sometimes forced to pay—in time, money, injuries, and loss of life—to protect their communities and natural resources, even when those resources are high-profile ecosystems of global ecological value and national significance. It also indicates the enormous influence that large corporations hold over state and federal regulatory bodies—and the tremendous difficulties citizens face when trying to prevent forest degradation.

Once the battle was joined, a pattern to the conflict emerged. EPIC filed lawsuit after lawsuit over specific consequences of particular logging plans in limited but successful efforts to stop MAXXAM from violating environmental, forestry, and water quality regulations. Although courts often ruled in EPIC's favor, the company would redo its logging plans or submit logging plans for a different site and so managed to continue relentlessly logging its ancient redwood and Douglas-fir. Marbled murrelets nest only in old-growth forests within thirty miles of the coast, and not until a federal judge in *Marbled Murrelet et al. v. Pacific Lumber* ruled that any logging of old growth in Southern Humboldt Country was a "take" of marbled murrelets under the federal Endangered Species Act did MAXXAM realize it would have to enter meaningful negotiations with the opposition and government regulators.[5]

The Headwaters struggle often made front-page news. For example, in 1990, Earth First! activist Judi Bari, a community organizer with a passion for labor, feminist, and environmental issues, and fellow-activist Darryl Cherney were organizing a "Redwood Summer" campaign of public education on clearcutting in the redwood region when a bomb filled with nails detonated in their car under Bari's car seat, causing horrific injuries to Bari and wounding Cherney. Instead of investigating the bombing, the FBI accused the nonviolent Earth First! activists of accidentally blowing themselves up with their own bomb and promptly arrested them. They were eventually exonerated and filed a successful lawsuit against the FBI and the Oakland Police in which a jury awarded the two $4.4 million. They collected $4 million in a post-trial settlement. Also in 1990, activists tried but narrowly failed to pass a $741 million California bond measure known as Forests Forever that would have provided funds for acquisition of roughly 3,000 acres of the Headwaters and ancient forests throughout the state.

To draw attention to the continued assault on the ancient forests, Earth First! organized annual protests. Each year from 1985 through 1997, as the marbled murrelet nesting season would end, thousands of people would rally legally and peacefully against Pacific Lumber's logging. Near the lumber mill at the gate to the road to the Headwaters, protestors led by Earth First! chained themselves to heavy equipment or barricaded logging roads to halt the logging. In the largest mass arrest in the forest protection movement's history, more than 7,000 people

demonstrated, and 1,033 were arrested in a single action at Pacific Lumber's sawmill in Carlotta, California, on September 15, 1996.[6] The protests continued for two more months, and another 350 people were arrested. In 1996 and 1997, protestors shut down logging roads leading to the forest and occupied the six main groves within it.

The mass protests and publicity generated by the years of litigation, struggle, arrests, jailings, and injuries educated the public about the need to save the Headwaters but failed to slow the pace of Pacific Lumber's logging. The company committed hundreds of violations of state and federal environmental regulations but found it more expedient to pay relatively small fines and fight agency restrictions than to change its profitable ways. The furor did gain the attention of state and federal politicians, however. Following the listing of the marbled murrelet as a state and federal endangered species in 1991 and 1992 respectively, the Headwaters Forest Act was introduced in Congress in 1993 by Representative Dan Hamburg (D-CA) that authorized the purchase of 44,000 acres of the Headwaters. A modified version passed the House in 1994, only to die in the Senate. The next year, EPIC won its landmark decision, *Marbled Murrelet et al. v. Pacific Lumber*, in which a federal court enjoined logging in the Owl Creek Grove and other ancient groves of the Headwaters (and elsewhere in southern Humboldt County) to protect the marbeled murrelet.

Knowing that the endangered murrelet and the threatened northern spotted owl were found on its lands, MAXXAM struck back in both state and federal court, charging that the Owl Creek decision, along with other state and federal actions, were a "taking" of the company's private property at Headwaters. EPIC's victory in *Marbled Murrelet et al. v. Pacific Lumber*—made possible by application of the Endangered Species Act—thus was the catalyst that prompted MAXXAM to sue the federal government and thereby propelled the federal government into negotiations with MAXXAM to buy the Headwaters. Although MAXXAM's case appears to have had little legal merit, its litigation against the federal government strengthened the company's hand in its negotiations by threatening to embroil the government in lengthy legal battles, thus motivating the government to seek an out-of-court settlement.[7]

MAXXAM and the government reached a framework agreement in 1996 that was designed to set in motion acquisition of a critical part of the Headwaters by the State of California and the U.S. Department of the Interior. But this initial agreement was followed by nearly three years of

negotiations during which the public was afforded only limited review of the proceedings. Environmentalists were never included in the settlement talks. During all this time, Pacific Lumber continued to log ancient forests and second-growth redwood forest land that was not part of the pending deal, provoking more demonstrations, arrests, and litigation. The company meanwhile committed hundreds of state logging regulation violations. The pattern of behavior was so flagrant and egregious between 1994 and 1997 that even the pro-timber-industry California Department of Forestry (CDF) felt obliged to suspend the company's annual timber license in 1998 and again in 1999.

Simultaneously, activists advanced alternative plans for the area. Earth First!, in conjunction with the Headwaters Forest Coordinating Committee (a political lobbying group), in 1993 produced a "Jobs and Restoration" plan for the Headwaters as an alternative to the boom-and-bust logging cycle to which it was being subjected. A few years later, the Trees Foundation of Humboldt County also produced a recovery plan for logged portions of the Headwaters with help from the Institute of Sustainable Forestry. The plan's aim was to protect the ecosystem while encouraging the recovery of old-growth forest characteristics.

The Headwaters Agreement

Both in Humboldt County and in the larger environmental community, many people grew increasingly alarmed from the late 1980s through the 1990s that MAXXAM would log all of Pacific Lumber's old-growth trees and destroy the Headwaters. Just in the decade between 1987 and 1997, the company cut more than half of its entire timber inventory.[8] This grave and imminent threat worked to Chairman Hurwitz's advantage and, in effect, allowed MAXXAM to hold Headwaters hostage as the company sought to exact a staggering price for its property from those who wanted it spared.

Ultimately, a deal known as the Headwaters Agreement was signed, on March 1, 1999, between MAXXAM, federal wildlife and fisheries agencies, and the CDF and California Department of Fish and Game (CDFG). MAXXAM succeeded in selling a small portion of the Headwaters Complex to the federal and state government for more than $95,000 an acre—more than half a billion dollars in cash, tax breaks, and adjoining unprotected forest land—all bundled in a complex, multi-part accord that allowed MAXXAM to remain in charge of more than 210,000 acres

of former Pacific Lumber forest land. By relinquishing less than five per-
cent of its recently acquired land, MAXXAM in a single deal was able to
recoup more than half of what it had paid for all of Pacific Lumber Com-
pany, while still retaining more than ninety-five percent of Pacific Lum-
ber's land and all its lumber mills.[9] What a sweetheart of a deal it was for
MAXXAM and its chairman.

Although politicians portrayed the deal as a conservation triumph,
and it was depicted by some in the press as an outright victory for environ-
mentalists, many in the environmental community were outraged. The
deal gave nearly half a billion dollars in public money to an enterprise
controlled by Charles Hurwitz, someone they regarded as a disreputable
scoundrel who had held an ancient forest hostage for a king's ransom.
Hurwitz's reputation had already been tarnished by the spectacular col-
lapse of a Texas savings and loan—United Savings Association of Texas—
that Hurwitz had controlled through MAXXAM and other companies
and which the federal government had had to bail out at a cost of $1.6
billion to U.S. taxpayers.[10] During his career, Hurwitz has been involved
in a series of bankruptcies and questionable financial deals. The role Hur-
witz played in the United Savings Association's debacle and its manage-
ment policies are beyond the scope of this brief account, but his tactics
led to administrative action against MAXXAM by the U.S. Treasury's
Office of Thrift Supervision (OTS) and a suit by the FDIC.[11] An OTS
administrative law judge subsequently absolved Hurwitz of legal responsi-
bility for the thrift's failure; Hurwitz and others paid the government a
$206,000 fine to settle the administrative action, and the FDIC dropped
its suit in 2002.[12] Hurwitz then filed a countersuit, and a sympathetic
Texas judge awarded Hurwitz almost $70 million as a sanction against the
FDIC. (The FDIC has appealed, and a spokesperson said that the FDIC is
confident that the verdict will be overturned on appeal.) MAXXAM, how-
ever, has been found guilty of illegal activities in numerous environmental
lawsuits. Many questions remain unanswered as to why OTS and FDIC
were unwilling or unable to prevail against Hurwitz, but it is well known
that he had many powerful political connections.

In reviewing the Headwaters Agreement, MAXXAM's opponents were
especially aggrieved at provisions which gave the company permission to
take (meaning to harm, harass, or kill) endangered species and to disturb
spawning streams on company lands. Many environmentalists had instead
demanded a "debt-for-nature" swap that would have required Hurwitz as

MAXXAM's chairman and CEO to surrender the Headwaters lands to the state or federal government as restitution for the expensive government bailout of United Savings Association of Texas.

But rather than insisting on a "debt-for-nature" approach or defending themselves vigorously in court against the lawsuit that MAXXAM/PL filed (which claimed that the company's lands were being illegally "taken" by the government's regulations), the government negotiators—including California Senator Dianne Feinstein and Interior Secretary Bruce Babbitt—instead gave the company a fortune of public funds and nearly 7,755 acres of high-quality, second-growth redwood timberland as well as several regulatory permits with extraordinarily generous provisions. All together, the money and land was worth a total of $480 million; other related agreements later brought the total to more than $530 million. In return, the federal government received title to 7,470 acres within the core of the Headwaters, and the state purchased two other valuable ancient forest groves, totalling an additional 1,622 acres. Nearly 7,000 acres of additional land retained by MAXXAM were established as Marbled Murrelet Conservation Areas, where logging was banned for fifty years. Thus, the transaction protected more than 16,000 acres of the Headwaters, more than half of which consisted of old-growth forest, but at a colossal price and with regulatory concessions to MAXXAM in two side-agreements that would later prove disastrous for the environment. These were the company's Habitat Conservation Plan and its Sustained Yield Plan, which the county district attorney would later charge were fraudulently obtained.

The Headwaters Agreement allowed Pacific Lumber to prepare a multi-species Habitat Conservation Plan for its entire property, which would be approved if it complied with the federal Endangered Species Act. In return for approval of its Habitat Conservation Plan, Pacific Lumber would receive incidental take permits from both the federal and state government applicable to marbled murrelets, northern spotted owls, coho salmon, and other struggling species on portions of its property, including numerous species intended for protection under federal and state law. These fifty-year incidental take permits contained a "no surprises" clause that relieved MAXXAM of any future obligation to ever employ more stringent conservation measures than those identified in the 1999 permit approvals, even if conditions thirty or forty years in the future became more adverse for the threatened or endangered species

or if new knowledge emerged indicating that more stringent habitat requirements needed to be adopted. (The legality of such "no surprises" clauses is currently being litigated.) Pacific Lumber also received approval by the CDF of a "Sustained Yield Plan," which authorized Pacific Lumber to harvest at a very high rate during a 120-year forest management period. Under the plan, Pacific Lumber was given the right to cut the majority of its remaining old-growth forests in the first decade (outside the territories ceded to the federal and state governments or granted explicit protection), with more than sixty percent of the old-growth redwoods and more than seventy percent of the old-growth Douglas-fir to be felled in the first ten years. This prescription for forest destruction and soil destabilization allowed for the removal of all of the remaining old growth within the first two decades of the 120-year span. The company was also given a property-wide Streambed Alteration permit (required under the California Fish and Game Code). This gave MAXXAM conditional approval to alter streams across its 211,000-acre property. In return, MAXXAM agreed to vacate its "private property taking" suits against the federal and state governments. (Ironically, as we will see, Humboldt County citizens would later take Pacific Lumber to court, charging that logging-related landslides were depriving them of the uses of their property and thus taking *their* property.) The Headwaters Forest Agreement was thus a complex out-of-court settlement in answer to Pacific Lumber's litigation. MAXXAM paid Charles Hurwitz $9 million for his part in securing the Headwaters Agreement.

Many observers were shocked that the company was granted permission to harvest such vast areas of ancient redwood and Douglas-fir forest at a blistering and unsustainable pace and to destroy so much necessary habitat for endangered species, such as the critically endangered marbled murrelet. As was clear from a subsequently released recovery plan for this species, loss of this habitat definitely increases the bird's risk of extinction.

EPIC, along with the Sierra Club and the United Steelworkers of America, immediately sued Pacific Lumber, the CDF, and the CDFG in California Superior Court for failing to evaluate adequately the environmental impacts of its permit approvals and the impact of continuing logging under Pacific Lumber's plans.

This 1999 legal action led to a 2002 court-ordered stay on all Pacific Lumber operations, which the company ignored by continuing to log, since the judge had not issued a preliminary injunction to back up the

stay. The Bay Area Coalition for Headwaters alleged that Pacific Lumber itself acknowledged logging more than a million board feet of timber a day (for a time) after the stay was issued.[13] The court stopped some logging by enjoining some timber harvest plans, but it allowed Pacific Lumber to log other sites due to its controversial claim of economic hardship. On October 31, 2003, however, the court in its final ruling apparently lost patience with Pacific Lumber and set aside all of the state permit approvals and enjoined Pacific Lumber from relying on them for any future harvests. The court's sweeping decision was a triumph for EPIC and its co-plaintiffs: the court found that the state agencies had violated their duties under the state's environmental laws and that the company's Sustained Yield Plan was, at best, incomplete and inadequate.[14]

As was the case before the Headwaters Agreement, when Pacific Lumber had been found in violation of state laws, but subsequent to the initial conceptual Headwaters framework agreement pact of 1996, Pacific Lumber once again failed to comply with regulatory controls. The state's North Coast Regional Water Quality Control Board (Regional Board) and its parent State Water Quality Control Board (State Board) both found the company to be fouling streams with sediment in violation of state and federal Clean Water Act regulations. (The Regional Board is one of nine regional water boards under the State Water Quality Control Board.[15] As explained in more detail later in this chapter, local Humboldt County residents were responsible for bringing these matters to the water boards' attention and for prodding the boards to enforce the water quality regulations. The state board was not a signatory to the Headwaters pact and thus is in a unique position to require water quality compliance. Nonetheless, Pacific Lumber consistently resisted the board's actions, so that continued enforcement and regulatory efforts were still in process in 2005. EPIC documented 325 violations of the California Forest Practices Act by Pacific Lumber over a three-year period since it signed its 1999 deal. According to the *North Coast Journal*, three-quarters of the violations were for illegal logging in streamside areas.[16] A Pacific Lumber spokesman dismissed EPIC's charges, saying that most of the violations were environmentally inconsequential. The CDFG, which issued 227 noncompliance notices to Pacific Lumber for violating its Habitat Conservation Plan, failed to alert the public to the systematic lawless behavior.

EPIC again filed suit on November 4, 2004, to challenge Pacific Lumber's logging plans under federal law, alleging that the company's logging

would have continued deleterious impacts on impaired watersheds and protected species, such as the marbled murrelet. EPIC charged that, in trying to "remove every stick from the forest," including "small, baby trees in addition to giant ancient redwoods," the company's logging under plans approved by the CDF was violating the state's Forest Practices Act and its Environmental Quality Act.[17] State regulators clearly had good reasons to be concerned about Pacific Lumber's behavior: badly disturbed forest soils from heavily logged or clearcut forests on MAXXAM's property cascaded into creeks, degrading fish habitat, and increasing the frequency and severity of flooding. Residents of three communities (Stafford, Elk River, and Freshwater Creek) near the Headwaters each sued Pacific Lumber over adverse impacts to their property and homes due to Pacific Lumber's logging practices. The company eventually settled the Stafford complaints out of court for more than $3.3 million to compensate the victims for property damage and emotional distress. Elk River and Freshwater Creek residents in late 2005 were still continuing to seek legal redress for their losses, though some had settled with the company.

Local Property Owners Resist

Local residents in small towns such as these have played an active and consequential role in opposing Pacific Lumber's logging since 1996. After MAXXAM took over Pacific Lumber and greatly increased its logging rates, the residents of the Elk River and Freshwater Creek watersheds found that, during heavy rains, large amounts of sediment would pour off logged hillsides into their local waterways. Elk River residents complained to the Regional Board in 1996 that the Elk River, their principal water supply, had become so silty and gritty that it was unusable.

Under Pacific Lumber's 135-years of forest ownership in Humboldt County, the Elk River and Freshwater Creek watersheds, two of the company's most important timber holdings, had been lightly logged at less than a percent of the standing timber per year, but, after MAXXAM took over, the company's overall logging rates there quadrupled. As the logging quickened and Pacific Lumber removed the forest canopy, runoff from the freshly denuded slopes increased sharply, dragging more soil into the creeks. A plague of new landslides—triggered by rain on freshly denuded slopes—dumped more sediment into creeks. Soon, creeks choked with massive deposits of sediment could no longer handle the heavy runoff, and local property owners found their access roads

blocked by repeated floods. Watersheds that had flooded twice in a decade now flooded badly four to six times a year. "All sins of logging end up in the creek," said local resident and property owner Al Cook of Freshwater. Kristi Wrigley, whose family has owned an Elk River apple farm since 1903, found that after Pacific Lumber's intensive logging of the North Fork of the Elk River, between five and ten feet of sediment accumulated in the riverbed. According to Wrigley, the ensuing flooding destroyed her farm and inundated her house. Joined by twenty-three other residents, she sued Pacific Lumber. The case was later settled out of court.

When local property owners had initially sought redress from Pacific Lumber, the CDF and the state's Board of Forestry (BF), they had come away deeply frustrated. Resident Cook recalls repeatedly calling and writing to the CDF and BF. "They were completely uninterested," Cook said.

Adverse Impacts are Acknowledged

Local Humboldt County residents formed the Humboldt Watershed Council (HWC) in 1997 to combat watershed degradation and property damages. The HWC quickly brought evidence of the damage to the attention of the state and regional water boards, other agencies, community residents, and erosion experts. The Regional Board staff acknowledged the sediment problems: A September 2000 staff report declared, "significant adverse impacts to beneficial uses of waters . . . occurred from discharges of sediment from the lands owned by the Pacific Lumber Company, Scotia Pacific Company, LLC, and the Salmon Creek Corporation (all owned by MAXXAM) . . ." The report said that the board staff, state agencies, and the public had all "observed and documented these impacts to beneficial uses." The report went on to note that "the Discharger's" logging and related activities "contributed significantly to the documented adverse impacts, and that, although the company had been required "to prevent further discharges, and to confirm that remediation and prevention activities were resulting in restoration and protection of the impaired beneficial uses . . . the Discharger has not adequately fulfilled these requirements."[18] The staff concluded that the company, therefore, should be more intensively regulated by the Regional Board. By 2003, the Regional Board record contained additional "ample evidence that flooding and other water quality problems have been exacerbated by clear-cutting in the drainage."[19]

The water boards, though responsible for regulating water quality, had no experience in monitoring suspended sediment loads, nor financial resources to do so. At first, the Regional Board professed that it did not have the authority to order a logging company to limit or even to monitor its sediment discharges. Yet, the agency was virtually the citizens' only administrative recourse outside the courtroom because, unlike the CDF and the CDFG, the State Water Board was not a signatory to either Pacific Lumber's Habitat Conservation Plan or its Sustained Yield Plan. The State Board thus was not bound to uphold the Headwaters Agreement and, therefore, was not prevented from opposing Pacific Lumber's logging practices.

The Humboldt Watershed Council's work was coordinated with a local nonprofit grassroots organization called Salmon Forever, founded in 1996. Because the Regional Board was stymied by a lack of local data on sediment and runoff, Salmon Forever volunteers set up computerized water-monitoring stations that reported on suspended sediment levels in local streams and rivers twenty-four hours a day. They used paid work-study students and set up a water quality laboratory in a volunteer's garage. The Environmental Protection Agency (EPA) helped fund the lab, which used the EPA quality assurance guidelines to ensure reliable measurements. Citizen volunteers also surveyed stream channel cross-sections to measure the volume of accumulated sediment. "We set out to prove that what Pacific Lumber, the water board, and the other agencies said couldn't be done, could be done," recalls Salmon Forever founder Jesse Noel. Salmon Forever's data clearly showed the relationship of sediment and turbidity to landslides and water quality. What the volunteers found confirmed their worst fears. It was as if, Noel said, "we were just performing an autopsy [or] watching a[n aquatic] system being buried alive."

Cumulative Damage from Logging Is Confirmed

With their newly gathered data, the locals again took their case against Pacific Lumber and the CDF's regulation to the regional board. In response to complaints presented to the board by the HWC, the EPIC, Salmon Forever, and the Sierra Club, a multi-agency task force[20] determined in 1997 that all five local watersheds heavily logged by Pacific Lumber (including Freshwater Creek and Elk River, two residential watersheds) were cumulatively impacted and impaired by logging-related sediment as defined by Section 303D of the federal Clean Water Act. [21]

Under provisions of California's Porter-Cologne Water Quality Control Act, the state's water boards must protect the beneficial uses (such as drinking, swimming, fishing, boating, and irrigation) of the state's waters. Where those water uses are impaired, the regional boards have a duty to mitigate the detrimental impacts and restore the impaired beneficial uses. The state's water boards also must regulate water impacts so that any new land management activities do not make existing water quality problems worse. Therefore, the Freshwater and Elk impairment declarations required state action and provided local residents the legal opportunity they needed to challenge California agencies, such as the CDF, under whose management their watersheds had become impaired. The water boards, the CDF, and other agencies involved in timber harvest reviews each have a responsibility to prevent any significant environmental impacts. When such an impact is regarded as likely, the agencies are all required to mitigate those impacts to a level below significant. When a watershed has been listed as impaired, however, the Regional Board must then go beyond merely preventing further impacts and *must* seek to recover the beneficial uses of water. By contrast, the CDF and other agencies can only require that a timber company not make a bad situation worse; they cannot require actual recovery. The difference in their mandates proved significant in Humboldt County and even led to interagency conflict.

Heretofore, each time the CDF had been asked to approve a timber harvest plan, the agency rarely if ever found any significant cumulative impacts that could not be mitigated. Almost invariably, the CDF would declare that each harvest, viewed in isolation, would have "no significant [environmental] effects." "To this day," local property owner Al Cook contends, "they never defined those terms." Nor did the CDF have a process to look at the cumulative impacts of multiple timber harvests. The Regional Board, however, was now telling the CDF that the logging permits it had routinely approved were cumulatively degrading the state's waters. In response, the CDF declared a moratorium on the issuance of new logging permits in the Elk River and Freshwater Creek drainages, although it allowed logging to continue under existing timber harvest permits. "The suspension of PL's [Pacific Lumber's] license had no impact on all PL's subcontractors, who continued logging unimpeded," property owner Cook declared. "Just prior to the suspension, CDF approved eight logging plans in Freshwater." It was another example, said

Cook, of the CDF allowing "business as usual" while publicly trying to appear to sanction Pacific Lumber. "All through the moratorium," Cook stated," the turbidity increased, the fish populations declined, and all the indicators of watershed health were going in the wrong direction." Yet, once the timber on the eight pre-approved timber harvest permits was cut, the CDF moved quickly to lift the logging moratorium, a move that MAXXAM surely appreciated.

The Failure of a Regulatory Regime

During and after the moratorium, citizens armed with their sediment data and aided by expert consultants had protested Pacific Lumber's logging before the CDF; filed petitions before the Regional Board; and lodged complaints in court. An Independent Scientific Review Panel—selected jointly by local residents, the water board, and MAXXAM—was eventually convened to figure out how to restore water quality in the five impaired watersheds, especially Freshwater and Elk. The panel unanimously concluded that the excessive rate and scale of logging was causing water quality problems and severe flooding and that no mitigation other than a steep and immediate reduction in the rate of logging would likely facilitate recovery and prevent further degradation. Nonetheless, the Regional Board in January 2003 voted to extend a waiver, originally passed in 1987, that categorically exempted the logging industry from compliance with the storm water pollution permit requirements of the state's Clean Water Act.[22] The decision seemed inconsistent to many observers with the board's concurrence in a growing body of evidence that Pacific Lumber's logging was harming the watershed. However, timber harvest permits in *impaired* watersheds, such as Elk and Freshwater, were *not* included in the waiver extension, and, therefore logging or any other activity that might degrade water quality, could not proceed there without waste discharge permits. Nonetheless, because of the widespread watershed impairment due to logging within the North Coast region, EPIC and the HWC jointly appealed to the State Board to overturn the extension of the logging industry's categorical exemption, and they sued the Regional Board in California Superior Court to rescind it. The Regional Board then finally began the process of watershed-wide waste discharge permits, the remedy sought by EPIC and the HWC, and the litigation was withdrawn.

As an answer to the Regional and State Board's long-term failures to exert their full legal authority to protect the state's water quality from log-

ging impacts, HWC and EPIC during 2002 and early 2003 supported the Sierra Club's successful efforts to craft and secure passage of California Senate Bill 810.[23] The measure modified the timber harvest section of the state's Public Resources Code to authorize the executive director of the Regional Board to disallow timber harvest plans that would violate the Regional Board's Basin Plan, a water use planning process required by the federal Clean Water Act. In effect, SB 810 restated the legislature's intent that the water boards were ultimately responsible for protecting the state's water quality and could overrule the CDF on a timber harvest permit by refusing to concur in it. This further reinforced the Regional Board's authority and gave MAXXAM's foes additional ammunition. Local citizens' monitoring had clearly demonstrated by 2003 that, contrary to the CDF's contentions, fine eroded sediments from logged hillsides of Freshwater and Elk were settling in creeks and causing chronic turbidity levels harmful to fish, agriculture, and domestic water use. In response, the Regional Board officially acknowledged that its existing regulatory approach with respect to Pacific Lumber's logging was "insufficient to protect water quality."[24]

New Watershed-Wide Discharge Permits Are Imposed

Using Salmon Forever's water quality and channel monitoring data and a peer-reviewed empirical sediment budget model that correlated logging with likely sediment discharges, the water board staff then lay the technical foundation for instituting a watershed-wide waste discharge permit system, hoping finally to bring an end to the uncontrolled degradation of the watershed while still allowing a reasonable amount of logging. "If any single accomplishment can be attributed jointly to citizen advocates and good science, it is the development and use of this straightforward method of estimating the cumulative watershed effects of logging-generated sediment," said Dr. Ken Miller of the HWC. "Finally the agencies had a way of quantifying how much disturbance a watershed could tolerate while still recovering from past land uses."[25]

Administrative steps toward tighter regulation of Pacific Lumber continued in 2004 when the Regional Board finally took the unprecedented step of accepting local citizens' contention that, under the federal Clean Water Act, the cumulative effects of logging needed to be evaluated on a watershed-scale before timber harvest permits could be issued, instead of assessing timber harvest plans in isolation one at a time. The Regional Board

then adopted an order requiring timber operators to obtain watershed-wide waste discharge permits. The ruling was called "General Waste Discharge Requirements for Discharges Related to Timber Activities in Non-Federal Lands in the North Coast Region."[26] Where the CDF had previously been able to ignore concerns raised by the Regional Board, it now could no longer approve logging plans over the board's objections. This thus returned the Regional Board to a more significant role in the timber harvest plan review process.

When the State Board further ruled in June 2005 that Pacific Lumber could not enroll its logging plans for Freshwater and Elk under the general permit program but would have to submit to a more rigorous individual permit review, the company sued the State Board to reverse the decision. The Regional Board, however, persevered in developing specific proposed permit requirements for the two endangered watersheds and continued to move towards approval of the two specific permits that would be required, scheduling hearings on them for September 14–15, 2005. Pacific Lumber objected, stating that having to meet the requirements of individual permits would severely limit its logging rates in those two watersheds.[27] "If these WWDRs [wastewater discharge requirements] are imposed in the manner proposed by staff," asserted company President and CEO Robert Manne, "it will be a terrible blow not only for SCOPAC [Scotia Pacific Company], but also to PALCO [Pacific Lumber Company].[28] In fact, the staff's proposed limitations are not necessary for any environmental purpose."[29] Pacific Lumber asserted that the Regional Board "has no authority . . . to regulate a landowner's rate of harvest, a task clearly within CDF's authority and expertise."[30] "This decision [by the Regional Board]," Pacific Lumber announced, "sets a flawed legal precedent and has caused PALCO grave financial harm, delayed watershed recovery, and blocked efforts to address flooding."[31] The day before the hearings on the Elk and Freshwater permits were to take place, PALCO went to court and was granted a temporary restraining order to block the Regional Board from imposing individual permit requirements. The order was eventually overturned, but PALCO's legal action delayed the Regional Board's permitting process and thereby prevented any logging in the two watersheds for nine months. The Regional Board ultimately approved the two individual watershed permits in May 2006. "No action ever taken by the Regional Water Board has had as much impact on PALCO's timber harvest rate as the company's own temporary restraining order," said Mark Lovelace of the HWC.

Because PALCO has repeatedly argued that the state and regional water boards' regulation of its operations were driving it toward bankruptcy, the HWC provided detailed accounts of MAXXAM's financial activities to the water boards. This information helped the Regional Board to produce a detailed refutation of the company's charges.[32] In a closely related action, the Humboldt County District Attorney (DA) in 2003 sued PALCO and the two other local MAXXAM subsidiaries in California Superior Court for alleged unfair business practices under section 17200 of the state's Business and Professions Code, known as the Unfair Competition Law.[33]

The DA later that year filed a First Amended Complaint, charging the company with "knowing or grossly negligent submission of false information to government decision makers" and failing to correct the "government's material reliance on false information" in connection with Pacific Lumber's final Environmental Impact Report, its Long-Term Sustained Yield projection, its Habitat Conservation Plan and Incidental Take Permit, and certain of its Timber Harvest Plans.[34] The complaint thus challenged the veracity of the major bedrock documents on which MAXXAM has relied for its operation since taking over Pacific Lumber. Finally, the DA's complaint charged MAXXAM with "taking $300 million dollars from escrow in contravention of implied condition that all escrow documents were untainted by fraud"[35]

PALCO, in June 2003, filed a counter motion known as a demurrer, which was sustained in part and denied in part. The DA responded in 2004 by filing a Second Amended Complaint, and PALCO once again filed a demurrer. The Second Amended Complaint charged that Pacific Lumber was motivated "to undermine at all costs" the agencies' review of its timber permit applications because of "great financial pressure" arising out of the company's sale of bonds, secured by its timberlands. "These bonds required that Pacific Lumber harvest sufficient timber volume to meet their ongoing bond payments. Pacific Lumber could not risk a reduction in their ability to meet this bond obligation without exposure to harsh financial liability."[36]

Taking Stock

While fraud and unfair business practices charges remain tied up in court on appeal by the DA, streams of Humboldt County continue flooding and hillsides disturbed by Pacific Lumber continue eroding. Local property

owners view the results of their ongoing fight against Pacific Lumber with mixed feelings. Jessie Noel, the founder of Salmon Forever, believes that the Regional Board may now be on the verge of requiring Pacific Lumber to obtain the waste discharge permits, unless pro-timber industry political pressure intrudes on the Regional Board's deliberations. Property owner Joyce King of McKinleyville does not mince words:

> CDF and BF have done an abysmal job of regulating logging in this area. Forestry was never meant to be a highly profitable industry here. In order to make it so, CDF and BF have sacrificed the watershed in order to permit logging to continue at a pace that should never have been allowed. Meanwhile, the water board's staff have been so pressured by water board members who seek to undermine their integrity that the water board itself now needs to be protected, so it doesn't go the way of CDF and the BF. Already some water board staff members have been harassed or transferred to different posts. We've had three Executive Officers at the [Regional] Water Board in the last five to six years, because of political pressure. Gallegos [the Humboldt County District Attorney suing PALCO/MAXXAM] is under tremendous political pressure.

Apple farm owner Kristi Wrigley is also concerned that, while the years of citizen efforts have produced wider public awareness of the county's water quality deterioration—eighty-five percent of the state's watersheds have now been formally listed as "impaired" by sediment under the federal Clean Water Act—the new waste discharge standards themselves can only prevent *future* exacerbation of the problem. "They don't reduce the problem created by the logging of 1987–1997," Wrigley stated. At a minimum, she believes, the excess sediment in the creeks needs to be removed.

Local property owner Cook notes that the CDFG has spent millions trying to repair watershed damage caused by Pacific Lumber, but the department's structural work has been washed away, suggesting the futility of trying to cure watershed wounds without correcting their cause. Cook recognizes that requiring timber companies to meet waste discharge permit requirements based on the cumulative effects of their logging is an enormously positive change. "But after nine years of fighting," he says, "we've prevented very little damage in our watershed." He hopes that, thanks to the efforts of local property owners, "other watersheds

won't have to fight as hard as we've had to." Local citizens' struggles might not have been so arduous, or even necessary, had the public been able to count on strong environmental leadership from California governors and federal officials who seemed to turn a blind eye toward MAXXAM's conduct and who failed to protect local citizens against a politically and financially powerful corporation.

As the fight over implementation of the Headwaters Agreement roils on, the company has begun removing tree-sitting protestors from its lands with teams of experienced climbers, and it has taken to characterizing its environmental opponents as radicals, extremists, and ecoterrorists. Following its long battles in the courts, the continuing demonstrations on its lands, and a string of unfavorable rulings in the courts and before regulatory agencies, the company was complaining in 2005 that the regulatory burden of complying with water quality laws as well as with the Habitat Conservation Plan and various limitations on logging were forcing it into bankruptcy. However, a detailed rebuttal of an economic white paper by MAXXAM, prepared by a senior staff financial expert for the State Board, analyzed this claim in painstaking detail and found it entirely without merit. "MAXXAM has taken money out of PALCO [Pacific Lumber Company] in subtle and complex ways and has directed PALCO to harvest trees at rates that greatly exceeds [sic] sustainable forest practices," wrote the financial analyst. "MAXXAM has put PALCO at risk by borrowing large sums of money, not paying down its long-term debt, and thereby keeping PALCO a highly leveraged company."[37] Whereas MAXXAM alleged that its "financial difficuilties" were a result of state regulatory decisions, the Water Board report concluded after reviewing the tangled web of MAXXAM's finances, "MAXXAM has removed at least $724 million in PALCO funds for its own use. . . . PALCO's financial difficulties are the result of deliberate business decisions, and not the result of any regulatory decision."[38] The report also found that MAXXAM had realized windfall profits of more than 500 percent on its initial investment in Pacific Lumber while simultaneously putting the company into a precarious financial position.

In what opponents viewed as an unjustified attempt at environmental blackmail, the company threatened in 2005 that, if it went bankrupt, it would abandon its environmental stewardship obligations under the Headwaters Agreement. While MAXXAM has realized roughly half a billion dollars from the sale of Pacific Lumber Company assets to the government and another fortune through its sale of the premium old-growth

redwood and Douglas-fir lumber from the trees it logged, the company has paid relatively little of the huge debt with which it saddled Pacific Lumber after its takeover. The debt incurred on purchase was converted to $879 million in long-term debt in 1986. As of December 31, 2004, PALCO still owed $703 million.[39] As MAXXAM (through its wholly owned subsidiary Scotia Pacific) faced the possibility of default proceedings over interest payments owed to bondholders of the refinanced Pacific Lumber debt, it continued to blame its predicament on its environmental opponents and regulators.[40] The company's self-inflicted travails are a sharp contrast to the prosperity and the harmonious public relations that the well-managed Pacific Lumber company had enjoyed before MAXXAM's hostile takeover and aggressive logging practices.

Neither MAXXAM nor its foes are satisfied today by the new status quo that has emerged from two decades of bitter struggle. While the story reveals that creative, determined activism can still save some priceless resources from destruction, MAXXAM's critics believe the tale also proves that, in twenty-first-century America, government is not tough enough on corporations that flout environmental laws. Darryl Cherney, an Earth First! organizer and co-founder of the Headwaters Campaign, puts it this way:

> In 1990, the environmental community was offered a deal by MAXXAM/PL to purchase 3,000 acres of the Headwaters Forest. But we turned that down and continued to fight for another nine years. This was an example of some of the best traditional activism in the U.S. We wound up with more acreage and a much larger protected area than we were offered in 1990, though we could have taken the easy way out. We didn't settle for what was offered to us.[41]

Yet, Cherney is pessimistic about the future of traditional activism and deeply disappointed that more was not accomplished. "Never," he lamented, "did so many do so much for so little. You can take some of the finest activists in the country and you can battle a corporation whose villany is as transparent as it comes, combat it from 25 different angles, and you still come out with the forest falling. We are still fighting tooth-and-nail to save the forest!" Cherney now believes that people will have to think "way outside the box if we're going to take on these corporations." His solution personally is to work more through the arts, such as music and film, "to reach people through their hearts as well as their minds."[42]

Two dramatic major developments have occurred in the MAXXAM/ Pacific Lumber story. First, on December 20th, 2006, Pacific Lumber and Scotia Pacific together filed suit against the state of California, claiming that the state had violated the 1996 Headwaters Agreement by restricting the companies' logging. The suit accused the state of forcing the companies into a financial crisis. Then, on January 19th, 2007, Pacific Lumber and other MAXXAM subsidiaries filed for Chapter 11 bankruptcy protection in federal bankruptcy court in Corpus Christi, Texas.

The company blamed its long-threatened bankruptcy on a "liquidity crisis arising from state regulatory limitations on timber harvesting." The filing came after the company was unable to make multi-million dollar interest payments to bond holders from whom the company had borrowed hundreds of millions of dollars, collateralized by the companies' timber holdings. Chapter 11 proceedings provide bankrupt companies with a reprieve from the demands of their creditors and allow them to remain in business while developing a reorganization plan. The plan typically allows for the canceling of certain types of debts and the rescheduling of repayments to remaining creditors.

Disputing Pacific Lumber's assertion that it was driven into bankruptcy by state environmental regulation, the HWC countered, in a statement issued on the day of the bankruptcy, that the filing was caused by the "crushing debt" inflicted on the company by MAXXAM's hostile takeover of Pacific Lumber and its "massive, unsustainable logging." The company had borrowed so much money, the council said, that, even if it "cut every tree on [its] land, it would not generate enough cash to pay off the debt." Because of Pacific Lumber's debt burden, the HWC stated, the company was led to "ignore science, violate regulations, log unsustainably, destroy the watersheds in which it operates, and to deplete the resource upon which it depends." Taking issue with the companies' claims that state regulations were the cause of the financial distress, the council stated, "The company's own filings show that they have been within 2% of their planned harvest rate over the last six years Palco's financial crisis has nothing to do with environmental regulations. Rather it is entirely the predictable result of greed and mismanagement."

TALES OF THE KITLOPE VALLEY

Not every forest-protection effort is so fractious and protracted as the Headwaters conflict, with its legal challenges, government negotiations,

civil disobedience, grassroots citizen activism and monitoring. For example, a remarkable forest-protection success story occurred some years ago in Canada's lush Kitlope Valley in British Columbia. The Kitlope Valley is of global ecological importance, since it is one of the world's largest remaining intact coastal temperate rainforests. The 1,224-square-mile ancient forest has been inhabited for millennia by the indigenous Haisla Nation. The area was threatened by logging, but, against all odds, the vast Kitlope rainforest, with 800-year-old trees, fjords, and mountains, was saved in 1994 by the voluntary action of a timber company that relinquished control over the valuable rainforest to its traditional native tribal occupants without even requiring any monetary compensation.

West Fraser Timber Company had obtained title to about 200 square miles of the Kitlope Valley from the government in the 1960s and was preparing to log its timber, worth an estimated $15 million. Although the company pledged that all the timber work would go to the Haisla, the Haisla flatly refused to participate and vowed to oppose anything that would harm the valley. Ecotrust of Portland, Oregon, helped the Haisla resist the proposed logging by mapping the Kitlope to document its unique ecological resources. The company then made an honorable and socially responsible decision: it abandoned its logging plans, renounced its title to the Kitlope, and asked for no compensation. British Columbia Premier Mike Harcourt then declared that the Kitlope would be permanently protected.

THE GREAT BEAR RAINFOREST: A HIGH-STAKES CONSERVATION EXPERIMENT

Economic pressure can sometimes forestall forest destruction when moral suasion fails. More than a decade ago, in British Columbia, the future of the world's largest intact coastal temperate rainforest looked bleak. Where once the coastal rainforest swept north in a continuous verdant sea of trees from California to Alaska, by the end of the twentieth century only British Columbia and Alaska still harbored large unbroken expanses of coastal rainforest. Due to their remoteness from population centers, these bastions of big trees and biodiversity had escaped logging.

In the early 1990s, however, timber companies' chainsaws were whirring, ancient trees were crashing to the ground, and an apparently inexorable liquidation of British Columbia's rainforest was underway. In the path of the saws lay the spectacular Great Bear Rainforest (Great Bear), a lush twenty-one-million-acre old-growth forest ecosystem that environmentalists and some native peoples have been fiercely determined to protect.

Here, in another long-term epic struggle, forest defenders had to rely heavily on a complex strategy. Their approach combined international economic pressure on timber companies with civil disobedience; participation in land-use planning and management negotiations with timber companies and other stakeholders; securing pledges of private and government funds for investment in sustainable regional economic development; and finally, implementing a no-holds-barred publicity campaign to win the public's "hearts and minds."

The Great Bear carnage was interrupted for five years by determined forest activists. Then, in early 2006, the Great Bear—an ecosystem the size of Switzerland on the province's Central Coast and North Coast—was finally accorded some lasting protection, protection that came in the form of a far-reaching decision by the provincial government to approve an agreement among environmental groups, timber companies, Canada's First Nations (native peoples), and the government.

The compact forbids logging on five million acres (a region twice the size of Yellowstone National Park), requires environmentally sound forestry practices on another ten million acres of the forest, and provides for the involvement of the First Nations in management of the region and for more sustainable economic development. In addition to placing wilderness land off-limits to logging, the pact's environmental restrictions require that logging companies operating on ten million additional acres protect critical watersheds, spawning streams, bear dens, and culturally significant areas, selected with guidance from the First Nations. The entente also will infuse $120 million of government and foundation money to diversify the rural economy, reducing reliance on logging and supporting more sustainable activities, such as ecotourism and shellfish aquaculture. The money has already been raised from U.S. and Canadian donors and from Canada's provincial and federal governments.[43] Simply getting the approval of the provincial government was an enormous triumph for the environmental community, as the government previously had received grades of "D" for land-use protection and "F" for ecological planning and management from local and national environmentalists.

In the Realm of the Spirit Bear

The largely roadless and wild Great Bear wilderness is the unspoiled ancestral homeland of more than a dozen First Nations tribes and is

integral to their economic survival and complex, sophisticated cultures. The vast and magnificent natural ecosystem in which they flourished for thousands of years is cool and shady year-round thanks to oceanic influences. Rarely disturbed by fire over the millennia, it is a sanctuary for biodiversity. The land teems with wildlife, including grizzly and black bears, wolf, wolverine, mountain goat, black-tailed deer, northern flying squirrel, bald eagle, all six species of salmon (including steelhead), and other very rare and endangered species. The rare white Kermode or "Spirit Bear" is found here, produced by the expression of a recessive gene in the black bear population. Thousand-year-old red cedars, massive Sitka spruce, and Douglas-fir flourish. Ferns and berry bushes thickly carpet the moist, spongy understory, along with straw mushrooms and medicinal plants. Offshore, orcas and humpback whales swim amidst an abundance of seals, sea lions, otter, and salmon on which the orcas have preyed since time immemorial.

The Great Bear is a globally rare ecotype—before development of the region, only 0.2 percent of the world's lands were coastal temperate rainforests, and, of these, only half remains. A quarter of that half is found in coastal British Columbia.

Trouble in Paradise

For every extraordinary spot on Earth, though, there is invariably someone bent on making a quick profit from it, regardless of the consequences. In fact, the more beautiful an area is and the more richly endowed with natural resources, the more attractive a target it is for those eager to turn those resources into cash. Thus, by the early 1990s, timber companies, such as International Forest Products (Interfor), TimberWest, Weyerhaeuser, Western Forest Products, and West Fraser, had begun large-scale clearcutting in the Great Bear, and more was planned. Although the timber companies were initially cutting mostly on the edges of the rainforest, virtually all remaining large intact valleys had been allocated to logging companies and were slated to be logged within the next decade. The entire rainforest ecosystem was gravely threatened by the prospect of future logging, mining, energy development, salmon farming, and offshore oil and gas development. Not only would all this resource extraction have finished off the forest, but it would also have destroyed the traditional subsistence economy on which tiny rural forest communities still depend.

Large industrial forestry operations typically conduct high-volume logging that converts trees into low-value products and creates a brief pulse of profits for faraway shareholders. The companies export raw logs and leave small forest communities with clearcut forests, eroding soil, polluted water, devastated streams, decimated wildlife, and depleted or extinct fish populations. When the forest has been stripped and the timber companies have moved on, shutting their mills, communities are left without the natural resources needed to build a sustainable economy or to continue with traditional subsistence activities that are vital to the survival of indigenous culture.

Taking Action—A Potent Coalition Emerges

Some of the complex dangers described still loom over parts of the Great Bear, but the rainforest's prospects have vastly improved thanks to a decade of struggle by a coalition of groups determined both to protect the forest and to work with their antagonists as well as other stakeholders. They have been engaged for most of the past ten years in a novel, comprehensive collaborative planning process that has brought former bitter foes to the conference table in hopes of curtailing long and costly confrontations in which neither side achieves its desired outcomes.

During 1994 to 1996, the threat to the Great Bear impelled First Nations in the rainforest to take independent actions within their traditional territories to protect areas important to them from logging. The Nuxalk Hereditary Chiefs from the Central Coast of British Columbia, for example, in 1996 invited Greenpeace and other environmental groups to witness the destruction of the Great Bear and join the Hereditary Chiefs in their efforts to stop the clearcutting of lands that they considered home. The Kitasoo First Nation started to develop its own land-use plan for its traditional territory, and members of the Heiltsuk First Nation blocked Western Forest Products from building a logging road into the Ellerslie Valley in their territory near Bella Bella. The Heiltsuk also invited the Sierra Club and other environmental groups to help them slow down logging until the community decided what it wanted in its traditional territory.[44]

The Clayoquot Sound Connection

The origins of the campaign to protect the Great Bear Rainforest go back to 1993, when some 900 people were arrested in the largest environmental

protests in Canadian history over clearcutting around Clayoquot Sound on Vancouver Island. Although protestors won some important victories, large-scale industrial logging at Clayoquot Sound on Vancouver Island was still continuing in 2005, although the allowable cut was much reduced.[45] But the tumultuous protests did put a spotlight on the broader destructive impacts of clearcutting in British Columbia. The popular resistance and the attendant publicity drew sympathetic world attention to the logging of Canada's ancient rainforest and inspired many activists to take on the challenge of protecting a whole region rather than a few valleys. Contacts made and lessons learned during the Clayoquot Sound campaign about how to bring market pressure on timber companies over their logging practices were later employed successfully in pressuring large wood buyers not to use Great Bear timber. Many wood buyers worldwide have now grown chary of buying wood from endangered forests or from old-growth trees.

Forest Blockades and International Economic Pressure

Greenpeace in 1995—joining hands with ForestEthics, the BC (British Columbia) Chapter of the Sierra Club of Canada, the Rainforest Action Network, various First Nations leaders, and others—launched the ad hoc efforts that would coalesce some two years later into the Great Bear Campaign to protect the rainforests of British Columbia's North Coast and Central Coast. This campaign combined international economic pressure on the timber companies, with dramatic logging blockades in rainforest valleys, which brought clearcutting to a halt for extended periods at a number of locations. As the arrest rolls grew, adverse publicity and logging delays dogged the timber companies.

In 1997, environmental groups formed a coalition, the Canadian Rainforest Network, and publicized what was now a coordinated campaign to save the region, with maps and posters of the Great Bear. Simultaneously, Greenpeace, ForestEthics, the Natural Resources Defense Council, and Rainforest Action Network (RAN) contacted major wood, pulp, and paper purchasers around the world; told them what was being done to British Columbia's rainforests; and urged them to stop buying products from ancient forests. The coalition also placed ads in *The New York Times* and hung protest banners and held demonstrations at timber company shareholder meetings and at various stores and Canadian consulates in the United States, Europe, and Japan. This international campaign lasted for more than two years and was extremely successful. Eventually, more

than eighty companies, including Home Depot, IBM, Ikea, and Staples, agreed to cancel contracts from companies logging the Great Bear or made a commitment to stop selling endangered forest products. All over the world, other companies pledged to alter their purchasing practices. Some cancelled contracts with International Forest Products, one of the biggest clearcutters in the Great Bear. Many large procurement contracts were cancelled, and other timber customers put the government and logging companies on notice that they would not buy timber from endangered forests or from forests logged without a conservation plan.

Stakeholders Assemble for a Remarkable Planning Process

Beginning about 1992, the provincial government had launched a region-by-region Land and Resource Management Planning Process for all of British Columbia, and, by 1996, it was devoting its attention to the Central Coast of British Columbia.[46] Environmentalists in the Central Coast, however, regarded the government's planning program as a "talk and log" process unlikely to result in significant protection of the rainforest, and they refused to participate in it.

To get the environmentalists to the "planning table," as it is known in Canada, the provincial government in 1999 lifted an earlier planning and negotiating stricture that would have held the total area reserved for protection to only twelve percent of the Great Bear. More importantly, the often intransigent logging companies consented to a temporary moratorium on logging in some thirty to forty large pristine watersheds in the Central Coast region. The logging firms were receptive to negotiations because of the forest defenders' effective economic pressure combined with forest blockades. Once the moratorium was adopted, environmentalists suspended their economic pressure and began actively participating in the planning process in an effort to get those pristine watersheds permanently protected.

The main participants in the negotiations were representatives of all the nongovernmental stakeholders: timber companies and their workers' union, tourism and recreational interests, and environmental groups. Native peoples and governmental representatives were at the table as well, to insure that they had input in the process, but their direct engagement would come later, in the negotiation of land-use plans once they received the stakeholders' recommendations. Meanwhile they independently developed land-use plans for their own territories.[47]

By 2000, after some disagreements in the negotiations temporarily led to the resumption of economic pressure, the talks produced additional important results. The logging industry consented to a temporary and voluntary expanded moratorium on logging in 100 large intact valleys and ecologically sensitive areas throughout the Great Bear and the islands of Haida Gwaii (north of Vancouver Island).[48] In return, the environmental groups agreed to suspend their blockades in the woods and to again halt their marketplace pressure.

Recognizing now that all the protests were drawing attention to the problems of the Great Bear but that no one was actually putting answers on the table, ForestEthics, Greenpeace, Rainforest Action Network, and the BC Chapter of the Sierra Club of Canada formed a new task force called The Rainforest Solutions Project. The coalition's goal was to gather ideas for an environmentally and economically sustainable future for the coast—a vision cognizant of the area's many diverse communities and their long-term economic needs.

Another major breakthrough in the negotiations occurred in 2001: the negotiators reached consensus on a "first phase" of conservation recommendations. They agreed to a government-sanctioned moratorium on logging in twenty intact rainforest valleys and a formal extension of the temporary moratorium on logging in sixty-eight additional watersheds in the Great Bear while land-use planning continued. The planners also agreed to create an internationally credible and independent $3 million team of scientists and economists to provide negotiators with ecological and planning data that was credible to all parties, rather than relying only on information from government and industry.[49] In negotiations that continued during 2003, they also made a commitment to develop, and implement by 2009, a new, sustainable way of logging, referred to as Ecosystem-Based Management.

With the planning process thus energized and productive, it seemed that all interest groups were finally working together to forge land-use plans—one for the Central Coast and one for the North Coast.

The Allure of Ecosystem-Based Management

The stakeholders further resolved in 2003 that, by 2009, land-use management practices in the rainforest would be governed by an Ecosystem-Based Management (EBM) system whose principles have by now been

delineated in a seventy-five-page scientific management handbook that partitions the area into zones dedicated to conservation, biodiversity, and those that permit commercial activity. If it works as intended, adherence to EBM would promote the coexistence of healthy, fully functioning natural ecosystems and the well-being of interrelated human communities. Whatever logging would be done after 2009 would be done on an ecologically sustainable basis. The capabilities of the proposed EBM approach still have to be demonstrated on the land and subsequently funded and enforced. Environmentalists, however, plan to see this new management model fully implemented and to assess thereafter how effective it is for truly conserving ecological values.

The Economic Vision: Sustainable Development and Ecological Health

The economic component of the stakeholders' vision for the Great Bear is outlined in a Sustainability Scenario for the region, drawn up with the help of a consulting economist. Conservation-oriented investment would be attracted to the area to revitalize local economies impacted by declines in the fishing industry and by jobs lost in the logging industry through mechanization.[50] The scenario includes local forestry joint ventures with First Nation partners. Environmentalists would like to win agreement that those projects meet forest certification standards of the Forest Stewardship Council. The intent of the economic vision is to create new local jobs to meet local employment needs in conservation, restoration, and resource monitoring, as well as in tourism, fishing, shellfish aquaculture, human services, and in harvesting nontimber forest products, such as mushrooms and ferns. As in some other regions of the world, it is nonetheless conceivable that some of even the most well-intentioned sustainable economic development stimuli in currently remote wilderness areas can create development nodes from which later development will break loose, its damaging effects propagating like cancer from multiple sites into the wilderness.

The Great Bear stakeholder negotiators eventually succeeded in producing two consensus regional plans for British Columbia's Central Coast and North Coast, and each of the eleven participating First Nation tribes also produced draft plans for amalgamation into a single final plan.[51] Significantly, the stakeholders were able to reach agreement on the amount of land to be protected, logging practices, and on some socioeconomic measures required. Of critical importance, they agreed to support setting

aside nearly 5.2 million acres—one third of the area of the forest (excluding Haida Gwai [the Queen Charlotte Islands] and certain other northeastern parts of the forest on which agreements are still pending)—as off-limits to logging, although some fourteen percent of the area set aside would still remain open to mining. Thus, slightly more than a quarter of the land base under active negotiation (twenty-eight percent) would receive complete protection. Two-thirds would be open to logging under EBM provisions, although how successfully conservationists would be able to enforce environmental laws and practices in those large development zones remains an open question.

What Has Been Accomplished?

Whereas environmental representatives to the negotiations sought to achieve higher levels of protection from logging than one acre in three, timber companies, logging unions, and mayors of logging towns were unwilling to forgo the expected profits that additional development would probably produce. By contrast, the scientific advisors to the planning table had made very clear to the stakeholders that more land—as much as forty-four to sixty percent—would need to be sequestered from logging and other high-impact industrial activities to create a high degree of confidence that the whole rainforest ecosystem would remain healthy and functional. Some scientists have called for protection of as much as half of the coastal rainforest from Alaska to the Central Coast of British Columbia. Clearly, protecting a third of the Great Bear would be insufficient to protect all of its biodiversity, but environmental, recreation, and tourism representatives have rationalized that it is better to protect a fourth to a third and have ecologically oriented management on the remainder than to have the entire rainforest open to unrestricted logging and mining. An advantage of EBM over a development free-for-all is that such management requires that scientifically selected reserve areas be put aside and that seventy percent of each ecosystem type be left in an "old" state at any time.

The scientific advisors to the planning table counseled that there was a chance that setting aside a third of the land would preserve most of the rainforest's key ecological attributes if EBM, using the best available science, were applied to the entire area. This would require leaving at least seventy percent of the natural old-growth forest for every forest ecosystem type on a subregional basis, meaning on the scale of each tribe's traditional landholdings.[52]

On paper, the timber companies were willing to agree to this goal of seventy percent and to other encouraging changes in their planning and logging practices. Evidently, no one in the environmental community seems to have had a plausible political strategy for obtaining a better deal for the forest, and so forest advocates coalesced behind the negotiated land-use plan.

Ambivalence and "Business-as-Usual"

In 2005, one year after the last major consensus recommendations for the North Coast were agreed upon, the government still had not turned any of the land-use agreements into law, and local environmental leaders reported that they could discern no changes in the companies' on-the-ground forest practices. Dismayed, the environmentalists accused timber companies of attempting to grandfather existing unsustainable forest practices into the pending new agreement, so logging under existing permits could continue for as many as four more years. (Business-as-usual logging practices in the Great Bear include clearcutting right to the banks of salmon spawning streams, which often destroys in-stream habitat and ruins the stream.)

For its part, although it co-funded the science on which the planning consensus is based, the provincial government for a long time resisted accepting the scientific recommendations of the independent scientists and instead sought to weaken environmental protections and delayed their implementation. Not until 2006 did the province ratify the consensus plan documents for the Central Coast, completed in 2003, or for the North Coast, completed in 2004. Despite the government's delay in approving the plans, the fact that consensus solutions were agreed upon led to a potential commitment of $100 million dollars of nongovernmental funding for First Nations and other rural communities for economic diversification, depending on the eventual implementation of the land-use plans and the commitment of provincial and federal money. This was of great interest to the region, where unemployment in some communities is as high as eighty percent.

Hope Thrives; Prospects Remain Guarded

Although frustrated by the government's labored acquiescence, members of The Rainforest Solutions Project are now elated. "Going from only about 10 percent of the area protected to 33 percent off-limits to logging is a significant step," said Lisa Matthaus of the BC Chapter of the Sierra

Club of Canada. "Moreover, the consensus plans are groundbreaking in that the selection of the areas to be set aside was informed by the best available scientific advice." Matthaus continued: "Another crucial thing accomplished is achieving international recognition that this area is globally significant from an ecological perspective. That recognition itself can be economically significant for a long-depressed region."[53]

As Merran Smith of ForestEthics commented, "A decade ago, the government was unwilling to consider far-reaching conservation measures in the Great Bear Rainforest, because of their impact on the logging industry. Now a land-use plan that protects 100 rainforest valleys and implements a new type of ecologically based forest management has been adopted. While our struggles aren't over yet, this is clearly a major North American conservation victory! Moreover, it was set us on a path to a conservation economy here that could truly protect the Great Bear Rainforest for decades to come."[54]

The great victory that has been wrung from the hands of the timber companies and the reluctant provincial government may still not provide as much protection as the Great Bear needs, for no one knows how the ecosystem will respond to disturbance of up to two-thirds of its land area nor how faithfully environmental rules will be followed and enforced over a ten-million-acre land mass. How poignant that, with so much of the planet's forests already reduced to shades of their former glory, rare gems such as the largely pristine Great Bear still face a shrouded future. Yet, what a challenge! Perhaps an activist who is reading this book will have the genius, commitment, and charisma to help the Great Bear Campaign assure that environmental safeguards are observed throughout the vast forest and to devise a strategy to double the protected area—perhaps to save it all.[55]

SAVING THE SIBERIA TAIGA: A FORMIDABLE CHALLENGE[56]

The plight of the Siberian forests offers further evidence that it is far easier to propose plausible remedies to deforestation than to implement them politically and economically, or even to alert the world about them.

Unfortunately, successes such as those in the Great Bear Rainforest and Kitlope Valley are all too infrequent. Horror stories of tragic and difficult-to-arrest forest despoliation are all too common, such as the ongoing but little-known destruction of Siberian taiga forests. The taiga contains half of the world's remaining evergreen forests and a fifth of the

entire world's remaining forests, absorbing carbon dioxide emissions from the industries of Europe and Russia and serving as a global storehouse of carbon. Yet, the taiga is currently being destroyed at an increasing rate by massive industrial logging operations and by a huge increase in fires that, in 2004, burned an area half the size of France and polluted the air in cities as far away as Seattle. Some of these fires were due to the warmer, drier conditions accompanying global warming. Many forests, however, were deliberately put to the torch by loggers in order to get government logging concessions at reduced costs, so the timber can be sold to China. This story is well told in a recent interview with Siberian forest fire expert Dr. Anatoly Sukhinin.[57]

A great deal of damage has already been done to Siberia, not only by recent logging, but by ruthless industrialization during the Soviet era. "Perhaps never has so vast a territory been so despoiled so rapidly," wrote correspondent Eugene Linden from Siberia.[58] Since the breakup of the Soviet Union and the demise of its strong central government, the economically unstable new regimes that have replaced it are proving receptive to foreign-financed schemes for wholesale exploitation of boreal forest ecosystems, known as taiga. These magnificent, often pristine, swampy coniferous forests extend across Siberia and the Russian Far East.[59] By some estimates, thirty to fifty percent of these lands may still be untouched by human activities.[60] Covering an area the size of the continental United States and twice the size of the Brazilian Amazon, taiga plays critical roles in global climate as a carbon sink and source of oxygen. Taiga also provides sustenance to indigenous hunters, trappers, and fishermen, as well as to endangered Siberian tigers, giant brown bears, sable, and elk. Yet, the taiga is being cut at the rate of some ten million acres a year, and the Russian government wants to increase timber production in order to stimulate its struggling, resource-dependent economy. The wood is normally exported raw, which does not produce milling jobs in the region and helps to conceal a large trade in illegally logged raw wood. Pristine forests that are surprisingly rich in biodiversity are now being logged by Rimbunan Hijau, a Malaysian logging firm, that controls more than 2.5 million acres in Russia's Khabarovsk region. Scientists fear that the region's soils may be incapable of supporting forest regeneration after clearcutting. Siberian soils are often thin and fragile, and growing seasons are short, making recovery from clearcut logging difficult. In addition, two-thirds of Siberia rests on permafrost, and clearcutting can lead to

melting of the permafrost, turning the ground to bog and releasing large quantities of climate-destabilizing methane gas.

Environmentalists have only recently begun using Russia's nascent judicial system to force timber companies to start obeying requirements to conduct environmental impact reviews. Environmental regulations, such as they are, still go largely unenforced, however. Multinational firms—from Malaysia and elsewhere—that engage in joint ventures with Russian companies are largely unaccountable to citizens for their operations. Japanese companies, which have been responsible for massive tropical deforestation in Malaysia and Indonesia, are now heavily engaged in purchases of boreal forest timber from Siberia, as well as from Alaska and Canada, while China's growing consumption of wood resources has made it the largest importer of wood from Russia. Local environmentalists in Russia complain about large amounts of illegal logging that is driven by the Chinese market. Unless meaningful international action is taken to insure protection of the world's last great boreal forests, they will rapidly be destroyed for chopsticks and toilet paper. What strategies, techniques, and tactics offer hope of stemming forest destruction domestically, as well as abroad? The balance of this chapter is devoted to considering those issues.

OBSTACLES TO GLOBAL FOREST PROTECTION

It is easy to proclaim that a moratorium should be imposed immediately on the destruction of primary tropical forest, ancient old-growth temperate forest, and boreal forest. A moratorium would make sense, ecologically and economically (to do otherwise destroys local subsistence economies). But major policy decisions about forests are not generally made on ecological grounds or for the commonweal; they are made by high government officials "under the influence." The intoxicant, however, is money, not alcohol—and it flows in vast quantities. Corrupt government officials routinely sacrifice forests for personal advancement, to win reelection, or to consolidate power, currying favor with big corporations and betraying public trust in the process. In democracies, the timber industry payments may come above board as contributions to a politician's campaign coffers; in many Third World tropical nations, payments take the form of outright bribes. In parts of the former Soviet Union, official patronage, favoritism, and corruption are a veritable way of life that is hardly even questioned.

In addition, many honest politicians and government officials throughout the world are simply ignorant of, or oblivious to, intrinsic natural eco-

logical values and services provided by forests and other natural resources.[61] The only values they ascribe to natural resources are those that the resources will bring them when auctioned to the highest bidder or their short-term liquidation value in the marketplace. Powerful modern technology and great wealth together have empowered such leaders with the means to destroy nature; ecological ignorance and lack of political accountability confer a sense of entitlement to do so. Thus, as nations continue to embrace global urbanization and to rely on technologies that enable individuals to separate themselves and become estranged from nature, political leaders commonly arise capable of sanctioning the destruction of vast ecosystems that sustain us all. Making matters more complicated, all forest sellouts do not occur at the apex of the political pyramid. In some developing countries, in-the-field government forestry officials are so poorly paid that they cannot live on their salaries alone. Unless these forest guardians are paid a decent wage, they will remain susceptible to bribery, selling the forest to help eke out their subsistence.

GLOBAL FOREST PROTECTION

Rather than simplistic quick fixes to save the world's forests, a comprehensive suite of programs needs to be put in place to improve the odds of success. These coordinated programs must be responsive to the fundamental causes of deforestation and must utilize or amplify those factors and tendencies that are protective of forests.

Whereas nothing these days provides forests with ironclad protection, forests tend to be more secure:

• If the land is recognized to have economic value either as a sustainable resource, such as a watershed, or for nondestructive cropping of local flora and fauna (medicinal herbs, butterflies, iguanas, etc.);

• If the land is established as an "extractive reserve" on which native people have recognized rights to live and pursue sustainable harvesting of forest products;

• If the forests are officially designated as parks, nature reserves, world heritage sites, or ecotourism destinations;

• If the property rights of native peoples are recognized, and the peoples are made custodians of the land for purposes of sustainable use (minus rights to alienate [sell] the land for development);

- If the forests are clearly demarcated to prevent incursions by poachers and timber thieves;

- If the forests are culturally regarded as sacred sites;

- If the forests are remote from roads and developed areas;

- If a professionally trained and properly remunerated cadre of forestry workers safeguards the forest;

- If the development rights have been locked up through the use of conservation easements or other legal means; and

- If an enforceable legal framework exists for severely punishing abuses of forest regulations.

Thus, forest-saving programs must be responsive to a whole range of cultural, ecological, economic, historical, social, and spiritual realities.

MEGA-STRATEGIES FOR SAVING FORESTS

One basic forest-saving strategy is to ensure that forest protection pays those who safeguard the forests more than forest destruction does. Thus, paradoxically yet predictably, the road to forest protection globally requires that we pay more, not less, attention to the trail of money and, even more importantly, to the economics of timber exploitation and protection. Recognizing that economic incentives have to be altered so that it is more profitable for governments and people to save forests than to destroy them, a steady stream of payments should be made by those nations that benefit from global forests and that can afford to pay "forest-guardian" nations that still have intact, healthy tropical forests. Such payments to developing tropical nations might well be offset by the tens of billions of dollars (or more) worth of pharmaceutical preparations that the developed nations have received, and may continue to receive, from compounds that originate in tropical forest plants. Payments to the developing nations could also recognize the climate-stabilizing benefits of the forests saved and could represent a form of climate "insurance premium." Forest-guardian nations might also receive money as tacit crop insurance payments for the additional tens of billions of dollars in value that the plant genes of tropical forest plants can save in the future by conferring disease- and pest-resistance on the world's agricultural crops.

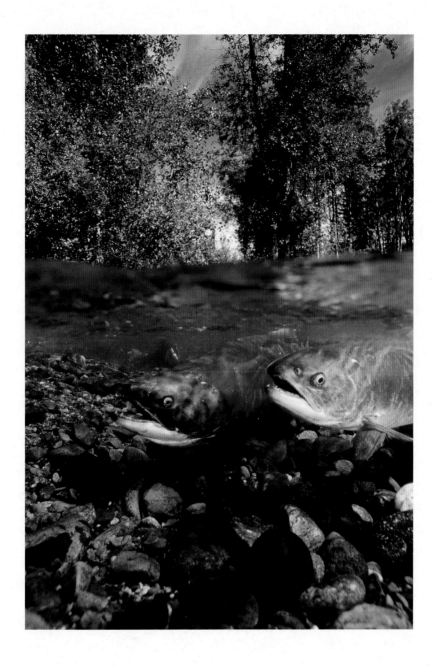

Fig. IV.1. Sockeye salmon in the Horsefly River, near Horsefly Foothills of the Columbia Mountains, British Columbia, Canada. Photograph © Mark Conlin/Larry Ulrich Photography.

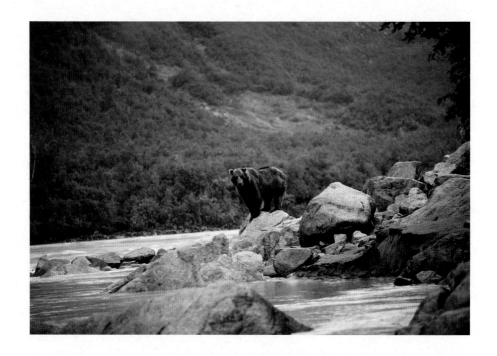

Fig. IV.2. This large grizzly bear emerged from the forest at the head of Abercrombie Falls on the Copper River in south-central Alaska, presumably to check out the "state of the salmon" at one of the bears' favorite fishing spots, where the river narrows and the salmon fight their way through the falls. Photograph © Benson Lee.

Fig IV.3. Acorns embedded in a tree trunk serve as a pantry for storage by an acorn woodpecker in Bear Valley, Point Reyes National Seashore, California. Photograph © Frank S. Balthis.

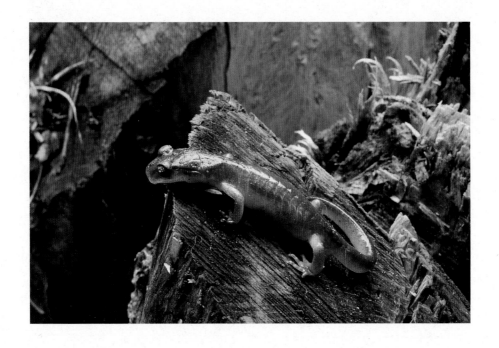

Fig. IV.4. A salamander in a forest in the Santa Cruz Mountains, near Santa Cruz, California. Photograph © Frank S. Balthis.

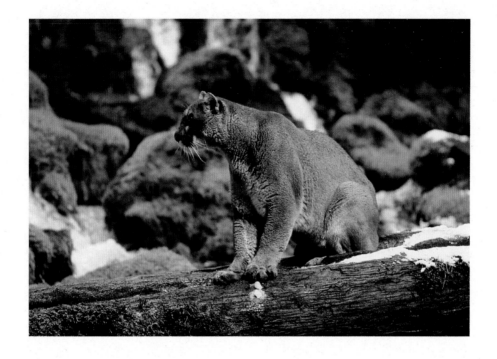

Fig. IV.5. A mountain lion in the Umpqua National Forest, Oregon. Photograph © Frank S. Balthis.

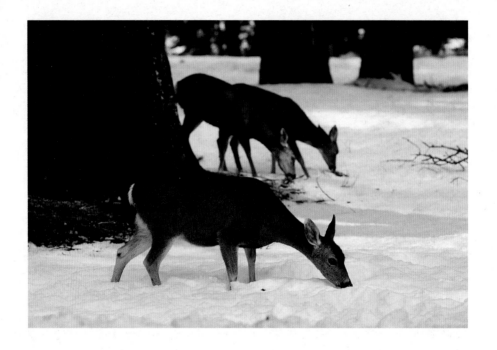

Fig. IV.6. Mule deer in Yosemite National Park, California. Photograph © Frank S. Balthis.

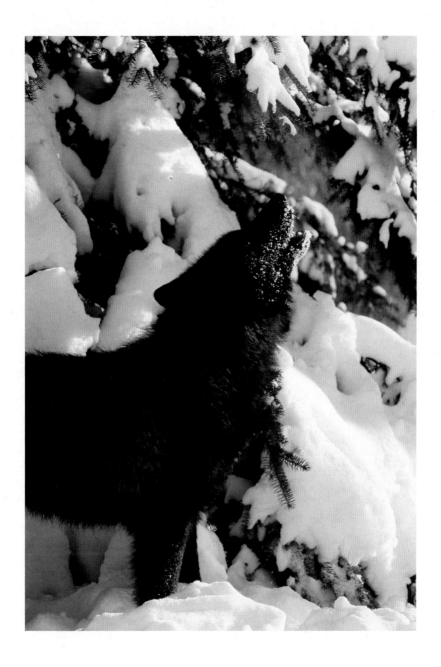

Fig. IV.7. A gray wolf in the forests of Carlton County, Minnesota. Photograph © Craig Blalock/Larry Ulrich Photography.

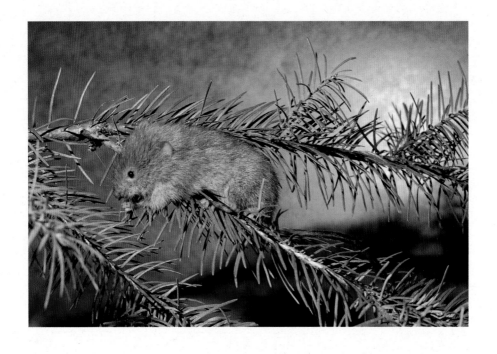

Fig. IV.8. A red tree vole, an indicator species of an ancient forest, near Monroe in Benton County, Oregon. Photograph © Ronn Altig.

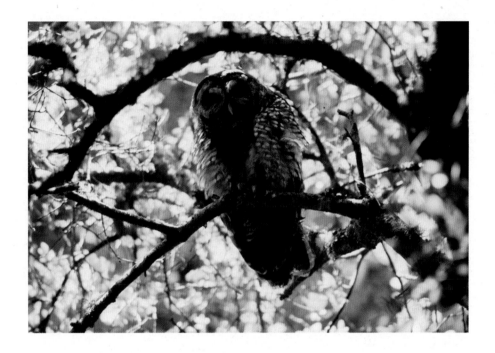

Fig. IV.9. The endangered northern spotted owl, an old-growth forest indicator species shown here in Tomales Bay State Park, near Point Reyes National Seashore in California, has become a cause célèbre in the Pacific Northwest. Photograph © Benson Lee.

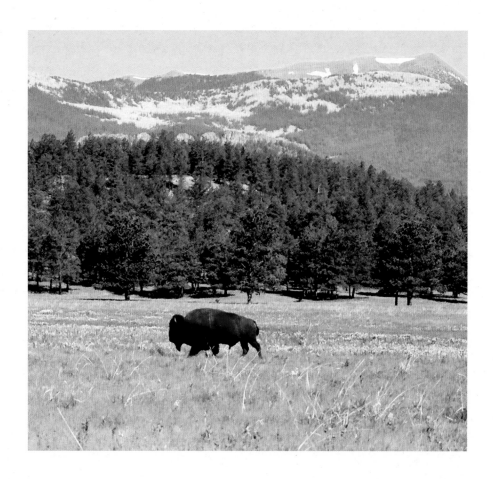

Fig. IV.10. Northern New Mexico's stunningly beautiful Valle Vidal, in the Sangre de Cristo Mountains, is threatened by coalbed methane drilling. Photograph courtesy of the Coalition for the Valle Vidal.

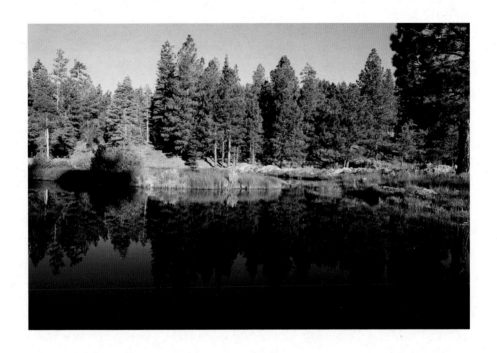

Fig. IV.11. Protecting wildlife and fish habitat by keeping logging away from lakes and ponds is one of the marks of the Forest Stewardship Council [FSC]-certified Collins Lakeview Forest in Lakeview, Oregon. Photograph © 2003 The Collins Companies.

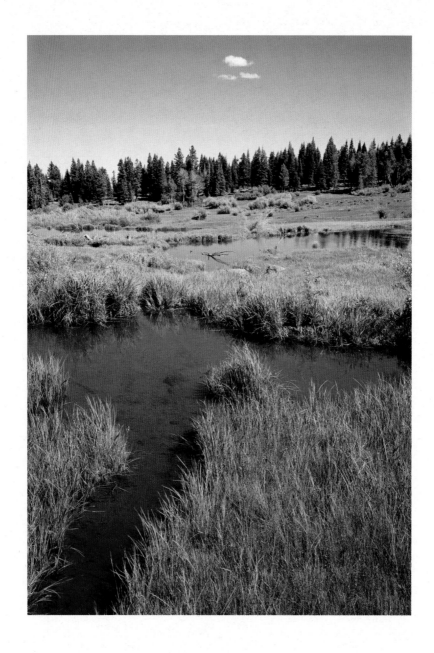

Fig. IV.12. This natural and active beaver pond in the Forest Stewardship Council [FSC]-certified Collins Lakeview Forest in Lakeview, Oregon, exemplifies the company's commitment to maintaining a natural, biodiverse forest. Photograph © 2003 The Collins Companies.

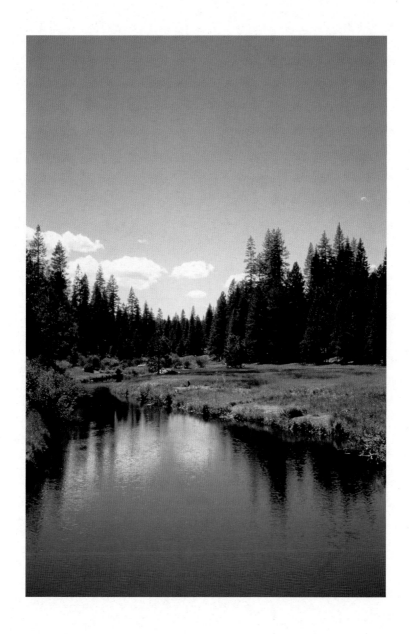

Fig. IV.13. The Forest Stewardship Council [FSC]-certified Collins Almanor Forest in Chester, California, has never seen a clearcut since the land was acquired in 1901. As a result, Butt Creek, shown here, is an example of how rivers and streams—and thus fish, birds, and wildlife habitat—are protected. Photograph © 2003 The Collins Companies.

Fig. IV.14. What you leave in a forest is more important than what you take, as seen here in the softwood Collins Lakeview Forest in Lakeview, Oregon. Photograph © 2003 The Collins Companies.

Fig. IV.15. Meadows and creeks wind through the mixed conifer stands in the Forest Stewardship Council [FSC]-certified Collins Lakeview Forest in Lakeview, Oregon. Photograph © 2003 The Collins Companies.

Fig. IV.16. To enhance fish and wildlife habitat, no logging or road building has ever occurred near the rivers, streams, creeks, or wetlands of the Forest Stewardship Council [FSC]-certified Collins Pennsylvania Forest in Kane, Pennsylvania. Photograph © 2003 The Collins Companies.

All payments would be on a sliding scale and would be contingent on successful action by recipient host nations to protect permanently their forests from destruction. The better the protection provided, the greater the payments would be. Consistent with the discussion of conservation easements in Chapter 14, payments could also be construed as easement payments to compensate recipients for not developing forest land and to support them in embarking on programs of nondestructive sustainable forest use. The payments could also be regarded as installment payments for future benefits that the developing countries will receive if the forests are maintained.

This subvention strategy admittedly has a potentially tragic flaw: it may result in payments to regimes that tyrannize their people as well as destroy their forests. (This condition unfortunately exists for all kinds of foreign aid, not just for forests.) To avoid supporting unjust governments while working for forest protection, parallel efforts need to be made in support of social justice and democratic leadership. Intense political pressure should accompany offers of tempting aid packages in return for effective action to protect forests. Another objection to subventions is the risk, perhaps even the probability, that much of the money paid would be misspent or embezzled and that little ultimately may reach the localities where protective actions are needed. While working to create government-to-government subventions for forest protection, forest defenders can simultaneously work to shift control over forests to interest groups most receptive to forest protection and least likely to violate public trust. In practice, this means working to reform patterns of forest property rights. Those groups with the deepest roots in the forest and, therefore, with the deepest commitments to its protection are the logical forest stewards and leading candidates for forest trusteeship responsibilities. It is they who should normally be given back day-to-day control over their resources. But no group, indigenous or other, should be allowed to take actions that destroy the resource base, a common heritage of all peoples.

In conclusion, the aggregate pattern of incentives affecting forests — from the international to the national to the local level — all must be orchestrated to reinforce and ensure that forest stewards—be they state forest departments, indigenous peoples, high-level diplomats, businessmen, elected officials, or dictators—all receive far greater rewards for nonconsumptive and nondestructive sustainable forest use than for its destruction.

SANCTIONS FOR MISBEHAVIOR

Concurrently, severe penalties need to be put in place for mistreatment of the land. These are crimes not only against nature, but against present and future generations that are being robbed of their natural resource heritage. At a minimum, civil penalties for corporations should include loss of existing timber concessions and loss of the right to contract for future timber purchases. For repeat or flagrant offenders, the penalties must be suspension or revocation of the right to practice commercial forestry and criminal penalties.

In addition to penalties sufficient to deter malfeasance, stricter enforcement of forest laws and regulations are needed, as well as substantial requirements for bonding, so that ample funds will exist to finance attempted restitution of damage, if needed. Funds for more vigorous enforcement of forestry laws and regulations should be derived from "stumpage fees" akin to, but proportionately greater than, royalties paid by mining companies on minerals removed from public lands. In the United States, stumpage fees, for example, ought to be sufficient to augment the often-inadequate funds available in the United States for reforestation through the Knutsen-Vandenberg Act of 1930. Also in the United States, although timber companies logging on the national forests are already liable to correct forest damage they cause, these sanctions ought to be much more frequently imposed.

THE SIERRA CLUB'S RESPONSE TO COMMERCIAL LOGGING ON U.S. PUBLIC LAND

In the United States, the Sierra Club has grown frustrated with federal mismanagement of the national forests and with the resulting forest damage. Since 1996, therefore, the Club has publicly opposed any further commercial logging on national forests or other public lands. The club took this position out of dissatisfaction with consistent failures by the U.S. Forest Service and the U.S. Bureau of Land Management (BLM) to fulfill their public trust responsibilities. As I have discussed at length elsewhere in the book, commercial logging on national forests and BLM lands has indeed caused severe environmental damage. In view of the two federal agencies' past performance, the Sierra Club believes they are unable to resist timber industry pressure and to protect public lands from abuse in the future. Moreover, the havoc wreaked on the public lands produces only about twelve percent of the nation's timber supply—an amount easily replaced

by more intensive recycling of used wood and waste paper, more efficient wood utilization, and use of wood fiber substitutes for paper production.

The club, therefore, supported the National Forest Protection Act of 1997 (discussed in Chapter 5), which has yet to be adopted. In a democracy, the possibility of passing far-reaching, forward-looking bills such as the National Forest Protection Act is an enduring source of hope to the forest protection movement. Whereas the act did not become law, like a seed beneath the snow waiting to germinate, the ideas the act embodied may one day surface in the right political climate.

ALTERNATIVES TO TREES

The United States, in the late 1990s, imported about $4 billion worth of newsprint made from Canadian forests. Yet, high-quality paper, cardboard, and fiberboard can be made from other sources of fiber, including straw and other regionally appropriate crops that can be grown sustainably on existing farms. Some researchers believe that U.S. paper consumption actually could be met entirely by using a feedstock consisting of an equal mixture of waste paper combined with nonwood agricultural products.[62] Kenaf and hemp are two practical and renewable alternatives to wood fiber for making paper and paper products. Kenaf (*Hibiscus cannabinus*), a tall, hardy grass that originated in Africa, can produce a smooth, soft, acid-free, chlorine-free paper that is delightful to the touch. The plant can reach heights of twelve to fourteen feet in just four to five months. It also is stronger, whiter, and yields higher-resolution photo reproductions than does newsprint.

Studies by the U.S. Department of Agriculture found that kenaf can yield six to eight tons of dry fiber per acre. That is up to five times the pulp per acre produced by an acre of fast-growing trees, such as Southern pine. Advocates of kenaf claim that its high yields can be achieved at half the cost of raising trees, while its deep roots also remove excess salt from saline soil. Kenaf pulp is also cheaper to process than wood pulp, since kenaf processing requires less chemicals and fifteen to twenty-five percent less process energy than the pulping of pines.

Whereas kenaf has been grown in Africa for about 4,000 years, hemp (*Cannabis sativa*) is another high-yielding plant that has been grown for food and fiber for some 12,000 years. Hemp fibers are the longest, strongest, and possibly the most durable alternatives to wood pulp. The

plant is very easily grown, widely distributed in northern latitudes, and several times more productive than most tree species. Because the fibers are low in lignin, it takes less energy and environmentally hazardous chemicals to pulp. Since it is naturally bright, hemp requires little or no chlorine bleach. Hemp can also be recycled more often than wood because its fibers are longer. Finally, because it is naturally pest-resistant and is grown in dense stands to maximize stalk production, it can be grown without pesticides and herbicides. The plant's seed can also be processed into a useful oil, while the fibers can be pressed into particle board and other valuable construction products. To produce soft paper, hemp may need to be blended with softer fibers, such as kenaf. Although hemp crops may deplete soil nitrogen and require fertilization or rotation with nitrogen-fixing crops, these are far from insurmountable obstacles.

Unfortunately, the hemp plant bears a serious stigma: the flowering tops and leaves can be smoked as marijuana. Industrial hemp, however, actually contains very little THC (tetrahydrocannabinol), the psychoactive compound in marijuana. Plants grown for marijuana generally contain many times the THC concentration of hemp. Smoking industrial hemp is a very unpleasant and unrewarding experience due to the large amount that would have to be consumed and the paucity of THC. Nonetheless, hemp's production in the United States continues to be hampered by laws designed to interdict marijuana.

Whereas it may be technically feasible to reduce vastly the consumption of virgin wood fiber for paper production, Carrere and Lohmann (1996) caution that such "new paths" are not going to be adopted by industry or government just because researchers identify or experiment with them. They advise that these solutions will not be embraced unless strong social and economic pressures are exerted in collaboration with popular movements that challenge established institutions and demand "more democratic control of the paper economy."[63]

Alternatives to wood fiber are entering the paper economy on a small scale, however; some FedEx Kinko's copy shops already offer hemp paper, and some U.S. paper companies have been seeking permission to grow the fibers domestically. The Greenpeace catalog and the Real Goods Trading Company of Ukiah, California, both sell kenaf paper. The International Kenaf Association (101 Depot Street, Ladonia, TX 75449) is a clearinghouse for information on kenaf.

DEMAND FOR WOOD CAN BE REDUCED

The nations of the world have enormous opportunities for reducing wood consumption, for recycling wood pulp, and for substituting other sources of pulp for trees. All of the wood fiber that has already been processed or that is already being farmed must be used efficiently before we dream of further damaging forests of high ecological value. According to the Worldwatch Institute, *one of every two trees cut is wasted through failure to recycle and inefficient wood utilitzation.*

Globally, more than half of all the wood used is consumed as fuel, but, as countries urbanize and industrialize, they can increase the efficiency of wood processing and combustion and can also substitute other fuels for wood. Wood consumption in developing nations can, therefore, diminish, just as it has in industrialized nations for the past century.

In addition to the available alternatives to trees for paper goods, excellent alternatives to trees for construction materials exist. For example, nonwood fibers can be incorporated today into pressed board products for which solid board was once needed. This suggests that, by using environmentally preferable substitutes and simultaneously raising the cost of solid wood—through public policies, conservation, and greater efficiency in wood use—we could eventually lower wood consumption, provided that population growth does not outpace conservation efforts.[64]

HOW TO WORK FOR FOREST PROTECTION

In the United States, citizens can help to protect forest resources in many ways—from commenting incisively on a proposed Forest Service timber sale (see Chapter 5 and Appendix A), to planting a grove of trees or shelter belt (see Chapter 15), perhaps to saving and restoring a large forest (see Chapter 12), to reducing our consumption of forest products. Since much of the forest destruction in the world is driven by demand for pulp, paper, timber, and other wood products, the more we personally conserve, recycle, and avoid unnecessary packaging, the less we contribute to deforestation. We can also work in many ways in the political arena, at the county, state, federal, and international level, or by participating in direct action and civil disobedience. The important thing is to take *some* forest-saving action. Even if those actions seem small relative to the challenge, they may inspire others and lead to important and sometimes unforeseeable results. As we continue to learn about forest and wildlife issues, for example, we can share our growing knowledge with children, friends,

coworkers, and neighbors. A child taught to love and respect nature today may be tomorrow's John Muir or Rachel Carson.

There are countless paths for sharing knowledge and communicating our concerns—from organizing concerned citizens to campaign for a wilderness area, to protecting an old-growth grove targeted for logging, to planting trees in a greenbelt, to helping park personnel restore damaged public forests, to urging timber and paper companies whose stock one may own to manage their commercial forests sustainably, to urging lumber retailers not to carry old-growth wood or lumber from forests not sustainably managed. In embarking on forest protection or environmental work of any kind, remember Catholic Worker Amon Hennessey's admonition: never underestimate the power of the committed individual to act effectively for good. Especially if one perseveres and joins together with like-minded people, the work could lead to the protection of a threatened wilderness or to the creation of a forest park, wildlife refuge, or national monument. It is so easy to be politically passive, complacent, and uninvolved in determining the outcome of today's critical environmental and political crises, but it is deeply rewarding to have an influence on problems far beyond what may seem possible.

David R. Brower, the late conservation leader extraordinaire, once asked, "How many people was Rachel Carson?" One could equally well ask, How many people was David Brower—Sierra Club board member and its executive director for many years; founder of Friends of the Earth, League of Conservation Voters, and Earth Island Institute; and a powerful force behind myriad conservation victories? Or how many is the Sierra Club's Dr. Edgar Wayburn, who campaigned successfully for the protection of 100 million acres of Alaskan public interest lands, or Earth First! co-founder Dave Foreman, who again and again placed himself in front of loggers bent on old-growth destruction and whose passionate speech, deeds, and writing have awakened millions of Americans to the perils threatening their forests, wilderness, and wildlife? How many people, too, was John Muir, who founded the Sierra Club, led the successful campaign for Yosemite National Park, and helped inspire Theodore Roosevelt to establish wilderness reserves, national monuments, and parks? Finally, how many people was Dr. Richard St. Barbe Baker, who during his life initiated programs that led to the planting of twenty-six *billion* trees?

Trite as it sounds, it is absolutely essential to let your state legislators, forestry board, governor, congressional representatives, president, and

cabinet members know that we support protection of all old-growth forest, parks, and wilderness. Write, call, and visit these people, who have the power to save endangered ecosystems and species and who control funds that could mitigate damage to them. *Develop long-term relationships with these leaders.* They may gradually come to respect your knowledge, concern, and perseverance in working to improve natural resources management. Let the media know of important environmental issues that concern you by calling, writing, and meeting with members of the press.

Finally, we must work together with environmental organizations and grassroots groups to protect and expand designated wilderness, parks, and ecosystem restoration efforts. The National Wildlife Federation's *Conservation Directory* can acquaint you with a broad spectrum of groups employing a wide range of tactics—from court action to public education, to land trust formation, to direct action. The Ecology Center of Southern California also publishes a very comprehensive environmental group directory. These groups will invariably be eager to tell you about their work and invite your participation and support. For more forest-saving ideas, consult the forestry sections of *This Land Is Your Land* and *Design for a Livable Planet*, or see *Saving the Forests* and *Saving Nature's Legacy*, all in the *Text References and Recommended Readings* section at the back of this book.

One last note: for inspiration regarding grassroots forest-saving action, remember the Chipko ("hug the tree") Movement, one of the world's most famous grassroots ecological campaigns.[65] The movement began in 1973 among the peasants of the Himalayan foothill country of Uttarakhand in Uttar Pradesh, India, situated between Nepal and Kashmir. Women played a prominent role in Chipko, but it was a broad social movement supported by men and children as well. The women of Uttarakhand hugged trees in nonviolent resistance to the state and private logging contractors who tried to cut down their local forests. Chipko's successful direct actions not only led to a moratorium on the felling of live trees in Uttarakhand, but also inspired other forest defenders in India and around the world, including the grassroots direct action forest protection movement in the United States, epitomized by Earth First! Through its reforestation work, marches, and other activities, Chipko expressed an inherently powerful vision of an ecologically sustainable and economically just society.

CHAPTER 14.
TROPICAL FORESTS AND INTERNATIONAL FORESTRY ISSUES

Among the scenes which are deeply impressed on my mind, none exceed in sublimity the primeval forests undefaced by the hand of man. . . .

—CHARLES DARWIN, *The Voyage of the Beagle* (1839)

No government had the ability and political will to combat deforestation in Brazil. Considering that data from 1994 already showed a worrisome situation, it is obvious that things are much worse today. We are reaching the point of 25,000 to 30,000 square kilometers of forest destruction. Urgent action must be taken.

—MARCELO FURTADO, CAMPAIGN DIRECTOR, GREENPEACE (2004)

THERE IS NO EFFECTIVE LAW ENFORCEMENT on the ground in Indonesia's forests. . . . Widespread corruption encourages open access to forest resources by enabling wealthier and better-connected individuals and groups to move outside the law with no fear of prosecution. Individuals in this group include companies, civilian government officials, law enforcement personnel, and legislators. . . . The military acts as private enforcer for companies by breaking up protests against 'land acquisitions' and company representatives, or burning down villages. . . . Foreign investment has broadly financed the Indonesian timber industry, accounting for U.S. $12 to 15 billion since the early 1990s. . . . Examples include mutilateral development banks, such as the World Bank and Export Credit Agencies (ECA). . . . ECAs from Finland, Germany, Spain, Denmark, Sweden, Belgium, and the U.S. supported the construction of pulp and paper mills.

—ESTHER SCHROEDER-WILDBERG AND ALEXANDER CARIUS, *Illegal Logging* (2003)

TROPICAL FORESTS are the richest sources of biodiversity in the world, containing two-thirds of the world's plants on only about twelve percent of its land area. One forest reserve in Costa Rica has more plant species than the whole of Great Britain; one river in Brazil has more fish species than all the rivers of the United States; one hectare (about 2.5 acres) of Amazonian forest may have forty times the number of species of a typical temperate forest hectare, which usually has only two to twenty tree species. A hectare of Atlantic coastal forest in eastern Brazil was found to contain 476 tree species, including 104 never seen before in that type of forest and five previously unknown tree species.[1]

TROPICAL FOREST LOSSES

A maelstrom of destruction is engulfing the world's tropical forests—each year, an area about the size of Louisiana (thirty-three million acres) is being lost to deforestation in the tropics. From 1981 to 1990, about 385 million acres of tropical forest were destroyed—an area three times the size of France. According to the United Nations Food and Agriculture Organization, the situation remained bleak from 1990–2000 as another 212 million acres were lost to deforestation. To date, the world has lost more than half of its tropical rainforest.

The world is now probably losing more than 130 species a day to extinction, according to scientific estimates.[2] Without exaggeration, time is rapidly running out for the tropical forests. Only the most vigorous, persistent, and sustained efforts offer much hope of stopping the holocaust of forest destruction before most of the world's remaining tropical forests are destroyed. They are disappearing so fast that a recent United States Agency for International Development (USAID) study reported that:

> Former major West African timber producers, e.g., Nigeria, Ghana, and the Ivory Coast, have severely reduced their stocks over the course of the 20th century Central African states, such as Gabon, Cameroon, and Congo/Brazzaville have likewise . . . felled much of their standing timber Along the African coast, the forest belt ran inland an average 200 miles for some 2,800 miles. Much of this forest has now been cleared[3]

Weak, troubled, strife-torn, and corrupt governments in tropical nations often encourage, allow, or condone deforestation. Thus, much of the

tropical forest that remains in Asia, Africa, and the Neotropics has already been pillaged for plants and animals and is severely degraded. Sought-after species, such as mahogany and teak, are already scarce in many countries where they used to be plentiful. If current trends in tropical deforestation continue, within about a decade the world will lose all but a few relics of its tropical forests throughout much of their range, much as North America has lost all but five to six percent of its old-growth forests. Even where forests still stand, large or even medium-sized mammals have been wiped out for food or for sale to the lucrative wildlife trade that now traffics in almost anything that walks, crawls, swims, or flies through the forest. These depleted ecosystems have even been given a name: "empty forests."

In Asia and Africa, a significant amount of deforestation is being driven by an enormous demand for wood from the People's Republic of China and Japan. China banned all domestic logging in the mid-1990s in response to severe domestic flooding and is now scouring Asia and Africa to supply its domestic timber demand. Unscrupulous logging companies and ruthless weapons dealers have been quick to profit from the situation. Former Liberian President Charles Taylor, a convicted felon indicted by the United Nations (UN) as a war criminal, found that he was able to trade tropical timber cut in Liberia and neighboring countries with Chinese traders for weapons. He used these arms to fight a ruinous civil war in Liberia and to conduct wars with neighboring countries that produced enormous human suffering and hundreds of thousands of refugees. Keith Alger, a vice president of Conservation International, a private organization seeking to protect global biodiversity, calls the trade in illegal timber, "a piggybank for bad actors that finance terrorism, crimes, or corruption."[4]

Most of the world's demand for timber today is driven not by military conflict, however, but by various economic pressures. Malaysia, Thailand, and Indonesia, for example, have large wood-processing mills with tremendous appetites for wood.[5] Elsewhere, the motive for large-scale deforestation often is eagerness to convert forests to agricultural land for the production of cash crops for export. In Brazil, vast areas of former forest and savanna have been converted to soybean fields to meet China's huge demand for soy protein.

THE DEFORESTATION OF INDONESIA

Indonesia still has 235 million acres of tropical forest, the third largest tropical forest area in the world (after Brazil and the Democratic Repub-

lic of Congo), but half is already degraded by human activity and some of the degradation is severe. As documented by researchers Esther Schroeder-Wildberg and Alexander Carius, in one of the most important tracts ever written on the causes and solutions to tropical deforestation, Indonesia's remaining forests are in a free-fall, and not even its national parks are safe from depredation.[6] The account that follows draws heavily upon their expert research.

Since 1996, an average of almost five million acres a year of natural forests have been deforested in Indonesia, and various observers project that all of that country's accessible natural forest may disappear in less than twelve years. Illegal logging is rampant and is reliably estimated to range from seventy-three to eighty-eight percent of all wood cut in the country. Indonesia's wood-processing industry and wood products export sector are all heavily reliant on illegal timber.

Poor governance is a root cause of this crisis. In Indonesia, the military is the country's sixth-largest legal timber concession holder and is widely known to be deeply involved in the illegal logging industry. Elements of Indonesia's police and the Ministry of Forestry are (or until very recently were) all active participants or beneficiaries of the deforestation. Prestigious international financial institutions, including Barclay's Bank, Bank of America, and Deutsche Bank, have provided the capital for the advanced technology that has helped make the carnage profitable, financing the nation's sawmills, paper mills, and pulp mills.

Whereas some raw logs are smuggled out of Indonesia, most of the illegally cut and exported wood is commingled and shipped with legally obtained forest products. These illegal logs often travel from Indonesia to Malaysia or Singapore, where they are given false documents that disguise their Indonesian origin to facilitate their trans-shipment to customers in Asia, Europe, and the United States. Existing and impending free-trade agreements may well make this timber laundering even easier.

The ecological and social results of deforestation in Indonesia have been nothing short of devastating. In addition to millions of acres of ruined land, hundreds of people have died, and, in just fourteen months, more than a million were driven from their homes by floods, landslides, and other natural disasters linked to widespread deforestation.[7] Communities of indigenous peoples have also been intentionally dispossessed or repressed so their forests could be looted. The environmental holocaust in Indonesia—including watershed destruction, biodiversity losses, soil

erosion, droughts, and overdrafting of natural aquifers—has been so fla-
grant that it has attained worldwide notoriety.

Effective international action, however, has not been forthcoming either
in the form of meaningful economic sanctions or in the form of a compre-
hensive, multibillion-dollar forest conservation aid program. Economic sanc-
tions might include an international boycott of Indonesian goods.
Opponents of sanctions rightly point out, however, that sanctions might
have the effect of alienating the Indonesian government and other segments
of society whose cooperation is deemed necessary to stop deforestation.

Incentives for forest protection might include offers of international
financial assistance contingent on the annual achievement by Indonesia
of a set of conservation goals. Among other obligations, Indonesia would
be required to devote an agreed-upon portion of the assistance to on-the-
ground protection of forest resources, to the extirpation of the illegal tim-
ber trade, and to the development of effective forest protection laws,
policies, and institutions. Some of the assistance would be earmarked
to assist with economic development projects that do not threaten
forested areas.

Without major improvements in governance in Indonesia, however,
corrupt officials are likely to continue diverting aid from intended pur-
poses and intended recipients, no matter how well-intentioned and well-
designed the aid may be. A spectrum of international, regional, and
bilateral reforms aimed at ending illegal Indonesian logging have been
formulated, but, unfortunately, few if any have been successfully imple-
mented.[8] Absent rapid and more decisive international action, forest
destruction will likely remain a way of life for many sectors of Indonesian
society until little accessible natural forest is left to destroy.

BRAZIL: FAINT RAYS OF HOPE AMIDST CHAOS AND FOREST DESTRUCTION

Unfortunately, results of the deforestation drama being played out in
Indonesia — and the international community's generally ineffectual
response — are not unique. In Brazil, for example, despite well-inten-
tioned, worldwide expressions of concern about tropical rainforest
destruction, the incineration of the Amazon rainforest region continues.
Weather satellite photos revealed more than 72,000 fires burning in the
Amazon just during the first half of August 1995. As much as six million
square kilometers (2.3 million square miles) were covered with thick, gray
smoke at one time. Some of the pall hung over Bolivia, Paraguay, and

Uruguay as well, indicating that the forest damage was not confined to Brazil. In 2002, more than 9,100 square miles of the Brazilian Amazon were destroyed. Current estimated annual rates of deforestation are 9,700 to 11,600 square miles per year.[9] Moreover, environmental activists report that some of the world's largest and most rapacious international timber companies, fresh from massive deforestation activities in Asia, are at work in the Amazon. According to Keith Alger, an expert with Conservation International, "Many countries, such as Bolivia, have policies that allow large logging concessions—and these have expanded greatly with Asian financing. Foreign timber companies prefer to operate where large logging concessions can be purchased from the government."[10] Unless their plans and operations are forestalled by a global public outcry and a change of policy by South American governments, these companies and the advanced logging and milling technology they bring will further devastate the Amazon.

In addition to some uncertainties about exactly how much acreage is being lost in the Amazon, no one seems to know how much of the land being burned is virgin rainforest or second-growth forest and range; what the impacts of the forest losses are on particular species of animals and plants; and what the hydrological cycle and climate stability impacts are. The Brazilian government reportedly has cancelled the subsidies it paid for years to those who cleared the forest, but the catastrophic large-scale conflagrations continue year after year, decade after decade. Brazil has been ambivalent where protection of the rainforest is concerned. In 1992, the Brazilian government hosted the UN Conference on Environment and Development (aka Earth Summit or "Rio Summit"), as a friend of the environment. Afterwards, however, instead of curtailing forest destruction, the government simply stopped systematically analyzing the crucial satellite image data previously used to monitor the forest's fate. The international commitments made by the assembled nations to reduce deforestation were to have been pursued by the UN Commission on Sustainable Development, but tangible results have been sparse. Neither UN nor other efforts will succeed without an unyielding determination to confront the political and economic interests that control forests.

Under criticism, Brazil reportedly has now ordered the satellite photo analysis to resume, but evidently it is incapable of bringing the incineration of the Amazon to an end without powerful international assistance. If

the world community as a whole remains complacent, irresolute, and ineffectual in its response to the crisis in Brazil, further massive rainforest destruction is a virtual certainty. It is still possible, however, to save tropical forest on a grand scale. In the state of Amapa, Brazil, Conservation International and its partners in 2002 successfully prodded the state and federal government to set up the Tumucamaque Mountains National Park, the world's largest tropical forest park.

This 9.5-million-acre preserve of remote, intact tropical rainforest is one of the most pristine tropical forests left anywhere on Earth. It contains 350 bird species, large mammals, such as jaguar, puma, and giant anteater, and at least eight species of primates, including the white-faced saki monkey. The historic conservation success in Amapa was sponsored by Conservation International's Global Conservation Fund. The fund first coordinated scientific assessments of the region and brought scientists together for conferences that led to the delineation of the park's boundaries and helped to win the support of Brazilian leaders. The boundaries were drawn as part of an overall sustainable development plan for Amapa state that offers economic benefits to various local stakeholder groups, while protecting the environment.

Elsewhere in much of the Brazilian Amazon, lawlessness, violence, and an unscrupulous disregard for the environment reign. As recently as 2005, the Brazilian government of Luiz Inácio Lula da Silva capitulated to pressure from corrupt logging companies which are razing the forest.[11] The Brazilian government in 2004 had cancelled land registrations for many large landowners in the northeastern Amazon state of Para, where, according to *The New York Times*, "lands owned by the federal government have been illegally occupied and subdivided and then repeatedly sold without proper land titles, often by and to logging groups."[12] But when loggers and their supporters marched, demonstrated, burned buses, and blockaded both a major highway and a tributary of the Amazon River in opposition to the government's attempts to regulate logging—and threatened to dump toxic chemicals into that tributary—the federal government's forestry agency knuckled under and reinstated the cancelled logging licenses. A short while later, however, in yet another reversal, the indecisive government rescinded the reinstated licenses.

Canceling the land registrations of large landholders in Brazil is a step toward the eviction of illegal loggers, which the government is reportedly planning. The government also plans to reregister land titles and then

allow regulated logging to continue under new land tenure regulations. That would normalize, control, and limit the forest destruction, rather than prevent it. How much forest this would save remains unclear. The forest, whether cut by a rogue logging company, a chainsaw-wielding squatter, or a properly titled landowner, is still no longer forest. Some observers doubt whether the government has the power to impose its land registration program in the Amazon or to get the policy reaffirmed by the Brazilian Congress. Unfortunately, instead of enforcing environmental laws firmly, with military force if necessary, the government has delegated environmental enforcement to Brazil's chronically and pathetically underfunded environmental agency, which lacks resources, money, staff, and political power to stop forest destruction.

Just how bad the situation is both for the people and the environment in the Amazon can be inferred from *The New York Times* article, which reported that "loggers have also been accused of using slave labor, not paying taxes on their profits and bribing bureaucrats to obtain export licenses."[13] Conservation International's Alger, however, sees signs of progress:

> Brazil has made a significant decision to reduce deforestation and has taken some of the most innovative measures to reduce it, including systematic monitoring of where the focus of deforestation is, and what its causes are—through what kind of economic activities and actors. Policies have now been adopted to better enforce existing laws and implement new laws, such as the new law to establish minimum-impact logging concessions rather than to allow continued illegal logging expansion.[14]

But Alger also emphasizes that the expansion of soybean cultivation in Latin America, to meet China's demand, as well as profound, far-reaching ecological challenges resulting from global warming, which makes fires more dangerous, are all working against the rainforest's survival. Alger believes that, if we are to save the Amazon, the world will have to pay for it to counter the enormous new economic pressures contributing to its deforestation.

THE IMPACTS AT GROUND ZERO

In logged and mined tropical forest regions, the lives, lands, and cultures of native peoples have been brutally disrupted. Even where the forest

canopy has not been removed, the once-clean forest streams and rivers from which people drank, and in which they bathed and fished, often have been turned into muddy, polluted channels, poisoned with mercury and other toxic mining wastes. Wildlife has been driven away, sickened, or killed. While the indigenous peoples whose forest homeland is being torn apart by forest destruction receive little or no compensation, large timber companies reap billions globally for denuding the forests. According to the World Bank, just the illegal logging and damage to natural resources costs developing countries "at least $10-15 billion per year of forest resources from public lands."[15]

Forest damage, short of total destruction, often does not show up in gross statistics of forest loss. The UN, for example, does not consider land to be deforested until more than ninety percent of all trees have been cut. Forest fragmentation (separation into isolated units), habitat loss, and, therefore, biodiversity losses are even more serious than the deforestation statistics suggest. Though they decry it now, for decades international organizations, such as the World Bank and the InterAmerican Development Bank, have provided capital for roads, large dams, huge plantations, industrial timber operations, and other projects that have greatly hastened forest fragmentation and tropical deforestation.

In tropical areas, few forests can recover from large-scale logging and burning. Tropical rainforest soils tend to be infertile, despite the profusion of vegetation. Most of the nutrients are found in the standing vegetation, from which they circulate rather rapidly to the soil and back into forest trees and other vegetation. Irreversible soil changes ensue within a few years of exposing many tropical forest soils to the hot sun and torrential rains. The extreme heat of the tropics bakes these soils once trees are removed and can literally turn the ground into a brick-like material. Rather than experiencing gradual decline, as do overcut forests in the northeastern United States, species-rich tropical forests are reduced to virtual wastelands through logging within a few years' time.

As much as three-quarters of the solar energy reaching the tropical forest is used in *evapotranspiration* (water lost by evaporation from the soil and transpiration by plants). Once the trees are gone, however, much of the energy will instead heat the air and soil. Soil temperatures can increase locally by nine degrees Fahrenheit. Simultaneously, as evapotranspiration is reduced over a large deforested region, the cloud cover will thin, allowing more solar energy to reach the ground. The deforested

area thus becomes hotter and drier. Other land that depended on the recycling of previously transpired rainfall into new clouds for a cycle of repeated rains will now be deprived of its moisture. The reduction in cloud formation will also interfere with the transfer of latent heat from the tropics to the temperate regions. Thus, the effects of large-scale deforestation extend far beyond the former forest land. The avoidance of those impacts is another powerful rationale to justify payments for forest protection.

The ratio of deforestation to reforestation in the tropics is something like ten acres to one. But meaningful reforestation with native species in naturalistic species assemblages is extremely rare, and little real sustainable forestry is attempted. Conservation International's chief economist, Dr. Richard Rice, asserts that, in a tropical context, money spent on sustainable development in tropical forests has been "a huge and very costly diversion" from the achievement of direct protection of threatened forests. The markets for the products of sustainable development schemes often do not exist, Dr. Rice notes, and the people trying to develop them often have no business experience. Without direct forest-protection activities, the outlook for tropical forests is not good. If their only salvation is reliance on sustainable forestry, whole tropical ecosystems and their species will be driven to the brink of extinction—or over it.

Concerned individuals can contribute to larger efforts to save tropical forests by only buying wood and paper from independently certified forestry operations and by insisting that retailers they patronize stock only those approved products. A "green seal" label developed by the Forest Stewardship Council tells consumers which timber has been produced in environmentally acceptable ways. Individuals can also reduce their demand for wood and paper made from virgin wood fiber by using substitutes, recycling, and limiting their consumption of these raw materials as much as possible. Last but not least, individuals can demand more action from their elected representatives to stop tropical deforestation and can vigorously support private organizations working on these issues with contributions of time and money.

OBSTACLES TO FOREST PROTECTION—AND GLIMMERS OF HOPE

The protection of the world's forests is intertwined with problems of global poverty and the inequitable distribution of wealth. Whereas wealthy people—especially large landowners—hire others to deforest the tropics for marketable timber, ranches, or agribusiness schemes, many desperately

poor people are driven to destroy forests through lack of economic opportunity. More than half of the deforestation in the tropics is done by these "displaced landless peasants." As noted earlier, dishonest public officials or corrupt politicians in developing countries are often willing to take payoffs from corporations in return for granting them timber concessions under which vast forests are legally cut down. While the landless, uneducated poor who enter and raze tropical forests in their desperate quest for subsistence can be forgiven because they may have few other options, much tropical forest devastation is commissioned by self-interested people running wealthy corporations who are evidently indifferent to the forest life they are exterminating. Effective solutions to tropical deforestation need to take cognizance of these and other complex realities.

What alternatives to deforestation do impoverished tropical nations and their people have? Local elites usually are unwilling to act altruistically to save forests either by opposing the corporations and individuals destroying forests or by providing capital for local sustainable development projects consistent with forest preservation. Similarly, the amounts of money made available by the national or international community for economic development are small. Yet, economic development and concomitant forest protection requires investment. If a sustainable, nondestructive, forest-based economy is a goal in a particular region, some entity must then not only fund the creation of "forest-friendly" indigenous industries, but also provide capital to develop markets for them and to provide the transportation and other infrastructure required to make the new industries economically viable. Certain less destructive activities assuredly can be conducted in natural forests, ranging from ecotourism to the gathering of medicinal plants, spices, scents, nuts, latex (for rubber), and fruits. The value of sustainable products such as these, collected by local people in a responsible manner, can, in theory, eventually provide more revenue than either one-time removal of timber or marginal cattle grazing. The global conservation movement, however, is increasingly turning away from support of isolated, small-scale agro-forestry demonstration projects and toward larger, landscape-scale projects such as the region-wide complex of protected areas and extractive reserves created in Amapa, Brazil. Conservationists are also simultaneously trying to anticipate and forestall large, proposed developments that are environmentally devastating, such as new settlement programs, construction of highways into inaccessible areas, or new dams.

THE COMPLEXITY OF ENDING TROPICAL DEFORESTATION

In the throes of the global deforestation crisis, it is easy for decision-makers to be swayed by simplistic explanations of tropical deforestation and to embrace superficial solutions. In reality, threats to forests are commingled in complex ways with broader threats to the planet's life-support systems from global climate change, other global ecological crises, wars, and the world's burgeoning population. The economic and political impacts of rapid urbanization, industrialization, international trade, and multinational corporations further complicate the problem. Multinationals engaged in the timber trade wield financial resources comparable to those of entire states and some nations, and they can make huge amounts of capital available for the exploitation of natural resources, even in remote and sparsely developed forest areas of the world. Simultaneously, they exert overwhelming political and economic power on local elected officials, resource agencies, rural communities, and even on national governments, especially in developing nations.

Among the simplistic and misleading explanations of deforestation are overpopulation, small farmers engaged in shifting cultivation, and the firewood needs of low-income people. These half-truths sometimes lead to blaming the victims of deforestation and turning to its perpetrators for solutions. True, some two billion people in developing countries are still said to depend on wood fuel for cooking, domestic heating, and industrial heat. While this is related to, and at times contributes to, deforestation, it by no means adequately explains it. Small-scale village firewood collection should not generally be confused with deforestation, especially the deforestation that occurs in remote and intact closed-canopy forests. Most firewood collection has been in proximity to population centers, and most villagers gather fallen and dead wood or cut branches rather than chopping down whole trees.

Whereas some wood for domestic use can be grown in managed plantations on previously deforested land, villagers should also have access to affordable and environmentally safe alternative (nonwood) sources of energy. Heat and electricity from a spectrum of solar-based renewable energy sources, for example, could be provided at reasonable cost to peoples of the developing world who have few alternatives to wood. Although population size and density contribute to pressure on land and other natural resources, the impact of population on nature depends on both the sum of each individual's consumption of energy and other resources (and

221

on the technology being wielded) and on national policies regarding natural resources. Inhabitants of affluent industrialized countries have more than forty times the resource impacts of people in developing nations through their greater wealth and per capita energy use.

Instead of helping to solve the problems of deforestation and unsustainable industrial practices, national policy in many tropical nations is to encourage tropical deforestation. Landless farmers are sent into the forests to colonize them, often displacing forest dwellers. But, whereas the landless cultivators are the physical agents of deforestation, these impoverished people who do backbreaking labor and often have to live under primitive conditions "are no more the *cause* of the problem than foot soldiers are the cause of wars."[16] Often they have been displaced from their lands by large, government-sanctioned logging, ranching, farming, and mining schemes, or by large dams. Thus, they are both the victims and symptoms of unjust political and social systems.

UNSUCCESSFUL EFFORTS TO REDUCE DEFORESTATION

Reduction of tropical deforestation was the goal of a now-defunct multibillion-dollar Tropical Forest Action Plan (TFAP), implemented in 1985 by international agencies, including the World Bank, the UN Development Programme, and the USAID in cooperation with the World Resources Institute, a U.S. environmental research organization.[17] Under the decade-long management of the United Nations Food and Agriculture Organization, however, the TFAP failed to bring tropical deforestation under control. Other international efforts have also foundered, including the International Tropical Timber Agreement and the International Tropical Timber Organization.

The TFAP illustrates why some efforts to stop deforestation have not succeeded. Despite the dearth of evidence that sustained-yield commercial forestry is even profitable in the tropics—and the clear evidence that it is not even attempted when promised—the TFAP was predicated on heavy investments in supposedly sustainable industrial forestry projects. Unlike genuine sustainable forestry, these projects replace natural forests with commercial plantations of eucalyptus and other fast-growing trees. The TFAP's critics pointed out from the start that the plan was not only doomed to failure, but would actually exacerbate deforestation. The chief reason is that it does nothing to prevent the large development projects that were often funded by the World Bank and other international agen-

cies. Instead, the plan treated symptoms rather than underlying causes. In addition, the plan allocated only ten percent of its budget for protection of intact forest ecosystems (1.5 percent of its budget in Latin America), but it proposed billions for investment in industrial forest development. As of 1988, all forty-two of the national forest sub-plans under the TFAP omitted ecosystem restoration and most ignored multi-purpose and traditional uses of natural forests to concentrate on logging. The rights of indigenous forest dwellers were barely addressed in most of these national plans—a predictable result, given the inadequate and belated involvement of representative grassroots organizations. By contrast, a major pulp and paper company was appointed to draw up the regional forest plan for Nepal and Sri Lanka. The TFAP remains an object lesson in how far off-base the international community can go in its pursuit of conservation.

CURRENT INTERNATIONAL ASSISTANCE EFFORTS

Prompted by the widely reported accounts of bad governance and illegal logging in the tropics, a number of international organizations are seeking to ameliorate these conditions. Among them are the Intergovernmental Panel on Forests, World Commission on Forestry and Sustainable Development, Global Witness, World Resources Institute, International Institute of Applied Systems Analysis, Worldwide Fund for Nature, World Wildlife Fund, and The Nature Conservancy.

The World Bank, for instance, through its Forest Governance Program, conducts research on forest problems, holds ministerial meetings, and seeks to form government and private partnerships to address problems. But the billions of dollars per year needed by governments and conservation groups to buy and to protect properly threatened forests never seem to be forthcoming. Ministerial conferences have been held on forest law enforcement and governance in East Asia and Africa, but these have been slow to produce solutions. Some reforestation efforts are funded by the World Bank's Global Environmental Facility, but the total global spending is relatively small. The G-8 group of industrialized nations also has had a program since 1998 to work toward the elimination of illegal logging and illegal timber trading.

Through another global program known as the Critical Ecosystem Partnership Fund (CEPF), which brings public and private donors together, each of five donor-participants has pledged $25 million per year for tropical forest conservation. The partners are the Global Environmental

Facility, World Bank, MacArthur Foundation, Japanese Ministry of Finance, and Conservation International. A major aim of the fund is to support the development of nongovernmental agencies (NGOs) in developing countries in an effort to "strengthen civil society" and to develop local indigenous capacities to protect biodiversity. To date, capacity-building programs have been conducted in Brazil, Costa Rica, and Mexico. With better-funded and more robust NGOs, including conservation organizations, forests gain more vocal and effective advocates.

WHAT GOVERNMENTS CAN DO

Generally speaking, the tools available to achieve conservation of tropical forests include creation of protected parks; creation of extractive reserves, where some resources are grown or harvested in the forest; negotiation of "debt-for-nature" swaps; and use of conservation incentive payments in return for direct protection of the forests. In these agreements, those in control of forests contract to receive certain annual economic benefits in return for guaranteeing certain conservation results, which are annually verified before payments are made.

Yet, the world today refuses to behave as if a tropical forest crisis exists. More forceful international environmental action and leadership by the United States, in particular—using the arts of diplomacy, coordinated international efforts, debt forgiveness, and multi-national foreign aid— would be invaluable in halting tropical deforestation. The first step is for all governments to stop condoning and subsidizing deforestation and to substitute policies and programs that will actively deter it.

Even if the governments of individual nations are unmoved by the horror and profligate waste of destroying exquisite animals and plants, they ought not to ignore the many utilitarian arguments for tropical forest preservation. Little-studied tropical forest plants can be used to improve valuable domestic crops through interbreeding or genetic engineering to increase crop yields and disease resistance. Other plants we are unaware of could be future sources of food, fuel, life-saving medicines, and remarkable scientific knowledge about our own evolution. This alone should be sound justification for governmental action.

Because of the speed and pervasiveness with which the world's tropical forests are disappearing, emergency measures are needed on an international scale. The $125 million provided by the CEPF is still a small sum relative to the global needs. The CEPF's director, Conservation Interna-

tional's Jorgen Thompsen, acknowledges that no one knows exactly how much the developing countries are currently spending on saving tropical forests, but he notes, "The fact is, not enough money is going into it."[18] Governments can only end deforestation by making major financial and political commitments to it and by sternly enforcing protective legislation that bans the destruction of forests. Governments also have a host of powerful economic weapons at their disposal. In some regions, governments can impose ecologically oriented taxation systems or fees on the conversion of forest land, on forest products, or on forest users in order to regulate forest use. Ecological tariffs of this sort then can be used to finance further conservation efforts. In principle, taxes, fees, and tariffs could ensure that all ecological costs of deforestation are reflected in forest product prices. This could help reduce logging and consumption of other forest products, but taxation schemes alone are unlikely to stop deforestation. As tropical timber gets rarer and costs rise, wealthy consumers can usually be found willing to pay more for the tropical woods they prize, and so demand persists.

DEBTS FOR NATURE AND THE TROPICAL FOREST CONSERVATION ACT

Beginning in the late 1980s and continuing to the present, some prosperous industrialized countries, such as the United States and the "Paris Club" of European nations, have engaged in a suite of financial transactions loosely known as "debt-for-nature" swaps with developing nations. Debt-for-nature swaps were originated by Peter Seligman, CEO and President of Conservation International. These transactions usually include debt reduction and debt restructuring for a nation that has a substantial debt burden and whose tropical forests are being lost to, or threatened by, deforestation. The initiator of the debt-for-nature partnership (a nation or private organization) generally purchases the developing country's foreign debt at a steep discount, either directly from a creditor or on a secondary financial market. The new owner of the debt enters into negotiation at some point with the debtor nation, offering to cancel the debt. In return, the developing nation agrees to supply funds equal to a percentage of the face value of the foreign debt (but in local currency) to fund local tropical forest conservation programs. The developing nation receives a significant debt reduction and is also relieved of the obligation to pay its debt in hard-to-obtain foreign currency. By contrast, when forced to pay in foreign exchange, debtor nations are often driven to export large

quantities of timber, cattle, or agricultural commodities raised at a steep environmental cost in order to earn that foreign currency.

The Enterprise for the Americas Initiative (EAI) of 1991 and the Tropical Forest Conservation Act (TFCA) of 1998 are two U.S. government aid programs that provide innovative financing for forest conservation and the environment. The EAI was set up to enable eligible Latin American and Caribbean countries to redirect a portion of hard currency debt repayments owed to the U.S. government into a local fund to support a range of environmental activities, including forest conservation, and child welfare programs. The TFCA is modeled after the Enterprise for the Americas Initiative, but it is open to countries around the world and focuses more narrowly on tropical forest conservation. Whereas both programs are ongoing, only the TFCA has received appropriated federal funding in recent years. (Without funding, the EAI program will not undertake new agreements.)[19]

Conservation organizations sometimes initiate debt-for-nature transactions in a three-party deal involving the organization in a partnership with an international organization or a government that collectively negotiates the deal with the debtor nation. Thompson, who manages the CEPF, notes that, under provisions of the TFCA, Conservation International, working with the U.S. Treasury, converted U.S.-held foreign debt into $10 million in local currency for targeted conservation efforts in Peru and another $10 million for efforts in Columbia. According to Thompson, Conservation International is now negotiating a similar debt swap in Guatemala. The U.S. Congressional Research Service has calculated that such trilateral swaps since 1987 have generated $117 million in developing nations' local currency for conservation projects. Instead of either these trilateral agreements or bilateral partnerships between a private organization and a government, debt swaps sometimes are in the form of direct bilateral agreements between a sympathetic government and a developing nation.

The United States became active in bilateral debt-for-nature initiatives under the EAI.[20] These EAI government-to-government transactions can take various forms, but typically they involve debt reduction or forgiveness; extended repayment arrangements; country debt buybacks; and sometimes the application of debt interest payments to conservation purposes. The EAI program has generated nearly $178 million for environmental, health, and social programs since the early 1990s through the

restructuring of almost $1 billion in Latin American debt.[21] Since 1998, the United States has pursued bilateral debt-for-nature agreements throughout the world under the TFCA, which has produced $70.4 million in local currency for forest conservation.[22] Funds designated for conservation are deposited in an environmental fund managed by representatives of conservation organizations and governments, and the principal or interest on it is dedicated to the protection and management of natural areas.

As worthwhile as these endeavors are, the funds devoted to conservation through debt-for-nature swaps are still minuscule relative to the immense global need for forest protection and restoration—and to the magnitude of developing nations' unpaid foreign debts. Debt-for-nature swaps must compete with other nonconservation-oriented debt relief programs offering larger debt reductions. Moreover, political and economic requirements that the United States has imposed under the EAI and the TFCA have made some nations ineligible to participate.

The conservation programs discussed in this chapter are still only first steps toward the resolution of an immense set of problems that require a massive, high-priority global effort. And, on balance, with some notable exceptions, international efforts to date have been misguided, overly timid, superficial, ineffectual, or just too little and too late.

LONG-TERM SOLUTIONS: TARGETING UNDERLYING CAUSES OF TROPICAL DEFORESTATION

The root causes of tropical deforestation are the unjust and exploitative social, political, and economic conditions that produce and perpetuate concentrated control over land and other resources by elites and multinational corporations. This situation stems, in part, from "misgovernance," as international organizations diplomatically refer to it, or, in common parlance, "corruption." Wealthy nations could address these problems by strongly pressuring less-affluent governments for political reforms and forest protection, and — in collaboration with host governments and NGOs—by funding conservation efforts on the massive scale needed.

In many parts of the world, forest land ownership patterns must be changed to protect forests. In some areas, it may be possible to implement public-interest forest stewardship by designating well-trained, ecologically qualified forest managers and by reinforcing the authority of local traditional forest users. When individuals other than local forest users and public-spirited managers control the forest, disinterest in the

forest's welfare and abuse of the forest are assured. Often, changing forest land tenure arrangements in favor of traditional local users means empowering indigenous peoples, who have traditionally protected and coexisted with the forest for millennia and who are less likely to destroy it because their cultural survival and survival of the forest are intertwined. But opposition to this approach is likely from outsiders, with greater financial resources and technical skills, who sometimes use their economic power to take command of a region's forests and other resources. NGOs may also oppose sweeping land-tenure changes, if they threaten relationships an NGO has painstakingly developed with host governments, multi-national corporations, and multi-national aid agencies.

Protection of forests also requires repricing forest products to reflect forests' full ecological value—and economic losses associated with damaging those values. Domestic and international levies placed on all tropical timber sold could be used to finance forest protection. This would naturally be resisted by timber producers and consumers. Identifying the real costs of harming forest resources and translating the damage into monetary terms is a fertile area for economic research. So is determining how much to charge forest users (and other beneficiaries) for a broad spectrum of forest-derived benefits.[23]

Although solutions to deforestation differ from continent to continent and from country to country, some generalities apply. Solutions usually must include a "carrot" of development assistance to encourage land tenure reform and other needed policies, often in conjunction with broader political and economic reform designed to produce more representative government. Even when the international community is unable to encourage socially and environmentally concerned political leadership, it should nonetheless sponsor programs that will make protection of tropical forests financially rewarding to the host nations and their political leaders, until more public-spirited political forces can come to power. Billions of dollars need to be made available on a global scale not only to compensate developing countries for revenues lost in not destroying their forests, but also to protect all remaining intact tropical forest. As stated earlier, large sums must also be made available to purchase threatened lands and land development rights, as well as to create and staff forest nature preserves and parks.

Based on its recent Asia- and Africa-wide study of conflicts caused, financed, or sustained by the logging and sale of timber, USAID came up

with several diverse recommendations for reducing these conflicts. Although some are predicated on questionable premises regarding sustainable forestry, the suggestions include fostering the development of groups in civil society committed to sustainable forestry; preventing donor nations and their financing agencies from financing large paper and pulp mills; making host country leaders more aware of the superior economic benefits to be had from sustainable forestry versus forest destruction; encouraging these leaders to adopt accepted financial controls to prevent people from laundering or otherwise protecting profits from illegal timber operations; and improving compensation for police and military forces to reduce their incentives for collaboration in illegal timber activities.

Human nature and self-interest being what they are, fail-safe mechanisms for forest protection must be put in place with international support and bolstered with rigorous enforcement procedures resistant to all manner of profiteering through continued forest destruction. Once international funds are available in quantity, they must be used to insure that ample trained personnel, adequate equipment, and other resources are coordinated by appropriate laws, policies, and unflinching commitment to defend the forest against logging, burning, and unregulated mineral exploitation. Nothing should be allowed to occur that further damages the ecological and hydrological integrity of the forests; disrupts forest dwellers' lives, cultures or land rights; or reduces biological diversity and the contributions of tropical forests to climate stability.

As suggested previously, after the forests are placed off-limits to industrial development, they need to be returned to the care of appropriate stewards, especially to the native peoples who are often most knowledgeable about them and who have lived sustainably with them for thousands of years. Granted, some traditional peoples, once in possession of mainstream society's more advanced industrial technology, will abandon traditional stewardship practices and liquidate their forest assets for cash. Time and again, local communities, including native residents—either in economic difficulty or tempted by wealth—have sold or damaged their forests. To preclude this, statutory trusts or provisions should be established to provide additional protection for repatriated land by attaching an environmental deed restriction to the land prohibiting its deforestation. Akin to a conservation easement, deed restrictions can be attached to land titles for which the development rights have been sold and

placed in trust permanently to insure they are never used. It then becomes illegal to log these protected lands.[24] Regardless of who its custodians may be, threatened tropical forest land must be held inviolate in a perpetual legal trust for humanity and for use in nondestructive traditional ways by native peoples or by others irrevocably committed to the protection of nature. The application of conservation deed restrictions to the land title, or other appropriate statuatory measures, can then prevent forest destruction by both the original native occupants and any future nontraditional descendants. By contrast, zoning the forest into nondevelopment and development "sacrifice areas," as some international agencies have suggested, is not going to protect forests in the long term. Similarly, road building into presently inaccessible areas should be stopped, because roads open regions to settlement and are generally the prelude to wider forest destruction. Intact but accessible areas must be given fail-safe protection.

The international organizations that have funded past destruction of tropical forests should, in reparation, provide funding for restoration efforts on degraded forest land and for the protection of traditional cultures. A portion of these mitigation funds should simultaneously be made available in grants, loans, and debt forgiveness for genuine development efforts in tropical nations to offer impoverished people economic alternatives to deforestation. In tribal areas, such development efforts should always involve indigenous people in program planning and should provide dispossessed and landless people with a means of livelihood on already-developed land as an alternative to forest destruction.

Until the permanent protection of tropical forests is assured, a worldwide ban should be instituted on all imports of timber and wood products from primary tropical forests to communicate a seriousness of purpose to nations with tropical forests and to put some economic muscle behind our nominal commitment to forest protection. In addition, imports of beef from deforested areas should be reduced or eliminated to avoid encouraging any further forest removal for ranching. If these measures are ineffective, even more powerful economic sanctions should be implemented. Trade barriers or other economic restrictions would, in time, be rescinded as each nation complied with international demands for forest protection.

The alternative to effective international forest-saving actions is totally unacceptable: by allowing more tropical forests to be cut down, we inten-

sify global warming and lose as yet undiscovered species and a vast treasure of genetic diversity. Beautiful living resources of inestimable value belonging to all humanity will be obliterated forever, and more forest dwellers will lose their livelihoods, homes, cultural identities, and lives. People who believe that the crime of tropical forest destruction is indeed a high crime against nature may wish to work on protecting tropical forests through the Rainforest Action Network in San Francisco, the World Rainforest Movement in Penang, Malaysia, or other environmental organizations. Only strong "bottom up" political pressure from citizens around the world is likely to overcome international complacency about tropical forest destruction.

CHAPTER 15.
HOW TO PLANT TREES

Work with nature! Invariably "nature knows best"....

—Merv Wilkinson, "Wildwood, A Forest for the Future" (1994)

FOREST PLANTING

As Chapter 12 on forest restoration makes clear, planting trees—or any isolated component of a forest, for that matter—is not in itself sufficient to recreate a forest, contrary to what decades of forest industry misinformation has led too many politicians and citizens to believe. Why, then, do I include a chapter on tree planting here? My reasons are that, under certain conditions where natural regeneration has faltered, tree planting may be a beneficial or necessary phase in a forest recovery program. Furthermore, tree planting in deforested or other ecologically damaged areas, such as eroding hillsides or mined lands, can be of great benefit to the air, soil, water, and wildlife, even if the trees at first are few, lack supporting forest integuments, or for other reasons do not constitute a viable forest.

Some environmentalists, however, still view tree planting as a "feel-good" diversion that distracts people from forest protection or from confronting fundamental causes of environmental disruption. Nonetheless, while planting a single tree may seem like a small gesture, with enough public support this simple act can be multiplied millions and even billions of times until significant local and regional ecological benefits are realized. These benefits can include soil protection, flood prevention, wildlife habitat, aesthetic rewards, the production of fruits, nuts, fiber, building materials, and useful renewable fuels, and the removal of airborne carbon dioxide. Tree planting can also modulate local temperature extremes. In lowering summer peak air temperatures in urban areas afflicted with "urban heat island" effects, air

conditioning energy can be saved and significant reductions in smog can be achieved, since smog formation is temperature-sensitive.

Apart from the social and environmental benefits, planting a tree is a pleasant and satisfying activity. Fortunately, it's also easy: the basic things that a tree needs are sunlight, water, carbon dioxide, oxygen, and space in which to grow, plus micro- and macro-nutrients. A tree may also need shade, protection from wind, and the presence of beneficial organisms to make soil nutrients more available and to assist in seed dispersal and germination. If you are attempting to plant a forest or woodland with native species rather than a tree or two, first convince yourself that properly protected natural regeneration will not accomplish the job. Sometimes fencing an area to protect it from livestock or human foot traffic may be all that is needed for its natural recovery. If planting is necessary, try to use locally grown and, therefore, locally adapted seed or plant stock. Even trees of the same species grown elsewhere in another region may not do as well in your particular soil and microclimate as will trees whose ancestors have been adapting to local conditions for hundreds, if not thousands, of years. If you are choosing to grow nonnative species for ornamental purposes, consider whether the reasons for using nonnatives outweigh the environmental benefits of restoring native vegetation, to which local native animal and plant species are adapted.

While seeds are less expensive than seedlings, their survival is less certain. The smaller and younger the sprout, the more vulnerable it is to drought, shading, and physical damage. Seeds are also susceptible to wildlife predation. Extra seed is normally planted, in expectation of inevitable losses. (They can be coated with repellent or fungicide to minimize losses.) To improve plant survival on inhospitable sites or where livestock or wildlife predation is expected, seedlings may benefit from extra help, including bud caping and caging (to protect against browsing), screening and shading to protect against full sun, mulching to help deter competing weedy vegetation, fertilization to compensate for soil deficiencies, and watering or irrigation to aid plant establishment.

Successful planting begins with the selection of healthy, undamaged, and pest-free stock. If using container stock, make sure the roots are neither circling nor kinked. Check this by exposing about an inch of soil with your finger. When planting, think about how the mature trees will fit in their environment. Make sure that they will not interfere with each other over time. If attempting to simulate a forest, space the trees irregularly

rather than on a uniform grid and allow for some forest openings. Most trees should be six or eight feet apart. Allow for average seedling mortality, which is usually twenty-five percent or more. (Some experts put it as high as forty percent.) Naturally, plant trees that have spreading foliage farther apart than those that are more upright in form. Try to include some of the native understory plants, if these are missing from the ecosystem, particularly species with edible seedpods, fruits, and nuts to support wildlife.

The forest stand or other planting area will probably have significant variations in slope, aspect, exposure, soil, and competing vegetation. The combined effect of these variables create different "microsites." Some will be cooler or warmer, windier or calmer, foggier on the coast side of a mountain and drier toward the interior. Match planting sites as closely as possible to your trees' requirements. If planting on a hill, consider whether the slope has a southern or northern exposure. Some trees are more shade-tolerant and may do well in the shelter of a bluff or partially shaded by an existing forest canopy. Left in full sun, these trees might suffer sunscald or may parch, while other species prefer full sun or only some direct sun. Similarly, some trees will flourish in poorly drained soils while other drought-tolerant trees require the substrate to be well-drained. These trees can be planted in sandy soils.

To maximize the chances of seedlings' or seeds' survival, competing brush, grasses, and weeds need to be removed around the new plantings. Sites can be cleared manually with heavy brush cutting and grubbing tools, such as a pulaski (a pick and axe combination), hoes, mattocks (a pick and hoe combination), shovels, chainsaws, and Brush Kings (gas-driven circular saws). On a large site or one that is overgrown with heavy brush, site preparation can be done by controlled burning or by heavy machinery, such as a bulldozer or tractor dragging brush rakes, harrows, or discs to prepare the ground. (Controlled burning requires permits, so check with your local fire department.) Light brush can usually be pushed aside into piles manually or by a bulldozer, if necessary, along with debris and logging slash. Other possible control methods are use of short-acting herbicides applied directly to stems or small areas and intense browsing and grazing by livestock. Professional advice and assistance should be obtained for all but manual brush-clearing methods. Mechanical seedling planters also exist, but seedling survival is usually higher with hand planting.

Generally, planting should be done in late fall or early spring. Hand planting techniques differ, depending on the seedling's size. Planting a small seedling from a tube with its plug of earth generally requires only a few deft strokes of a short hoe, planting bar, or shovel. Technique depends on tool choice and site conditions. Any of two dozen tools may be used. When a spade or shovel is used, a hole is dug and the seedling is inserted perpendicular to the horizontal plane of the soil, regardless of the ground's slope. For proper tree growth, roots must have enough room to hang straight down in the hole and must not be either jammed together, bent into a "J," or forced to circle the hole. Seedlings do not need to be staked. The roots of a bare root seedling should be pruned to remove dead or damaged roots and then soaked overnight in water before planting. Avoid exposing roots to air, because tiny roots will dry out immediately and the tree will be harmed.

If planting a conifer, the tree should be buried just below the start of the needles. Deciduous trees should be planted so that, when the soil settles, the top of the root crown will be flush with the soil level. Planting lower leads to root crown rot, and planting higher causes drying. A timed-release fertilizer tab may be inserted in the bottom of the hole to aid the tree in getting established. If the terrain is rocky, trees can even be planted amongst rocks, provided that the hole is filled with soil and that water can drain through the rocks. If soil is very compacted, it may be necessary to auger or dig it out and then backfill soil into the hole, so that the tree's roots can penetrate the soil more easily.

Once the tree is planted, soil is scraped back in to fill the hole, and the soil is tamped down around the seedling with the heel of one's boot to eliminate air pockets. When a planting bar, hoe, or mattock is used, the procedure is similar, but the tool is inserted into the soil near to the first hole or slit into which the seedling has been placed, and the tool is used as a lever to force the soil to close on the hole, compressing the soil firmly around the roots. The second hole is also filled to prevent drying of the seedling's roots nearby. Finally, the planter's boot is used to pack the soil down around the seedling.

If planting a well-developed tree with soil from a pot or in a rootball, the hole needs to be correctly sized, and care must be taken to insure adequate contact between the rootball with its soil and the surrounding ground, so that the roots do not dry out. Container grown trees should have a temporary watering basin—a circular rim of earth built around the

tree well beyond the circle formed by its outermost branches—to increase water percolation to the roots.

If the tree comes in a large container with a heavy mass of soil around the roots, tap the container to loosen the mass, tilt the container, and slide the tree out onto a shovel or ground to support the tree. Lifting the tree and root mass by its trunk can damage the roots. Some experts advise gently spraying away the outer inch or so of soil from around the roots with a garden hose. Staking is not recommended unless the tree is unable to support itself. When the hole is prepared, tamp soil down in the bottom firmly enough so the tree will not settle—but not so tightly that the packed soil forms a barrier for the roots. If the sides of the hole are smooth, roughen them to facilitate root penetration. Use your spade to continue supporting the tree as you set it into the hole. Once the tree is in the hole, double-check to see that the top of the root mass will be flush with the ground surface when the soil settles.

As with seedlings, exposing the roots to the air can dry and damage them, whereas piling soil against the trunk can lead to rot. In a hot, arid area, however, with sandy soil and occasional wet winters, it may be preferable to plant the tree slightly lower in the ground to collect moisture and avoid drying of the root collar. In some climates, natural rainfall may be sufficient to establish new trees with a high probability of success. Otherwise, the trees may require irrigation or individual watering deeply in the dry season, until their roots reach the damp soil of the water table or become hardy enough to depend on the vagaries of natural rainfall. Two or three growing seasons (or more) may be required until this occurs, depending on ground conditions. The frequency of watering depends on climate, species, and soil. The rule is that the root zone should be moist but well drained. Watering might need to be as often as once a week (or more) for the first two or three years during the dry seasons to keep roots moist. Monthly watering (or none) might be sufficient during the third dry season. Excessive watering that causes a tree to remain wet is likely to cause fungus.

After planting, stands of trees will benefit from weeding, brush control, thinning, improvement cutting (to remove defective trees), and pruning. Protection from uncontrolled and unwanted fire, insects, damage, and disease may also be necessary.[1] Information on yard and ornamental trees can be obtained from gardening books, such as those by Sunset. Finally, unless your silvicultural goal is forest preservation, you will need to know when and how to harvest commercial timber. Specific advice about trees

in your area can be had from local nurseries; federal and state agricul-
tural agencies and extension services; ecology, forestry, and landscape
architecture departments at colleges and universities; the library; and
foresters and landscape architects in private practice. The general
requirements of each species may be found in a botanical encyclopedia.

WELCOME MATS FOR WILDLIFE

If you're lucky enough to have property where trees will grow, you can
also have lots of fun by managing the land for native wildlife. By observ-
ing your land carefully and considering the needs of the wildlife you wish
to attract, you can often determine what it lacks in the way of food, water,
or shelter. If any of these ingredients is in short supply, providing it will
increase the land's carrying capacity. Nesting cavities, dens, brush piles,
hedgerows, and ditches all have their functions as shelter for wildlife.
Many species can benefit from nut trees, such as oaks, hickories, walnuts,
and piñon pines, as food sources. Wildlife also appreciate autumn olive,
cherry, crabapple and apple, American cranberry bush, and holly. If nec-
essary, small springs and seeps can be developed into more accessible
water sources, ponds can be created or expanded, and catchments can be
built where rainwater is scarce.

Books on wildlife management, local fish and game officers, soil con-
servation district agents, or wildlife management professors can be
sources of additional ideas suitable for your land. Two excellent introduc-
tory books are Malcolm Margolin's *The Earth Manual: How to Work on Wild
Land Without Taming It* and James R. Fazio's *The Woodland Steward* (both
are cited in the *Text References and Recommended Readings* section).

CONCLUSION

Although you'll be mopping the sweat from your brow when you plant lots
of trees, you can dream of how wonderful your site will be once your
seedlings or saplings reach maturity. Imagine what the spot will look like
with mighty trees reaching 100 feet or more into the sky. Children may play
beneath them in the cool shade. One day hundreds of years from now, they
may even become old-growth forest. You can take satisfaction in the joy
these trees will give people generations hence and the good that the trees
will do for the living earth. Perhaps you will also draw strength and confi-
dence from these simple good deeds to work in other ways—politically,
educationally, or scientifically—for healthy, sustainable forests.

APPENDIX A.
CITIZEN PARTICIPATION IN PUBLIC FOREST MANAGEMENT AND PLANNING

HOW THE NATIONAL FOREST PLANNING PROCESS FUNCTIONS

Under the Forest and Rangeland Renewable Resource Planning Act (FRRPA) of 1974 and amendments, as embodied in the National Forest Management Act of 1976 (NFMA), forest management plans must be prepared for each national forest at least every fifteen years and be kept updated. The plans not only determine which areas are destined for particular uses, such as logging, grazing, mining, watersheds, wildlife and fisheries, wilderness, research, or outdoor recreation, but also how those activities shall be managed. The U.S. Forest Service (USFS) to date has prepared or revised such plans more than 150 times since NFMA's passage. In 2007, some forty forest plan revisions were under way, with another thirty-three plans awaiting revision. (There are 155 national forests in total.) Currently, the USFS intends to complete some 100 additional forest management plans in the decade between 2004 and 2014.

I will now review USFS public participation procedures and offer guidelines for successful participation. In a subsequent section of this appendix, I describe the formal regulations governing public participation, as outlined in a 2004 Final Forest Service Rule for implementation of NFMA.

Nationally, the FRRPA requires the USFS to prepare an assessment of renewable resources every ten years and to formulate a national renewable resource management policy along with multiple-use goals for the national forests (and other public lands) in keeping with the Multiple-Use and Sustained Yield Act (MUSYA) of 1960. The NFMA regulations and the MUSYA make three unenforceable stipulations, which include some worthwhile aims: (1) management goals and objectives must protect and, where appropriate, enhance the quality of all renewable resources; (2) all forest uses must receive full and equal consideration; and (3) uses of the

forest's renewable resources shall not diminish the land's future productivity. All but the second set of stipulations are laudable, but, as the USFS interprets point #2, it has sometimes asserted that this stipulation requires all MUSYA uses on all forests, even down to the ranger district level. Thus, the USFS has maintained, even in a forest that is not well suited for providing ranching, that the forest plan must provide for at least some ranching. Congress undoubtedly had a reasonable intent in drafting this language, but the USFS has insisted on an unreasonable interpretation.

The USFS's legal commitment to point #3 was significantly diluted, however, by the NFMA regulations' caveat, in its definition of multiple use: that renewable resources are to be "utilized in a combination *that will best meet the needs of the American people; making the most judicious use of the land*" and by other allowable departures from sustained yield timber management. [1]

The FRRPA provides the policy framework and goals within which national timber output goals must be set, consistent with the local resource capabilities of individual national forests and other public lands. Forest activists and concerned citizens alike are allowed to provide detailed critical input to USFS management plans, but the service has broad discretion to disregard public input if it chooses, and citizens must then file an administrative appeal or take the USFS to court if there is some clear legal standard that has been violated. Many environmentalists are ambivalent about participating in these administrative procedures because of doubts about whether their participation can be at all efficacious. To these activists, the process is a time-consuming sham designed to cloak predetermined industrial forestry policies in legitimacy.

The fact that many important management decisions are made or reviewed in the USFS planning process is a good enough reason for many forest activists to participate in it, however, while recognizing realistically that the whole process leaves much to be desired, given that its rules and regulations are set by the USFS, which has a great deal of discretion over which criticisms to act upon. The activists find that many state and local timber harvest plans can be improved, that their environmental impacts can be partially mitigated, that the proceedings can afford useful opportunities for public education, and that occasionally some of the most environmentally damaging timber plans and management alternatives can be blocked. In addition, while some activists engage in the national forest planning process to improve the plans, others have, in the past, gotten

involved to delay logging through the filing of administrative appeals or as a necessary step in exhausting administrative remedies to clear the way for court challenges to USFS plans. Though expensive and time consuming, these lawsuits have at times had far-reaching impacts.

HOW PUBLIC PARTICIPATION PROCESS WORKS UNDER NFMA

Among its many provisions, the NFMA directs the USFS to provide opportunities for public participation in forest management plans and proposed timber sales on the national forests. The opportunity for public involvement begins with the publication of a legal notice in a newspaper of record, signaling the start or modification of a forest plan, or, in the case of an opportunity for comment on a rule-making process, with a notice in the *Federal Register*.

In preparing a forest plan under the NFMA, the USFS must hold activities, such as meetings, workshops, conferences, tours, and hearings, to foster public participation, and it is supposed to make its documents available through its principal offices (national headquarters, regional offices, forest supervisors' offices, district rangers' offices) and at other locations. The formal regulations for public participation were thoroughly revised in 2004 and supersede earlier regulations. Public input to national forest plans occurs in the context of a decision framework determined by Congress and senior USFS officials.

Following completion of a forest natural resource assessment called for by the FRRPA, the responsible official for each forest estimates a range of possible timber production outputs, corresponding to the forest's resource capabilities, and various possible logging rates. The projected timber outputs from all national forests are aggregated to produce a range of national timber production outputs which are reviewed by the USFS and Congress against an estimate of projected national timber demand.

A top-down decision is then made by the USFS, subject to approval by Congress and the President, as to the overall timber output desired from the national forests. The total volume of timber desired is then divided into production quotas that are assigned to each of the USFS's nine regions. Within each region, portions of the quotas are reallocated to the individual forests within those regions. Supervisors of individual national forests (Forest Supervisors) can challenge these quotas as inconsistent with local resource capabilities and can negotiate them with their Regional Forester if

they believe that fulfillment of the quota will cause unacceptable environmental harm and impair the forest for other uses. Regional Supervisors, in turn, can negotiate assigned regional objectives with the Chief Forester of the USFS. In practice, it is not easy for quotas to be revised and often, at best, excessive logging activities may merely be shifted from one national forest to another. "Timber targets are influenced by an 'iron triangle,'" observes attorney Doug Heiken of the Oregon Natural Resources Council. "(1) The timber industry gives campaign money to Congress, (2) Congress writes the Forest Service budget and sets quotas for timber harvest, and (3) the Forest Service closes the loop and delivers logs to the timber industry."[2]

Traditionally, over the past twenty-five years, each forest plan has been developed in a ten-step process that begins with the identification of salient issues and concerns. Citizen input is particularly useful in this formative stage of the process, as it serves to define the scope of the planning effort. Other stages of the forest planning process include development of process and decision criteria; data collection (inventorying); resource capability analysis; and formulation of alternatives. The alternatives are supposed to be responsive to the issues and concerns raised in the initial scoping step. If they are not, citizens at this stage can suggest additional alternatives for inclusion in the analysis. Next, the impacts of each alternative are studied and then evaluated according to criteria developed earlier in the process, and a preferred alternative is selected which becomes the basis for the draft forest plan. A monitoring program also must be developed prior to plan completion.

After affording a number of opportunities for public involvement during the steps described, the USFS will produce its comprehensive draft forest plan. Prior to the introduction of the 2004 Final Forest Service Rule, the USFS also had to develop an accompanying draft environmental impact statement (DEIS), which identified the USFS's preferred management alternative. Members of the public then usually had three months to provide written comments on the DEIS to the Regional Supervisor's office. The USFS then reviewed public comments on these drafts and responded to them in its final draft forest plan and an Environmental Impact Statement (EIS). How diligently the traditional ten-step planning process will be pursued, or whether it will be pursued at all, now that environmental impact statements no longer are required, remains to be seen.

Before a plan is approved the public has thirty days in which to object. At this point, "any person or organization, other than a Federal agency,

who participated in the planning process through the submission of written comments may object to a plan, plan amendment"—except when a plan amendment is approved at the same time as a project or activity and when the official responsible for the proceedings is an official of the U.S. Department of Agriculture at a level higher than the Chief of the USFS, "in which case there is no opportunity for administrative review."[3] The objections have to be in writing and filed within thirty days following the publication date of the legal notice of the plan, amendment, or revision. The USFS's reviewing officer then has an obligation to write a prompt written response to the objection and send it by certified U.S. mail to the objector.

Previously, before the 2004 Final Forest Service Rule was passed to change the public participation process, a delay in implementation of a forest plan or particular management actions could be requested, although the USFS was not obligated to grant the stay. A citizen could also request a hearing in which to appeal a decision and request that the appeal be heard before the chief. First, however, the Regional Forester would respond to the appeal and send the appeal record to the Chief of the USFS for a decision. If the request for a hearing were granted, the hearing would be informal and would afford the complainant an opportunity to discuss, negotiate, and settle both policy and site-specific issues without litigation and without needing the presence of an attorney. Naturally, legal advice was valuable in formulating arguments to be brought to the chief, especially if the citizen or organization bringing them anticipated ultimately taking the issues to court.

If someone wishes to become involved in USFS planning and timber sales, it is important to become intimately familiar with the relevant administrative procedures and rules governing the forest planning process in which the person intends to participate as well as procedures for reviewing, commenting on, or appealing the forest plan or timber sale. Obviously, it is important to next obtain copies of, or access to, all relevant planning documents. These need to be scrutinized in great detail for consistency with applicable NFMA rules and regulations and with other legal requirements that the USFS must meet. Of course, all public meetings at which documents are reviewed need to be attended. This is an opportunity to raise questions about anything you don't understand or agree with or to seek expert advice on critical points of forest ecology and environmental law. Concerns about the plan must be communicated in

writing by certified mail within relevant deadlines as well as discussed directly with representatives of the agencies involved. Public influence is probably greatest at the local level and closest to home. In the early stages, the completeness and correctness of every element of a local timber harvest plan is open to challenge.

Among the larger issues to consider at both local and national levels during plan review are compliance with environmental statutes, especially regarding endangered species and cumulative environmental impacts; logging practices (including timing of harvest); suitability of land for timber production; timber removal prescriptions; maintaining viable populations of all native species; and restoring or preserving the natural range of ecological variability in the forest, including the natural disturbance processes.[4] The public can comment on the sizes of proposed withdrawal (no-cut) areas or special treatment areas, forest regeneration practices, and on retention of snags and downed logs, as well as on matters such as logging equipment, roading, sedimentation, water temperature impacts to fisheries and amphibians, peak flow effects, and other aquatic impacts. Among many possible issues to raise, the public can propose modifications in the size of the area proposed for logging and in the logging methods. The public can also challenge the breadth and depth of the environmental assessment methods used, if any, the qualifications of the assessment personnel, and whether feasible alternatives and mitigation have been adequately considered. Since it is illegal to log lands that either cannot be cut without irreversible damage to soils, productivity, or watershed or cannot be adequately restocked after logging, the public can also challenge national timber sales and plans on the suitability-for-harvest issue. Unfortunately, it is rare to prevail on these grounds.

Once you have done your best to improve or stop a local timber sale and the sale has nonetheless been approved, you can stay involved. By informally monitoring the timber sale and compliance with any restrictions incorporated in it, including mitigation requirements, you can help assure that forest damage is kept to a minimum. Should you discover that sale conditions are not being observed by the timber operator, you can request inspections from the agency or agencies whose regulations are being violated or whose resources are affected. As a last resort, you can sue to have rules enforced.

An important point to remember is that, whether you prevail initially or not, your comments, if properly presented and backed up with good science

and policy documentation, can be the basis for pro-environment litigation, if the USFS ignores your comments. The agency is required to respond in writing to your comments, and the agency must enter your comments into the public record. This provides a basis for following up on specific agency responses to expressed concerns, including in court, if need be.

Many, if not most, citizens will feel the process of appealing a timber sale or modifying a forest plan is demanding and that they can't possibly grasp the complicated issues, science and procedures involved, and therefore can't really influence the process, especially if they lack credentials in a relevant area. But this isn't necessarily true. Many, if not most, successful forest plan modifications and timber sale appeals are made by ordinary concerned citizens who are self-taught go-getters.

RECENT FOREST SERVICE RULE CHANGES THAT AFFECT PUBLIC PARTICIPATION

I will now summarize recent policy changes in the NFMA, as these set some important guideposts for public participation in USFS planning. As of this writing, the most pertinent summary of the rules could be found in the January 2005 *Federal Register* announcement, which will be discussed in detail below.[5]

Implementing regulations for the NFMA were initially promulgated in 1979 and revised in 1982 and again in 2000. The 1982 regulations described the USFS's land management planning process and the procedures required for complying with the NFMA. As of early 2005, all forest plans still had been prepared under the 1979 and 1982 regulations. One of the many stipulations in the 1982 regulations was that the USFS had to maintain viable populations of all native vertebrate species. This was to be accomplished, in part, by collecting population data on "management indicator species." Other provisions of the regulations required protection of streams and watercourses and limited the size of clearcuts to forty acres, for most forest types.

In 2000, however, after receiving a great deal of scientific and public input, the USFS revised and updated the 1982 NFMA implementing regulations that guide the preparation of forest management plans. The 2000 regulations weakened the NFMA environmental safeguards by eliminating the viable populations requirement and by removing virtually all of the mandatory, enforceable language pertinent to wildlife and habitat protection. The 2000 regulations did, however, place greater emphasis on the use of scientific information for maintaining wildlife populations and

on the achievement of ecological sustainability. In addition, the new regulations contained provisions to require that the ecological values of roadless areas would be evaluated and protected, and they also increased public participation in the planning process.

In mid-May 2001, however, Secretary of Agriculture Ann Veneman, whose department supervises the USFS, announced a pending suspension of the 2000 rules, which were eventually superseded in 2004 by a Final Rule.[6] With the issuance of this rule, the USFS formally abolished the 2000 regulations. Calling the 2004 Final Rule "a paradigm shift in land management planning," the USFS stated that forest plans under the new rule would be "more strategic and less prescriptive in nature than under the 1982 planning rule."[7] Henceforth, forest plans were to set goals describing desired future conditions of the land as well as objectives and guidelines for meeting them, but they would not have the force of law nor would they include as many specific management prescriptions or prohibitions as before. Most significantly, an EIS would no longer need to accompany the revision of forest plans, so the enforceable aspects of National Environmental Policy Act of 1969 (NEPA) regarding the requirements for public involvement and scientific integrity of an EIS would no longer apply. Of course, the plans still have to comply with existing laws, regulations, and policies, and they are supposed to utilize science and an "environmental management system" approach. Future conditions described in the plans, however, are characterized by the USFS as only "aspirational" and are "neither commitments nor final decisions approving projects and activities."[8] The George W. Bush Administration thus intended to transform the plans from powerful enforceable instruments that outlined the management ends and means for each forest to a more mutable and unenforceable internal agency planning tool that could be readily modified by the USFS at will under a process known as "adaptive management." As attorney Douglas Heiken of the Oregon Natural Resources Council noted, "The public may argue for and win compromises in the planning process but then the Forest Service can break those promises without suffering any adverse legal consequences."[9] In a surprising turn of events, however, a federal court in March 2007 rejected the Bush Administration's efforts to relax the NFMA's environmental safeguards regarding forest planning and management. (See the last paragraph of this appendix for more information.)

Section 219.9 of the 2004 NFMA Final Rule sets forth the regulations that describe the public's formal role in national forest management and planning. These 2004 regulations gave great discretion to the USFS officer in charge of each planning process, and, as noted, they exempt the plan from NEPA. Section 219.9 stated that the USFS must provide opportunities for and encourage the public to collaborate and participate openly and meaningfully in the planning process, including development of the plan's components, monitoring program, and evaluation design.[10] The rule also required that formal public notification be provided when the development of the plan or its revision is initiated; at the start of the ninety-day comment period on a proposed plan, plan amendment, or plan revision; and at the start of a thirty-day objection period that will be available prior to approval of a plan, amendment, or revision.

The forest plans, plan amendments, and plan revisions, however, "may be categorically excluded from NEPA documentation as provided in agency NEPA procedures. . . ."[11] Simultaneously with this rulemaking, the USFS also proposed to revise its NEPA procedures to exclude, categorically, forest plan development, plan amendments, and plan revisions from NEPA. "The categorical exclusion proposed in connection with this final rule clarifies," the USFS stated, "that plan development, plan amendment or plan revisions in accordance with this final rule do not significantly affect the environment, and thus are categorically excluded from further NEPA analysis, unless extraordinary circumstances are present."[12] The rule went on to assert that the USFS would comply "with all applicable NEPA requirements, including preparation of an EA [Environmental Assessment] or an EIS *where appropriate*, when considering specific projects or making other project-specific decisions affecting the environment."[13]

The USFS also added that it might offer the public "other methods of participation outside the formal public notice and comment process on a case-by-case basis and implemented on a unit-specific basis" so that they are adapted to local situations. The USFS official in charge of the plan, for example, has the discretion to establish an advisory committee to guide the preparation of the plan or determine other methods of public involvement.[14]

Readers who want more guidance on how to become involved in national and local forest planning should contact local and regional forest protection groups and alliances. National organizations that have

been heavily involved in national forest management and planning include The Wilderness Society, Earthjustice, the Sierra Club, the Natural Resources Defense Council, the National Audubon Society, and the National Wildlife Federation. These organizations should be able to provide assistance if you need either legal advice on forest planning issues or referrals to regional and local groups that are involved and knowledgeable about particular national forests.

As this book was going to press, a federal judge in San Francisco enjoined the Bush Administration from implementing and utilizing the national forest planning and management rule changes issued by the USFS in late 2004 and 2005. The ruling at the end of March 2007 was brought against the U.S. Department of Agriculture and the American Forest & Paper Association et al., by attorneys for Earthjustice on behalf of various environmental organizations, as plaintiffs. The sixty-page decision held that the Bush Administration's changes to the 2005 NFMA rule violated provisions of NEPA, the Endangered Species Act, and the Administrative Procedures Act. The court directed the USFS to conduct further analysis and evaluation of the impact of the 2005 rule in accordance with those statutes.[15]

APPENDIX B.
PRINCIPAL FOREST SERVICE AUTHORIZING STATUTES GOVERNING MANAGEMENT ON THE NATIONAL FORESTS[1]

A Note to the Reader: The following entries appear in chronological order by year.

The Organic Administration Act of 1897 (16 U.S.C. 473-475) authorizes the Secretary of Agriculture to establish regulations governing the occupancy and use of national forests and to protect the forests from destruction.

The Knutson-Vandenberg Act of 1930 (16 U.S.C. 576-576b), as amended by the National Forest Management Act of 1976 (16 U.S.C. 472a), directs the Secretary of Agriculture to provide for improvement of the productivity of renewable resources within national forest system timber sale areas. The act also authorizes the collection and use of timber receipts for these purposes.

The Small Business Act of 1953, as amended (15 U.S.C. 644), provides for agencies to participate in programs with the Small Business Administration. This is the authority for the Small Business Timber Sale Set-Aside program (FSM 2439).

The Multiple-Use, Sustained-Yield Act (MUSYA) *of 1960* (16 U.S.C. 528-531) recognizes timber as one of five major resources for which national forests are to be managed. This act further directs the Secretary of Agriculture to develop and administer the renewable surface resources of national forests for multiple use and sustained yield of the many products and services obtained from these resources.

The National Forest Roads and Trails Systems Act of 1964 (16 U.S.C. 532-538) directs the Secretary of Agriculture to provide for the existence of an adequate system of roads and trails within and near national forests.

The National Environmental Policy Act (NEPA) of 1969 (16 U.S.C. 4321) requires agencies to analyze the physical, social, and economic effects associated with proposed plans and decisions, to consider alternatives to the action proposed, and to document the results of the analysis.

The Forest and Rangeland Renewable Resources Planning Act (RPA) of 1974 (16 U.S.C. 1600-1614), as amended by National Forest Management Act of 1976, directs the Secretary of Agriculture to assess periodically the forest and rangeland resources of the nation and to submit to Congress at regular intervals recommendations for long-range U.S. Forest Service programs essential to meet future resource needs.

The National Forest Management Act (NFMA) of 1976 (16 U.S.C. 472a) sets forth the requirements for land and resource management plans for the national forest system. It also amends several of the basic acts applicable to timber management and specifically addresses most aspects of timber management and how it is related to other resources. It is the primary authority governing the management and use of timber resources on national forests system lands.

The Forest Resources Conservation and Shortage Relief Act of 1990, as amended in 1997 (16 U.S.C. 620), sets forth restrictions on export of unprocessed timber originating from federal lands. It addresses certain exceptions to export restrictions and establishes reporting requirements.

The Healthy Forests Restoration Act (HFRA) of 2003 (Pub.L. 108-148) provides processes for implementing hazardous fuel reduction projects on certain types of "at-risk" national forest system and U.S. Bureau of Land Management lands. It also provides other authorities with direction to help reduce hazardous fuel and to restore healthy forest and rangeland conditions on lands of all ownerships.

Section 323 of Public Law 108-7 (16 U.S.C. 2104 note) grants the U.S. Forest Service authority, until September 30, 2013, to enter into stewardship contracting projects with private persons or public or private entities, by contract or agreement, to perform services to achieve land management goals for national forests or public lands that meet local and rural community needs.

NOTES

A Note to the Reader: Explanatory notes and published quotations are cited in this section. General references and recommended readings are cited separately in the *Text References and Recommended Readings* section.

INTRODUCTION

1. One reflection of this situation is that, in the U.S. presidential election of 2004, the environment was scarcely mentioned by either George W. Bush or John Kerry in their nationally televised debates, and it did not show up in exit polls as a top concern of most voters.

2. Forest damage due to global climate change, pathogens, or invasive species is, however, in the short term, generally beyond the control of forest managers and policymakers.

3. See American Lands Alliance, *This Land Is Your Land: The Bush Administration's Assault on America's National Forest Legacy* (Washington, DC: www.americanlands.org, 2004).

CHAPTER 1

1. Chris Maser, *Sustainable Forestry: Philosophy, Science, and Economics* (Del Ray Beach, FL: Saint Lucie Press, 1994).

2. Robert Steelquist, "Salmon and forests: fog brothers—exploitation of trees and salmon in the Pacific Northwest—Watershed Wars," *American Forests* (July–August 1992).

3. As amended (16 U.S.C. 1531, et seq.). See, also, Brian Czech and Paul R. Krausman, *The Endangered Species Act: History, Conservation, and Public Policy* (Baltimore: The Johns Hopkins University Press, in association with the Center for American Places, 2001).

4. The Regulatory Transition Act, 104th Congress, 1st session. (HR 450).

5. "Priority Guidance Questions and Answers" (Endangered Species Section of the U.S. Fish and Wildlife Service's Website, October 22, 1999).

6. "Is There Really No Money for the Endangered Species Act? How the Bush Administration Has Manufactured a Budget Crisis to Withhold Protections from Endangered Species and Critical Habitats," (Center for Biological Diversity's Website, www.biologicaldiversity.org, 2004).

The U.S. Fish and Wildlife Service (USFWS) has thus been unable to perform its duties properly under the Act or to comply with court-ordered actions to protect endangered species. As of November 10, 2004, the USFWS had listed 518 U.S. species of animals and 746 species of plants as endangered, but only 472 species had any designated critical habitat and more than 200 had no approved recovery plans. Only twenty-two additional species of animals and no plant species were proposed for Endangered Species Act listing in late 2004, at a time when scientists were telling us that a vast and ever-growing mass of species is imperiled. By early in 2006, only fourteen species were proposed. "The *living world* is disappearing before our eyes," according to Professor Sir Peter Crane, the distinguished Director of the Royal Botanic Gardens at Kew, England. "Around one in ten of all the world's bird species and a quarter of its mammals are officially listed as threatened with extinction, while up to two-thirds of other animal species are also endangered."

CHAPTER 3

1. World Resources Institute, *Last Frontier Forests: Ecosystems and Economics on the Edge* (Washington, DC: www.wri.org, 1997).

2. "First Scientific Assessment of Condition of World's Forests Shows Much More Than Tropical Forests At Risk," World Resources Institute Press Release, March 4, 1997. The information cited pertained to eighty-seven percent of Central America's forests as well as to seventy-five percent of all pristine forests in Africa and Oceania, among other areas.

3. W. R. J. Sutton, "The World's Need for Wood," *Proceedings: The Globalization of Wood: Supply, Processes, Products, and Markets* (Portland, OR: Forest Products Society, 1993).

4. Food and Agriculture Organization of the United Nations, 2004 FAO-STAT on-line statistical service at http://apps.fao.org, as cited on the World Resources Institute Website: www.wri.org.

5. Lester Brown, from his foreword to John Perlin's *A Forest Journey: The Role of Wood in the Development of Civilization* (New York: W. W. Norton and Company, 1989).

6. USDA-NAAS *Agricultural Statistics 2005*, Chapter XII, "Agricultural, Conservation, and Forestry Statistics," Table 12–20, p. 18.

7. Estimates vary by as much as sixty million acres for legitimate reasons, such as at what point a plantation of tree seedlings comprises a forest and should be included in forest statistics. Millions of acres of land have been restocked with trees in the United States—1.4 million acres of land in the United States were seeded or planted with trees in 2002 alone. These restocked lands, of course, are usually very different from natural forests.

8. Daniel Worster, *Nature's Economy: The Roots of Ecology* (Garden City, NY: Anchor Books, Anchor Press/Doubleday, 1979), p. 67.

9. *Ibid.*

10. Net timber growth in 2002 (growth minus death) was 23.7 billion cubic feet while sixteen billion cubic feet were harvested. Thus, U.S. standing timber volume was increasing. Source: USDA-NAAS *Agricultural Statistics 2004*, Chapter XII, "Agricultural, Conservation, and Forestry Statistics," Table 12–22, p. 18.

11. As of 2002, net softwood growth of 13.6 billion cubic feet exceeded softwood timber removal by 3.6 billion cubic feet.

12. These U.S. Forest Services statistics include as forest those lands that are at least ten percent stocked with trees of any size, even seedlings.

13. There are pests and diseases native to North America, such as the devastating spruce budworm *Choristoneura fumiferana* (Clemens). What makes imported pests and diseases so pernicious, however, is the fact that they come without natural enemies and reach epidemic proportions; unchecked, they wipe out entire species, such as the native elm. Dutch elm disease is a fungus transmitted by a bark beetle that kills elm trees by causing their leaves to yellow, wilt, and drop off. Larvae of the introduced

gypsy moth (*Lymantria dispar*) is another potent introduced pest. The larvae consume the leaves of many different hardwood tree species, though they are most commonly found on oaks and aspens. The gypsy moth larva is the most damaging insect defoliator in North America and can not only reach very high population densities in North American forests, but also defoliate whole trees and ultimately kill them. The gypsy moth has spread widely since its introduction from abroad in the late nineteenth century, and it is still expanding its range despite all efforts at control.

14. USDA-NAAS, *Agricultural Statistics 2004*, Chapter XII, "Agricultural, Conservation, and Forestry Statistics," Table 12–34, "Timber products: Production, imports, exports, and consumption, United States, 1993–2002," p. 34.

15. USDA-NAAS, *Agricultural Statistics 2005*, Chapter XII, "Agriculture, Conservation, and Forestry Statistics," Table 12–23, "Timber growth, removals, and mortality: Net annual growth, removals, and mortality of growing stock on timberland by softwoods and hardwoods and regions, 2002," p. 19.

16. W. Brad Smith, Patrick D. Miles, John S. Vissage, and Scott A. Pugh, *Forest Resources of the United States, 2002*, Table 25, "Net volume of all growing stock on timberland in the United States by ownership group, region, subregion, and State, 2002, 1987, 1977, and 1953" (St. Paul, MN.: North Central Research Station, Forest Service-USDA, 2004. www.ncrs.fs.fed.us).

CHAPTER 4

1. Marsh's work was a departure from the widespread eighteenth-century assumption (which had numerous adherents in the nineteenth and twentieth centuries as well) that nature existed primarily to be tamed for the benefit of humanity.

2. Aligned with American transcendentalism (an anti-materialist philosophical movement exemplified by Emerson and Thoreau), Muir admired and worshipped nature in all its infinite forms as an expression of divinity. Like the Native American, he knew nature intimately and saw a spirituality in all things.

3. A broadly based social and political reform movement of the early twentieth century, the Progressive Movement arose in reaction to the

excesses of monopolistic business trusts, wasteful exploitation of natural resources, urban poverty and its related social ills, and municipal and state governmental corruption, especially the abuses of "political machines," and in response to the depression of 1893–1897, unfair labor practices, unemployment, and labor unrest. Imbued with a faith in the possibility of progress, the Progressives stood for greater federal economic regulation of corporations, a stronger role for the federal government in conservation, and protection of public health, safety, and welfare through consumer and labor regulations. Progressives also generally strove for civic reform through greater honesty and efficiency in government, social justice and equality, including women's rights, and more representative democracy.

4. The Homestead Act of 1862 gave 160 acres of public land to those who agreed to settle on it and improve it for at least five years.

5. Harold K. Steen, *The U.S. Forest Service: A History* (Seattle: University of Washington Press, 2004), Appendix I, "Chronological Summary of Events Important to the History of the U.S. Forest Service," p. 325. (See 33 Stat. 861, 872–73.)

6. Benjamin Kline, *First Along the River: A Brief History of the U.S. Environmental Movement* (San Francisco: Acada Books, 2000).

7. Frank Graham, Jr., *Man's Dominion: The Story of Conservation in America* (New York: M. Evans, 1971), p. 135, as cited in Kline, *ibid.*

8. Samuel Dana Trask and Sally K. Fairfax, *Forest and Range Policy* (New York: McGraw-Hill 1980).

9. *Ibid.*

10. The Environmental Defense Fund, now known as Environmental Defense, was established by the National Audubon Society to work for a ban on DDT out of the society's early alarm over the decimation of birds caused by the widespread spraying of DDT. (Richard Pough, an Audubon official who went on to found The Nature Conservancy, warned eloquently of the dangers of DDT in a *New Yorker* interview in 1945, but his warning went unheeded by most people until 1962 when biologist Rachel Carson's book, *Silent Spring,* documented the hazards of DDT in a powerful, meticulously researched, irrefutable, and widely read indictment that led to the banning of DDT and helped launch the modern environmental

movement). Environmental Defense gradually became a broad-spectrum environmental organization. Other important twentieth-century contributors to the conservation and environmental movements include the International Union for the Preservation of Nature and Natural Resources, Ducks Unlimited, Trout Unlimited, the Natural Resources Defense Council, and many more national, state, and local environmental and nature protection groups.

11. Leopold early in his career had been a vigorous proponent of predator control, a position he later disavowed. See Les Line, ed., *National Audubon Society: Speaking for Nature, a Century of Conservation* (New York: The National Audubon Society, 1999), p. 65.

12. The Appalachian Mountain Club, founded in 1876, is the nation's oldest outdoor recreation and conservation organization. It promotes the protection, enjoyment, and wise use of the mountains, rivers, and trails of the American Northeast. In 2007, it had nearly 90,000 members in twelve chapters, 20,000 volunteers, and more than 450 full-time and seasonal staff to coordinate thousands of outdoor trips a year as well as operate numerous campgrounds, lodges, and other rustic facilities.

13. Les Line, *op. cit.*, p. 149.

14. *Ibid.*, p. 215.

15. *Ibid.*, pp. 146, 148, and 149.

16. As early as 1939, the U.S. Forest Service had issued regulations to establish "Wilderness and Wild Areas" in which roads, logging, and motor vehicles are banned.

17. An earlier landmark Alaskan land management statute, the Alaska Native Claims Settlement Act (ANCSA) of 1971, ceded millions of acres of communal aboriginal lands, including a great deal of wilderness, to for-profit Alaskan Native Corporations. Because these corporations privatized hitherto tribal lands and were required to pay taxes, ANCSA created an impetus for the sale and development of natural areas, including the clearcutting of old-growth forests in southeastern Alaska. See Thomas R. Berger. *A Village Journey: The Report of the Alaska Native Review Commission* (New York: Hill and Wang, 1985).

18. See *Appendix B* (p. 250) for a description of the act.

CHAPTER 5

1. The driest summer in the park's 125-year history occurred in 1988 and caused a severe drought in the Greater Yellowstone Ecosystem. Lightening from the early rainless summer thunderstorms ignited numerous fires. High winds and dry forest fuels made the largest wind-whipped blazes virtually uncontrollable. More than 150,000 acres burned on the worst single day (August 20, 1988), and, by winter, 793,000 acres (slightly more than a third) of the park had burned. Most of the park's wildlife recovered quickly from the event.

2. *Audit Report, USDA Forest Service's Financial Statements for Fiscal Years 2003 and 2002*, Report No. 08401-3-FM, January 2004.

3. Ervin G. Schuster and Michael A. Krebs, *Forest Service programs, authorities, and relationships: A technical document supporting the 2000 USDA Forest Service RPA Assessment*, Gen. Tech. Rep. RMRS-GTR-112 (Fort Collins, CO: USDA, Forest Service, Rocky Mountain Research Station, 2003).

4. *Ibid.*

5. USDA Forest Service, *Strategic Plan for Fiscal Years 2004–08*. FS-810. November 2004.

6. *Ibid.*

7. Timothy Egan, "Oregon, Foiling Forecasters, Thrives As It Protects Owls," *The New York Times*, September 12, 1995.

8. The mill shut down in 1997. See http://www.state.ak.us/de/spar/csp/sites/kpc.htm.

9. See www.taxpayer.net/forest/roadwrecked/tongasscasestudy.htm.

10. USDA-NAAS, *Agricultural Statistics 2004*, Table 12–28, "Forest Products Cut on National Forest System Lands: Volume and Value of Timber Cut and Value of All Products, United States, Fiscal Years 1993–2002." pp. xii–21, and Table 638, "Forest Products Cut on National Forest System Lands: Volume and Value of Timber Cut and Value of All Products, United States, Fiscal Years 1984–1993," p. 421.

11. *Ibid.*, Table 12–28.

12. Schuster and Krebs, *op. cit.*

13. In FY 2002, 340 million cubic feet of timber were harvested from the national forests, according to the U.S. Forest Service, "Timber Harvested on The National Forests," FY 2002 data, www.fs.fed.us/forestmanagement/reports/sold-harvest/index.shtml. By contrast, USDA National Agricultural Statistics Service 2004, *Agricultural Statistics 2004*, Table 12–33, "Timber products; Production, imports, exports, and consumption, United States, 1993–2002," shows that total U.S. timber product consumption for 2002 was 18.7 billion cubic feet. Table 12-22, "Timber growth, removals and mortality; Net annual growth, removals, and mortality of growing stock on timberland by softwoods and hardwoods and regions, 2002," shows that the total U.S. merchantable timber removals for 2002 were sixteen billion cubic feet.

14. Real improvement in senior leadership may be contingent on reform of political campaign contribution laws that permit undue corporate influence on Congress and the White House.

15. Personal communication with former U.S. Forest Service Deputy Chief James Furnish by telephone during 2005.

16. FY 1991 was the first year that Congress authorized the spending of the road appropriations on decommissioning. Under authorizing Statute 23 USC 205a, the spending of road money on decommissioning was previously considered a violation of the Anti-Deficiency Act (34 Stat. 48, Ch. 10, Sec. 3).

17. Schuster and Krebs, *op. cit.*, p. 2.

18. The U.S. Forest Service has acknowledged that it has nearly an $8 billion backlog of road and bridge capital improvement and maintenance needs. The addition of routine administrative costs and indirect agency costs to this total brings the liability to more than $10 billion. See www.taxpayer.net/forest/roadwrecked/maintenanceandImprov for an analysis of the situation.

19. See Taxpayers for Common Sense, www.taxpayer.net/forest/roadwrecked/roadsubsidies.

20. Reliance on natural regeneration means that trees are allowed to resprout naturally, from seeds already in the soil or dropped from trees on site. Sometimes brush is cleared or other preparation is done to increase the success of natural regeneration.

21. "Annual appropriations have been insufficient to keep pace with burgeoning resource recovery needs, including reforestation needs, following large-disturbance events, which are now the principal driver in creating these needs on the national forests. Long-standing authorities enable the Agency to respond to these events by applying appropriately designed timber harvest prescriptions as a means of helping to promote resource recovery and thereby deriving a source of revenue to pay for needed follow-up actions. We are not using these authorities to the fullest possible extent, in my personal view. With no offsetting increase in annual appropriations to cover this work, we lack the financial wherewithal to address these collective resource recovery needs. The prospect for seeing these increases in annual appropriations is very dim, as the Administration wrestles with growing budget deficits and the need to provide the budgetary resources needed by a nation at war." Ecosystem & Planning Team, Forest and Rangeland Management Staff, U.S. Forest Service Office in Washington, DC, personal communication, 2005.

22. USDA Forest Service, *Forest Service Performance and Accountability Report—Fiscal Year 2003*, Washington, DC.

23. Other U.S. Forest Service (USFS) industrial forestry cutting methods employed by USFS contractors amount to clearcuts on the installment plan. Examples include "seed tree cuts," "removal cuts," and patch cuts that, over time, cumulatively amount to a clearcut. Clearcuts are now limited to forty acres in size by the National Forest Management Act of 1976, but they are usually no more than ten to fifteen acres. A critical number to watch is the total acreage cut by all techniques. In 1991, that number was 900,000 acres; by 2003, it had fallen to 224,000 acres. See Chapter 7 for more discussion of logging methods.

24. USDA Forest Service, *The Forest Service Program for Forest and Rangeland Resources: A Long-Term Strategic Plan*, Draft, 1995 RPA Program, Washington, DC.

25. "Maintaining or restoring conditions of late-successional and old-growth forest ecosystems will be the primary objective of old-growth management areas." *Ibid.*

26. USDA Forest Service, *Strategic Plan for Fiscal Years 2004-2008*, FS-810, November 2004.

27. USDA Forest Service, *Strategic FY 2003 Performance Report.*

28. *Ibid.*

29. *Ibid.*

30. *Ibid.*

31. Elizabeth Beaver, et al., *Seeing the Forest Service for the Trees: A Survey of Proposals for Changing National Forest Policy* (Natural Resources Law Center, University of Colorado School of Law, Boulder, CO 80309-0401). See, also, www.Colorado.edu/Law/NRLC/NRLC@Spot.Colorado.edu.

32. William R. Bentley and William D. Langbein, *Final Report,* Seventh American Forest Congress, Washington, DC, February 20–24, 1996.

33. Randal O'Toole, *Reforming the Forest Service* (Covelo, CA, and Washington, DC: Island Press, 1988).

34. National Forest Protection and Restoration Act of 1999 (H.R. 1396), sponsored by Representative Cynthia McKinney (D-GA). See http://thomas.loc.gov.

35. USDA Committee of Scientists, *Sustaining the People's Lands: Recommendations for Stewardship of the National Forests and Grasslands into the Next Century,* March 1999. See www.fs.fed.us/news/science.

36. United States General Accounting Office, *Forest Service Planning: Better Integration of Broad-Scale Assessments into Forest Plans is Needed,* GAO/RCED-00-56, February 2000. See www.gao.gov.

37. For more information, see http://www.saveamericasforests.org/congress/congress.htm.

38. See www.tws.org/standbylands/forests/specialreports.htm.

39. Bentley and Langbein, *op. cit.*

40. The Secure Rural Schools and Community Self-Determination Act of 2000 (PL. 106-393). See http://thomas.loc.gov.

CHAPTER 6

1. Even on land where gross ecological damage is not apparent, unmistakable signs of overuse, abuse, and disrespect for the land are widespread.

Many areas of the national forests in the United States are marred by ORV (off-road vehicle) use, soil compaction, beer cans, shotgun shells, and other garbage. It is common to find trampled campsites and stream-banks, crude and dirty firepits, and weedy nonnative plants. Much of the land appears victimized by people without a land ethic who are neither properly instructed nor properly supervised in its use.

2. This was accomplished by having White House Chief of Staff Andrew Card issue a memorandum on President Bush's authority.

3. See "Bush Launches 'Sneak Attack' on the Roadless Area Conservation Plan," May 4, 2001. www.nrdc.org/bushrecord/articles/br_465.asp.

4. See www.nrdc.org.

5. He left the Department of the Interior in early 2005 to form a lobbying firm (Lundquist, Nethercutt and Griles) in Washington, DC, with two other former government officials.

6. See www.nrdc.org.

7. See http://www.biological diversity.org/swcbd/activist/ESA/bush-esa.html for details.

8. These designations are an essential tool for the protection of species listed under the Endangered Species Act of 1973. Data from the U.S. Fish and Wildlife Service and National Marine Fisheries Service indicate that species with critical habitat are twice as likely to be recovering as species without it.

9. Kieran Suckling, Policy Director, Center for Biological Diversity, personal communication, 2005.

10. In December 2003, the U.S. Forest Service granted the Flathead Snowmobile Association permission to build a bridge across a creek in the Flathead National Forest of Montana, giving the snowmobilers springtime access to prime grizzly bear habitat, against the advice of the U.S. Fish and Wildlife Service.

11. All fire data are from the National Interagency Fire Center of Boise, Idaho: "Wildland Fire Statistics;" "Wildland Fire Season 2000 At A Glance;" and "Wildland Fire Season 2002 At A Glance." See www.nifc.gov.

12. *Ibid.*

13. GAO-03-689R, Forest Service Fuels Reduction, May 14, 2003.

14. The U.S. Forest Service (USFS), however, was barred from "salvage logging" in the Malheur National Forest in December 2004 by a federal judge after opponents of the project proved that the USFS had clearly marked live trees for removal. (Salvage logging regulations in eastern Washington and eastern Oregon only permit the cutting of dead trees.) Rolf Sklar, personal communication, March 15, 2005.

15. "Interim Final Rule for the Predecisional Administrative Review Process for Hazardous Fuel Reduction Projects Authorized Under the Healthy Forests Restoration Act of 2003," *Federal Register* 69, No. 6 (1529–37), January 9, 2004.

16. The Wildland Urban Interface Zone is an area that is often at high risk from wildfire, because it is an area where wild land, such as a forest, meets homes or other residential or commercial development. An uncontrolled wildland fire within The Wildland Urban Interface Zone thus presents a real threat to human life and property. Of related interest, see Jessie McKinley and Kirk Johnson. "On Fringe of Forests, Homes and Wildfires Meet," *The New York Times,* June 26, 2007, pp. A1 and A14.

17. See www.ucsusa.org. The statement also faults the George W. Bush Administration for removing scientists from advisory panels for political reasons, disbanding some scientific advisory committees altogether, and restricting international communication on scientific issues.

CHAPTER 7

1. On private lands in California, those long-term forest plans are referred to as sustained yield plans.

California's Forest Practices Act is widely regarded as the nation's strictest. It requires the preparation of a timber harvest plan (THP) for state and private industrial timber removal operations. Smaller ownerships (less than 2,500 acres) that secure an approved non-industrial timber management plan (NTMP) are excused from preparing the more comprehensive THP. They are, instead, allowed to submit a timber harvest notice that briefly describes the proposed logging site and the operations to be conducted on it.

Despite its image as a rigorous regulatory framework, the act has major loopholes and is far too lenient to protect many forest ecosystems. For

example, it excuses managers of salvage logging operations from filing THPs. In recent years, the number of acres harvested under salvage exemptions far exceeded the number harvested under conventional THPs. Moreover, even when a full THP is required, timber contractors at times inadvertantly or intentionally fail to follow the plan's precise instructions. Sometimes, for example, the operator accidentally cuts the wrong trees or strays over the plan's boundary. Severe penalties for these transgressions can be made part of timber sales contracts, but nothing will bring back a beautiful old tree that was meant to be preserved and was felled instead. Culverts or other erosion control devices may also be improperly installed in a badly conducted logging operation and, later, may be inadequately maintained. Within watercourse buffer zones, operators sometimes fail to maintain adequate controls on the use of heavy equipment, thereby injuring tree trunks, damaging roots, and allowing disturbed soil to enter waterways.

2. For example, appearance-grade figured hard maple veneer logs with a heavy burl pattern can bring up to \$8,200 per thousand board foot [MBF]. A sliced veneer cherry log may command over \$7,000 per MBF. See Jan Wiedenbeck et al., *Defining Hardwood Veneer Log Quality Attributes* (USDA Forest Service Northeastern Research Station, General Technical Report NE-313, January 2004).

CHAPTER 8

1. Option 9 required the protection of eighty percent of the Pacific Northwest's old-growth forest within the northern spotted owl's range, yet it allowed some regulated logging there. The options describe how federal forest lands in three states in the Pacific Northwest should be categorized and the rules under which the different categories of land should be managed. The categories used are: Congressionally withdrawn lands, including the late successional (old-growth) forests found in national parks, wilderness areas, research natural areas, and other areas reserved by Congressional authority; late-successional reserves to be left essentially unlogged; managed late-successional areas; riparian reserves; and matrix lands (that is, intervening federal lands on which the full range of silvicultural practices can be used). Option 9 is one of the ten options presented in the *Draft Supplemental Environmental Impact Statement (DSEIS) for the Northwest Forest Plan and examined in the Report of the Forest Ecosystem Management*

Assessment Team, one of three task forces set up after President Clinton's 1993 Forest Conference. Option 9 permits the annual removal of 1.2 billion board-feet of timber from the forest, and it was roundly criticized by some environmentalists for failing to provide adequate protection to the region's ancient forests and biodiversity. See Jim Britell, *Zero Cut is for Wimps: The Scientific Case for Option Minus 9,* Joint comments of Kalmiopsis Audubon Society and The Native Forest Council on the Clinton Forest Plan, October 1993. See www.britell.com/misc/cfp.html.

2. Michael C. Blumm, "The Bush Administration's Sweetheart Settlement Policy: A Trojan Horse Strategy for Advancing Commodity Production on Public Land." *Environmental Law Reporter,* Vol. 34 (May 2004), p. 10397. See http://ssrn.com/abstract=539302.

3. See http://www.earthjustice.org/news/display.html?ID=581.

4. USFWS 2004, *Estimated Trends in Suitable Habitat for the Northern Spotted Owl on Federal Lands from 1994 to 2003.* "Gray literature" prepared in support of the five-year status review prepared by Sustainable Ecosystems Institute. (http://www.sei.org/owl/home.htm): M. Moeur, T. A. Spies, M. Hemstrom, J. Alegria, J. Browning, J. Cissel, W. B. Cohen, T. E. Demeo, S. Healy, and R. Warbington (in review), *Northwest Forest Plan— The First Ten Years (1994-2000): Status and Trends of Late-Successional and Old Growth Forests*; USDA Forest Service General Technical Report (in press); and Doug Heiken, Esquire, personal communication, January-February 2006.

5. Doug Heiken, *Science Summary: Thinning to Enhance Biodiversity in Young Plantations West of the Cascades,* Version 1.1, Oregon Natural Resources Council, January 2003. See http://www.efn.org/%7Eonrcdoug/THIN-NING_SCIENCE.htm

6. Before dissolved nutrient levels in Lake Tahoe rose to their current, artificially elevated levels, algal growth in the lake was limited, according to Leibig's Law of the Minimum, by those nutrients in shortest supply. A decade ago, the nutrients most limiting algae were nitrogen and phosphorus; now, nitrogen levels have gotten so high that algal growth is currently limited only by phosphorus.

7. Dr. Michael G. Barbour, personal communication, February 24, 2006.

CHAPTER 9

1. The tree trunks absorb thermal energy from sunlight and gradually reradiate it over time, creating warmer more hospitable microclimates for nearby seedlings struggling to get established.

2. Gordon Robinson, *The Forest and the Trees: A Guide to Excellent Forestry* (Covelo, CA and Washington, DC: Island Press. 1989).

CHAPTER 10

1. Ray Raphael, *Tree Talk: The People and Politics of Timber* (Covelo, CA, and Washington, DC: Island Press, 1981).

2. *Ibid.*

3. S. Charnley, E. Donoghue, C. Stuart, C. Dillingham, L. Buttolph, W. Kay, R. McLain, C. Moseley, and R. Phillips, USFS *Northwest Forest Plan: The First Ten Years. Socioeconomic Monitoring Results. Volume 1: Key Findings,* Gen. Tech. Rep. PNW-GTR-649, USDA Forest Service (Portland, OR.: Pacific Northwest Research Station. 2006).

4. Alan Thein Durning, *Saving the Forests, What Will It Take?* Worldwatch Paper #117 (Washington, DC: Worldwatch Institute, 1993).

CHAPTER 11

1. Herb Hammond, *Seeing the Forest Among the Trees: The Case for Wholistic Forestry* (Vancouver, BC: Polestar Press, 1991).

2. Jay Rastogi, Manager of Site Services, Wildwood Forest, Ladysmith, British Columbia, personal communication (e-mail), April 4, 2005; and Herb Hammond, "Restoration Forestry in British Columbia and Canada: A Resource Guide," in Michael Pilarski, ed., *Restoration Forestry: An International Guide to Sustainable Forestry Practices* (Durango, CO: Kivaki Press, 1994), pp. 253–254.

3. Hans Burkhardt, "Environmental Protection and Maximum Perpetual Revenue," *International Journal of Ecoforestry*, Vol. 12, No.1 (Spring 1996): 188-92.

4. Craig Blencowe, "Building Up the Forest," In Institute for Sustainable Forestry, *Working Your Woods: An Introductory Guide to Sustainable Forestry* (Redway, CA: Institute for Sustainable Forestry, 1996).

5. Thom J. McEvoy, *Positive Impact Forestry: A Sustainable Approach to Managing Woodlands* (Covelo, CA, and Washington, DC: Island Press, 2004).

6. Chris Maser, *Sustainable Forestry: Philosophy, Science, and Economics* (Del Ray Beach, FL: Saint Lucie Press, 1994).

7. Herb Hammond, *Ecosystem-based Conservation Planning: Definition, Principles, and Process* (Slocan Park, Canada: Silva Forest Foundation. 2004).

8. The word "naturalistic" is used here since forest managers are only mimicking natural processes; their work, by definition, is neither indigenous nor inherently natural to the forest.

9. Merv Wilkinson, "Wildwood: A Forest for the Future," in Michael Pilarski, ed., *Restoration Forestry: An International Guide to Sustainable Forestry Practices* (Durango, CO: Kivaki Press, 1994).

10. *Ibid.*

11. Ted Kerasote, "Good Wood," *Audubon Magazine* (January-February 2001).

12. A company called Environmental Advantage is attempting to set up a similar buyers' group in the United States, in conjunction with several major environmental organizations.

13. The fee, which can range from $2,000 to more than $100,000, depends on the forest's size and location, the complexity of certification, and other factors.

14. Robert Hrubies, personal communication (telephone conversation), 2005. Encouraging current events involve guitar makers working to ensure the long-term survival of old-growth forests and Greenpeace wanting private logging companies to apply for certification by the Forest Stewardship Council. See Glenn Rifkin, "Saving Trees Is Music To Guitar Makers' Ears: Picking Up the Tempo for Sustainability," *The New York Times,* June 7, 2007, p. C4.

15. American Forest & Paper Association Sustainable Forestry Principles and Guidelines.

16. *Ibid.*

17. David Lamb and Don Gilmour, *Rehabilitation and Restoration of Degraded Forests* (Gland, Switzerland, and Cambridge, England: International Union for the Conservation of Nature, April 2003).

18. This section and the next come from the Amberican Forest & Paper Association. Only minor editorial changes (such as punctuation) have been made to the original.

CHAPTER 12

1. David Lamb and Don Gilmour, *Rehabilitation and Restoration of Degraded Forests* (Gland, Switzerland, and Cambridge, England: International Union for the Conservation of Nature, April 2003).

2. See Stephen H. Schneider et al., eds. *Climate Change Policy: A Survey.* (Covelo, CA, and Washington, DC: Island Press, 2002).

3. Lamb and Gilmour, *op. cit.*

4. Dominick A. DellaSala, et al., "A Citizen's Call for Ecological Forest Restoration: Forest Restoration Principles and Criteria," *Ecological Restoration*, Vol. 21, No. 1 (2003).

5. See Karr and Dudley (1981) and Karr (2000), as cited in DellaSala, *ibid.*

6. DellaSala, *op. cit.*

7. John J. Berger, *Evaluating Ecological Restoration and Protection Projects: A Holistic Approach to the Assessment of Complex, Multi-Attribute Resource Management Problems*, Ph.D. dissertation, University of California, Davis, 1990.

8. Lamb and Gilmour, *op. cit.*

9. A thoughtful and comprehensive discussion of forest restoration principles and an "inclusive" approach to forest restoration, along with a checklist for conducting projects, can be found in "A Citizen's Call for Ecological Forest Restoration: Forest Restoration Principles and Criteria," by DellaSala, *op. cit.*

10. Herb Hammond, *Ecosystem-based Conservation Planning: Definition, Principles and Process: Revised Boreal Version* (Slocan Park, BC: Silva Forest Foundation, 2004).

11. Steven Albert, et al., "Restoring Biodiversity to Piñon-Juniper Woodlands," *Restoration Ecology* 22:1 (March 2004).

12. Lamb and Gilmour, *op. cit.*

13. *Ibid.*

CHAPTER 13

1. "Shortly after the acquisition, Pacific Lumber . . . tripled its logging output to finance the purchase," according to Evelyn Nieves. "Timber Company Approves Deal to Save Redwoods. *The New York Times*, March 3, 1999. Data from a 1998 MAXXAM bond offering, however, shows MAXXAM/PL logging rates of 290 million board-feet (MBF) in 1995, 291 MBF in 1996, and 309 MBF in 1997 contrasted with the old Pacific Lumber's typical logging rate of 120 MBF.

Also, please note that the Headwaters Forest Complex and the Headwaters Forest are not identical. I use the two terms with specific intent to refer to *two different zones.* The "Headwaters Forest Complex" is a larger, more inclusive area; the "Headwaters Forest" per se is the sub-area that was subject to a formal agreement, The Headwaters Agreement. I write out "the Headwaters Complex" on the few occasions when that is the area referred to, and I use "the Headwaters" in all other cases.

2. Michael W. Gjerde, State Water Resources Control Board, Office of Statewide Initiatives, *Comments on the Pacific Lumber Company Economic White Paper*, April 27, 2005.

3. Pacific Lumber retirees later filed suit in an effort to reclaim the millions they claim MAXXAM took from the pension fund; the state's insurance commissioner eventually interceded on the workers' behalf.

4. EPIC eventually filed about twenty-three lawsuits against MAXXAM/PL. Personal communication (e-mail) with Cynthia Elkins, former EPIC staff member, May 27, 2005.

5. *Marbled Murrelet et al. v. Pacific Lumber*, 880 F. Supp 1343 (N.D. Cal. 1995), aff'd, 83 F. 3d 1060 (9th Cir. 1996), cert denied 519 U.S. 1108 (1997). State and federal defendants, including U.S. Secretary of the Interior Bruce Babbitt et al. in the case as originally filed were dismissed from the case in September 1993.

6. "The Headwaters Forest: This Land is Your Land," *Awareness Journal*, Tucson, Arizona, unsigned and undated.

7. Customarily, a valid "takings" claim requires the plaintiff to show that the government's action would cause the property owner to lose nearly all use of the property. By contrast in this case, relatively little of Pacific Lumber's property was off-limits to logging, and, to the extent that the disputed environmental limitations were imposed, they were consistent with requirements of the federal Endangered Species Act of 1973, which was already in force when MAXXAM acquired Pacific Lumber in 1985.

8. Gjerde, *op. cit.*

9. According to the Gjerde report, "Hurwitz and members of his immediate family and trusts they control collectively own approximately 68.8% of the aggregate voting power of MAXXAM"

10. Based on information from the U.S. Treasury Office of Thrift Supervision, United Savings Association of Texas was a wholly owned subsidiary of United Financial Group, an entity in which MAXXAM, its predecessor MCO Holdings, Inc., and Federated Development Company held controlling financial interests. Hurwitz was a controlling shareholder as well as Chairman and CEO of Federated Development Company, which, in turn, was a controlling shareholder of MAXXAM. Both the Office of Thrift Supervision and Federal Deposit Insurance Corporation legal documents treated Hurwitz as a controlling person of United Savings Association of Texas.

11. An assemblage of documents and links containing critical information about Charles Hurwitz and MAXXAM can be found at www.jailhurwitz. com, a vitriolic Website that offers "a $50,000 reward for information leading to the arrest, conviction, and jailing of corporate raider Charles Hurwitz."

12. "FDIC v. Hurwitz Restitution Demanded By MAXXAM," *Bank & Lender Liability Litigation Reporter* (Andrews Publications, Inc.), Vol. 9, No. 7 (September 4, 2003): 8.

13. Bay Area Coalition for Headwaters press release, October 15, 2002.

14. Among the state laws the court found to have been violated were the Forest Practices Act, California Endangered Species Act, and California Environmental Quality Act.

15. State Water Resources Control Board Mission Statement, p. 1, http://www.swrcb.ca.gov.

16. Keith Easthouse, "The More Things Change . . . PL and EPIC at Odds Again" (editorial), *North Coast Journal,* June 1, 2004. See www.north-coastjournal.com.

17. See the Environmental Protection Information Center's Website: www.wildcalifornia.org.

18. North Coast Regional Water Quality Control Board, *Staff Report for Proposed Regional Water board Actions in the North Fork Elk River, Bear Creek, Freshwater Creek, Jordan Creek, and Stitz Creek waters,* September 9, 2000.

19. In the Matter of the Petition of Humboldt Watershed Council, Environmental Protection Information Center, and Sierra Club for Review of Directive to Enroll Pacific Lumber Company Timber Harvesting Plans under General Waste Discharge Requirements, Order No. R1-2004-0030 California Regional Water.

20. Consisting of representatives from the state's Department of Forestry, Department of Fish and Game, and Division of Mines and Geology (recently renamed the California Geological Services).

21. State of California Porter-Cologne Water Quality Control Act. California Water Code. Division 7. Effective as amended in January 2005.

22. This categorical exemption extended the one originally adopted in 1987 under the presumption that CDF would protect water quality through proper enforcement of the state's Forest Practices Rules. (The rules govern conditions for timber harvest permits and other related matters.)

23. *California State Senate Bill 810. Amendment to the California Public Resources Code. Natural Resources: Timber Harvesting,* February 21, 2003.

24. In the Matter of the Petition of Humboldt Watershed Council, Environmental Protection Information Center, and Sierra Club for Review of Directive to Enroll Pacific Lumber Company Timber Harvesting Plans under General Waste Discharge Requirements.

25. Dr. Kenneth Miller, Humboldt Watershed Council, personal communication (e-mail), 2005.

26. *General Waste Discharge Requirements for Discharges Related to Timber Activities on Non-Federal Lands in the North Coast Region,* California Regional Water Quality Control Board, North Coast Region, Order No. R1-2004-0030.

27. "09/07/2005—Scotia Pacific Annual Harvest Levels Projected to Fall Significantly and Threatened by Regional Water Board Staff Proposal," Pacific Lumber Company press release. See www.palco.com.

28. SCOPAC Company, a wholly owned subsidiary of MAXXAM, was created to hold Pacific Lumber's timber assets.

29. "09/07/2005—Scotia Pacific Annual Harvest Levels Projected to Fall," *op. cit.*

30. *Ibid.*

31. "07/15/2005—PALCO Challenges State Water Board Ruling in Court," Pacific Lumber Company press release. See www.palco.com.

32. Gjerde, *op. cit.*

33. *The People of the State of California v. The Pacific Lumber Company; Scotia Pacific Lumber Company; Salmon Creek Corporation; and DOES 1 through 10,* State of California Superior Court Case No. DR030070, February 23, 2003.

34. Second Amended Complaint, *People v. The Pacific Lumber Company,* State of California Superior Court, filed May 27, 2004.

35. *Ibid.*

36. *Ibid.*

37. Gjerde, *op. cit.*

38. *Ibid.*

39. *Ibid.*

40. In August 1998, MAXXAM refinanced Pacific Lumber's debt and secured it with the assets—principally Pacific Lumber's timberlands— now owned by Scotia Pacific, a wholly owned subsidiary of Pacific Lumber, which is, in turn, a wholly owned subsidiary of MAXXAM. As noted elsewhere in this chapter, Pacific Lumber and other MAXXAM subsidiaries eventually were forced to file for bankruptcy on January 19, 2007.

41. Darryl Cherney, EarthFirst!, telephone interviews with the author, May 17, 2005.

42. *Ibid.*

43. The provincial government has committed $30 million, and the Canadian national government has confirmed its $30 million commitment. Private philanthropic donors are providing the remaining $60 million.

44. The Heiltsuk people blockaded the logging road on their own and requested that the environmental community support the protest by alerting the media.

45. About a quarter of the sound's ancient rainforest has been cut, a third of the unprotected land was protected in 1994, and forty percent is still open to logging, despite the fact that three-quarters of the coastal temperate forest on surrounding Vancouver Island has already been clearcut.

46. This process reached the North Coast in 2002.

47. The First Nations refused to participate in these negotiations as "stakeholders" and insisted, instead, on government-to-government negotiations. The environmental community supported the First Nations in this bid, and the First Nations achieved their goal in 2001, an achievement that bolstered their influence over regional land-use decisions.

48. Haida Gwaii is the First Nations name for the Queen Charlotte Islands.

49. The team was co-funded by industry, government, and environmental groups, and it was co-chaired by the provincial government and First Nations.

50. The vast majority of the logging jobs were for workers outside the region. By contrast, the conservation-oriented investment is to go predominantly to local communities, so they can build local economies that are not entirely dependent on logging.

51. The Central Coast Long Range Management Plan was adopted in December 2003. The North Coast consensus recommendations were adopted in 2004, but the North Coast Long Range Management Plan was finalized in discussions between the provincial government and First Naitons in 2005. Final land-use plans were accepted by the provincial government and by First Nations in February 2006.

52. This means that the traditional lands held by each tribe are categorized by ecosystem type and that at least seventy percent of the old growth in each of these subregional ecotypes is to be protected. By contrast, if seventy percent of the old growth were protected on a regional basis, certain tribal subregions might be heavily clearcut while others would enjoy complete protection.

53. Lisa Matthaus, British Columbia Chapter of the Sierra Club of Canada, personal communication, 2005.

54. Merran Smith, ForestEthics, personal communication. 2005.

55. Websites that contain valuable information about the Great Bear Rainforest and efforts to protect it include the following:

The Rainforest Solutions Project
www.savethegreatbear.org

Coast Forest Conservation Initiative (CFCI)
http://www.coastforestconservationinitiative.com

Central Coast LRMP:
http://srmwww.gov.bc.ca/cr/resource_mgmt/lrmp/cencoast

North Coast LRMP:
http://srmwww.gov.bc.ca/ske/lrmp/ncoast

Haida Gwaii/Queen Charlotte Islands LUP
http://srmwww.gov.bc.ca/cr/qci

Coast Information Team
www.citbc.org

Greenpeace Canada
www.greenpeace.ca

Sierra Club, British Columbia Chapter
www.sierraclub.ca/bc

Forest Ethics
www.forestethics.org

Rainforest Action Network
www.ran.org

56. The account that follows focuses on the logging of Siberia by timber companies and is adapted from work by David Gordon and others at the Siberian Forests Protection Project of Pacific Environment, a nonprofit based in San Francisco, California.

57. Steve Connor, "Fiddling While Siberia Burns: 'Lungs of Europe' Under Threat From Forest Fires," *The Independent*, May 31, 2005. See http://news.independent.co.uk/europe/story.jsp:story=642847.

58. Eugene Linden, *Time*, September 4, 1995.

59. The moist subarctic spruce and fir forests of Europe and North America are also known as taiga.

60. Connor, *op. cit.*

61. Scientific literacy and knowledge is also remarkably sparse in the United States Congress as well.

62. Ricardo Carrere and Larry Lohmann, *Pulping the South: Industrial Tree Plantations and the World Paper Economy* (London and Atlantic Highlands, NJ: Zed Books Ltd. 1996), p. 247.

63. *Ibid.*

64. For more information on substitutes for wood, see "Shopper, Spare That Tree," by Vince Bielski in the July-August 1996 issue of *Sierra*; and for alternatives to tropical wood, contact the Rainforest Action Network for literature on these topics.

65. For a detailed account of the Chipko Movement, see Tariq Banuri and Frederique Apffel Marglin, eds., *Who Will Save the Forests? Knowledge, Power, and Environmental Destruction* (London and Atlantic Highlands, NJ: Zed Books. 1993).

CHAPTER 14

1. *Tree Variety Sets Record*, Associated Press Science Desk story in *The New York Times*, unsigned, November 12, 1996.

2. The UN Development Program Website (http://www.undp.org/biodiversity/biodiversitycd/bioCrisis.htm) states: "Since the total number of species on earth can only be estimated, the exact rate of current species loss is difficult to gauge. *The figure probably stands at between 50 and 150 extinctions per day*" (emphasis added). From my reading of various other divergent scientific estimates, I have come to the conclusion that 130 species is a reasonable estimate. Sources for other information include: The IUCN Red List of Threatened Species, NatureServe, Conservation Information System, GLOBIO, Ecolynx: Information Context for Biodiversity Conservation, and Millenium Assessment.org.

3. Jamie Thomson and Ramzy Kanaan, *Conflict Timber: Dimensions of the Problem in Asia and Africa, Vol. I: Synthesis Report.* The final report was submitted to the U.S. Agency for International Development by ARD, Inc., Burlington, VT., Under Biodiversity and Sustainable Forest Contract No. LAG-I-00-99-00013-00, Task Order 09.

4. Keith Alger, Vice President, Conservation International, telephone interviews with the author, 2005.

5. Thomson and Kanaan, *Conflict Timber.*

6. Esther Schroeder-Wildberg and Alexander Carius, *Illegal Logging, Conflict, and the Business Sector in Indonesia* (Berlin, Germany: Internationale Weiterbildung und Entwicklungg GmbH/Capacity Building International, Germany and Alelphi Research, December 2003). See, also, Peter Gelling, "Forest Loss in Sumatra Becomes a Global Issue," *The New York Times*, December 6, 2007, p. A15.

7. The specific dates were from January 2002 to March 2003. Schroeder-Wildberg and Carius, *ibid.*

8. *Ibid.*

9. "Amazon Deforestation Causing Global Warming, Brazilian Government Says," Correio Braziliense's Website, Brasilia, in Portuguese, December 9, 2004, BBC Monitoring Latin America—Political. Supplied by BBC Worldwide Monitoring. December 10, 2004. See www.bbc.co.uk/world-service.

10. Alger, personal communication, 2005.

11. Larry Rohter, "Brazil, Bowing to Protests, Reopens Logging in Amazon," *The New York Times*, February 13, 2005.

12. *Ibid.*

13. *Ibid.*

14. *Ibid.*

15. The World Bank Group, Forest Governance Program. See http://lnweb18.worldbank.org/ESS/ardext.nsf.

16. According to the World Rainforest Movement's "*Rainforest Destruction: Causes, Effects & False Solutions*" (Penang, Malaysia: World Rainforest Movement, 1990).

17. For further information about the Tropical Forests Action, see the Websites and archives of its sponsors: the UN Food and Agricultural Organisation, UN Environment and Development Programme and the Washington-based NGO World Resources Institute

18. Jorgen Thompsen, Director, Critical Ecosystem Partnership Fund, personal communication, 2005.

19. U.S. Agency for International Development Website (http://www.usaid.gov/our_work_environment/forestry/tfca/html).

20. Title 15, Section 1512 of the Food, Agriculture Conservation and Trade Act of 1990 (P.L. 101-624; 7 U.S.C. 1738).

21. Pervaze A. Sheikh, *Debt-for-Nature Initiatives and the Tropical Forest Conservation Act: Status and Implementation*, Resources, Science, and Industry Division Congressional Research Service (CRS), Library of Congress, CRS Report for Congress, Order Code RL31286.

22. See P.L. 105-214;22 U.S.C. 2431.

23. Alan Thein Durning, *Saving the Forests, What Will It Take?* Worldwatch Paper #117 (Washington, DC: Worldwatch Institute, 1993).

24. Experts at Conservation International refer to these instruments as "conservation concessions."

CHAPTER 15

1. James R. Fazio, *The Woodland Steward* (Moscow, ID: The Woodland Press, 1985).

APPENDIX A

1. See *Federal Register* 70, No. 3 (January 5, 2005), pp. 1023–61; see, also, http://www.fs.fed.us/emc/nfma/includes/rule%20.pdf.

2. Douglas Heiken, Esq., Oregon Natural Resources Council, personal communication, 2005.

3. See *Federal Register, op. cit.*, pp. 1023–61.

4. See discussion of *Committee of Scientists' Report* (USDA March 15, 1999) at http://www.fs.fed.us/emc/nfma/includes/cosreport/Committee%20of%20Scientists%20Report.htm, pp. 1029–31.

5. See *Federal Register, op. cit.*, pp.1021–61.

6. *Ibid.*

7. Pre-publication version of the *Final National Forest System Land Management Planning Rule*, Forest Service Document 3410-11-P. 36 CFR Part 219. RIN 0596-AB86. See Section 3, Overview of the Final 2004 Rule, pp. 5–6.

8. *Ibid.*, p. 11.

9. Douglas Heiken, Esq., Oregon Natural Resources Council, personal communication, 2005.

10. The plan components include desired forest conditions, objectives, guidelines, the suitability of areas for particular uses, and designation of any special areas. See section 219.9, "Regional Guide Content," 36 CFR Part 219. Available at www.wildlaw.org/Eco-Laws/nfmaregs.html and http://www.fs.fed.us/emc/nfma/includes/rule%20.pdf.

11. See *Federal Register, op. cit.,* pp. 1030–33.

12. *Ibid.*

13. *Ibid.*

14. *Ibid.*

15. *Citizens for Better Forestry et al. v. U.S. Department of Agriculture and American Forest & Paper Assn. et al.; Defenders of Wildlife et al. and People of the State of California v. Mike Johanns, Secretary, United States Department of Agriculture, in his official capacity, et al., and American Forest & Paper Assn. et al.,* Ruling No. C. http://www.earthjustice.org/library/legal_docs/nfma-decision-3-30-07.pdf.

APPENDIX B

1. Source: Forest Service Manual 2400—Timber Management, Chapter Zero Code. Section 2401.1—Laws

GLOSSARY

A Note to the Reader: The following terms appear in boldface italics the first time they are used in the text.

AUTOTROPH "Self-feeder." A class of organism, including all green plants, certain bacteria, and certain protozoa, capable of synthesizing organic nutrients from carbon dioxide or carbonates and inorganic nitrogen using energy obtained from light rather than by consuming plants or other autotrophs; also, certain bacteria that obtain their energy from sulfur-containing compounds rather than from solar energy or from other autotrophs.

BOARD FOOT The volume of a board that is a foot in length, a foot in width, and an inch in height, thus 144 cubic inches.

BOREAL The northern terrestrial biogeographic zone of the northern hemisphere characterized biotically by the dominance of coniferous forests and tundra.

CLEARCUT A former forest or timbered site on which all the trees have been cut down.

CLIMAX FOREST A forest community that has reached the final, self-perpetuating stage of its natural ecological development for a particular climate and site. No new species will become dominant in a climax community unless the ecosystem is assailed by invasive species or by natural disturbances, such as avalanches, earthquakes, fires, floods, and windstorms. Absent these perturbations, the system will remain dynamically stable.

CONIFEROUS A wooded area dominated by trees of the order *Pinales* that bear cones.

CONTROLLED BURN (also known as a PRESCRIBED BURN) An intentionally set and contained fire in a forest or stand of trees (or in other ecosystems, such as prairie) ignited for the purpose of improving the area's ecological health or condition (e.g., by reducing the accumulation of flammable material or by controlling pests, pathogens, or invasive species).

DECIDUOUS The dropping or shedding of leaves (or fruit, petals, antlers, and hair) on an annual basis at the end of the growing season.

DECOMPOSER An organism that feeds on dead organic matter and thus facilitates the breakdown or decay of that organic matter into simpler compounds.

DETRITUS Loose fragmentary material found on the forest floor, derived from the breakup of rock or organic material, or found on the bed of an aquatic system, including dead leaves, twigs, decaying and excreted matter.

EDGE EFFECT An ecological stress radiating into a forest from its periphery where the forest ecosystem meets unforested land, often land that has been wholly or partially deforested or developed. At the forest margin, the forest is exposed to sunlight, the drying influence of wind, the danger of windthrow, and the incursion of species that do not normally inhabit the forest interior. The term "edge effect" also refers to the convergence zone of two ecosystems wherein an increase in habitat diversity is produced that then supports an increase in species diversity and abundance.

EPIPHYTE A nonparasitic plant that grows on another plant or inanimate structure and gets its nutrients and moisture from the air.

EVAPOTRANSPIRATION The loss of water resulting from a combination of evaporation from soil and water surfaces, plant surfaces, and plant transpiration (the removal of water from soil by plants and its subsequent release as water vapor to the atmosphere).

EVERGREEN Nondeciduous and, therefore, perennially green plants.

FOOD WEB (also known as a FOOD PYRAMID) The network of organisms that supply and consume food (nutrients and energy) in an ecosystem. In a simpler linear component of a food web known as a food chain, the organisms that are lower on the chain (closer to the autotrophs at its base) supply food to those higher up.

FOREST PLAN A strategic document outlining management goals, objectives, and practices for a forest.

FRONTIER FOREST A large, relatively natural, relatively undisturbed, and essentially intact natural forest.

HETEROGENEITY The state or quality of being heterogeneous (i.e., having a dissimilar, irregular, or otherwise diverse nature, components or ingredients); a heterogeneous habitat thus provides a large range of ecological niches (see NICHE).

HETEROTROPHS The class of organisms that feeds upon autotrophs because it is unable to combine carbon dioxide or carbonates with inorganic nitrogen to produce its own complex organic compounds.

INDUSTRIAL FOREST A forest managed mainly for the production of wood and fiber and owned by a company that has wood processing capacity and a full-time forestry staff.

INTEGRATED PEST MANAGEMENT (IPM) A sophisticated system of controlling forest diseases and pests through a combination of applied ecology (e.g., use of natural predators, elimination of alternate hosts, and modified cutting) and strategic applications of pesticide based on knowledge of pest life cycles and population dynamics in order to achieve pest control with a minimum amount of pesticide.

MICROCLIMATE The highly variable meteorological conditions found on different small parts of a site because of local geophysical features that produce variations in moisture, shading, temperature, and sheltering.

MICROSITE A specific small location on a site having a set of distinctive ecological conditions favorable to certain organisms with regard to moisture, soil, exposure, and illumination.

MONOCULTURE The cultivation of a single species of plant to the exclusion of other species.

MONTANE The biogeographic zone of cool, moist mountain slopes below timberline dominated by large conifers and associated plants.

MYCELIUM A mass of interwoven hyphae (filaments) produced by fungi (and some bacteria) and penetrating the host or substrate to which the fungi are attached.

MYCORRHYZAE Soil fungi that grow on decaying matter and symbiotically in contact with the roots of certain trees and other vegetation, exchanging inorganic nutrients (mainly phosphorus) with those roots in return for sugars and other compounds.

NATIVE FOREST A forest comprising all of the species and habitats indigenous to that locale.

NICHE A particular type of physical locale providing the specific conditions required for a particular organism; also, the particular role that an organism or taxon fulfills in its ecosystem, as indicated by its activities and resource use.

OLD-GROWTH FOREST A structurally complex natural forest ecosystem with large, old, living and dead trees along with downed wood and understory vegetation overshadowed by a canopy showing the accumulated effects and irregularities of multiple disturbances.

PATCH CUT A clearcut of relatively small area surrounded by uncut forest or stands.

PERCOLATION The infiltration of water through forest soil into an underlying aquifer.

PHOTOSYNTHESIS A series of biochemical reactions through which plants use chlorophyll and other light-absorbing pigments to transform carbon dioxide and water into carbohydrates and molecular oxygen with the energy derived from visible light.

PRESCRIBED BURN (see CONTROLLED BURN)

RESPIRATION A biological process in which plants, trees, and other living organisms intake oxygen and release carbon dioxide as a result of the oxidation of organic substances.

ROTATION The period of time required for timber regeneration between successive timber harvests.

SALE AREA IMPROVEMENT PLAN (SAIP) A management plan for the modification of a logged site in order to improve it or to mitigate the damage done by logging. Typically, the plan includes reforestation or thinning and control of animals and any vegetation that competes with the crop of trees to be raised.

SALVAGE LOGGING Commercial removal of diseased, dead, damaged, or dying timber.

SECOND GROWTH A forest or timber stand that has regenerated following logging of the natural forest.

SEED TREE CUT The silvicultural system in which all but a few seed trees are removed, leaving only the seed trees thinly dispersed over the logging site to provide seed for the next generation. Once these new trees become established, the seed trees themselves are cut.

SHELTERWOOD CUT A modified clearcut very similar to a seed tree cut but with more trees left standing to shelter the next generation. Once the newly seeded trees become established, the overstory trees are removed.

SILVICS The study of the life histories and characteristics of forest trees, especially as influenced by environmental factors.

SILVICULTURE The branch of forestry concerned with controlling the establishment, growth, reproduction, and care of forest trees for commercial use.

SOIL SEED BANK The accumulation of seeds, fruits, and propagules found in or on the soil, even after removal of trees or other vegetation.

STOMATA Microscopic pores on the leaf cuticles of plants that control the amount and rate of water vapor released from plants as well as the exchange of oxygen and carbon dioxide.

SUCCESSION Directional change of an ecosystem with regard to species composition (and, for forests, with regard to stand structure) in response to disturbance.

SUSTAINABLE FORESTRY Forestry practice that protects the whole forest as an ecosystem and limits the extraction of its products to their incremental growth between cycles of extraction.

SUSTAINED YIELD The amount of timber and other forest services that can be continuously produced in perpetuity from a forest or stand managed for timber production without degradation; more narrowly, a volume of timber cut but one that is replaced by new forest growth in the period between cuts.

TAIGA The boreal, often moist or swampy, coniferous forest ecosystems covering vast regions of the North American and Eurasian subarctic.

THERMAL ISLAND EFFECT The absorption and reradiation of solar energy as heat, producing an increase in temperature in the immediate vicinity of a heat-absorbing structure, such as a tree trunk or boulder.

TIMBER HARVEST PLAN (THP) A document required by the California Forest Practices Act setting forth the requirements that must be met for the conduct of a logging operation..

TIMBER STAND IMPROVEMENT Activities (such as precommercial thinning, commercial thinning, brush control, pesticide and herbicide applications) designed to improve the quality and quantity of timber produced.

VECTOR A mobile species (such as an aphid carrying a plant virus) capable of transmitting a pathogen from one host to another; also, any organism harboring the pathogen during a phase of its life cycle.

WATER BARS An earthen ridge or other erosion-control structure (such as a wooden beam embedded in or staked to the ground) across a hilly road to divert water off to the side.

WATERCOURSE Any stream or streambed capable of moving water and, therefore, capable of transporting sediment and debris.

WATERSHED The expanse of land from which water flows into a water body; also, a drainage basin.

WATER TABLE The below-ground level at which the ground is saturated with water.

WINDTHROW A tree uprooted by wind.

YARDING Skidding, dragging, or otherwise moving a log from its stump to a loading area or truck for removal.

TEXT REFERENCES AND RECOMMENDED READING

A Note to the Reader: An asterisk (*) denotes a book of special interest.

Alverson, William S., Walter Kuhlmann, and Donald M. Waller. *Wild Forests: Conservation Biology and Public Policy* (Covelo, CA, and Washington, DC: Island Press, 1994).

American Lands Alliance. *This Land is Your Land: The Bush Administration's Assault on America's National Forest Legacy* (Washington, DC: www.american-lands.org, 2004).

Atyi, Richard Eba'a, and Markku Simula. "Forest Certification: Pending Challenges for Tropical Timber." Background paper presented at ITTO International Workshop on Comparability and Equivalence of Forest Certification Schemes. Kuala Lumpur, April 3–4, 2002.

Banuri, Tariq, and Frederique Apffel Marglin, eds. *Who Will Save the Forests? Knowledge, Power and Environmental Destruction* (London and New Jersey: Zed Books, 1993).

Berger, John J. *Restoring the Earth: How Americans Are Working to Renew Our Damaged Environment* (New York: Alfred A. Knopf, 1985, and Doubleday Anchor Books, 1987), especially Chapter 5, "Redwoods Rising," pp. 69–78.

_____, ed. *Environmental Restoration: Science and Strategies for Restoring the Earth,* (Covelo, CA, and Washington, DC: Island Press, 1990).

Blencowe, Craig. "Building Up the Forest." In Institute for Sustainable Forestry, *Working Your Woods: An Introductory Guide to Sustainable Forestry* (Redway, CA: Institute for Sustainable Forestry, 1996).

Bradshaw, A. D., and M. J. Chadwick. *The Restoration of Land: The Ecology and Reclamation of Derelict and Degraded Land* (Berkeley and Los Angeles: University of California Press, 1980).

Brechin, Stephen R. *Planting Trees in the Developing World: A Sociology of International Organizations* (Baltimore: The Johns Hopkins University Press, in association with the Center for American Places, 1997).

Brown, R. *Thinning, Fire, and Forest Restoration: A Science-Based Approach for National Forests in the Interior Northwest* (Washington, DC: Defenders of Wildlife, 2000).

Cairns, J., Jr. *The Recovery Process in Damaged Ecosystems* (Ann Arbor: Ann Arbor Science Publishers, 1980).

Cairns, J., Jr., K. L. Dickson, and E. E. Herricks. *Recovery and Restoration of Damaged Ecosystems* (Charlottesville: University Press of Virginia, 1975).

Carrere, Ricardo, and Larry Lohmann. *Pulping the South: Industrial Tree Plantations and the World Paper Economy* (London and Atlantic Highlands, NJ: Zed Books, 1996).

Cascade Holistic Economic Consultants. *The Citizen's Guide to the Forest Industry.* Special Issue of *Forest Watch*, Vol. 12, No. 1 (1991).

Caufield, Catherine. *In the Rainforest* (New York: Alfred A. Knopf, 1985).

Chadwick, M. J., and G. T. Goodman. *The Ecology of Resource Degradation and Renewal* (New York: John Wiley & Sons, 1975).

Chase, Alston. *In a Dark Wood: The Fight Over Forests and the Rising Tyranny of Ecology* (New York: Houghton Mifflin, 1995).

Coile, Zachary. "Wildlife Scientists Feeling Heat." *San Francisco Chronicle*, February 10, 2005.

Correio Braziliense's Website. "Amazon Deforestation Causing Global Warming, Brazilian Government Says." Brasilia, in Portuguese, December 9, 2004, BBC Monitoring Latin American—Political. Supplied by BBC Worldwide Monitoring. December 10, 2004. www.bbc.co.uk/worldservice.

Council on Environmental Quality. *Global Future: Time to Act.* Report to the President on Global Resources, Environment and Population (Washington, DC: Government Printing Office, 1981).

Cubbage, F. W. "Regulation of Private Forest Practices: What Rights, Which Policies?" *Journal of Forestry*, Vol. 93, No. 6 (1995): 14–20.

Dana, Samuel Trask, and Sally K. Fairfax. *Forest and Range Policy* (New York: McGraw-Hill Book Company, 1980).

Darwin, Charles. *The Voyage of the Beagle* [originally published in 1839 as *Journal of Researches*], edited with an introduction by Janet Browne and Michael Neve (London: Penguin Books, 1989).

* Davis, Mary Byrd (ed.). *Eastern Old Growth Forests: Prospects for Rediscovery and Recovery*, (Covelo, CA, and Washington, DC: Island Press, 1996).

* Devall, Bill. *Clearcut: The Tragedy of Industrial Forestry* (San Francisco: Sierra Club/Earth Island Press, 1994).

Devine, Robert S. *Bush Versus the Environment* (New York: Anchor Books/Random House, 2004).

Doughty, Robin W. *The Eucalyptus: A Natural and Commercial History of the Gum Tree* (Baltimore: The Johns Hopkins University Press, in association with the Center for American Places, 2000).

* Dudley, Nigel, Jean-Paul Jeanrenaud, and Francis Sullivan. *Bad Harvest? The Timber Trade and the Degradation of the World's Forests* (London: Earthscan Publications, Ltd., 1999).

Dunning, Joan, with photographs by Doug Thron. *From the Redwood Forest: Ancient Trees and the Bottom Line: A Headwaters Journey* (White River Junction, VT: Chelsea Green Books, 1999).

Durning, Alan Thein. *Saving the Forests: What Will It Take?* (Washington, DC: Worldwatch Institute, 1993).

Edlin, Herbert, and Maurice Nimmo. *The Illustrated Encyclopedia of Trees: Timbers and Forests of the World* (New York: Harmony Books, 1978).

Ehrlich, Paul, and Anne Ehrlich. *Extinction: The Causes and Consequences of the Disappearance of Species* (New York: Random House, 1981).

Fazio, James R. 1985. *The Woodland Steward* (Moscow, ID: The Woodland Press, 1985).

Ferraro, Paul J., and Agnes Kiss, "Direct Payments to Conserve Biodiversity." *Science*, Vol. 298, No. 5599 (2002): 1718–19.

Food and Agriculture Organization of the United Nations. *Forestry 1993 Statistics Today for Tomorrow* (Rome), p. 47.

Foss, Tim. "New Forestry: A State of Mind." In Michael Pilarski, ed. *Restoration Forestry: An International Guide to Sustainable Forestry Practices* (Durango, CO: Kivaki Press, 1994).

Fox, Stephen. *John Muir and His Legacy: The American Conservation Movement* (Boston: Little, Brown and Company, 1981).

Franklin, Jerry F. 1995. "Scientists in Wonderland: Experiences in Development of Forest Policy." *Bioscience* supplement (1995): 74–78.

Gradwohl, Judith, and Russell Greenberg. *Saving the Tropical Forests* (Covelo, CA, and Washington, DC: Island Press, 1988).

Guha, Ramachandra. "The Malign Encounter: The Chipko Movement and Competing Visions of Nature." In Banuri and Marglin, eds., *op. cit.*

*Hammond, Herb. *Seeing the Forest Among the Trees: The Case for Wholistic Forest Use* (Vancouver, BC: Polestar Press, 1991).

Hardner, Jared, and Richard Rice. "Rethinking Green Consumerism." *Scientific American* (May 2002): 89–95. See, also, www.sciam.com.

Hardt, R. A. and D. H. Newman. "Regional Policies for National Forest Old-Growth Planning." *Journal of Forestry,* Vol. 93, No. 6 (1995): 32–35.

Henning, Daniel H., and William R. Mangun. *Managing the Environmental Crisis* (Durham: Duke University Press, 1989).

Herndon, Grace. *Cut & Run: Saying Goodbye to the Last Great Forests in the West* (Telluride, CO: Western Eye Press, 1991).

Hicks, Ray R., Jr. *Ecology and Management of Central Hardwood Forests* (Hoboken, NJ: John Wiley & Sons, 1998).

Higgs, E. S. "What Is Good Ecological Restoration?" *Conservation Biology,* Vol. 11, No. 2 (1997): 338–48.

Hirt, Paul W. *A Conspiracy of Optimism: Management of the National Forests Since World War Two* (Lincoln: University of Nebraska Press, 1994).

Holdgate, M. W., and M. J. Woodman. *The Breakdown and Restoration of Ecosystems* (New York: Plenum Press, 1978).

Institute for Sustainable Forestry. *Pacific Certified Ecological Forest Products Landowner and Forester Handbook* (Redway, CA: Institute for Sustainable Forestry, 1994).

_____. *Working Your Woods: An Introductory Guide to Sustainable Forestry* (Redway, CA: Institute for Sustainable Forestry, 1996).

International Institute for Environment and Development. *Valuing Forests: A review of methods and applications in developing countries.* Environmental Economics Programme, series case studies on markets for environmental services (London, England: International Institute for Environment and Development, 2003).

Jordan, Richard. *Trees and People: Forestland, Ecosystems and Our Future* (Washington, DC: Regnery Publishing, Inc., 1994).

Karr, James R. "Health, Integrity, and Biological Assessment: The Importance of Measuring Whole Things." In David Pimentel, Laura Westra, and Reed Noss, eds., *op. cit.*

Karr, James R., and D. R. Dudley. "Ecological Perspective on Water Quality Goals." *Environmental Management,* Vol. 5, No. 1 (1981): 55–68.

Kelly, Brian, and Mark London. *Amazon* (New York: Harcourt Brace Jovanovich, 1983).

Kennedy., Jr., Robert F. *Crimes Against Nature: How George W. Bush and His Corporate Pals Are Plundering the Country and Hijacking Our Democracy* (New York: HarperCollins, 2004).

Kimmins, Hamish. *Balancing Act: Environmental Issues in Forestry* (Vancouver: University of British Columbia Press, 1992).

* Lamb, David, and Don Gilmour. *Rehabilitation and Restoration of Degraded Forests* (Gland, Switzerland and Cambridge, England: International Union for the Conservation of Nature, 2003).

*Leopold, Aldo. *A Sand County Almanac and Sketches Here and There* (New York: Oxford University Press, 1949).

Lanner, Ronald M. *Conifers of California* (Los Olivos, CA: Cachuma Press, 1999).

Line, Les, ed. *The National Audubon Society: Speaking for Nature* (New York: National Audubon Society, 1999).

* Little, Charles E. *The Dying of the Trees: The Pandemic in America's Forests* (New York: Viking, 1994).

MacCleery, Douglas W. *American Forests: A History of Resiliency and Recovery* (Durham, NC: Forest Historical Society, 1996).

_____. "A Forest Retrospective." *Forest Watch,* Vol. 12, No. 2. (1991): 20–25.

_____."America's Forests, The Graphic Facts." *Forest Watch,* Vol. 11, No. 5 (1990): 20–25.

_____. "Resiliency and Recovery: A Brief History of Conditions and Trends in U.S. Forests." *Forest & Conservation History,* Vol. 38 (1994): 135–39.

MacDougall, A. Kent. Four-part series in *The Los Angeles Times* on forest conservation: "Worldwide Costs Mount as Trees Fall" (June 14, 1987); "Need for Wood Forestalled Conservation" (June 17, 1987); "Drought, Floods, Erosion Add to Impact of Tree Loss" (June 19, 1987); "Forest Reclamation: Last Resort After Conservation" (June 22, 1987).

MacLean, Jayne T. *Herbicides: Ecological Effects January 1985–September 1991.* Quick Bibliography Series, 92–06 (Beltsville, MD: National Agricultural Library, 1991).

Malhotra, K. C., and Mark Poffenberger. *Forest Regeneration through Community Protection: The West Bengal Experience.* Proceedings of the Working Group Meeting on Forest Protection Committees (Calcutta, India: West Bengal Forest Department and Indian Institute for BioSocial Research and Development, 1989).

Margolin, Malcolm. *The Earth Manual: How to Work on Wild Land Without Taming It* (Berkeley, CA: Heyday Books, 1985).

* Maser, Chris. *Sustainable Forestry: Philosophy, Science, and Economics* (Del Ray Beach, FL: Saint Lucie Press, 1994).

* McEvoy, Thom J. *Positive Impact Forestry: A Sustainable Approach to Managing Woodlands* (Covelo, CA, and Washington, DC: Island Press, 2004).

Meyers, Norman. "The World's Forest: Need for a Policy Appraisal." *Science,* Vol. 268, No. 5212 (1995): 823–34.

Middleton, David. *Ancient Forests: A Celebration of North America's Old-Growth Wilderness* (San Francisco: Chronicle Books, 1992).

Mitchell, John G. *Dispatches from the Deep Woods* (Lincoln: University of Nebraska Press, 1991).

Naar, Jon. *Design for a Livable Planet* (New York: Harper & Row Publishers, 1990).

Naar, Jon, and Alex J. Naar. *This Land is Your Land: A Guide to North America's Endangered Ecosystems* (New York: HarperCollins Publishers, 1992).

National Council for *Science and the Environment. Science and Sustainable Forestry: A Findings Report of the National Commission on Science for Sustainable Forestry* (Washington, DC.: National Council for Science and the Environment, 2004).

Nemetz, Peter N., ed. *Emerging Issues in Forest Policy* (Vancouver: University of British Columbia Press, 1992).

Niesten, E., and Richard Rice. "Conservation Incentive Agreements as an Alternative to Tropical Forest Exploitation." Chapter 24 in William F. Laurance and Carlos A. Peres, eds. *Emerging Threats to Tropical Forests* (Chicago: University of Chicago Press, 2006).

Noss, Reed F., and Allen Y. Cooperider. *Saving Nature's Legacy: Protecting and Restoring Biodiversity* (Covelo, CA, and Washington, DC: Island Press, 1994).

Pagiola, S., K. von Ritter, and J. Bishop. *Assessing the Economic Value of Ecosystem Conservation.* Environment Department Paper No. 101 (Washington, DC: The World Bank, 2004).

Pavlik, Bruce M., Pamela C. Muick, Sharon Johnson, and Marjorie Popper. *Oaks of California* (Los Olivos, CA: Cachuma Press/California Oak Foundation, 1991).

Perlin, John. *A Forest Journey: The Role of Wood in the Development of Civilization* (New York: W. W. Norton and Company, 1989).

Peterken, George F. *Woodland Conservation and Management* (London and New York: Chapman & Hall, 1993).

* Pilarski, Michael, ed. *Restoration Forestry: An International Guide to Sustainable Forestry Practices* (Durango, CO: Kivaki Press, 1994).

Pimentel, David, Laura Westra, and Reed Noss, eds. *Ecological Integrity: Integrating Environment, Conservation, and Health* (Covelo, CA, and Washington, DC: Island Press, 2000).

Preston, B. B. "Forestry in the 104th Congress: Political Winds in America's Forestlands." *Journal of Forestry,* Vol. 93, No. 6 (1995): 4–7.

Poore, Duncan. *Changing Landscapes: The Development of the International Tropical Timber Organization and Its Influence on Tropical Forest Management* (London: Earthscan Publications Ltd., 2003).

* Raphael, Ray. *Tree Talk* (Covelo, CA, and Washington, DC: Island Press, 1982).

* _____. *More Tree Talk* (Covelo, CA, and Washington, DC: Island Press, 1994).

Reed, David D., and Glenn D. Mroz. *Resource Assessment in Forested Landscapes* (Hoboken, NJ: John Wiley & Sons, 1997).

Rice, Richard. *Conservation Incentive Agreements—Concept Description* (Center for Applied Biodiversity Science, unpublished monograph, 2004).

Rice, Richard E., Cheri A. Sugal, Shelley M. Ratay, and Gustavo A. B. da Fonseca. *Sustainable Forest Management: A Review of Conventional Wisdom.* Advances in Applied Biodiversity Science, No. 3 (Washington, DC: Center for Applied Biodiversity Science/Conservation International, 2001).

* Robinson, Gordon. *The Forest and the Trees: A Guide to Excellent Forestry* (Covelo, CA, and Washington, DC: Island Press, 1988).

Rothman, Hal K. *Saving the Planet: The American Response to the Environment in the Twentieth Century* (Chicago: Ivan R. Dee, 2000).

Schliechtl, Hugo. *Bioengineering for Land Reclamation and Conservation* (Edmonton: University of Alberta Press, 1980).

Schreuder, Hans T., Timothy G. Gregoire, and Geoffrey B. Wood. *Sampling Methods for Multiresource Forest Inventory* (Hoboken, NJ: John Wiley & Sons, 1993).

Schroeder-Wildberg, Esther, and Alexander Carius. *Illegal Logging: Conflict and the Business Sector in Indonesia* (Berlin, Germany: Internationale Weiterbildung und Entwicklungg GmbH/Capacity Building International, Germany and Alelphi Research, 2003).

Steelquist, Robert. "Salmon & Forests: Fog Brothers—Exploitation of Trees and Salmon in the Pacific Northwest—Watershed Wars." *American Forests* (July–August 1992).

Tainter, F. H., and F. A. Baker. *Principles of Forest Pathology* (Hoboken, NJ: John Wiley & Sons, 1996).

Tandy, Cliff. *Landscape of Industry* (London: Leonard Hill Books, 1975).

Thomas, William L., Lewis Mumford, and Carl O. Sauer. *Man's Role in Changing the Face of the Earth* (Chicago: University of Chicago Press, 1956).

United Nations Development Programme, United Nations Environment Programme, World Bank, World Resources Institute. "Data Tables." In *World Resources 2002–2004: Decisions for the Earth: Balance, Voice, and Power* (Washington, DC: World Resources Institute, 2003).

Ulrich, Alice. *U.S. Timber Production, Trade, Consumption, and Price Statistics 1960–1988.* Miscellaneous Publication No. 1486 (Washington, DC: USDA Forest Service, 1990).

U.S. Department of Agriculture. *Report of the Forest Service* (Washington, DC: USDA Forest Service, undated).

* Wayburn, M. D., Edgar. *Your Land and Mine: Evolution of a Conservationist* (San Francisco: Sierra Club Books, 2004).

Wenger, Karl F., ed. *Forestry Handbook, Second Edition* (Hoboken, NJ: John Wiley & Sons, 1984).

West, Terry L. *Centennial Mini-Histories of the Forest Service* (Washington, DC USDA Forest Service, 1991).

Wilderness Society. *National Forests: Policies for the Future, Vols. I–IV* (Washington, DC: The Wilderness Society, 1988).

Wilderness Society, et al. *National Forest Planning: A Conservationist's Guide* (Washington, DC: The Wilderness Society, 1983).

Wilkinson, Merv. "Wildwood: A Forest for the Future." In Michael Pilarski, ed., *op. cit.*

Wolf, Edward C. *Klamath Heartlands: A Guide to the Klamath Reservation Forest Plan* (Portland, OR: Ecotrust, 2004).

World Rainforest Movement. *Rainforest Destruction: Causes, Effects & False Solutions* (Penang, Malaysia: World Rainforest Movement, 1990).

Worster, Donald. *Nature's Economy: The Roots of Ecology* (Garden City, NY: Anchor Books, Anchor Press/Doubleday: 1979).

Zuckerman, Seth. *Saving Our Ancient Forests* (Los Angeles: Living Planet Press, 1991).

INDEX

ABOUT THE AUTHOR

JOHN J. BERGER is an author and consultant specializing in natural resources, energy, and the environment. His books include *Beating the Heat: How and Why We Must Combat Global Warming* (Berkeley Hills Books, 2000); *Understanding Forests* (Sierra Club Books, 1998); *Charging Ahead: The Business of Renewable Energy and What It Means for America* (Henry Holt, 1997, and University of California Press, 1998); *Ecological Restoration in the San Francisco Bay Area* (Restoring the Earth, 1990); editor, *Environmental Restoration: Science and Strategies for Restoring the Earth* (Island Press, 1990); *Restoring the Earth: How Americans Are Working to Renew Our Damaged Environment* (Alfred A. Knopf, 1985, and Doubleday Anchor Books, 1987); and *Nuclear Power, The Unviable Option: A Critical Look At Our Energy Alternatives* (Ramparts Press, 1976, and Dell Books, 1977). Berger received his B.A. in political science from Stanford University, his M.A. in energy and natural resources from the University of California, Berkeley, and his Ph.D. in ecology from the University of California, Davis. He has served as a special consultant on environmental restoration science and policy to the National Research Council of the National Academy of Sciences and as a consultant on restoration ecology to the Office of Technology Assessment of the U.S. Congress, and he has been an adjunct professor of environmental science at the University of San Francisco and a visiting associate professor of environmental policy at the Graduate School of Public Affairs of the University of Maryland. His popular writing on environmental issues has appeared in publications such as *Audubon, The Boston Globe, The Los Angeles Times, Omni,* and *Sierra.* Currently, he is writing once again on global climate change and on natural resource issues in Alaska. He resides in El Cerrito, California, and maintains an office in Berkeley, California.

FORESTS FOREVER

FORESTS FOREVER FOUNDATION

Founded in 1998, Forests Forever Foundation's mission is to inform and educate Californians about the health and protection of the state's seventeen million acres of diverse woodlands.

A chief source of drinking water, wildlife, and spiritual refreshment, California's magnificent forests help define the special character of the place where we live. Forests Forever Foundation fulfills a unique function in the forestry-reform community by carrying out a program of broad-based citizen education through direct-contact grassroots organizing.

Forests Forever coalesced around the campaign to save the Headwaters Forest. Located in Humboldt County near Eureka, Headwaters Forest was slated for logging by Pacific Lumber Company. Forests Forever generated crucial public pressure on decision-makers through thousands of letters, calls, faxes, and petition signatures. The campaign helped bring about the eventual acquisition of the 7,500-acre Headwaters Preserve by the state and federal governments.

Forests Forever Foundation conducts research, mounts litigation, and sponsors publishing activities to educate the public on forest issues.

For more information on Forests Forever's work to protect and restore California's forests and watersheds, please write or phone at 50 First Street, #401, San Francisco, CA 94105; (415)974-3636; fax: 415/974-3664. More information on individual campaigns may also be found at http://www.forestsforever.org

Center for American Places
AT COLUMBIA COLLEGE CHICAGO

THE CENTER FOR AMERICAN PLACES AT COLUMBIA COLLEGE CHICAGO is a nonprofit organization, founded in 1990 by George F. Thompson, whose educational mission is to enhance the public's understanding of, appreciation for, and affection for the places of the Americas and the rest of the world—whether urban, suburban, rural, or wild. Underpinning this mission is the belief that books provide an indispensable foundation for comprehending and caring for the places where we live, work, and commune. Books live. Books endure. Books make a difference. Books are gifts to civilization.

With offices in Chicago, Santa Fe, and Staunton, Virginia, the Center has brought to publication more than 320 books under the Center's imprint and in association with many publishing partners. Center books have won or shared more than 100 editorial awards and citations, including multiple best-book honors in more than thirty academic fields.

For more information, please send inquiries to the Center for American Places at Columbia College Chicago, 600 South Michigan Avenue, Chicago, IL 60605–1996, U.S.A., or visit the Center's Website (www.americanplaces.org).

ABOUT THE BOOK:

Forests Forever: Their Ecology, Restoration, and Protection is the second volume in the *Center Books in Natural History* series, George F. Thompson, series founder and director. The book is a completely revised, updated, and expanded version of John J. Berger's *Understanding Forests* (Sierra Club Books, 1998), and it was brought to publication with the generous financial assistance of the Forests Forever Foundation, Friends of the Center for American Places, and the many individuals and foundations mentioned in the author's acknowledgments.

Forests Forever was issued as a "green book" in an edition of 500 hardcover and 3,500 paperback copies. The text was set in New Baskerville. The paper is certified 100% post-consumer waste recycled Chinese Goldeast, 128 gsm weight for the text and 140 gsm weight for the galleries. The book was professionally printed and bound in China.

For more information about the Forests Forever Foundation and the Center for American Places at Columbia College Chicago, please see pages 304–05.

FOR THE CENTER FOR AMERICAN PLACES AT COLUMBIA COLLEGE CHICAGO:

George F. Thompson, Founder and Director
Randall B. Jones, Independent Editor
Amber K. Lautigar, Operations Manager and Marketing Coordinator
A. Lenore Lautigar, Associate Editor and Publishing Liaison
Ashleigh A. Frank, Catherine R. Babbie,
 and Elizabeth S. Dattilio, Assistant Editors
Kristine K. Harmon and Purna Makaram, Manuscript Editors
David Skolkin, Book Designer and Art Director
Marcie McKinley, Design Assistant
Dave Keck, of Global Ink, Inc., Production Coordinator